THE INNOCENT EYE

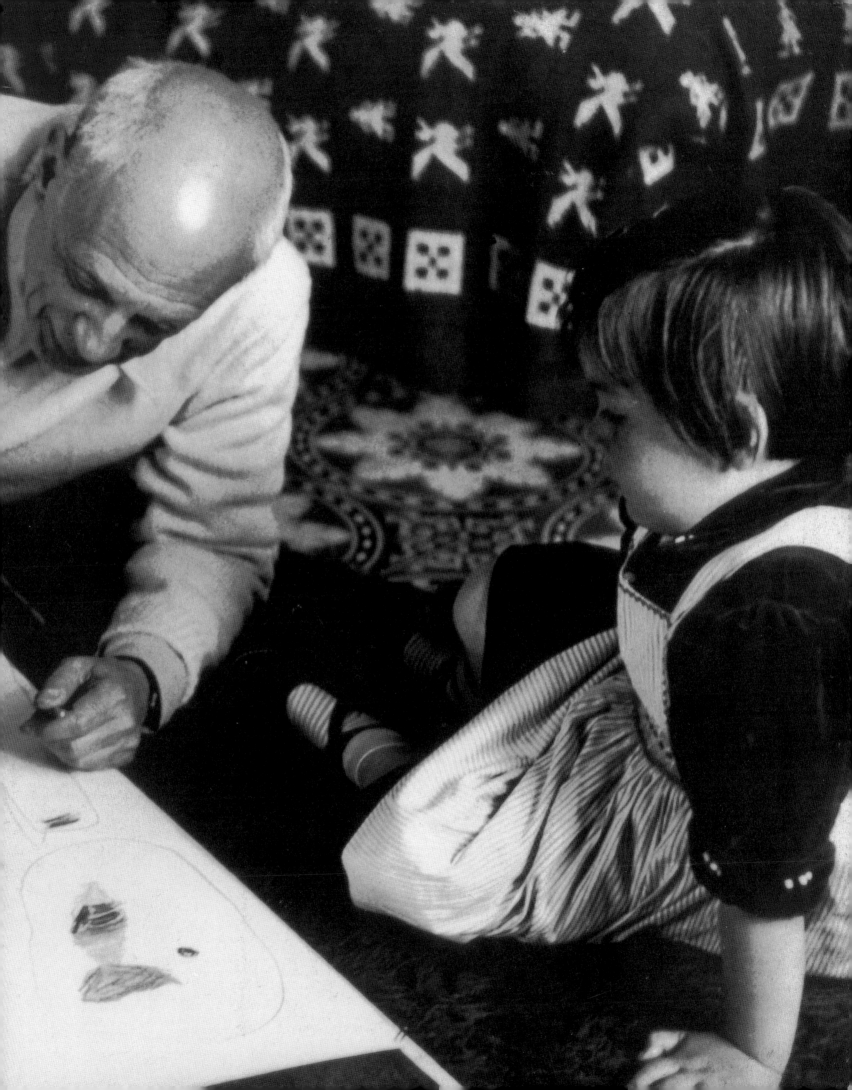

THE INNOCENT EYE

Children's Art and the Modern Artist

Jonathan Fineberg

PRINCETON UNIVERSITY PRESS

Copyright © 1997 by Jonathan Fineberg
Published by Princeton University Press, 41 William Street,
Princeton, New Jersey 08540
In the United Kingdom: Princeton University Press, Chichester, West Sussex

Library of Congress Cataloging-in-Publication Data

Fineberg, Jonathan David.
 [Mit dem Auge des Kindes. English]
 The innocent eye : children's art and the modern artist / Jonathan
Fineberg.
 p. cm.
 Includes bibliographical references.
 ISBN 0-691-01685-2 (CL : acid-free paper)
 1. Children's art. 2. Child artists—Psychology. 3. Art,
Modern—20th century—Themes, motives. 4. Art, Comparative.
I. Title.
N352.F47513 1997
704'.054—dc21 97-4341

Publication of this book has been aided by a grant from the Research Board
of the University of Illinois at Urbana-Champaign and a grant from the Millard
Meiss Publication Fund of the College Art Association of America

MM

This book has been composed in Linotronic Futura by
The Composing Room of Michigan, Inc.

Princeton University Press books are printed on acid-free paper and meet the
guidelines for permanence and durability of the Committee on Production Guidelines
for Book Longevity of the Council on Library Resources

Printed in Singapore by CS Graphics

10 9 8 7 6 5 4 3 2 1

10 9 8 7 6 5 4 3 2 1 (pbk.)

Design adapted by Carol S. Cates

Jacket illustrations: (front) Paul Klee, Burnt Mask, 1939, Private collection, Switzerland,
© 1997 Artists Rights Society (ARS), New York/VG Bild-Kunst, Bonn; (back) Joan Miró
holding a drawing by his daughter Dolorès and discussing it with her, ca. 1938.
Photograph courtesy Dolorès Miró

To all creative children—which is *all* children until they are told otherwise—
and especially to my own creators of "original children's art":
Maya, **Naomi**, and **Henry**.

CONTENTS

PREFACE AND ACKNOWLEDGMENTS

This book (and the exhibition it became in Munich and Bern in 1995) began more than a decade ago when the Detroit Institute of Arts asked my teacher and friend Rudolf Arnheim, who by then had retired from Harvard to Ann Arbor, to curate an exhibition comparing children's art with great works of modern art. He sent them to me and they eventually dropped out of the project. But after getting over my initial skepticism I was hooked. Indeed following out Arnheim's intuitive lead proved to be the most exciting journey into art history I have ever undertaken.

I went first to the prewar works of Kandinsky on which I had written my doctoral dissertation. Looking at Kandinsky's first abstractions of 1909–14 with this question in mind I recognized a range of reference to child styles of rendering that made me certain the artist must have studied children's art in detail. He simply knew too much about it! There were of course passages in his art theory that pointed to this, but like everyone else I hadn't taken them seriously enough.

Once I realized that Kandinsky must have had an extensive collection of child art it wasn't hard to figure out where it would be if it still existed: I went straight to the storage taken from the Murnau house he had shared with Gabriele Münter before the war. I asked my friend Armin Zweite—then director of the Gabriele Münter archive and director of the Lenbachhaus—to look among the papers of Gabriele Münter for a collection of this kind and he found it immediately. This remarkable find set me on a systematic course of investigation that led, over the next ten or so years, to the astonishing discovery of the original collections of children's works that belonged to one major master after another.

Almost the only literature on this subject was a chapter in the book on *Primitivism in Twentieth Century Art* written by Robert Goldwater (1986), who had concluded with regard to these very same artists that "motif-by-motif comparisons with individual child pictures are not very fruitful" (p. 199). On the contrary, such comparisons turned out to be *very* fruitful; indeed, the discovery of this body of source material has opened for me a hitherto unavailable glimpse into the creative processes of the greatest artists of the twentieth century—and in every case the motives which led each artist to child art and the influences it had upon their own oeuvres are utterly different.

I hope this book will allow us to acknowledge without fear what even the

most uninformed viewer of modern art has always intuitively known: that a fundamental connection exists between modern art and the art of children. But in validating this perception I hope to lead such a viewer beyond the reductive assertion of similarities to a fuller understanding of the profound human questions that drive artists to do the work they do. Seeing how modern artists have looked at the art of children forces us, as artists often do, to reconsider the images that inspired them, and we will, I trust, come away with fresh curiosity about what our own children do and how we interact with them over it. But I also believe that the revelations in this book (and in the exhibition which I hope some day finds an American venue) will bring even the most sophisticated among us to a greater appreciation of the intellectual depth and the rich complexity of the great masterpieces of modernism.

I want to take this opportunity to express my warmest thanks to Rudolf Arnheim, John Carlin, Helmut Friedel, Josef Helfenstein, Hélène Lassalle, Steven Mansbach, John Neff, Theodore Zernich and Jerrold Ziff who have believed in this project from the outset and whose support really made it possible to carry out. I also want to thank Gerd Hatje for his superb production of the German edition of this book and the editors of the Princeton University Press (especially Patricia Fidler, Elizabeth Johnson and Elizabeth Powers) who stood by their intellectual commitment to the book despite all of our worries over how we were going to pay for it. I am grateful as well to various colleagues who have generously shared their ideas or in various ways given of their energies to help me realize this project: Pierre Alechinsky, Karel Appel, Natasha Avtonomova, Donald Baechler, Elena Basner, Bruno Bischofberger, Anja Chavez, Anne d'Harnoncourt, Samuel Edgerton, the late Albert Elsen, Stefan Fry, Eric Gibson, Christopher Green, Nina Gurianova, Anne Hanson, Ilse Holzinger, Jan Krugier, Irving Lavin, Mrs. John Lefebre, Alexander Liberman, Isabelle Maeght, Katherine Manthorne, Achim Moeller, Youri Molok, Elizabeth Murray, Robert Panzer, Theodore Reff, Marie-François Robert, Jim Rubin, Igor Sanovitch, Julian Schnabel, Richard Shiff, Dmitry Shvidkovsky, Charles Slichter, Seymour Slive, Candida Smith, Rebecca Smith, Olga Soffer, Katia Steiglitz, Peter Stevens, Dominick Taglialatella, Donald Taglialatella, Michel Thévoz, Dodge Thompson, Armande de Trentinian, Garry Trudeau, Harriet De Visser, Diane Voss, Michael Werner, Barbara Wörwag and Armin Zweite.

Over the extended time it has taken to bring this research to fruition it was underwritten by various divisions of the University of Illinois—the Research Board, the School of Art and Design, International Programs and Studies, the Center for Advanced Studies and the College of Fine and Applied Arts—as well as the National Endowment for the Humanities and the American Philosophical Society; I am deeply grateful for the support of all of them. I particu-

larly want to underscore the contribution of the Research Board of the University of Illinois in having the vision to follow through with this project over its entire evolution; without that long perspective from this group of fellow scholars who understood what was at stake intellectually and how long it takes to realize such a project, neither the exhibition nor the book would ever have seen the light of day. The Millard Meiss Committee of the College Art Association also thankfully came through in the last agonizing throes of trying to get this book to an English-speaking audience; I am very grateful for that help which came just when it seemed like there was no place left to turn. In addition, I want to acknowledge the work of my terrific present and former research assistants at the University of Illinois—especially Mary Coffey, Lorraine Morales Menar, Mysoon Rizk and Lisa Wainwright—and to the staff of the Ricker Library of Art and Architecture at the University of Illinois, Urbana-Champaign.

Finally, I am most grateful to the families of the artists—especially Aljoscha Klee, Dolorès Miró, Juan Miró, Claude Picasso, Paloma Picasso, Candida Smith, Rebecca Smith and Peter Stevens—for their help and insight; to the living artists who were so generous with me—including Pierre Alechinsky, Karel Appel, Donald Baechler, Jasper Johns and Claes Oldenburg; and, as always, to my wife, Marianne, who always sees right away what I must labor to find.

—Jonathan Fineberg
Urbana, Illinois

THE INNOCENT EYE

1. The Postman Did It

In letters to the editor in the February 1955 *Art News*, several dismayed readers complained that their grandchildren painted as well as Hans Hofmann, whose work had been reproduced on the cover of the Christmas issue [fig. 1.1]. The editor responded with his best wishes to all these "talented grandchildren," and expressed his hope that they might "keep up the good work."[1]

The idea that modern art looks like something a child could do is one of the oldest clichés around; it has been with us since the inception of the avant-garde. In its most familiar form, the comparison of vanguard painting and sculpture with the "awkward scrawls" of children has served as a rhetoric for dismissing the significance of radical ideas in art, as when a German critic in 1933 described the work of Paul Klee as "mad, infantile smearings"[2] or in 1908 when a journalist in Paris wrote that an exhibition of "infantile . . . sketches by urchins between the ages of six and sixteen, none of whom is gifted," were "better than the *fauves*."[3] Even in the nineteenth century critics often rebuked adventurous modernists with accusations of childishness: in 1874, for example, a reviewer complained that Monet's *Impression—Sunrise* was executed "with the childish hand of a schoolboy who was painting for the first time."[4]

Yet as far back as the romantic period of the late eighteenth and early nineteenth centuries, there were some to whom this association of modern art with the aesthetic of a child was not invidious. Like the great German painter Caspar David Friedrich, some praised the child as a model for the artist: "The only true source of art," Friedrich wrote, in 1830, "is our heart, the language of a pure childlike spirit. A creation, not flowing from these springs, can only be mannerisms. Every true work of art is received in consecrated hours and born in jubilant—to the artist often unknown—inner urges of the heart."[5]

Thus, for Friedrich art comes as a gift of revelation and the child represents—in inverse proportion to its acquisition of the conventions of civilized culture—both a more direct path to such inspiration and an ability to see the "truth" of what it is. The idea that children, being less "civilized," are more a part of nature implied to the romantics that they are also closer to the meaning in nature. Schiller argued, in his essay "Concerning Naive and Sentimental

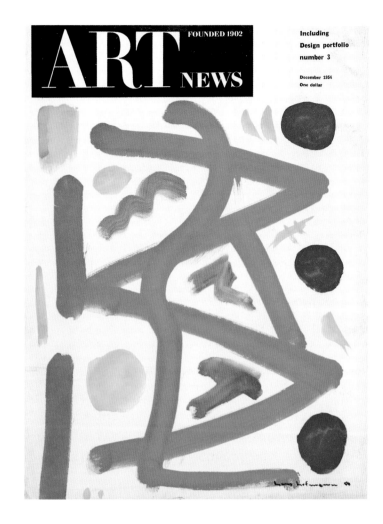

1.1
Hans Hofmann
Art News, no. 3
(December 1954), cover

Poetry" (1795), that: "They *are* what we *were*; they are what we should again *become*. We were nature like them and our culture must, through reason and liberty, lead us back to nature. They are at the same time a rendering of our own lost childhood which remains for eternity our most cherished possession."[6]

Although there is an ancient tradition of the child as an unknowing seer, it was the romantics who allied the naiveté of the child with "genius." Wordsworth and Coleridge debated: "In what sense is a child . . . a philosopher? In what sense does he *read* 'the eternal deep?'"[7] (Coleridge). Rousseau's *Emile* (1762) is a treatise on how such natural gifts might be cultivated; Shelley is even reputed to have lifted an infant from a pram in 1810 and demanded: "Tell me about pre-existence!"[8]

This wish to return to nature through the child was new intellectual territory in the eighteenth century. Indeed, Rousseau had revolutionized thinking on education by suggesting that the natural tendencies of children should be encouraged, rather than repressed as expressions of original sin.[9] But Rousseau had no sympathy for the drawings that the untutored child actually produced. On

the contrary he sought to train his Emile to render nature as accurately as possible in order to teach him to see "objectively."

"Sight is, of all the senses, the one from which the mind's judgments can least be separated," Rousseau explained, and it is through the experience of touching things that one learns to see. So Rousseau wanted the child to learn by experiment to judge recession in space, and to imitate forms and then to verify them "by real measures in order that he correct his errors," because "at bottom, this imitation depends absolutely only on the laws of perspective, and one can estimate extension by its appearances only if one has some feeling for these laws. Children, who are great imitators, all try to draw. I would want my child to cultivate this art, not precisely for the art itself but for making his eye exact and his hand flexible."[10]

Underlying this concern with developing the child's innate objectivity of vision is a wish to divine the underlying plan of nature. Thus "objective" observation came together with intuition at the end of the eighteenth century, emphasizing individual observation and inspiration (rather than classical traditions of form). This was expressed in a range of views from the more secular, as in Thomas Jefferson,[11] to the theologian William Paley, who made the famous comparison of the deity with a consummate watchmaker, designing every detail of nature with purpose.[12] As a corollary to this, a virtually universal resistance arose to the idea of a uniform style of the beautiful. Thus many romantic artists turned for inspiration to the so-called primitive fifteenth-century Italian and Flemish masters in preference to the "high" Renaissance, which was more concerned with classical form and therefore seen as less "direct" in expression.

The romantic painter Tommaso Minardi, in a celebrated statement of this point of view, argued in 1834 that Giotto was as great a painter as Raphael and described two aspects of expression in painting: "one material through the formal images of things they represent, the other spiritual or moral through the rapport they establish with man's feelings." Minardi held up the child as a model of the pure expression of the spiritual and said that if the young child had the ability to paint he would choose only the forms appropriate to expressing this spiritual truth. The hypothetical child's painting would be

> *of the truest character, because he takes it from truth itself. . . . And this painting would naturally be of a perfect unity of composition. Since the child's soul, completely involved in the sentiment of the loving image, would feel only that which is strictly connected with the expression of the image itself, all accessory matter would simply remain unobserved. So there would be nothing superfluous, nothing useless.*[13]

Anticipating the further development of the idea in Ruskin and Baudelaire that genius involves the gift of seeing with this childlike objectivity and intuition,

Adolphe Thiers wrote in 1822 that we long for the naive but "we cannot be at once children and men"; only a genius has the ability to retrieve that innocence of observation.[14]

Thus the nineteenth century inherited a double legacy about the child's "innocent eye"; it was innocent enough of convention to see through the emperor's new clothes, so to speak, and at the same time the child was gifted with a privileged view into the mysteries of the divine plan. Charles Baudelaire's 1857 poem, "Correspondances," was a paradigmatic statement of the premise for the latter. In this poem he asserted that everything in the tangible world was merely the material manifestation of an intangible higher reality, a sign to be read by the clear-sighted poet. "Nature is a temple," he wrote, and " . . . man passes there through forests of symbols. . . ."[15]

Baudelaire regarded the child as having a raw receptivity to the "correspondences" between the visible world and the higher truths that underlie it, a clairvoyance like that of the poet or artist but lacking in the analytic skills to fashion this intuition into art.[16] "The child sees everything in a state of newness," he wrote in "The Painter of Modern Life" (1863). But whereas in the "man of genius" he says, "reason has taken up a considerable position," in the child "sensibility is almost the whole being," and he concludes that "genius is nothing more nor less than *childhood regained* at will—a childhood now equipped for self-expression with manhood's capacities and a power of analysis."[17]

Even though Baudelaire admired children's "great capacity for abstraction and their highly imaginative power" (which he contrasted with "the impotent imagination of the blasé public"),[18] his romantic concept of the child had little to do with the reality of what children drew. For him the child symbolized an idea. But neither he nor any other writer but one had actually studied children's drawings per se in any great detail. The Swiss artist and educator Rodolphe Töpffer seems to have been the first to do so in devoting two chapters of his 1848 *Reflections and Remarks of a Genevan Painter* to his analysis of them. Töpffer was also groundbreaking in that he extolled the expressive genius in the art of children and, by implication, he emphasized the centrality of ideas in art over technical execution.

"There is less difference," Töpffer wrote "between Michelangelo the child scribbler [*gamin griffoneur*] and Michelangelo the immortal artist than between Michelangelo after having become an immortal artist and Michelangelo while still an apprentice."[19] Thus academic skills, according to Töpffer, had less to do with the artist's mature genius than the guileless expressivity present in childhood and, as Meyer Schapiro has pointed out, even such established French critics of the period as Théophile Gautier were intrigued by Töpffer's idea that

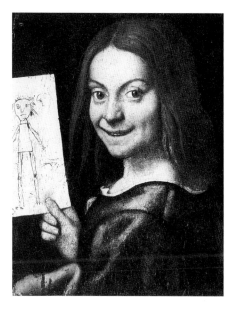

1.2
Giovanni Francesco Caroto
Fanciullo con Pupazzetta (portrait of
a boy with his stick-figure drawing),
ca. 1520

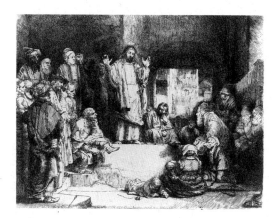

1.3
Rembrandt Harmensz van Rijn
Christ Preaching (La Petite Tombe),
ca. 1652

children's art had the quality of rendering, in Gautier's words, a "thought in a few decisive strokes without losing any of its strength."[20]

A considerable literature exists on child art from the perspectives of pedagogy and developmental psychology. The former goes back to Castiglione (in the sixteenth century) and includes Rousseau and Pestalozzi (in the eighteenth century); the latter gets underway with a serious "scientific" intent toward the end of the nineteenth century when writers such as Herbert Spencer (*Education*, 1861), influenced by Darwin and Lamarck, began to look at children's drawings from a developmental point of view. G. Stanley Hall's book, *The Content of Children's Minds* (1883), and Corrado Ricci's *L'arte dei bambini* (1887), are among the first to attempt a systematic classification and study of the motives in children's art, but by the 1890s there was a rapidly growing body of studies on child art and, increasingly, even public exhibitions of children's drawings.[21]

However, nearly nothing was written on child art from the point of view of its aesthetic inventiveness. It was artists, on the whole, who explored it on these terms and for the most part they did so on canvas rather than on the printed page. Artists discovered child art by way of reflecting on their own work, and they did it long before any significant writing existed on the subject. There is early evidence of the interest of artists in the mind and creativity of the child in Giovanni Francesco Caroto's portrait (ca. 1520) of a boy with his prototypical child's *bonhomme* on an easel [fig. 1.2] and perhaps in the "tadpole figures," as the art educators now call them (figures consisting of heads and limbs but no trunk), that recur in the paintings of Hieronymus Bosch at the end of the fifteenth century.[22]

Artists from the seventeenth through the nineteenth centuries represented children engaged in drawing with increasing frequency—from Rembrandt's ca. 1652 etching of *Christ Preaching* [fig. 1.3], which shows a boy making lines with his finger in the dirt, through Courbet's 1855 painting of *The Painter's Studio, a real allegory* [fig. 1.4], in which the artist portrays his friend Champfleury with a child on the floor at his feet drawing a stick-figure *bonhomme*.[23] Generally, such depictions involve little concern with the actual drawings produced by children; rather, the artists use stereotypes of children's drawings as symbols of innocence, as Rembrandt does (although the more we learn about children's drawings, the less "innocent" of both inborn and cultural influences they seem), or later the "uncultivated genius" as set out in Rousseau's *Emile*. In Thomas Cole's *The Course of Empire: The Arcadian Pastoral* (1836) [fig. 1.5], the boy chalking a stick figure on the stones with a classical muse looking on is another of these "uncultivated geniuses" who stands in the same relation to the artist as the bucolic arcadia does to the fulfillment of America's "manifest destiny." Thus in this painting the image involves a discourse not only on convention and talent but also on geopolitics and national ideology.

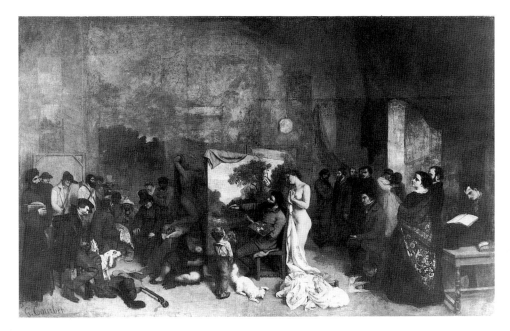

1.4
Gustave Courbet
*The Painter's Studio, a real allegory describing a
seven year period of my artistic life*, 1855

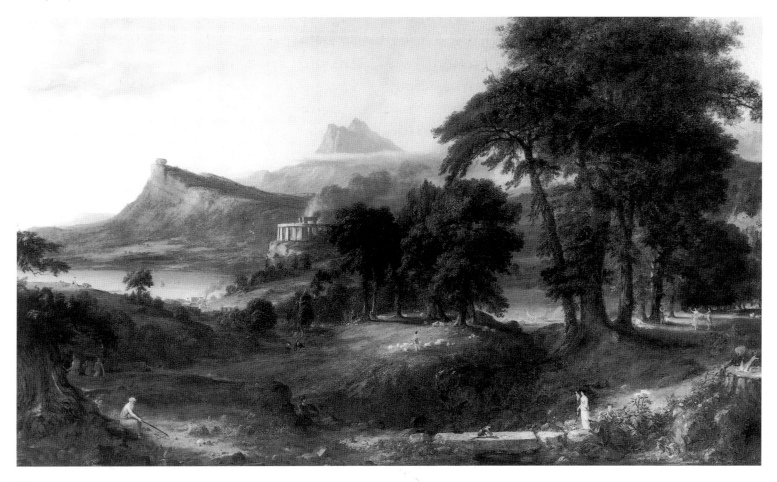

1.5
Thomas Cole
The Course of Empire: The Arcadian Pastoral, 1836

From time to time artists of the nineteenth century and earlier have looked at children's drawings themselves and represented them scribbled on walls, as in Saenredam's seventeenth-century *Interior of the Buurkerck, Utrecht* [fig. 1.6], or inscribed on paper (*and* the furniture), as in Sir David Wilkie's painting of *The Blind Fiddler* (1806) [fig. 1.7]. In the Wilkie, a crude grafitto of a cat is scratched into the side of the wooden cupboard (at the right) with a child's drawing pinned up just above it. Wilkie's reference involves Rousseau's idea of the child's natural inclination to draw, and in addition, the child's drawings and the humbleness of the shoemaker's home, in which this poor family gathers to hear the melodies of the ragged fiddler, both affirm the noble simplicity and the directness with which Wordsworth entreated the readers of this period to approach the experience of nature. These two children's drawings in the Wilkie also reveal, however, a careful look at what children really do draw rather than the recurrent *bonhommes*.

In Courbet's *The Painter's Studio*, the two children (one drawing and the older one standing beside the artist, looking on) directly concern the parameters of the artist's new style of "realism" in that realism was putatively founded on a childlike innocence of seeing what was there in front of him, without interpretation. "Everything that does not take shape on the retina," Courbet remarked, "is outside the realm of painting."[24] The idea of seeing like a child had a direct bearing on Camille Corot's approach to his subject, too. "I always entreat the good Lord to give me my childhood back," he confessed, "that is to

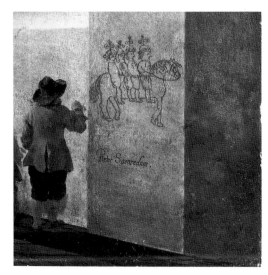

1.6
Pieter Janszoon Saenredam
Interior of the Buurkerck, Utrecht, detail,
1644

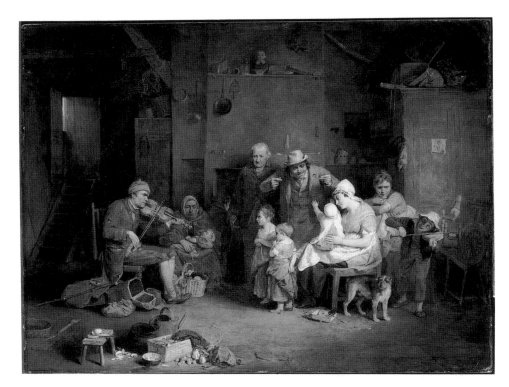

1.7
Sir David Wilkie
The Blind Fiddler, 1806

say, to grant that I may see nature and render it like a child, without prejudice."[25] Yet Courbet was probably no more interested in what children actually drew than was Cole, whereas Corot is purported to have saved a body of his own childhood scribbles, which occasioned conversation among the impressionists, who also had a particular interest in the issue of naive spontaneity.[26]

It was precisely at this point—when the emphasis on spontaneity overtook a reverence for traditional formal values—that a fundamental change occurred which made possible the "primitivism" of the turn of the century. Throughout the nineteenth century, artists wished to maintain the status of painting and sculpture as equal to the liberal arts—rather than connected with the more narrowly practical character of the professions—and they took pains to demonstrate its learned content, its reason and moral nature.[27] The ascendance of empirical observation and spontaneous discovery made it possible to pursue the implications of the romantic idea of the "innocent eye" more directly.

Sometime around the turn of the century, Monet confided to Lilla Cabot Perry, his neighbor at Giverny, that he "wished he had been born blind and then suddenly gained his sight so that he could have begun to paint in this way without knowing what the objects were that he saw before him."[28] The Enlightenment concept of the child's innate objectivity of vision still lingers behind Monet's remark in that it supposes one *could* see without interpretation. But, as Charles Stuckey has noted, Monet probably got this idea from Ruskin who advised artists, in *The Elements of Drawing* (1857):

> *Everything that you can see in the world around you, presents itself to your eyes as an arrangement of different colours variously shaded. . . . The whole technical power of painting depends on our recovery of what may be called the* innocence of the eye; *that is to say, of a sort of childish perception of these flat stains of colour, merely as such, without consciousness of what they signify,—as a blind man would see them if suddenly gifted by sight.*[29]

This "innocence of the eye" was only the surface of the child's "innocence," however. Ruskin also said that the artist needed to maintain a childlike vitality and freshness that he called the "condition of childhood."[30] "You do not see *with* the lens of the eye," Ruskin said emphatically. "You see *through* that, and by means of that, but you see with the soul of the eye."[31] This "condition of childhood" resembles that "state of newness" discussed by Baudelaire, and it manifested itself in the "objectivity" of Monet's classic impressionism of the 1870s as well as in the subjectivity of his later *Grainstacks, Rouen Cathedrals* and *Waterlilies*. The inspired "condition of childhood" is perhaps what Cézanne had in mind, too, when he told Emile Bernard in 1904: "As for me, I would like to be a child."[32]

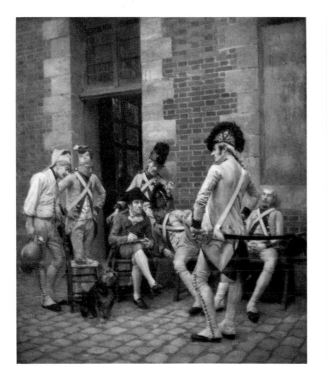

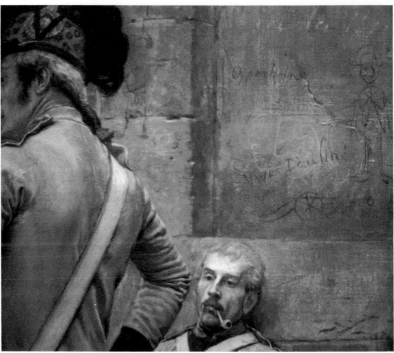

1.8
Ernest Meissonier
Portrait of the Sergeant, 1874

1.9
Ernest Meissonier
Portrait of the Sergeant, detail

Even some dedicated academics, whose styles were founded on skillful rendering (which is the opposite of "the awkward scrawl"), knew that it was the spiritual depth—some version of that "condition of childhood"—and not objective vision or proper academic execution that makes a great painting. Ernest Meissonier, one of the most celebrated military portraitists in nineteenth-century France, seems to have engaged in some poignant introspection on precisely this point in his 1874 *Portrait of the Sergeant* [figs. 1.8, 1.9]. The child's graffiti on the wall (to the right) tentatively fords the treacherous waters of self-examination with a wooden parody of the posturing narcissist in the foreground, on whom the artist and his dog lavish such attention.

As Robert Herbert pointed out, Ruskin's "condition of childhood" is what writers in the twentieth century have referred to as "primitivism."[33] By the end of the nineteenth century, the cultivation of naiveté had been absorbed into a wider interest in seeking all that the overdeveloped culture of fin-de-siècle Europe had buried. Freud's archaeological excavation of the unconscious mind and the debate over Darwin's evolutionary theories paralleled the pervasive "primitivism" of vanguard art from Gauguin to Stravinsky, and Baudelaire's speculations on "childhood regained" were subsumed under a broader desire for authenticity. "You will always find vital sap coursing through the primitive arts," Gauguin wrote. "In the arts of an elaborate civilization, I doubt it!"[34] The advice of the symbolist critic Albert Aurier was "to exile ourselves, far, very far, to take refuge in the distant countries of the Orient, closed to the unhealthy influences of Europe."[35]

Friedrich Nietzsche brilliantly embodied this end-of-the-century malaise in the metaphors of Greek myth. He described a perennial opposition of what he called the Apollonian tendencies for restraint, harmony, measure, and the creativity of the dream against a powerful drive to exceed all norms that found an outlet in the drunken frenzy of the Dionysian festivals. Dionysus was the only Greek god with a fully developed childhood and he represented an unbroken continuum of the child's primitive urges and irrationality into adulthood.[36] Nietzsche saw an affirmation of life in the Dionysian excesses and, in *The Birth of Tragedy*, he attacked the over-rationalized naturalism of what he called "esthetic Socratism." He suggested that "perhaps there is a realm of wisdom, after all, from which the logician is excluded? Perhaps art must be seen as the necessary complement of rational discourse?"[37]

So on the one hand, primitivism offered a purgative for Western culture's materialism and for the rigor mortis of its cultural hierarchies; in this regard the attraction to child art was a subspecies of primitivism. Another aspect of the primitivism of the late nineteenth century was, as Kirk Varnedoe has noted, "the notion of 'the primitive,' in the sense of the original, beginning condition or form, [which] preoccupied not only biologists but also social theorists, linguists, and psychologists . . . all the various disciplines studied and compared the 'primitif,' in prehistory, in childhood, and in tribal societies, as evidence for their arguments over man's limitations, potientials, and place in the natural order."[38] Childhood represented the prehistory of the adult and thus the child became a kind of domestic noble savage. "In order to produce something new," Gauguin wrote, "one must return to the original source, to the childhood of mankind,"[39] while in his own painting, he said, "I have gone far back, farther back than the horses of the Parthenon . . . as far back as the Dada of my babyhood, the good rocking-horse."[40]

In the 1880s and 1890s, a number of researchers connected child art with tribal art. Alfred Lichtwark, director of the Hamburg Kunsthalle, linked them in his book *Die Kunst in der Schule* (Art in the school, 1887), probably the first book to do so in a substantive way; James Sully's *Studies of Childhood* (1896) relates children's artistic development to the development of "primitive" peoples; and Carl Götze associated them in his catalogue for an exhibition of free children's drawings for the Kunsthalle in Hamburg in 1898 called *Das Kind als Künstler* (The Child as artist).[41] But even Töpffer had casually compared *bonhommes* to the idols of Easter Island.

Toward the end of the 1890s, exhibitions of child art and a rapidly escalating number of studies of children's artistic development and production began appearing. In 1890 Alexander Koch, one of the founders of the Jugendstil artist's colony at Darmstadt, Germany, began publication of *Kind und Kunst*, an illus-

trated journal of art for and by children. Most of this interest in child art was still anthropological, psychological or pedagogical in character; but an influential Viennese artist and teacher named Franz Cižek became intrigued with the idea that "Child Art is an art which only the child can produce,"[42] and in 1897 he decided to offer "Juvenile Art Classes" with the express purpose of providing children with creative liberty and the chance to work from imagination. Only a few of the investigators studying child art at the time shared Cižek's appreciation for the unique aesthetic of children in itself. But there were increasing numbers of educators like Ebenezer Cooke, Konrad Lange, Georg Hirth and Carl Götze who anticipated or confirmed Cižek's belief that art instruction could awaken the creative powers of the child by encouraging free drawing and imagination.

Some of the early studies of child art resulted in important collections that were either published or available to be seen in exhibitions. Ricci collected some 1,450 drawings and Georg Kerschensteiner, superintendant of schools for Munich, gathered nearly half a million of them as a data sample for his 1905 book, *The Development of the Gift of Drawing*.[43] In 1907 the first volume of the Leipzig journal *Zeitschrift für angewandte Psychologie* was devoted entirely to child art and it cites various collections and exhibitions of child art circulating at the time, including the collections of Dr. Kerschensteiner and that of the historian Karl Lamprecht in Geneva. Cižek also toured an exhibition of his collection. Indeed, there were prominent exhibitions of child art every year in important art centers from the turn of the century to the beginning of World War I.

Artists were increasingly involved in organizing the growing number of exhibitions of child art after the turn of the century while at the same time looking ever more closely at various aspects of how children drew as a stimulus to their own work. For the artists of the twentieth century, a serious interest in the art of children became as remarkably varied and complex from one artist to the next as it was pervasive. Expressionists, cubists, futurists and the artists of the avant-garde Russian movements all hung the art of children alongside their own in their pioneering exhibitions in the early years of the century: the first room of the 1908 Vienna "Kunstschau" (in which Oskar Kokoschka debuted) was an exhibition of children's art from the classes of Franz Cižek. Alfred Stieglitz organized four exhibitions of children's art at his "291" gallery in New York in the four years from 1912 through 1916; according to a contemporary review in the New York *Evening Sun* the exhibition of 1912 was the first of its kind in America and it quoted Stieglitz as remarking that the work of these two- through eleven-year-olds had "much of the spirit of so-called modern work."[44] Roger Fry also showed child art at the Omega Workshops in London in 1917 and 1919; in Cologne, the 1919 dada exhibition included child art, African art and the art of psychotics beside that of Max Ernst and the other dadaists.[45]

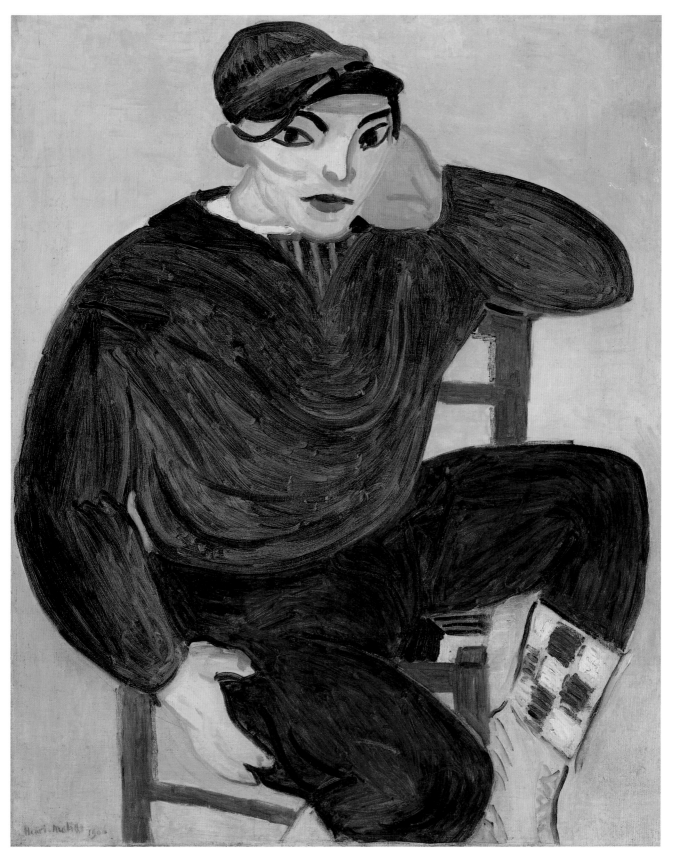

1.10
Henri Matisse
The Young Sailor (II),
Collioure, summer 1906

In addition, many of the greatest artists of the twentieth century avidly collected children's art and took, in some instances quite specific, cues from them; Mikhail Larionov, Gabriele Münter and Vasily Kandinsky, Paul Klee, Pablo Picasso, Joan Miró, Jean Dubuffet and the Cobra artists are the leading examples and the ones upon whom this book is focused since substantial portions of their collections still survive. But other artists as far back as Girodet are reputed to have collected children's drawings[46] and there are a number of important artists of the twentieth century who seem likely to have done so as well, even though their collections cannot, at this time, be documented in detail. Certainly Chagall's mature style reflects his fascination with the child's naive directness and the character of his own childhood (and childlike) fantasy. The "nabis," who came together under Gauguin's influence, found authenticity in a return to childhood. That idea was at the root of Serusier's theory of "subjective deformation," and both Bonnard and Maurice Denis cultivated the awkwardness of children's drawings in the interest of freer expression.[47] One wonders if they didn't also collect the material that inspired these thoughts.

One of the most tantalizing examples is that of Matisse. Matisse is rumored to have helped to organize a *salon des enfants* in Paris before the First World War and he had enough interest in the drawings of his thirteen-year-old son Pierre to include one on the wall in the background to his paintings *Woman on a High Stool* [fig. 1.11] and *Still Life with Lemons, which correspond in their forms to a drawing of a black vase upon the wall,* both of 1914.[48] Certainly many critics of the time noted—both in praise and condemnation—a connection between Matisse's work and that of children: in 1913 a New York critic wrote that Matisse "paints as a child might have painted in the dawn of art, seeing only the essentials in form and color."[49] An anonymous reviewer of an exhibition early in 1908 remarked that "Impressionism reaches its second childhood . . . with M. Matisse motive and treatment alike are infantile."[50] In 1914 another critic said that Matisse used "the method of a child-man, facing nature with untutored eyes and trying to give expression to what instinct told him about life."[51] One of the most extreme negative examples was a review of the Christmas 1908 exhibition of Matisse's works at the Paul Cassirer Gallery in Berlin in which the critic for the Leipzig *Kunstchronik,* after careful consideration, concluded that Matisse's work represented a "danger" to young German artists because it was so "ridiculous and childish!"[52]

On 7 June 1914, Apollinaire reviewed an exhibition at the Galerie Malpel in Paris of *Dessins d'enfants* in which he particularly praised the work done from imagination by the children (many of whom were the children of artists, including Van Dongen's daughter). The review concludes with two paragraphs about Matisse. "I remember when Matisse used to show off his children's drawings,"

Apollinaire wrote, "some of which were really astonishing. Matisse was very much interested in them. 'Nevertheless,' he used to say, 'I don't believe that we should make a lot of fuss about children's drawings, because they don't know what they are doing.'"[53]

Maybe not, but that did not stop Matisse from using a vocabulary of simplification that was inspired by child art as a lever "to free himself from literal renderings imposed by objects," as Jack Flam has described Matisse's concerns of 1906.[54] The pivotal works were the two versions of *The Young Sailor* and *The Pink Onions* [figs. 1.10, 1.13] from the summer of 1906, the portrait of *Marguerite* of 1906–7 [fig. 1.12], and the 1909 portrait of *Pierre*. Matisse spent the summer of 1906 in Collioure and he said of himself and Derain that summer: "We were at the time like children in the face of nature and we let our temperaments speak. . . ."[55]

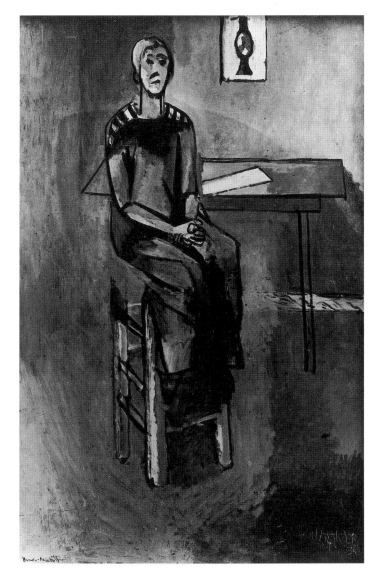

1.11
Henri Matisse
*Woman on a High Stool
(Germaine Reynal)*,
early 1914

Leo Stein reported that Matisse had brought the two paintings of *The Young Sailor* back from the country at the end of the summer and at first pretended to Stein that the postman had painted the highly abstract (and childlike) second version and then, later, reluctantly admitted he had painted it himself. Flam rightly identified the influence of a more "primitive" style in it and noted that Matisse needed to get away from his own empirical tendencies by making the painting from another painting rather than from nature. But the style has the deliberate awkwardness of child art, not the highly schematized simplification of African carvings; indeed, it looks like the drawing of a twelve-year-old––which was precisely the age of Matisse's daughter Marguerite that year. At that age, children begin to have an awakening concern with visual realism but still use the highly simplified, flat patterns and reductive descriptions of forms.

Leo Stein's anecdote about *The Young Sailor II* acquires further significance when one learns that during that same summer Matisse told his fauve colleague Jean Puy that the postman painted *The Pink Onions*, and then recanted.[56] Flam is perhaps correct that these works were so radical and new that Matisse was feeling unsure and consequently embarrassed about them. Certainly, the connection to child art was loaded for Matisse (as it would be for

1.12
Henri Matisse
Marguerite, 1906–7

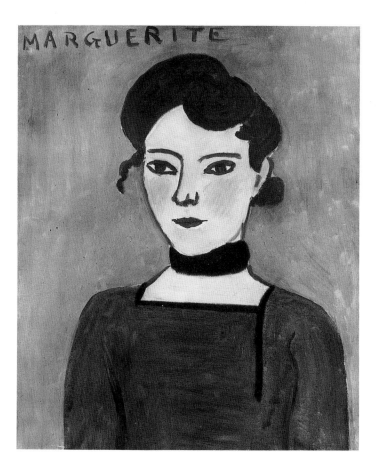

1.13
Henri Matisse
The Pink Onions,
Collioure, summer 1906

any vanguard artist in the first half of the century); he may also have wished not to have to explain himself while still trying to work out what he was finding there. In the 1906–7 *Marguerite*, which immediately followed, Matisse deliberately emulated a child's style not only in the flat, unmodeled, contour renderings of the forms but in the typically childlike patches of pink on the cheeks and the unabashed reference to children's drawings in the juvenile block lettering of the child's name, awkwardly situated at the top margin.

A number of important Matisse works over the next three years seem deeply engaged with the simplifications of child art. John Elderfield has argued that "before Fauvism, Matisse had dealt iconographically with the theme of childhood. Now, with Fauvism, he has created a form of painting made as if with the temperament of a child. The next step will be to repaint, with the benefit of his new, more appropriate vocabulary, an instinctive, prelapsarian world associable with childhood experience. Matisse takes that step in *Le bonheur de vivre*."[57] If *Le bonheur* is painted with "the temperament of a child," Matisse goes still further in systematically exploiting a childlike vocabulary with *The Young Sailor* and *The Young Sailor II*, done immediately after *Le bonheur*; he followed a similar pattern with *Le Luxe I* and *Le Luxe II* (painted over the summer of 1907 through winter 1907–8, with an even more childlike manner of simplification). He then painted the portrait of *Pierre* in the summer of 1909 (resembling *Marguerite* in style) and the sequence of greatly simplified, large figure compositions from *Le Luxe II* to *Dance II* and *Music* of 1911, which are also influenced by the simplified vocabulary of child art (in combination with many other important sources).

However complex the genesis of the large figure compositions of Matisse before World War I, he did title his retrospective glance over his career, "Looking at Life with the Eyes of a Child," and remarked that "the artist . . . has to look at everything as though he saw it for the first time: he has to look at life as he did when he was a child and if he loses that faculty, he cannot express himself in an original, that is, a personal way."[58]

When Picasso and Matisse decided to trade paintings in 1907 it was *Marguerite* that Picasso selected, later explaining:

> *At the time people thought I had deliberately chosen a bad example of Matisse's work out of malice. This is quite untrue. I thought it a key picture then, and still do. Critics are always talking about this and that influence on Matisse's work. Well, the influence on Matisse when he painted this work was his children, who had just started to draw. Their naïve drawings fascinated him and completely changed his style. Nobody realizes this, and yet it's one of the keys to Matisse.*[59]

Of Matisse's contemporaries, André Derain was quite explicit in a letter to Maurice Vlaminck of August 1902: "I'd like to study the drawings of kids. That's where the truth is, without a doubt."[60] Vlaminck, some years later, commented: "I always look at everything with the eyes of a child."[61]

The Brücke artists, including E.-L. Kirchner and Emil Nolde, were Matisse's German contemporaries. But it was not until June 1928 that Kirchner wrote in a diary that: "The artist is after all the free responsive child, who reacts to each new stimulus, . . . not in any logical or historic sense, but reconstructing them in his dreams [or imagination],"[62] and that: "The development of an artist's language of forms certainly comes from a highly ecstatic vision, but along with this, it is created through a [deliberate] consciousness [implying it is not aimless], thus the artist is no different than the child who draws. . . ."[63] It was also during the mid-1920s that he made a series of woodcuts for Gustave Schiefler after drawings he had done in or around 1884, when he was three and a half years old [figs. 1.14, 1.15].

The art historian Will Grohmann, who knew Kirchner, remarked that: "Repeatedly Kirchner points out the relationship of his later development as an artist to his childhood drawings, which he loved to reproduce beside his mature works."[64] But several of the Brücke (including Kirchner) already had a keen interest in the inspiration of children as a source for their work before the war; indeed, the Brücke had children like the twelve-year-old Franzi and her sister

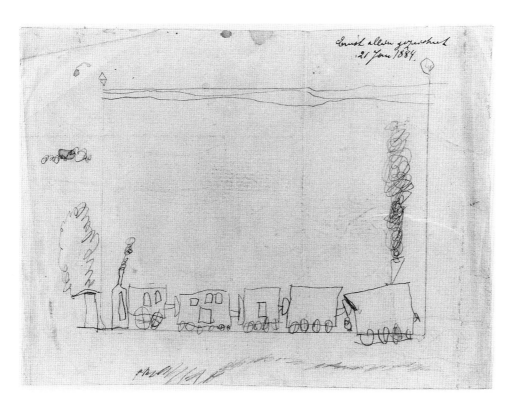

1.14
E.-L. Kirchner (age 3)
Railroad Train, 21 January 1884

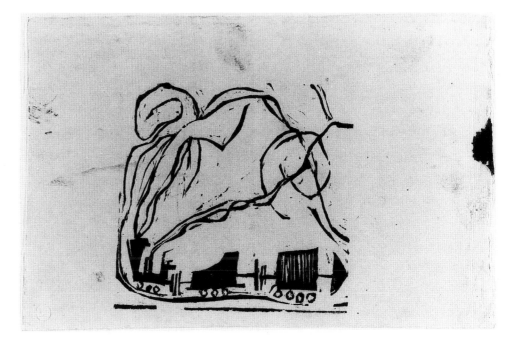

1.15
E.-L. Kirchner
Railroad, 1926–27

Marzella and then Nelly and Milly virtually living among them as models from 1909.[65] Emil Nolde mused in his prewar diaries that: "With the greatest certainty of my ability, I would like to remain childlike for when this is missing in the artist, there is no beautiful resonance to [his] work."[66] Some pages later, he went on:

> *Children only one year old can already draw, and one year later, they are drawing everything. One of my most astonishing experiences was to occasionally watch the work of two young boys. They would draw and paint unimpeded, with an ease [or freedom] unfamiliar to me; groups of people, trains, hunters, landscapes, animals, indeed everything, which stirred them in this particular hour. The drawing paper was scarcely ready, before the next was already half done, all in their childish manner, but with unbelievable skill and full of sparkling life. I would stay the entire day watching the fantasy world of these "child artists," searching to grasp all of it.[67]*

We will discuss below the involvement of Paul Klee, the artists in the Blaue Reiter circle, the Russian avant-garde, and Picasso with child art before (and after) the First World War, but it is worth remarking that with them and the artists already mentioned there emerges a picture of the breadth of interest in child art by the leading artists of the first decades of the century. The outstanding exception is, curiously, dada, which named itself after the infantile term for a child's hobbyhorse and constantly referred to its hankering after the perambulator and yet seems to have found little inspiration in the *actual* work of children. For

the dadaists, childhood was largely a symbol for their own strategic retreat from social norms; in August 1916, Hugo Ball remarked: "To outdo oneself in simplicity and childlike thoughts—that is still the best defense."[68]

Among the surrealists, Miró is certainly the artist most seriously involved with child art, as we shall see in the chapters that follow. Much of the other important new painting in the interwar era was quite formal or monumental in character and seemed less concerned with the romantic tendencies that would lead to an interest in child art, although it continues to crop up in surprising contexts, such as in the studies for Picasso's *Guernica*, the most terrifying *and* political *and* monumental canvas of his career (a connection we will address in chapter 5) and in Le Corbusier's Pavillon des Temps Nouveaux for the 1937 Exposition Universelle in Paris. For the pavilion's interior Le Corbusier had a studio assistant of Léger's (this just happened to be the young Asger Jorn, who a few years later would be a leading figure in the formation of Cobra) enlarge two drawings by a twelve-year-old boy to 50 square meters each, as murals for the walls [fig. 1.16].[69]

After World War II Jean Dubuffet as well as the Cobra artists collected and worked with ideas from child art. But virtually every major artist in the first generation after the Second World War became involved with psychoanalysis and existentialism, which in turn led them back to childhood through personal introspection. By the 1950s the vocabulary of child art and psychoanalytic introspection were so much a part of the common language that the widespread interest of artists in the second half of the twentieth century in child art hardly seems remarkable. Yet the same exchange of accusation and denial perseveres and as with the artists of the first half of the century, finding out how the more recent artists have used such material also reveals a great deal about the aspirations of the individual artists and the meaning of their work.

William Blake, in *Songs of Innocence* (1789), was perhaps the first artist to praise the "innocent" vision of childhood as a model for the artist. For Wordsworth "The Child is Father to the Man."[70] Marcel Duchamp's pun *"enfant-phare"* ("Headlight child")[71] also invokes the romantic idea of the prescience of the naive child. Who hasn't heard, or even repeated, the line, "out of the mouth of babes"?[72] It is, by now, commonplace to recognize the freshness of vision that children possess and how often it "innocently" reveals profound insights. Moreover, we admire child art for its expressive directness and its ability to communicate an emotion to a wide range of viewers. But aren't these characterizing traits of child art also qualities for which we praise the great paintings in museums? Yet no aspect of modern art has elicited more anger from its defenders and its alienated viewers alike than the sense that it looks in some way like what children do.

1.16
Le Corbusier
Pavillon des Temps Nouveaux, 1937
Plate 36, showing a mural enlarged by Asger Jorn
from a child's drawing of harvesters, 1937

Childhood is, after all, something all humans have in common. Yet "the child within" each of us, to use the phrase of the Cobra artists, is a child necessarily buried by the conventions of adult socialization. It is taken for granted today that this hidden "child within" nonetheless exercises potent influences on the entire range of the adult's behavior, all the more so when buried beyond recognition in the adult unconscious where one cannot easily reach it to address and modify its energy. Perhaps that is precisely why we use "childish" as a term of denial and rebuke—a taboo for the adult—and find the revelation of the childlike in works of modern art so disturbing; they threaten our pact with the world. The influence of child art on modern artists has barely been mentioned as a possibility in the scholarship on modern art and not even the artists have been eager to discuss it. The cliché that my child can paint a Hans Hofmann wards off our recognition in works of modern art of the primal urges of our own childhood, attempting to trivialize the unspeakable revelation of the unconscious mind.

1. Thomas Hess, "Editor's letters," Art News 53, no. 10 (February 1955), 6.
2. Robert Scholz, "Kunstgötzen stürzen," Deutsche Kultur-Wacht (1933), fasc. 10, p. 5; cited in O. K. Werckmeister, "The Issue of Childhood in the Art of Paul Klee," Arts Magazine 52, no. 1 (September 1977), 149.
3. Mirodack Josephin Peladan, "The Salon d'Automne and Its El Greco and Monticelli Retrospectives," La Revue Hebdomadaire (17 October 1908); cited in Jack Flam, ed., Matisse: A Retrospective (New York: Hugh Lanter Levin Associates, 1988), 73.
4. "Avec la main enfantine d'un écolier qui étale pour la première fois des couleurs." Cited in Pierre Georgel, "L'Enfant au Bonhomme," in Klaus Gallwitz and Klaus Herding, eds., Malerei und Theorie: Das Courbet-Colloquium 1979 (Frankfurt am Main: Städelschen Kunstinstitut, 1980), 107. Translated by the author.
5. Caspar David Friedrich, "Äusserung bei Betrachtung einer Sammlung von Gemälden von grössten-teils noch lebenden und unlängst verstorbenen Künstlern" (1830), in Sigrid Hinz, ed., Caspar David Friedrich in Briefen und Bekenntnissen (Munich: Rogner and Bernhard, 1968), 92. "Die Kunst ist einem Kinde, die Wissenschaft einem Manne zu vergleichen. Die einzig wahre Quelle der Kunst ist unser Herz, die Sprache eines reinen kindlichen Gemütes. Ein Gebilde, so nicht aus diesem Borne ent-sprungen, kann nur Künstelei sein. Jedes echte Kunstwerk wird in geweihter Stunde empfangen und in glücklicher geboren, oft dem Künstler unbewusst aus innerem Drange des Herzens." Translated by the author.
6. Friedrich Schiller, "Über naive und sentimentalische Dichtung" (1795), Schillers Werke, Band 1 (Berlin and Weimar: Aufbau-Verlag, Bibliothek Deutscher Klassiker, 1967), 249. "Sie sind, was wir waren; sie sind, was wir wieder werden sollen. Wir waren Natur wie sie, und unsere Kultur soll uns, auf dem Wege der Vernunft und der Freiheit, zur Natur zurückführen. Sie sind also zugleich Darstellung un-serer verlorenen Kindheit, die uns ewig das Teuerste bleibt." Translated by the author.
7. Samuel Taylor Coleridge, Biographia Literaria, vol. 2, eds. James Engell and W. J. Bate, from The Collected Works of Samuel Taylor Coleridge, vol. 7 (Princeton, N.J.: Princeton University Press, 1982), 138.
8. There are various versions of the anecdote but it appears to be accepted. See Thomas Jefferson Hogg, The Life of Percy Bysshe Shelley, vol. 1 (London: E. Moxon, 1858), 239–41.
9. It is interesting that a century later, in the 1880s and 1890s, the French criminologist Cesare Lombroso would theorize that criminals were a kind of evolutionary throwback to animals, "sav-ages," and people of "lower races." As Stephen Jay Gould noted, "Lombroso needed only to

proclaim the child as inherently criminal—for the child is an ancestral adult, a living primitive," and only a few years later Lambroso did just that, arguing that the young child manifests criminal tendencies which in the lower classes, where the natural criminality of childhood is not repressed, can be seen quite clearly. See Cesare Lombroso, *L'homme criminel* (Paris: F. Alcan, 1887); cited in Stephen Jay Gould, *The Mismeasure of Man* (New York and London: W. W. Norton, 1981), 126–27.

10. Jean-Jacques Rousseau, *Emile or On Education*, trans. Allan Bloom (New York: Basic Books, 1979), 143.

11. See, for example, Thomas Jefferson, letter to Dr. Benjamin Rush, 21 April 1803, in *Thomas Jefferson: Writings*, ed. Merrill Peterson (New York: Library of America, 1984), 1125, in which he sets aside the question of Christ "being a member of the Godhead, or in direct communication with it, claimed for him by some of his followers."

12. William Paley, *Natural Theology; or Evidences of the Existence and Attributes of the Deity* (1802), ed. Frederick Ferre (Indianapolis: University of Indiana Press, 1964), 49–59.

13. Tommaso Minardi, "On the Essential Quality of Italian Painting from Its Renaissance to the Period of Its Perfection" (1834), in Joshua C. Taylor, ed., *Nineteenth-Century Theories of Art* (Berkeley and Los Angeles: University of California Press, 1987), 178–79.

14. Adolphe Thiers, "On Naïveté in the Arts," *Le Constitutionnel* (1822); cited in Joshua C. Taylor, ed., *Nineteenth-Century Theories of Art*, 171.

15. Charles Baudelaire, "Correspondances," *Les Fleurs du Mal*, in *Oeuvres Complètes* (Paris: Gallimard, 1961), 11.

16. Charles Baudelaire, "Salon of 1846," in *Art in Paris, 1845–1862*, trans. and ed. Jonathan Mayne (New York: Phaidon Press, 1965), 81. "Le sublime doit fuir les détails,—l'art pour se perfectionner revient vers son enfance. . . . Toute la différence, c'est qu'en faisant tout d'une venue les bras et les jambes de leurs figures, ce n'etaient pas eux qui fuyaient les détails, mais les détails qui les fuyaient; car pour choisir il faut posséder."

17. Charles Baudelaire, "The Painter of Modern Life," in *The Painter of Modern Life and Other Essays*, trans. and ed. Jonathan Mayne (London: Phaidon Press, 1964), 8. "L'enfant voit tout en nouveauté; il est toujours ivre. . . . L'homme de génie a les nerfs solides; l'enfant les a faibles. Chez l'un, la raison a pris une place considérable; chez l'autre, la sensibilité occupe presque tout l'être. Mais le génie n'est que l'enfance retrouvée à volonté, l'enfance douée maintenant, pour s'exprimer, d'organes virils et de l'esprit analytique qui lui permet d'ordonner la somme de materiaux involontairement amassée." Baudelaire's phrasing of the idea has reappeared often since, as in Alfred Stieglitz's 1912 comment to the press on his child art exhibition: "The great geniuses," says Stieglitz, "are those who have kept their childlike spirit and have added to it breadth of vision and experience." Anonymous review, "Some Remarkable Work by Very Young Artists," *Evening Sun* (27 April 1912), 9; reproduced as a plate in Dorothy Norman, *Alfred Stieglitz: An American Seer* (New York: Random House, 1960), 116. In 1948, Julien Levy (the pioneering dealer of the surrealists in New York) said in an essay on Max Ernst that Ernst "develops the child's approach, combined with an adult perfection." Julien Levy, "Max Ernst," in *Max Ernst: Beyond Painting* (New York: Wittenborn, Schultz, 1948), 190.

18. Charles Baudelaire, "A Philosophy of Toys," in *The Painter of Modern Life and Other Essays*, 198. "De leur grande faculté d'abstraction et de leur haute puissance imaginative" as contrasted with "impuissante imagination ce public blasé."

19. Rodolphe Töpffer, *Réflexions et menus propos d'un peintre génevois* (Genève, 1848), 254, 255; cited in Meyer Schapiro, "Courbet and Popular Imagery," *Modern Art* (New York: George Braziller, 1978), 61.

20. Théophile Gautier, "Du beau dans l'art," *L'art moderne* (Paris, 1856), 130, 131; cited in Meyer Schapiro, *Modern Art*, 63.

21. A detailed chronology of the literature on child art and the history of exhibitions of child art, annotated with summaries and commentary, is forthcoming in my book and exhibition catalogue on the nature and history of child art, *When We Were Young: The Art of the Child*, forthcoming.

22. The literature on Bosch offers no significant discussion of the sources for such images, although "surreal" combinations of human and animal or insect parts occur not only in Bosch and his followers but earlier in the marginalia of medieval illuminated manuscripts. These, too, may be informed by childhood fantasy and by dreams.

23. See the discussions in Werner Hoffmann, "The Art of Unlearning," in Jonathan Fineberg, ed., *Discovering Child Art: Essays on Childhood, Primitivism, and Modernism* (Princeton, N.J.: Princeton University Press, forthcoming), and Pierre Georgel, "L'Enfant au Bonhomme," in Klaus Gallwitz and Klaus Herding, eds., *Malerei und Theorie: Das Courbet-Colloquium 1979*, 105–15.

24. Gustave Courbet, cited in Jules Castagnary, *Salons (1857–1870)*, vol. I (Paris: G. Charpentier, 1892),

146–48; cited in Charles F. Stuckey, "Monet's Art and the Act of Vision," in John Rewald and Frances Weitzenhoffer, eds., *Aspects of Monet: A Symposium on the Artist's Life and Times* (New York: Harry N. Abrams, 1984), 112. "Tout ce qui ne se dessine pas sur la rétine est en dehors du domaine de la peinture."

25. Camille Corot, in *Corot raconté par lui-même et par ses amis*, vol. I (Vésenaz and Geneva: Pierre Cailler, 1946), 96; cited in Charles F. Stuckey, "Monet's Art and the Act of Vision," in John Rewald and Frances Weitzenhoffer, eds., *Aspects of Monet: A Symposium on the Artist's Life and Times*, 110.

26. This was reported to me by Dr. Richard Brettell, who said he saw them in the course of his research in Paris.

27. I want to thank my colleague Jerrold Ziff for helping me put these thoughts together.

28. Lilla Cabot Perry, "Reminiscences of Claude Monet from 1889 to 1909," *American Magazine of Art* 18, no. 3 (March 1927), 120; cited in Charles F. Stuckey, "Monet's Art and the Act of Vision," in John Rewald and Frances Weitzenhoffer, eds., *Aspects of Monet: A Symposium on the Artist's Life and Times*, 108.

29. John Ruskin, *The Elements of Drawing* (1857), in *The Works of John Ruskin*, eds. E. T. Cook and Alexander Wedderburn, vol. XV (London: G. Allen; New York: Logman's, Green, and Co., 1903–12), 27; cited in Charles F. Stuckey, "Monet's Art and the Act of Vision," in John Rewald and Frances Weitzenhoffer, eds., *Aspects of Monet: A Symposium on the Artist's Life and Times*, 108.

30. See John Ruskin, *The Seven Lamps of Architecture* (1849), in *The Works of John Ruskin*, vol. VIII, 194.

31. John Ruskin, *The Eagle's Nest* (1872), in *The Works of John Ruskin*, vol. XXII, 194.

32. "Quant à moi, je veux être un enfant." Paul Cézanne, first published in *Mercure de France* (June 1921), and reprinted in *Souvenirs sur Paul Cézanne* (Paris: Michel, n.d.), 104–5; cited in Charles F. Stuckey, "Monet's Art and the Act of Vision," in John Rewald and Frances Weitzenhoffer, eds., *Aspects of Monet: A Symposium on the Artist's Life and Times*, 108.

33. Robert L. Herbert, introduction, to Robert L. Herbert, ed., *The Art Criticism of John Ruskin* (New York: Doubleday, 1964), xii.

34. Paul Gauguin, *Noa Noa*, trans. O. F. Theis (New York: Noonday Press, 1957), 47.

35. Albert Aurier, cited in Patricia Mathews, *Aurier's Symbolist Art Criticism and Theory* (Ann Arbor: U.M.I. Research Press, 1986), 49.

36. Professor Stephan Fineberg, of Knox College, pointed this out in the manuscript of his forthcoming book on Dionysus.

37. Friedrich Nietzsche, *The Birth of Tragedy and the Genealogy of Morals*, trans. Francis Golffing (New York: Doubleday, 1956), 79, 90. More recently, Theodor Adorno observed that society has divided and reduced thinking to a hierarchical set of functions where reason—more evidently useful than memory, emotion or fantasy but barren without them—had been given prominence to the detriment of thinking. See Theodor Adorno, *Minima Moralia: Reflections from Damaged Life* (1951; London: Verso, 1978), 123.

38. Kirk Varnedoe, "Gauguin," in William Rubin, ed., *"Primitivism" in 20th Century Art* (New York: Museum of Modern Art, 1984), 181–82.

39. Paul Gauguin, *L'Echo*, 15 August 1895; cited in Daniel Guérin, ed., *Oviri, écrits d'un sauvage* (Paris: Gallimard, 1974), 111.

40. Paul Gauguin, *Intimate Journals*, trans. Van Wyck Brooks, preface by Emil Gauguin (New York: Crown Publishers, 1936), 41. Vincent van Gogh reported in a letter to Theo that Gauguin and Bernard talked of "painting like children"; in Vincent van Gogh, *The Complete Letters of Vincent van Gogh* (Greenwich, Conn.: New York Graphic Society, 1958), III, letter 527, 20. Also, Dr. Marc Gerstein of the Toledo Museum of Art pointed out to me that Gauguin may have taken inspiration for the geese in the background of his 1886 Breton Women from Caldecott's illustrations for children. See A. S. Hartrick, *A Painter's Pilgrimage Through Fifty Years* (Cambridge, England: The University Press, 1939), 33, for Gauguin's remarks to Hartrick about Caldecott. Nevertheless, child art itself seems not to have influenced him particularly.

41. There is a concise history of the general idea that children resemble primitive peoples in their thought and recapitulate the evolution of the human race in George Boas, *The Cult of Childhood*, Studies of the Warburg Institute, vol. 29 (London, 1966), 60–67.

42. Franz Cižek, quoted in Wilhelm Viola, *Child Art* (Peoria, Ill.: Chas. A. Bennett Co., 1944), 34.

43. Georg Kerschensteiner, *Die Entwicklung der zeichnerischen Begabung* (Munich: Verlag Carl Gerber, 1905).

44. Anonymous review, "Some Remarkable Work by Very Young Artists," *Evening Sun* (27 April 1912), 9; reproduced as a plate in Dorothy Norman, *Alfred Stieglitz: An American Seer*, 116.

45. Noted in John MacGregor, *The Discovery of the Art of the Insane* (Princeton, N.J.: Princeton University Press, 1989), 279.

46. Noted by Pierre Georgel, "L'Enfant au Bonhomme," in Klaus Gallwitz and Klaus Herding, eds., *Malerei und Theorie: Das Courbet-Colloquium 1979*, 109. In addition, Girodet's own childhood drawing of a giraffe survives today in the drawing collection of the Louvre, presumably saved by the artist who, we must conclude, found it interesting enough to preserve.

47. See Sasha M. Newman, "Nudes and Landscapes," in Colta Ives et al., *Pierre Bonnard: The Graphic Art* (New York: Metropolitan Museum of Art and Harry N. Abrams, 1989), 153. See also Maurice Denis, "Aristide Maillol," in Maurice Denis, *Théories, 1890–1910, du symbolisme et de Gauguin vers un nouvel ordre classique*, 4eme ed. (Paris: L. Rouart et J. Watelin, 1920), 242; cited in Helen Giambruni, "Domestic Scenes," in Colta Ives et al., *Pierre Bonnard: The Graphic Art*, 60: "J'appelle gaucherie cette sorte de maladroite affirmation par quoi se traduit, en dehors de formules admises, l'émotion personelle d'un artiste."

48. See Alfred H. Barr, Jr., *Matisse: His Art and His Public* (New York: Museum of Modern Art, 1951), 42, 184. See also John Elderfield, *Matisse in the Collection of the Museum of Modern Art* (New York: Museum of Modern Art, 1978), 92–94, and nn. 202–3.

49. Clara T. MacChesney, "A Talk with Matisse, Leader of Post-Impressionism," *New York Times Magazine* (9 March 1913); cited in Jack Flam, ed., *Matisse: A Retrospective*, 132.

50. Anonymous review, "The Last Phase of Impressionism," *Burlington Magazine* XII (February 1908), 272; cited in Alfred H. Barr, Jr., *Matisse: His Art and His Public*, 110.

51. Charles Caffin, *How to Study the Modern Painters* (New York: Century Co., 1914), 210–11.

52. M. O., "Matisse Ausstellung," *Kunstchronik* 20 (5 February 1909), 238–39; cited in Alfred H. Barr, Jr., *Matisse: His Art and His Public*, 108–9.

53. Guillaume Apollinaire, *Chroniques d'Art* (1902–18), ed. L.-C. Breunig (Paris: Gallimard, 1960), 393–94, trans. in Guillaume Apollinaire, *Apollinaire on Art: Essays and Reviews, 1902–1918*, ed. L.-C. Breunig, trans. Susan Suleiman (New York: Viking, Documents of 20th Century Art, 1972), 403.

54. Jack Flam, *Matisse: The Man and His Art, 1869–1918* (Ithaca and London: Cornell University Press, 1986), 174.

55. Gaston Diehl, *Henri Matisse* (Paris: Pierre Tisné, 1954), 32; cited in John Elderfield, *Henri Matisse: A Retrospective*, 52.

56. Jack Flam, *Matisse: The Man and His Art, 1869–1918*, 190.

57. John Elderfield, *Henri Matisse: A Retrospective*, 52.

58. Henri Matisse, "Looking at Life with the Eyes of a Child," *Art News and Review* (6 February 1954); reprinted in Jack Flam, *Matisse on Art* (London: Phaidon Press, 1973), 148–49.

59. Pablo Picasso, in Dore Ashton, ed., *Picasso on Art* (New York: Viking, 1972), 164.

60. André Derain, *Lettres à Vlaminck* (Paris, 1955), 63. "Je voudrais étudier des dessins de gosses. La vérité y est, sans doute."

61. Maurice Vlaminck, *Dangerous Corner* (1929), trans. Michael Ross, with an introduction by Denys Sutton (London: Elek Books, 1961), 18.

62. "Der Künstler ist ja überfall das leicht reagierende Kind, das auf jeden neuen Formreiz reagiert und ihn in sich, abseits von logischen oder historischen Tatsachen, umbildet, um seine Träume hinein zugiessen." E.-L. Kirchner, *E. L. Kirchners Davoser Tagebuch*, ed. Lothar Grisebach (Cologne: Verlag M. DuMont Schaubert, 1968), 178, entry of June 1928.

63. E.-L. Kirchner, "Wo doch jeder Denkende begreifen muss, das die Entwicklung der Formensprache eines Künstlers gewiss mit sehr viel ekstatischer Vision aber dabei durchaus bewusst geschehen kann, sonst unterschiede sich ja der Künstler in nichts von den zeichnungen Kind." Kirchner, letter of 9 June 1928, *Maler des Expressionismus im Briefwechsel mit Eberhard Grisebach*, ed. Lothar Grisebach (Hamburg: Christian Wegner Verlag, 1962), 231.

64. Will Grohmann, *E. L. Kirchner* (New York: Arts Inc., 1961), 32.

65. Karlheinz Gabler, *E. L. Kirchner Dokumente* (Aschaffenburg: Museum der Stadt Aschaffenburg, 1980), 68.

66. Emil Nolde, *Jahre der Kämpfe* (Berlin: Rembrandt-Verlag, 1934), 180: "Neben aller gewonnenen Sicherheit im Bewusstsein des Könnens, wollte ich so gern, dass mir das Kindliche erhalten bleibe, denn wo im Künstler dies fehlt, gibt es im Werk den schönsten Vollklang nicht."

67. Ibid., 218. "Kinder, einige Jahre nur alt, können schon zeichnen, und einige Jahre später, dann zeichnen sie alles. Eines meiner erstaunlichsten Erlebnisse war, als gelegentlich ich dem Arbeiten zweier Knaben zuschauen durfte. Sie zeichneten und malten unbehindert mit einer mir unbekannten Leichtigkeit ganze Menschengruppen, Raubritterzüge, Schlachten und Jagden, Landschaften, Tiere, ja alles, was zu dieser Stunde ihnen eben einfiel. Kaum war eines der Blätter fertig, bevor das Nächste auch schon halbfertig war, alle in ihrer kindlichen Art, aber mit unglaublichem Geschick und voll sprühendem Leben. Ich ging tagelang nachher in der Wunderwelt dieser 'Knabenkünstler,' alles zu fassen suchend. Manches bleibt so unverständlich."

68. Hugo Ball, note of 5 August 1916, *Flight Out of Time: A Dada Diary* (New York: Viking, 1974), 72.

69. See Jean-Clarence Lambert, *Cobra* (New York: Abbeville Press, 1984), 30; and Guy Atkins, *Jorn in Scandinavia, 1930–1953* (London: Lund Humphries, 1968), 94.

70. William Wordsworth, "My heart leaps up when I behold" (also known as "The Rainbow") (1802), in Stephen Gill, ed., *William Wordsworth* (New York and London: Oxford University Press, 1984), 246.

71. Duchamp's *enfant phare* was conceived as part of a never executed two-sided panel called the *Jura-Paris Road*, which was to have the *enfant phare* in nickel and platinum on one side. There is mention of it in Duchamp's notes for *Le Grand Verre* (The Large glass) in note 109, titled *Traduction picturale* (Pictorial Translation); in Marcel Duchamp, *Notes*, arranged and translated by Paul Matisse (Boston: G. K. Hall, Documents of 20th Century Art, 1983), n. 109. The *enfant phare* is a play on "fanfare," according to John Golding, *Duchamp: The Bride Stripped Bare by her Bachelors, Even* (New York: Viking, 1972), 47.

72. Psalms 8:2.

2. Mikhail Larionov and the "Childhood" of Russia

The *Donkey's Tail* exhibition of 1912 in Moscow was one of a series of manifestations of a vital Russian avant-garde that rivaled the contemporary achievements of the Brücke group in Berlin, the Blaue Reiter artists of Munich, and the Milanese futurists on the eve of World War I. Only Paris had a more historically important community of vanguard artists. Mikhail Larionov, a principal organizer of *The Donkey's Tail*, took inspiration for the title of this artists' group and exhibition from the submission of three paintings by "Joachim-Raphael Boronali" to the 1910 Salon des Artistes Indépendants in Paris. Boronali, it turns out, was a donkey—the four-legged variety. A group of French art students had affixed a brush to the "artist's" tail to produce his soon to be infamous *chefs d'oeuvre*, and entered them into the salon.[1]

Larionov identified with this dadaistic attack on established standards, and by extension on the centrality of Paris in modernism; he wanted to assert instead the importance and independence of his own circle in Moscow. Yet he nevertheless looked to Paris for the symbolism of his assault, and there, in microcosm, lay the prevailing dilemma not only of Larionov but of the whole Russian avant-garde from 1905 through 1914. "We are striving toward the East and we turn our attention to national art," Larionov wrote in March of 1913. "We protest against a slavish subordination to the West."[2] But the vehemence of his rejection simultaneously revealed the depth of his anxiety about influences that clearly persevered.

Ever since the end of the seventeenth century, when Peter the Great forced the Russian aristocracy to cut their beards and replace their caftans with Western attire, a dichotomy between indigenous "Slavic" culture and Western influence has been a defining feature of Russian intellectual life. Peter even made French the language of the court in St. Petersburg, virtually eclipsing cultural discourse in Russian for more than a century. For Larionov, turning to native sources of inspiration—Russian folk art, the work of amateur sign painters and the art of children—served as a way of heightening the uniqueness of the Russian artists' contribution to the international avant-garde.

As the art historian Yevgeny Kovtun has pointed out, for Russian artists "it

was not necessary to go, as Gauguin did, to Tahiti; it was sufficient to set out for Volodskaia or Tulskaia provinces in order to collide with deep, almost archaic artistic traditions."[3] Because of this, Russian primitivism had a distinctly national character. Nevertheless, primitivism also became, at precisely this moment, central to the agenda of contemporary Western artists from Picasso to the German expressionists, who turned for inspiration to the ethnographic collections of Paris, Dresden, Munich and Berlin.

Larionov, Nataliya Goncharova, Kasimir Malevich [fig. 2.1] and David Burlyuk were the leading artists of Russian "neo-primitivism," which reached its apogee between 1909 and 1912,[4] and was celebrated in the *Donkey's Tail* and *Target* exhibitions (of 1912 and 1913). The highly original fusion of Italian futurism and French cubism into the Russian "cubo-futurism" of 1911–14 and the groundbreaking beginnings of Russian abstraction around 1912–15 (Kandinsky's abstract expressionism, the "rayism" of Larionov and Goncharova, the "suprematism" of Malevich, and the radical constructed reliefs of Vladimir Tatlin) all have roots in Russian neo-primitivism.

At the core of neo-primitivism and more or less overtly permeating much of the innovative art in Russia through the 1920s was, on the one hand, an ardent faith in the singularity, depth and superior spiritual force of "the Russian soul" and, on the other, an aspiration to participate at the leading edge of world culture. The artists of the Russian avant-garde regarded neo-primitivism as providing simultaneously an authentic connection with the native Russian spirit and a universal language so fundamental as to be unimpeded in its ability to communicate by the particularizing veneers of different cultures.

Works such as Goncharova's 1914 lithograph of *Mystical Images of War: Angels and Airplanes* [fig. 2.2] exemplify this duality. Here the artist casts angels as atavistic embodiments of the ancient heartbeat of Russia, expressions of a distinctive spirituality that, from the point of view of the Russian avant-garde, gave them an inherent supremacy over Western artists. The airplane was the most breathtaking new innovation of Western technology. The Russian futurists had great enthusiasm for it—some even became pilots—and took it as an emblem of their own dynamic thrust into the future. At times it even symbolized mystic flight. But here the angels engage the airplanes, manipulating them like toys. The clear superiority of the angels in Goncharova's lithograph precisely reflects the hierarchy in which the Russian neo-primitivists saw themselves in relation to Western culture.

In his 1913 manifesto of *Neo-primitivism*—asserting a position pioneered by Larionov and Goncharova—the painter and theorist Aleksandr Shevchenko went so far as to argue that:

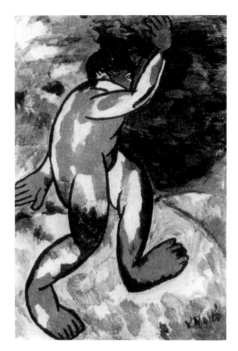

2.1
Kasimir Malevich
Bather, 1911

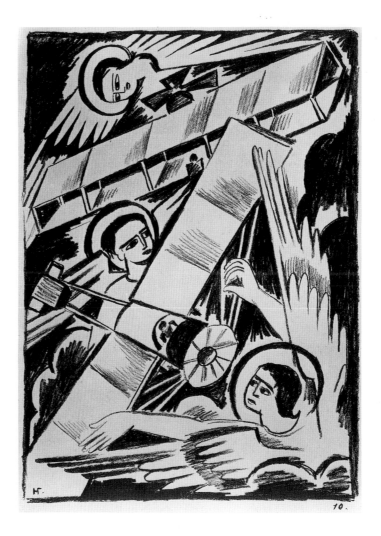

a procession of arts has resulted—from us, from the East, from the Caucasus to Byzantium, then to Italy, and thence, adopting a little oil-painting technique and easel-painting technique, it comes back to us. . . . There is no longer any point in using the products of the West, which has obtained them from the East. . . .

Shevchenko regarded Western art as enervated and derivative, whereas Russian "neo-primitivism," he went on to say, "is entirely original." And he added that "one's own national art . . . plays a large part, just as children's art does—this unique, always profound, genuine primitivism; art in which our Asiatic origin is evident in its entirety."[5]

For Shevchenko and his fellow members of the Donkey's Tail group, children's art flowed together with ancient Scythian carvings, painted shop signs, peasant ornament and textiles, Russian religious icons, the indigenous arts of the East, and *lubok* prints (a popular genre of anonymous, frequently devotional, woodblock images) as expressions of the authentic "childhood" of Russia from which the rest of its culture had grown. Larionov had an especially

strong passion for child art and, according to the art historian Camilla Gray, he influenced the Russian futurist poets in "the imitation of children's art," as well as in adaptations of folk art.[6] (Futurism, it should be noted, is a broader term in Russian art than in Italian; it encompasses nearly the whole Russian avant-garde of the early 1910s.)

The attraction of the Russian futurists to the creativity of children is evident. In the futurist anthology *Worldbackwards*[7] and in several other works, Aleksei Kruchenykh wrote using rubber-stamped letters, he occasionally reversed letters, and he deliberately scattered misspellings and misplaced capitals throughout the text—all in emulation of the unself-conscious awkwardness of children. In addition, Kruchenykh's story line for the landmark futurist play *Victory over the Sun* (1913) and the paradigm of "the new man of the future," which he presented there, both have a pointedly childlike simplicity. In 1914, he published a volume of *Actual Stories and Drawings of Children*[8] and coauthored the book *Piglets* with an eleven-year-old girl.[9]

The other futurist poets admired the expressive devices of children, too. Vasily Kamensky collected children's art and various of his poetic inventions allude directly to the way children write.[10] The form of Elena Guro's stories and illustrations reflects the influence of children's syntax as well; she even wrote a story, called "Childhood," from an explicitly child's-eye view[11]; and Mikhail Matyushin used a drawing by Guro's seven-year-old niece for the cover of her posthumous collection of free verse, *Baby Camels of the Sky* (1914).[12] The poet Velimir Khlebnikov built poems on infantile vocabulary[13] and he insisted that two poems by a thirteen-year-old girl be included in the futurist compendium *Hatchery of Judges 2*.[14] Indeed, as Roman Jakobson (a celebrated linguist and comrade of the futurists) pointed out, the important futurist invention of *zaum* (transrational language) derived in part from the language of children: "We knew very well that there were children's folktales that contained sounds without meaning; we were aware of incantations and glossolalia. And this played a great role. My first conversation with Khlebnikov occurred when I brought him texts that I collected for him of children's folklore and incantations that were completely *zaum*, without any words."[15]

In 1913, Kruchenykh wrote a theoretical tract called "The New Ways of the Word" in which he articulated the futurist idea of revealing the transrational through illogical gestures. "There was no verbal art before us," he insisted, " . . . everything was done to stifle the primeval feeling for one's native tongue."[16] As evidence he cited the subordination of the word to meaning and urged his fellow futurists to proceed instead *through* the word to direct knowledge. "One should write in a new way," he exhorted his friends, "and the more disorder we bring to the composition of sentences, the better." By cultivating

2.3
Child's drawing
Dog on a Chain, formerly in
the collection of Mikhail Larionov

2.4
Child's drawing
Cock and Dog, formerly in
the collection of Mikhail Larionov

confusion the futurists sought to stimulate a dynamic instability of meaning that would provoke an "innocent" perception of the everyday world—indeed, the same freshness of perspective on experience that they found in the expressive language of children. This is the key to the interest of Larionov and the Russian futurists in the art of children.

Even the symbolists had looked to the child as a model for the more direct expression of the truth of the inner self which they sought. Aleksandr Benua, who directed the symbolist[17] exhibition society and journal *World of Art* (*Mir iskusstva*) with Serge Diaghilev, insisted that "all children's play is art. All of their inventions are art."[18] He focused on the creative act more than on objects and in retrospect saw his own childhood games as the key antecedents of his mature work as an artist. Leon Bakst, another central figure in the World of Art group, wrote: "What attracts, what delights, and, I say, even, moves us, in children's pictures? . . . candour/sincerity, movement, and clear, clean colors."[19] Bakst also singled out the innocent intellect of child artists for instinctively portraying what matters instead of worrying about the rendering and finish.

In the 1880s the leading arts and crafts colonies at Talashkino and Abramtsevo (the forerunners of World of Art) had already taken an interest in children's art.[20] But the neo-primitivist and futurist painters and poets seem to

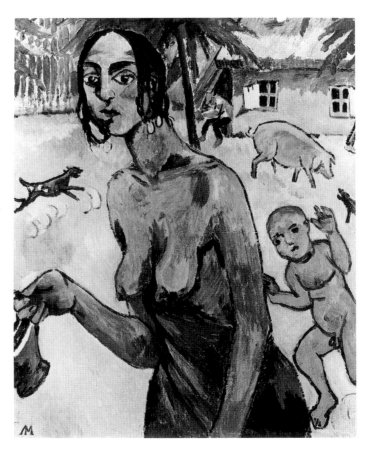

2.5
Mikhail Larionov
The Gypsy Woman
(*The Gypsy in Tiraspol*),
1909

have been the first in Russia to have collected children's drawings and exhibited them alongside their own work. The Moscow Salon group, of which Larionov was a member, showed two rooms of child art in their exhibition of 1911.[21] Larionov and Goncharova included selections of children's drawings from the collections of Shevchenko and N. D. Vinogradov when they organized the *Target* show of March 1913.[22] Pavel Filonov, a leading member of the St. Petersburg group "Union of Youth," also actively investigated children's art.[23]

In 1912, Vladimir Markov, an artist and critic close to both the Union of Youth and the Donkey's Tail, described children's play as a wild, primitive and free state in which the utilitarian purpose of things is forgotten, as are inhibitions that make us self-conscious. This form of play is therefore instinctive, vivid and expressive of the true inner self.[24] The same premise underlay the antilogic of the performances and public antics of the Russian futurists—of Larionov and David Burlyuk when they painted their faces and wore wooden spoons in their buttonholes, and of Vladimir Mayakovsky and Kruchenykh who wrote plays with such pointedly illogical titles as *A Cloud in Pants* and *Victory over the Sun*. The *Donkey's Tail* exhibition itself not only expressed a rebellion against the academic standards of St. Petersburg (a revolt modeled on the West), but it also alluded to an absurdist and playful art action which resembled those the Russian futurists undertook in order to release revelations of the transrational self.

In Russian painting, this expression of childlike directness was achieved most successfully in the mature neo-primitivist paintings of Larionov—of which the outstanding examples are *The Soldier on a Horse* (1911), *Venus and Mikhail* (1912), and the two series of paintings on the theme of "the seasons" (1912). Larionov's neo-primitivism emerged in 1909,[25] heavily influenced by French post-impressionism and by fauvism (which he had seen on his visit to the 1906 Salon d'Automne in Paris). Paintings such as *The Gypsy Woman*[26] [fig. 2.5] and *Woman Passing By* of (probably early) 1909 resonate with the influence of Gauguin and Cézanne. *The Blue Pig*, of (perhaps later) 1909 [fig. 2.6], shows more stylistic self-confidence and independence even though it is still clearly indebted to the primitivist drawing and brilliant palette of French fauvism.

In *The Blue Pig* the radically simplified delineation of the pig and of the foreground figure, the flattening of the forms, the unmodulated color areas, and the general crudeness of the outlining also lead one to suspect the influence of children's art, along with other formal sources. However, by the time Larionov painted *The Officer's Barber* [fig. 2.7] at the end of the year or early in 1910 the influence of child art seems perfectly clear. In this latter work, the deliberately "uncontrolled" description of anatomy, its flatness and perspective distortion, the reduction of the space into the two planes of foreground and background, the inconsistencies of scale (as in the enlarged scissors), and the limitation of the

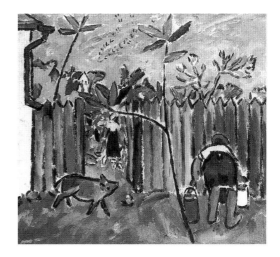

2.6
Mikhail Larionov
The Blue Pig, 1909

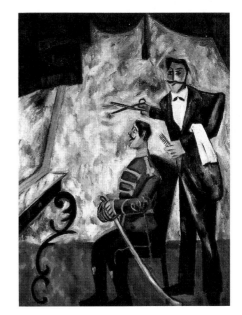

2.7
Mikhail Larionov
The Officer's Barber, 1909–10

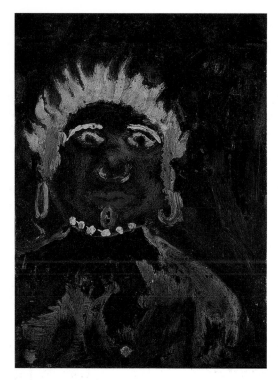

2.8
Child's drawing
Papuan, formerly in
the collection of Mikhail Larionov

palette to a domination of brilliant red, blue and brown all seem closely related to the simplicity of the children's paintings that Larionov himself had collected at the time [figs. 2.3, 2.4, 2.8].[27]

Scholars have suggested connections between Larionov's neo-primitivist paintings and the influence of shop signs, naive painting and *lubok* prints as well as children's art, and it is clear that the artist not only appreciated all these genres but encouraged their inclusion in the exhibitions he organized; he considered them spiritually coextensive with his own work. Nevertheless, the different artists among the Russian neo-primitivists tended to favor one or another of these sources as inspiration for their own work.

It was above all Mikhail Le Dantu, for example, who seems to have been attracted to the naive paintings of Niko Pirosmanashvili[28] (who has been characterized as a Russian Douanier Rousseau), and in a letter to Le Dantu, Ilya Zdanevich makes it clear that it was the two of them who collected Pirosmanashvili's works for Larionov to include in the *Target* exhibition of 1913.[29] The primitive shop signs that they all admired were represented in paintings by Larionov but did not appreciably influence his style as they did Aleksandr Shevchenko's, for example.[30] Both signboards and *lubki* figured prominently in the work of Malevich[31] and Goncharova. For Goncharova in particular, the influence of the *lubki* (which can be seen in her *Mystical Images of War*) began earlier and lasted longer than it did for the other major artists. Meanwhile, she collaborated with Larionov in collecting child art, yet its impact on her own work seems relatively insignificant.

For Larionov, child art and the influence of Henri Matisse were the central beacons for his neo-primitivism. Whereas Larionov's *Barber* of 1907 is clearly fauvist, *The Officer's Barber* shows just as clearly the influence of his collection of children's paintings and probably dates his discovery of child art. The childlike openness which came to the fore at the end of 1909 in works like *The Officer's Barber* differs from the *lubki* and signboards; the *lubki*, for example, characteristically render recurrent details such as mouths, eyes and hands by convention rather than by treating each instance with the expression and individuality one sees in child art, and that childlike attention to such specifics is clearly present in *The Officer's Barber*. In general, the work has an expressive directness that is not found in the *lubki*, the signs or generally in folk art.

Larionov painted a number of compositions on the theme of soldiers in 1909 and 1910 (coincident with his experience in the military reserves) and in 1912 his friend David Burlyuk singled out Larionov's "soldier" paintings as an example of the equivalence between what he called "free drawing" by children and the art of the avant-garde.[32] *Soldier on a Horse* (ca. 1911) [fig. 2.9], perhaps the consummate work in the series, has the same outlining and flatness in the

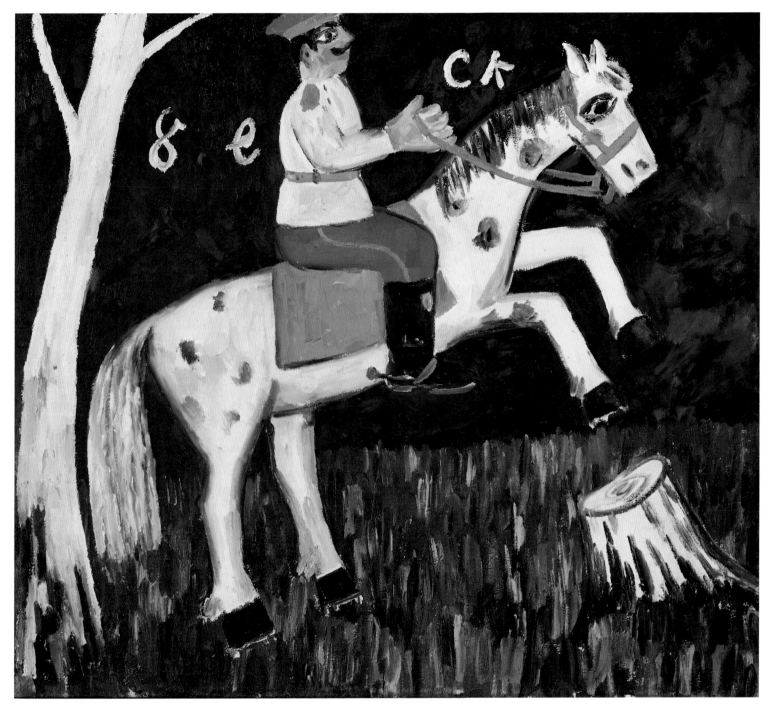

2.9
Mikhail Larionov
Soldier on a Horse, ca. 1911

2.10
Child's drawing
Plate 60, from Georg Kerschensteiner,
*Die Entwicklung der zeichnerischen
Begabung* (The Development of the
gift of drawing), Munich, 1905

forms as well as the same simplicity in the description of its background plane as some of the paintings by children that Larionov owned at the time, such as *Dog on a Chain* [fig. 2.3]. These two works even resemble one another in the yellow accents in the grass.[33] The strict profile employed by Larionov is a commonplace of child art, as are the boxlike rendering of the muzzle of the horse and the oddly stuck-on look of the legs on the animal's far side. In addition, the artist has *named* the picture, as children often do, with lettering in the sky: "8 esk" for "8th squadron" (*eskadron*).

Meanwhile, the impact of Matisse's work on Larionov's *Soldier on a Horse* and to an even greater extent on his paintings of late 1911 and 1912 can hardly be overestimated. Matisse came to Moscow in October 1911 to install his great masterpieces of that year, *Music* and *Dance II*, in the collection of Sergei Schtschukin, where many of his earlier works were already on display. While he was there Matisse and Larionov met. But Matisse's visit, together with the powerful impression made by these two extraordinary new paintings, seems to have been entirely too affecting for Larionov (as well as for Goncharova), and immediately after Matisse's visit they felt compelled to take an extreme public stand against his influence. Thus after helping to organize the *Knave of Diamonds* exhibition of 1911, in which Matisse, Picasso and Italian futurism were the stylistic lighthouses by which the participants navigated, Larionov and Goncharova acrimoniously broke with the group before its second show (of January 1912) and organized the *Donkey's Tail* exhibition, excluding all foreigners and even rejecting Russians working abroad (except Chagall).[34]

As late as 1911, a Russian critic sarcastically referred to Larionov as "a Matisse,"[35] and one can readily see why. Even in a masterpiece of 1912 such as Larionov's *Venus and Mikhail* [fig. 2.11], the flat, cutout nude with no modeling immediately recalls the figures in Matisse's *Dance II*; the cap of black hair, the linear schema of the face, and the way the figure hovers in front of the white sheet instead of resting on it resemble *Music*. In addition, the disconcerting proximity of tone between Larionov's figure and the equally unmodulated gold background suggest a response to the way in which Matisse related the near complementary colors of figures and ground in both *Dance II* and *Music*.

Unlike these great works by Matisse, however, Larionov's *Venus* has an infantile eroticism—a childlike simultaneity of innocence and frank sexuality. He also "names" the picture, inscribing "Venus" in the upper left, next to a tree drawn in the manner of a child (see, for example, fig. 2.10). The oversized numbers with which the artist has inscribed the date and the signature of only the artist's first name, "Mikhail," also seem like reversions to childhood modes of expression. At the same time the sweet little hovering cupid, shaped like a stuffed rag doll, seems to present this *Venus* to the viewer as though she were

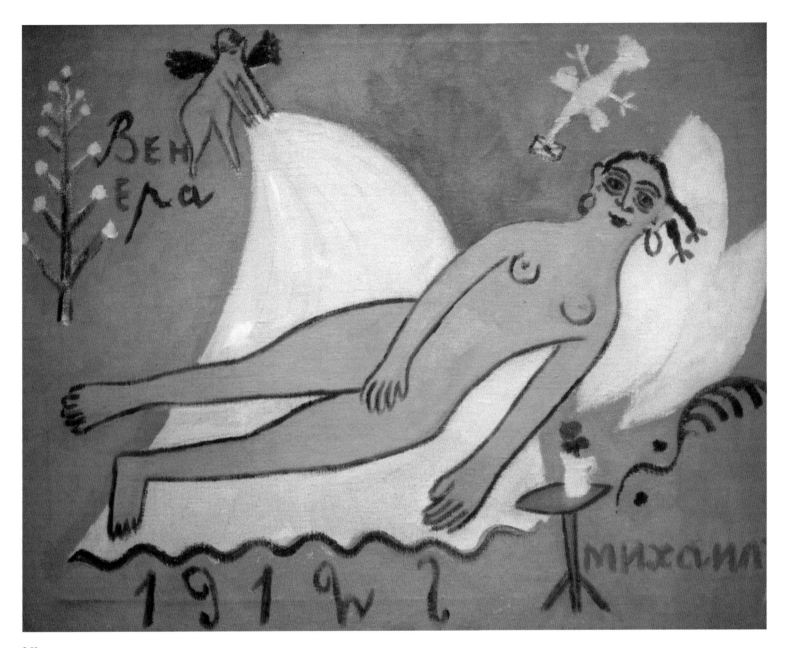

2.11
Mikhail Larionov
Venus and Mikhail, 1912

an exquisite *bonbon*. It is obviously in the tradition of Manet's *Olympia* (by then a celebrated masterpiece of modernism). But if the work portrays a prostitute, as has been suggested by other commentators,[36] she seems charmingly innocent with her pigtails and adolescent figure. Larionov painted her with an evident glow of affection; she has nothing of the *Olympia*'s hard, cold stare. Here the eroticism is matter-of-factly a part of life; it is a pure, childlike sensuality that utterly lacks the self-consciousness of an adult morality. In this sense the work also has a destabilizing instinctuality that causes one to encounter reality with a childlike freshness of vision.

Whereas the *Venus* paintings devolve in a kind of reverse ontogenesis from a more sophisticated naturalism (albeit simplified and informed by cubism) to the neo-primitivist *Venus and Mikhail*, Larionov's 1912 series of the four seasons is uniform in style and constitutes both a composite *chef d'oeuvre* of the artist's neo-primitivism and its swansong [figs. 2.12, 2.13, 2.15]. With a deliberately awkward unevenness, Larionov divided each of these paintings into four spatially unrelated quadrants (as is common in folk art). In each composition one of the lower quadrants contains a saccharine little poem such as children write about the seasons:

> *Spring is bright*
> *Spring is wonderful*
> *with Bright Colors*
> *and White Clouds*
>
> *Summer is sweltering*
> *with Stormy Clouds with*
> *Scorched earth with*
> *a blue sky with mature wheat*
>
> *Fall is happy shining like gold*
> *with ripe grapes*
> *with tipsy wine*
>
> *Winter is cold snowy windy*
> *enveloped in blizzard*
> *and chained with ice*

In these poems the block lettering, the lack of punctuation, the awkward hodgepodge of cursive and printing, lowercase and capitals, variant sizes, and random mistakes in spelling, all seem as deliberately childlike as the poetry and form in Aleksei Kruchenykh's contribution to *Worldbackwards*, created just a few months after these paintings, in the same year, and containing illustrations by

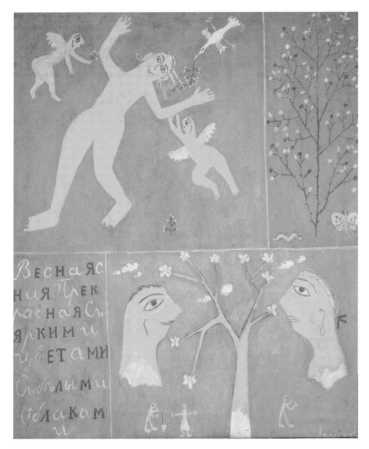

2.12 Mikhail Larionov, *Spring* (from *The Seasons*), 1912

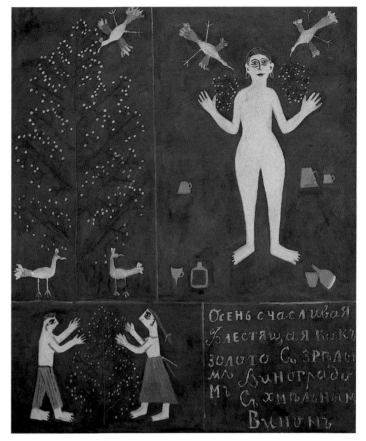

2.13 Mikhail Larionov, *Autumn* (from *The Seasons*), 1912

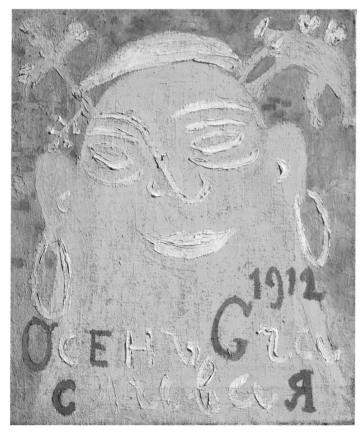

2.14 Mikhail Larionov, *A Happy Autumn*, 1912

2.15 Mikhail Larionov, *Winter* (from *The Seasons*), 1912

2.16
Diagram showing the transmutation of the initial of Larionov's last name, the Cyrillic *L*, into a schematic head

2.17
Mikhail Larionov
Cover for the futurist book *Pomade*, by Kruchenykh, 1913

Larionov in his neo-primitivist style.[37] In Larionov's poem for *Autumn* [fig. 2.13], for example, "happy" is misspelled with a "t" left out. The little white bird flying in with a letter in *Venus and Mikhail* recurs in three of these panels (and often elsewhere); in *Autumn* it carries branches laden with fruit in the upper right and feeds on a bountiful tree at left. These paintings of the seasons also have a number of other forms that are rendered as though by a child: butterflies and caterpillars, dogs, people and cupids all randomly (and disconcertingly) out of scale to one another. The houses and dog in the lower left sector of *Winter* [fig. 2.15] make a particularly unmistakable allusion to child styles of drawing.

The influence of child art is by no means the only source of Larionov's neo-primitivism; for example, *lubok* prints and graffiti (what the artists referred to as "fence painting") occasionally leave letters out and contain phonetic spelling, too, and there is no punctuation in the medieval psalters that Larionov doubtless knew. But Larionov and the circle of futurist poets around him were deeply involved with infantilism not merely as a lexicon of formal devices but for its ability to undermine fixed ideas about the world. He painted designs on his face together with Burlyuk, staged cabaret happenings inspired by child's play, and illustrated a number of futurist books in a child-inspired neo-primitivism, as in the futurist book *Pomade* (1913) [fig. 2.17], which also contains Kruchenykh's first *zaum* poem. Larionov repeatedly used the primitive head seen on the cover of *Pomade* in works such as *A Happy Autumn* [fig. 2.14] and *Spring* (both of 1912 and evidently part of a separate series of seasons organized around this head). Larionov may even have deliberately derived this head—which became a virtually "signatory" device—in the playful spirit of Kruchenykh's puns and other futurist games by transmuting the initial of his last name, the Cyrillic *L*, into a schematic head [fig. 2.16].

In *Pomade* Larionov included both neo-primitivist drawings and illustrations

in his new abstract ("rayist") style side by side, suggesting that he did not see them as incompatible nor necessarily even sequential in concept. Similarly, he exhibited his "rayist" pictures together with his great neo-primitive canvases as well as with hand-painted signs and children's drawings[38] in the March 1913 *Target* exhibition. Larionov's written manifestos of 1913 make it clear that the dynamic activity of light is the subject in "rayism," as it emanates from, moves around and reveals objects. As Larionov became preoccupied with the metaphysics and style of "rayism" in 1913, he ceased to innovate in a neo-primitive idiom, even though he continued repeating neo-primitive motifs, like personal icons, for much of the rest of his career. Yet, the light in "rayism" does still retain an echo of the Slavophile orientation of neo-primitivism; the metaphoric possibilities of the fact that the sun rises in the east was not lost on Larionov, as Margareta Tupitsyn has pointed out.[39]

Larionov left Russia in 1915 and never again produced work on the level of his prewar painting. Moreover, the irretrievably dissident attitude of the futurists went out of favor after the revolution, and they largely disappeared too, except for those like Tatlin and Malevich who allied themselves with constructivism and endeavored to collaborate with the regime. However, neo-primitivism, despite its connection with futurism, never entirely disappeared; indeed, it perpetuated an undercurrent of symbolist spirituality (and an interest in child art) until the decline of constructivism at the end of the 1920s. Vsevolod Meyerhold (the great Russian stage director of the 1920s), for example, praised the art of children because, he said, they give objects the proportion that relates to their actual importance in the event being depicted—a good paradigm for the didactic task of the Marxist theatre. But this admiration for the child's intuitive sense of what is "important" also implies a lingering primitivism.[40]

After 1918, "their muses were machines," as the artist Naum Gabo later remarked of the constructivists.[41] Yet beneath the postrevolutionary duality of the city proletariat (the factory worker) and the rural peasant was the old Slavophile and Westernizer debate. Furthermore, the new soviet social theory, with its revolutionary slogan of "art for the people," continued a centuries-old tradition, begun with Russian icon painting, of looking to art to give spiritual meaning to life. Even the devices of the public art and theatre that the government relied upon to convey the new values of the proletarian state to the people were modeled on the popular traveling carnivals of the nineteenth century.[42]

Moreover, in the heated debates on art theory in the 1920s, the art of the future was, according to some, founded on primitivism, especially the authentic primitivism of the child[43] as Shevchenko had described it. For one thing, child art offered an indigenous expression, representing Russia in a non-Western format, and from the soviet point of view it also offered a means to the new art

of the future—a true proletarian and nonbourgeois art, untainted by class and virtually noncommodifiable. Thus after the revolution serious efforts were made to grant children's art a legitimate status in art history and criticism. Filonov, for example, proposed a plan for the reorganization of the Academy of Arts in 1922–23 which included the establishment of a section on children's art, while the State Academy of Artistic Sciences in the mid-1920s actually housed a "Cabinet for Primitive Art and Children's Creativity," under the aegis of which the critic Alexei Bakushinsky produced a number of important findings.[44]

Among Bakushinsky's arguments was that the first stage of a child's artistic development was characterized by motor and tactile impulses, and that the child artist was therefore interested in movement and in the continuum, rather than in a fixed result. It is tempting to trace a connection from this idea to the avant-garde's sudden interest in kinetic art just after the revolution, as in Tatlin's *Monument to the Third International* (with its four revolving chambers) and Naum Gabo's dynamic light contructions. In effect, Bakushinsky sought to resurrect the past (ontogenetically) in order to give rise to the future (historically).

In Velimir Khlebnikov's play *Worldbackwards* (of the same title, but otherwise unrelated to the anthology which he had edited a year and half earlier with Kruchenykh) the hero rises from his own funeral and he and his wife begin to live their lives in reverse; the play ends with them both as infants in prams, surrounded by balloons.[45] The style of Larionov's neo-primitivism also celebrates this regained childhood, indeed this spiritual return to childhood is a pervasive concern of Larionov's circle. Yet for Bakushinsky (the cultural theorist of the 1920s), for these futurist poets of 1912–14, for Larionov's neo-primitivism, and even for the Russian symbolists before them there was a unifying conviction that art had to recapture, as one artist put it in 1901, the "harmony and purity of the child's soul."[46] Like any vanguard art, Larionov's neo-primitivism, as well as these writings by Khlebnikov and Kruchenykh, in effect provide a mirror for the culture as a whole—as it were a glass in which to arrange oneself and it seems that from the turn of the century through the 1920s, one frequently encountered a child there.

1. Société des Artistes Indépendants, *Catalogue de la 26ème Exposition* (Paris, 1910), 50. Most accounts refer to one work, titled *Et le soleil s'endormit sur l'Adriatique*, and some give the year as 1905. The spring 1910 exhibition catalogue cites three works by J.-R. Boronali: *Et le soleil s'endormit* (604), *Sur l'Adriatique* (605), *Marine* (606). The catalogue also gives the artist's address as 53, rue des Martyrs, Paris, and indicates that he was born in Genoa (the French word for Genoa is *Gênes*; *gêne* means an embarrassment or annoyance).
2. Mikhail Larionov, introduction to *Katalog Vystavki Kartin Gruppy Khudozhnikov Mishen'* (Catalog for exhibit by the Target group) (Moscow, 1913), 6. Unless otherwise specified, translations from Russian in this chapter were done for me by Roann Barris.

3. Yevgeny Kovtun, "Mikhail Larionov i Zhivopisnaia Vyveska" (Mikhail Larionov and the painted sign), in Jochen Poetter and Eugeniia A. Petrova, *Avangard i ego russkie istochniki* (The Avant-garde and its Russian sources) (St. Petersburg: State Russian Museum, 1993), 39.

4. Traditionally, scholars have seen Larionov's primitivist period as dating back to works I would call symbolist, such as the provincial series (*progulki*—strolls or outings) in which the artist tends to re-peat figures or motifs within individual works or from work to work. In other paintings (around 1907) which do not otherwise appear primitivist, Larionov includes representations of primitive objects. Sarab'ianov suggests that the artist's use of figures in multiple views signals the beginning of Larionov's experimentation with traditional *lubok* styles. (See Dmitrii Sarab'ianov, *Russkaia zhivopis'—kontsa 1900-kh do nachala 1910-kh godov* [Russian painting from the end of 1900 to the beginning of 1910] [Moscow, 1971]). This may well be true and I would agree that primitive influences appear around 1907, but what seems to me a fully developed primitivist style dates to works such as *The Blue Pig* in the latter part of 1909.

5. Aleksandr Shevchenko, *Neo-primitivism: Its Theory, Its Potentials, Its Achievements* (Moscow, 1913); cited in John E. Bowlt, *Russian Art of the Avant-Garde: Theory and Criticism 1902–1934* (New York: Viking, 1976), 49. Shevchenko even included a reproduction of a child's drawing in his 1913 book on cubism: Aleksandr Shevchenko, *Printsipy kubizma i drugikh sovremennyjh techenii v zhivopisi vsekh vremen i narodov* (The Principles of cubism and other contemporary trends in painting of all ages and all nations) (Moscow, 1913); noted in John E. Bowlt, *Russian Art of the Avant-Garde*, 41.

6. Camilla Gray, *The Great Experiment: Russian Art, 1863–1922* (London: Thames and Hudson, 1962), 94; cited in Vladimir Markov, *Russian Futurism: A History* (Berkeley and Los Angeles: University of California Press, 1968), 36.

7. Aleksei Kruchenykh and Velimir Khlebnikov, *Mirskonsa* (Worldbackwards) (Moscow, 1912). The reader will find varied renderings of this title as one word or three in the bibliography on Russian literature because at various times editors of the Russian futurist books, without consulting the au-thors, attempted to put this into "correct" Russian even though it was an invented word. Kruchenykh and Khlebnikov deliberately ran the words together in emulation of a child's orthography (thus also making it appropriate to translate the title as one word: "Worldbackwards"). See also note 45 below.

8. Aleksei Kruchenykh, *Sobstvennye Razskazy I Risunki Detei* (Actual stories and drawings of children) (St. Petersburg, 1914). The volume included poems and stories by children between the ages of seven and eleven. A somewhat revised edition appeared in 1923 in Moscow.

9. Aleksei Kruchenykh, *Porosiata* (Piglets) (St. Petersburg, 1914). See John E. Bowlt, "Esoteric Culture and Russian Society," in Maurice Tuchman, ed., *The Spiritual in Art: Abstract Painting 1890–1985* (Los Angeles: Los Angeles County Museum of Art, 1986), 178.

10. Vladimir Markov, *Russian Futurism: A History* (Berkeley and Los Angeles: University of California Press, 1968), 36, 170–71, 328–29. See Vasily Kamensky, *Devushki bosikom* (Barefooted girls) (Tiflis, 1916).

11. See Kjeld Bjornager Jensen, *Russian Futurism, Urbanism and Elena Guro* (Denmark, 1977), 34–39.

12. Elena Guro, *Nebesnye verbliuzhata* (Baby camels of the sky) (St. Petersburg, 1914). Matyushin, Guro's husband, prepared the book for publication. See John E. Bowlt, "Esoteric Culture and Rus-sian Society," in Maurice Tuchman, ed., *The Spiritual in Art: Abstract Painting 1890–1985*, 178.

13. As noted by Vladimir Markov, *Russian Futurism: A History*, 36.

14. Velimir Khlebnikov, *Sadok sudei 2* (Hatchery of judges 2) (St. Petersburg, February 1913). There were two issues of this miscellany, *Sadok sudei*, each with a different collection of contributions; the first one was published in April 1910. See John E. Bowlt, "Esoteric Culture and Russian Society," in Maurice Tuchman, ed., *The Spiritual in Art: Abstract Painting 1890–1985*, 178.

15. Roman Jakobson, "Art and Poetry: The Cubo-Futurists," in Stephanie Barron and Maurice Tuchman, eds., *The Avant-Garde in Russia, 1910–1930: New Perspectives* (Los Angeles: Los Angeles County Museum of Art; Cambridge, Mass.: MIT Press, 1980), 18; see also Christina Lodder, *Russian Con-structivism* (New Haven and London: Yale University Press, 1983), 269 n. 31.

16. Aleksei Kruchenykh, "Novye puti slova" (The New ways of the word), in *Troe* (The Three) (September 1913); cited and discussed in Vladimir Markov, *Russian Futurism: A History*, 126–28.

17. The literature on Russian art tends to call the *World of Art* group "art nouveau" and to reserve the term "symbolism" to refer to the Blue Rose group that succeeded World of Art. I have used the term "symbolism" in the sense that it is increasingly applied in Western European art, a general tendency toward spirituality, romanticism and subjectivity that encompasses *l'art nouveau* as well as a wide range of subjectivist painting from the *nabis* to the post-impressionist works of artists such as Monet and Gauguin. World of Art was a defined organization with a formal membership but it was also the focus of symbolism (using the term in the broader sense that I have defined here).

18. Aleksandr Benua, "Vystavka 'Iskusstvo v shizne rebenka'," *Rech* (26 November 1908), 3; cited in Janet Kennedy, *The "Mir iskusstva" Group and Russian Art* (New York: Garland, 1977), 275.

19. Leon Bakst, "Puti klassitsizma v iskusstve" (Paths of classicism in art), *Apollon*, no. 2 (November 1909), 63–78; cited in *Slavistic Printings and Reprintings* (The Hague and Paris: Mouton, 1971), 54, where it is dated as *Apollon*, no. 3 (December 1909).

20. According to John E. Bowlt, *Russian Art of the Avant-Garde*, xxxxvii.

21. See Anthony Parton, *Mikhail Larionov and the Russian Avant-Garde* (Princeton, N.J.: Princeton University Press, 1993), 94.

22. This is widely reported in the literature, most recently in Anthony Parton, *Mikhail Larionov and the Russian Avant-Garde*, 94. Parton gives Vinogradov's initials inaccurately as I. D.

23. See Nicoletta Misler, "Pavel Filonov, Painter of Metamorphosis," in Nicoletta Misler and John E. Bowlt, trans. and ed., *Pavel Filonov: A Hero and His Fate* (Austin, Tex.: Silvergirl, 1983), 25–52. See also Jeremy Howard, *The Union of Youth: An Artists' Society of the Russian Avant-Garde* (Manchester: Manchester University Press; New York: St. Martin's Press, 1992), 66.

24. Vladimir Markov, "The Principles of the New Art" (1912), in John E. Bowlt, *Russian Art of the Avant-Garde*, 30–31. There is also a direct precedent for this view in the great Russian post-impressionist Mikhail Vrubel who is reported to have walked around Kiev with his nose painted. See Nikolai Prakhov, *Stranitsy proshlogo* (Pages of the past) (Kiev: Derzhavne vidavnitstvo, 1958), 116.

25. Some Russian writers have connected Larionov's early impressionist-influenced works with the native tradition of Russian lyricism. N. Punin, for example, in an article of 1928, discussed this (cited in Dmitrii Sarab'ianov, *Russkaia zhivopis'—kontsa 1900-kh do nachala 1910-kh godov*, 99–116). Sarab'ianov suggests that such a connection makes the relationship between Larionov's impressionist period and his primitivism seem more organic.

26. This work is dated to 1909 in Anthony Parton, *Mikhail Larionov and the Russian Avant-Garde*, 23. It is referred to as *Tzigane à Tiraspol* and dated 1903 in Waldemar George, *Larionov*, (Paris: La Bibliothèque des Arts, 1966), 31. George's dating in general seems to have been based on conversations with the artist who, most scholars now agree, predated works considerably. Parton has attempted to redate the important pictures with mixed success. Parton dates *The Officer's Barber* to 1910–12 (see pages 81 and 90), despite the published documentation to the contrary; stylistically it seems to me more likely to be a work of later 1909, after *The Gypsy Woman* but before *Soldier on a Horse*, where the artist has more confidence with this childlike vocabulary. Waldemar George (page 63) dates *The Officer's Barber* to 1907, and the picture is signed and dated 1907 by the artist. But it was presumably signed long after it was painted and deliberately predated by the artist. I do take as accurate the documentation of François Daulte et al., that the earliest known reference to this work's having been exhibited is from the end of 1909 in Moscow at the exhibition of *La Toison d'Or* (The Golden Fleece), which corroborates my suggestion on stylistic grounds that it looks like a work of later 1909. (See François Daulte et al., *Larionov Goncharova Rétrospective* [Brussels: Musée d'Ixelles, 1976], cat. entry 34.) I agree with Parton on the dating of the *Venus* and *Seasons* series to 1912. I concur with Povelikhina and Kovtun's dating (in Alla Povelikhina and Yevgeny Kovtun, *Russian Painted Shop Signs and Avant-Garde Artists* [Leningrad: Aurora Art Publishers, 1991], 88, 94, 96, 97, and 99) of the works I discuss.

27. Larionov had an extensive collection of child art before 1915 and continued to collect it all his life. Unfortunately, much of what remains of these collections is in storage at the Tretyakov Gallery in Moscow, under circumstances that make it unavailable for study and exhibition. The particular examples shown here were given by Larionov to a friend before emigrating from Moscow in 1915, providing a *terminus ad quem* for their entry into Larionov's possession.

28. See, for example, Alla Povelikhina and Yevgeny Kovtun, *Russian Painted Shop Signs and Avant-Garde Artists*, 76–77.

29. Ilya Zdanevich, letter to Mikhail Le Dantu, January 1913, Manuscript Department, The Russian Museum, St. Petersburg, f.135, ed.khr. 5, II. 1–2 (recto and verso), translated in Alla Povelikhina and Yevgeny Kovtun, *Russian Painted Shop Signs and Avant-Garde Artists*, 185.

30. See Alla Povelikhina and Yevgeny Kovtun, *Russian Painted Shop Signs and Avant-Garde Artists*, 110.

31. Ibid., 134–35.

32. David Burlyuk, "Kubizm" (Cubism [Surface-Plane]), *Poshchechina obshchestvennomu vkusu* (A Slap in the face of public taste) (Moscow, December 1912); cited in John E. Bowlt, *Russian Art of the Avant-Garde*, 77.

33. Anthony Parton, in *Mikhail Larionov and the Russian Avant-Garde*, 83, compares *Soldier on a Horse* to an eighteenth-century *lubok* of an armored horseman, but the similarity of subject confuses the issue by making the comparison seem more plausible than the stylistic evidence warrants.

34. *The Donkey's Tail* opened in Moscow on 11 March 1912. It contained about 300 works, 58 of them by Larionov himself, and it attracted nearly 10,000 visitors. See Anthony Parton, *Mikhail Larionov and the Russian Avant-Garde*, 42.

35. "M. F. Larionov," *Protiv techeniya*, no. 48 (17 December 1911), 3; cited in Anthony Parton, *Mikhail Larionov and the Russian Avant-Garde*, 38.

36. Anthony Parton, who regards the subjects of all the *Venus* paintings of 1911–12 as prostitutes, actually sounds a little shocked by the "vulgar" sexuality. But this may also be seen as a rich, sensual vitality which is integral to Larionov's neo-primitivism and evidently not perceived by Parton. See Anthony Parton, *Mikhail Larionov and the Russian Avant-Garde*, 50–52.

37. The book also contains illustrations by Goncharova in a style that is unusually childlike for her.

38. Evidentally these were chiefly from the collections of Vinogradov and Shevchenko. See Valentine Marcadé, *Le Renouveau de l'art pictural russe 1863–1914* (Lausanne: Editions l'age d'homme, 1971), 329–31.

39. Margareta Tupitsyn, "Collaborating on the Paradigm of the Future," *Art Journal* 52, no. 4 (Winter 1993), 23.

40. V. E. Meyerhold, *Meyerhold on Theatre*, trans. Edward Braun (New York: Hill and Wang, 1969), 320–21.

41. Naum Gabo, *Of Divers Arts*, Bollingen series 11:XXXV (Princeton, N.J.: Princeton University Press, 1962), 156; cited in S. Frederick Starr, "Foreword," *Russian Avant-Garde: 1908–1922*, exh. cat. (New York: Leonard Hutton Galleries, 1971), 7.

42. This connection has been dealt with in detail with regard to constructive stage design in Roann Barris, "Chaos By Design: The Constructivist Stage and Its Reception" (Ph.D. diss., Urbana-Champaign: University of Illinois, 1994).

43. See A. Grech, "K Voprosu o vneprofessional'nom iskusstve," presented in debate at the State Academy of Artistic Sciences in the late 1920s; fond 941, opus 3, delo 173 at TsGALI (Central State Archive of Literature and Art, Moscow); a reference given to me by Roann Barris.

44. See N. Staroseltseva, ed., *Revoliutsiia, iskusstva, deti* (Revolution, art, children) (Moscow: Prosveshchenie, 1966–67), 2, 40–41.

45. Velimir Khlebnikov, "Mirskonsa" (Worldbackwards), in Velimir Khlebnikov, *Riav Perchatki 1908–1914* (Roar! The gauntlets 1908–1914) (St. Petersburg, 1914). The play itself is five pages long, and the book as a whole contains about thirty pages of Khlebnikov's writings from 1908–14 along with illustrations by David Burlyuk and Kasimir Malevich. As Susan Compton has pointed out, Aleksei Kruchenykh's *Worldbackwards* also has a connection to this idea of return to childhood in that it looks back to the slightly earlier writings of Nikolai Kulbin. In an essay of 1908 called "Free Art as the Basis of Life" Kulbin advocated a biogenetic view of children's art based on the classic paradigm that "ontogeny recapitulates phylogeny." See Susan P. Compton, *The World Backwards: Russian Futurist Books 1912–16* (London: British Museum, 1978), 95; and Nikolai Kulbin, "Svobodnoe iskusstva kak osnova zhini" (Free art as the basis of life) (1908), in *Studija impressionistov* (Studio of the impressionists) (St. Petersburg, 1910).

46. N. Minsky, "Filosofskie razgovory," *Mir isskustva*, no. 6 (1901), 1–16; cited in John E. Bowlt, "Realism to Surrealism," in *Russian Art 1875–1975: A Collection of Essays* (New York: MSS Information Corp., 1976), 156.

3. In Search of Universality: The Vasily Kandinsky and Gabriele Münter Collection

"The child," Vasily Kandinsky wrote in 1912, "is indifferent to practical meanings since he looks at everything with fresh eyes, and he still has the natural ability to absorb the thing as such. . . . Without exception, in each child's drawing the inner sound of the subject is revealed automatically."[1] In this essay, entitled "On the Question of Form," Kandinsky enlarged on Arthur Schopenhauer's challenge to Immanuel Kant's separation of the appearance of a thing from the "thing in itself." For Schopenhauer, knowledge of the self demonstrated the continuity from the phenomenal world to the noumena (the thing in itself); one can perceive oneself as a presence in the world and at the same time one has intimations of one's essence.

Kandinsky found a parallel in Schopenhauer's discussion of the self for the viewer's access to a universally significant subject matter in painting. For Kandinsky, childlike modes of perception—represented in children's compositional devices as well as in the style of their imagery—provided prototypes for passing through the elements of the recognizable world to a higher order of meaning. Kandinsky's "inner necessity" and "inner sound" derive from Schopenhauer's concept of "will,"[2] and the recognizable objects in his abstract paintings emulate the way in which the style of children's rendering facilitates access to this "inner sound." He explained:

> Adults, especially teachers, try to force the practical meaning upon the child. They criticize the child's drawing from this superficial point of view: "Your man cannot walk because he has only one leg," "Nobody can sit on your chair because it is lopsided," and so on. The child laughs at himself. But he should cry. Besides being able to ignore the external, the gifted child also has the ability to express the abiding internal in such a form that it emerges and affects very forcefully (or as people say, "It speaks"!). . . . The artist, whose whole life is similar in many ways to that of a child, can often realize the inner sound of things more easily than anyone else.[3]

Kandinsky's art theoretical writings make it clear that he sought in the art of children stylistic principles for pushing aside the "worldly" sophistication of nat-

3.1 Child's drawing (Paulot Seddeler, age 4), 1910–12, from the collection of Kandinsky and Münter

3.2 Child's drawing (Kätchen Busse), from the collection of Kandinsky and Münter

3.3 Child's drawing (Joseph Wechsler), from the collection of Kandinsky and Münter

3.4 Child's drawing, from the collection of Kandinsky and Münter

3.5
Child's drawing (Robert Böhm),
from the collection of Kandinsky
and Münter

3.6
Child's drawing (Lilja Kenda,
Russian), from the collection of
Kandinsky and Münter

3.7
Child's drawing,
from the collection of Kandinsky
and Münter

uralistic rendering in his art, to reveal a more universal, visual language. He wanted to address a subject that transcended the materialism of his age in a form that bypassed cultural convention and resonated directly with his viewer's inner, spiritual consciousness.

August Macke outlined a similar point of view in an essay for Kandinsky's *Der Blaue Reiter Almanac* (1912): "Incomprehensible ideas express themselves in comprehensible forms. . . . To create forms means: to live. Are not children more creative in drawing directly from the secret of their sensations than the imitator of Greek forms? . . . Man expresses his life in forms. Each form of art is an expression of his inner life."[4]

Kandinsky and Gabriele Münter (who had an intimate relationship from 1902 until he left Munich to return to Russia in 1916) had begun collecting children's drawings together as early as 1908 [figs. 3.1–3.8].[5] This collection of roughly 250 drawings and paintings on paper have clear connections to the prewar paintings of both artists and was an interest they shared with others in their circle, including Paul Klee, Alexei Jawlensky and Lyonel Feininger. Kandinsky also remained in touch with Larionov and others in the Russian avant-garde who avidly collected child art,[6] and in the 1920s at the Bauhaus Kandinsky began collecting children's drawings again in tandem with his close friend Klee.

3.8
Child's drawing (Lilja Kenda, Russian),
from the collection of Kandinsky
and Münter

In addition, children's drawings appeared often in the collective exhibitions in which Kandinsky participated before the war; in some cases it is clear that it was he who insisted upon it.[7]

It is interesting that the children's drawings which Kandinsky reproduced in the *Blaue Reiter Almanac* were by a thirteen-year-old girl named Lydia Wieber and rather adult in style,[8] unlike most of what he and Münter collected for themselves. Since much of the most vituperative criticism of the prewar expressionists involved the accusation that they were either insane or as inept as children, perhaps Kandinsky decided to take a cautious public stance on this issue in the *Almanac*. But it seems that he did not even bother to save the drawings by Wieber (which do not exist either in the collection that Münter preserved or in the contents of the Paris studio) and found inspiration instead in the more radically naive work of younger children.[9]

Kandinsky excerpted extensively from the drawings by children in his collection for his "abstractions" of 1908 through 1914. But he also altered them considerably en route to his paintings, consistently giving them an even more "childlike" appearance than the children themselves had done. His version of *The Elephant* (1908), for example, is considerably more primitive than the one he owned by a child [figs. 3.8, 3.9].

Likewise, the children who drew the steam engines in his collection [figs. 3.11, 3.13] attended to detail with greater precision than Kandinsky himself did in his own paintings of this subject [figs. 3.10, 3.12]. Kandinsky seems to have been more intent on analyzing and exploiting the general characteristics that made the children's renderings "childlike." He looked back to a point in the evolution of visual language that he thought might precede the influences of culture and individual personality; he sought common denominators in the representational syntax of children's drawings that might serve his project of constructing a universal language of art.[10]

The drawing of "my horse-cart, my flag and me," from a school notebook in Kandinsky and Münter's collection by Münter's niece Annemarie, is not necessarily the source for Kandinsky's troika in his 1912 painting *The Black Spot*, but it is at the very least exemplary of a class of child renderings that provided prototypes for Kandinsky's handling of the motif here and elsewhere at the time [figs. 3.14–3.17].[11] Once again Kandinsky's version of the motif is more "childlike" than the child's in an effort to extract the general principles from children's drawings that would help him move the entirety of his pictorial language toward a more intuitive and universal legibility.

The same is true of other motifs in Kandinsky's painting of *The Black Spot*, although his collection does not contain specific children's drawings that resemble all of these other images. In the top center of the painting, Kandinsky

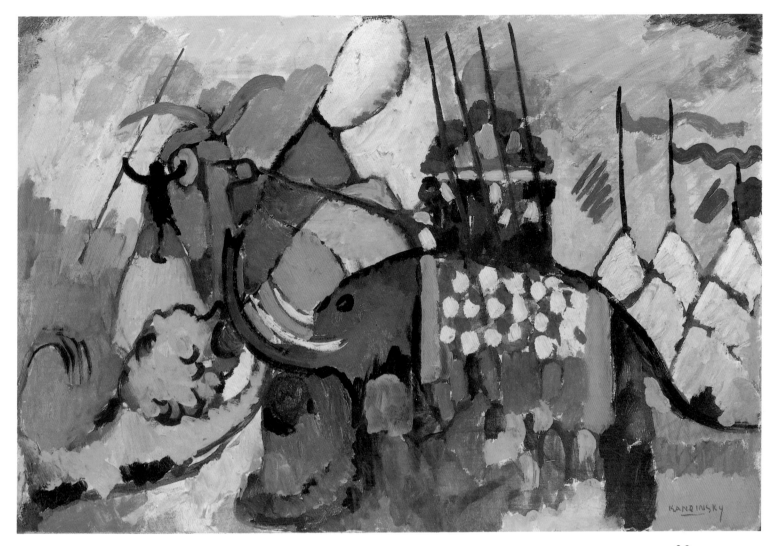

3.9
Vasily Kandinsky
The Elephant, 1909

drew a boat (a simple half circle) with two rowers (one pink and one in white, yellow and blue) and two long black oars. This childlike rendering of the boat probably refers to the Flood in the Old Testament, which provides a metaphor for the artist's well-known aspiration for the spiritual rebirth of society. The open cart, pulled by a troika (with the horses reduced to a spare three black lines with an inverted arc as the harness) are just below and to the left of the boat. The troika—which is perhaps more legible in the drawing for this composition [fig. 3.15]—refers to the artist's nostalgia for his native Russia while at the same time expressing his vision of the artist as charioteer, leading the charge into the future, as outlined in his book *On the Spiritual in Art*: the artist, he says, "sees and points. Sometimes he would gladly be rid of this higher gift, which is often a heavy cross for him to bear. But he cannot. Through mockery and hatred, he continues to drag the heavy cartload of struggling humanity, getting stuck amidst the stones, ever onward and upward."[12]

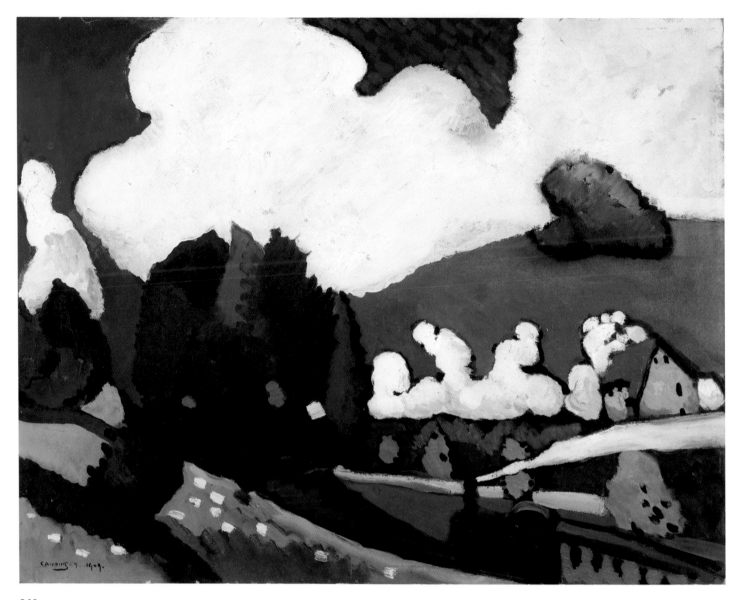

3.10
Vasily Kandinsky
Landscape near Murnau with Locomotive, 1909

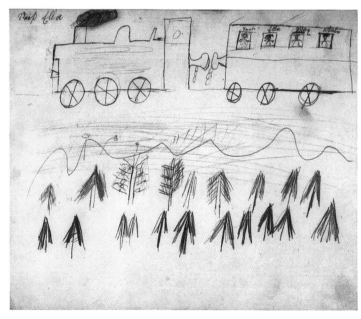

3.11
Child's drawing (Ella Reiss),
from the collection of Kandinsky
and Münter

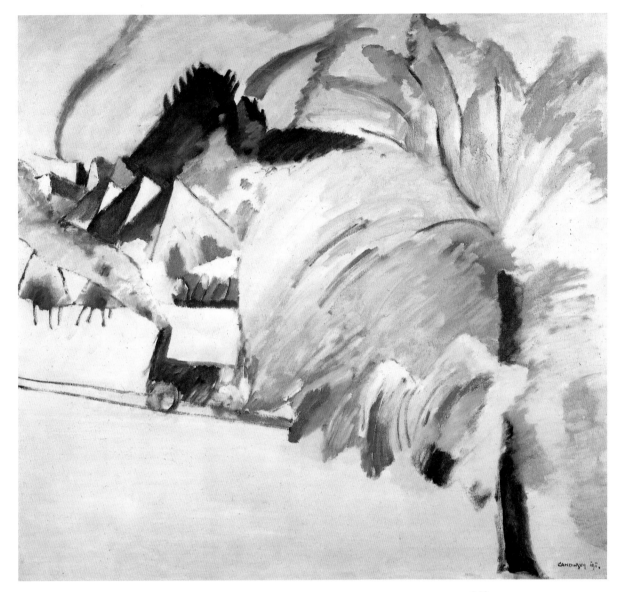

3.12
Vasily Kandinsky
Murnau with Locomotive, 1911

3.13
Child's drawing (Joseph Wechsler,
age 10), 7 October 1906, from the collection
of Kandinsky and Münter

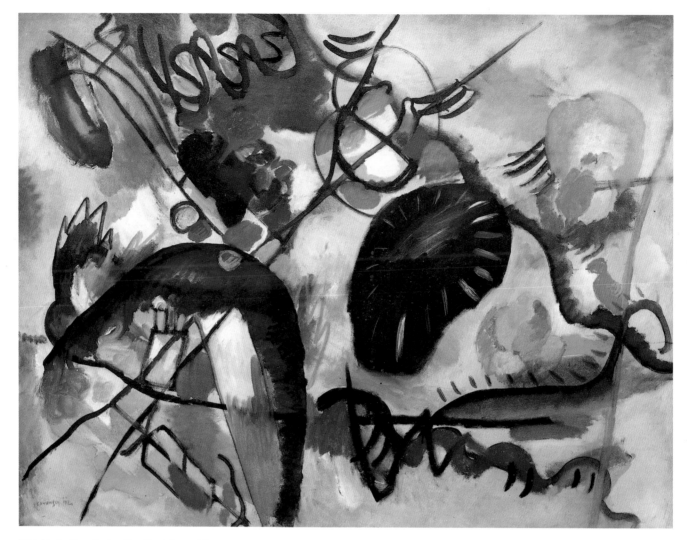

3.14 Vasily Kandinsky, *The Black Spot*, 1912

3.15 Vasily Kandinsky,
Sketch for The Black Spot I, 1912

3.16
Child's drawing (Annemarie Münter),
page 13 of a sketchbook, from the
collection of Kandinsky and Münter

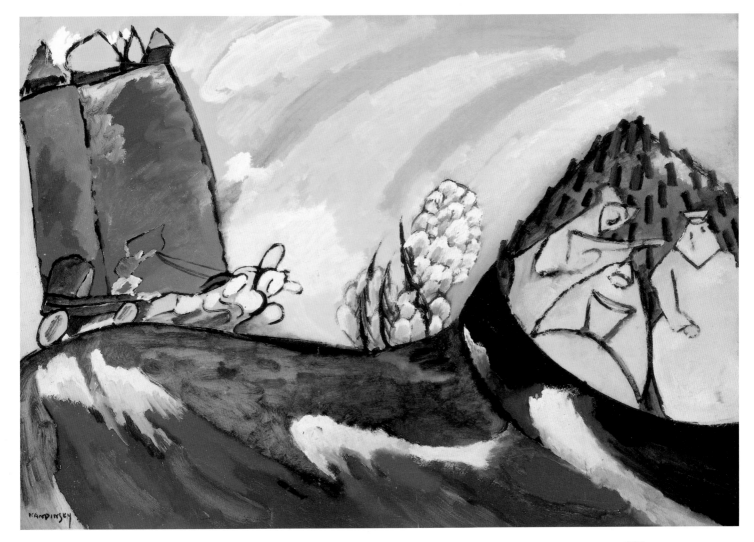

3.17
Vasily Kandinsky
Painting with Troika, 1911

A predominantly yellow and green, triangular mountain occupies the lower left quadrant of *The Black Spot*, and on the left near the top Kandinsky has placed a medieval, walled city with onion-domed towers, modeled on the Kremlin. This is his hieroglyph of the heavenly Jerusalem and recurs frequently in his paintings well into the 1920s. Behind this looms a larger blue mountain and to the left of it another familiar hieroglyph in Kandinsky's oeuvre, that of the dragon from his paintings on the theme of St. George. At the same time, the artist has focused on a purely formal feature of this work in the title—the large black spot to the right of center—giving it as much specificity in the painting as the objective references and (especially in the drawing) it even has a morphological affinity to the child's spotted horse [fig. 3.16].

Kandinsky also took descriptive devices from children's drawings. In *Horses* of 1909 and in the *Sketch for Composition II* of 1910, for example, the raised foreleg of the white steed in the center of both of these works flexes as though

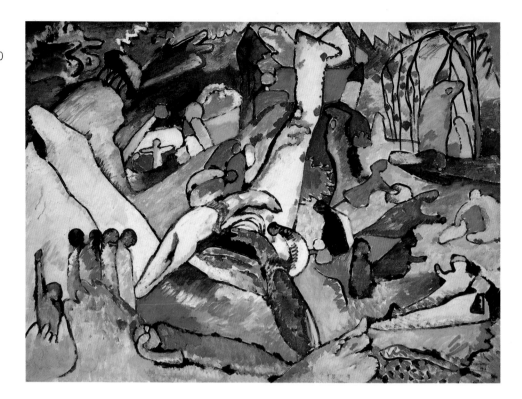

3.19
Child's drawing (Maschura),
inscribed in Russian by Kandinsky,
from the collection of Kandinsky
and Münter

3.20
Child's drawing (child of Albert Bloch),
10 November 1913, from the collection
of Kandinsky and Münter

made of rubber, like the horses' legs in several of the children's drawings in Kandinsky and Münter's collection [figs. 3.18–3.21]. In *Impression VI (Sunday)* of 1911, the segmented anatomy of the large couple in the foreground as well as the button eyes and the outline rendering of the bowler hat resemble details in the children's drawings he owned [figs. 3.24–3.26, 3.29]. The ubiquitous, stiff, cruciform figures, as in *Sketch for Composition II*, also seem to derive from child art in the Kandinsky-Münter collection [figs. 3.18, 3.22, 3.23].

Yet even more significant than Kandinsky's use of the children's drawings as a source of vocabulary for his rendering are the spatial concepts. In *Improvisation 30 (Cannons)* of 1913, Kandinsky not only described the imagery—the cluster of buildings and the cannons to the right or the bundle of narrow figures in the lower left (lined up like paper dolls)—in a vocabulary derived from the drawings by children in his collection [figs. 3.27, 3.28, 3.30], but he also annihilated the smooth transitions of space from foreground to background, isolating the images from one another. In addition, the amorphous clouds of color in *Improvisation 30* resemble the color handling in one of the children's drawings he owned [fig. 3.27]. Kandinsky also picked up on the concept of free spatial orientation, as in the house turned sideways in the child's picture, when he painted images like the boat with oars on the right edge of his 1913 *Little Pleasures* and the 1911 paintings *Improvisation 21a* and *With Sun* [figs. 3.33, 3.34].

Spatial ideas such as these suggest an even more profound and crucial influence of child art on Kandinsky's prewar painting. In all of these major paint-

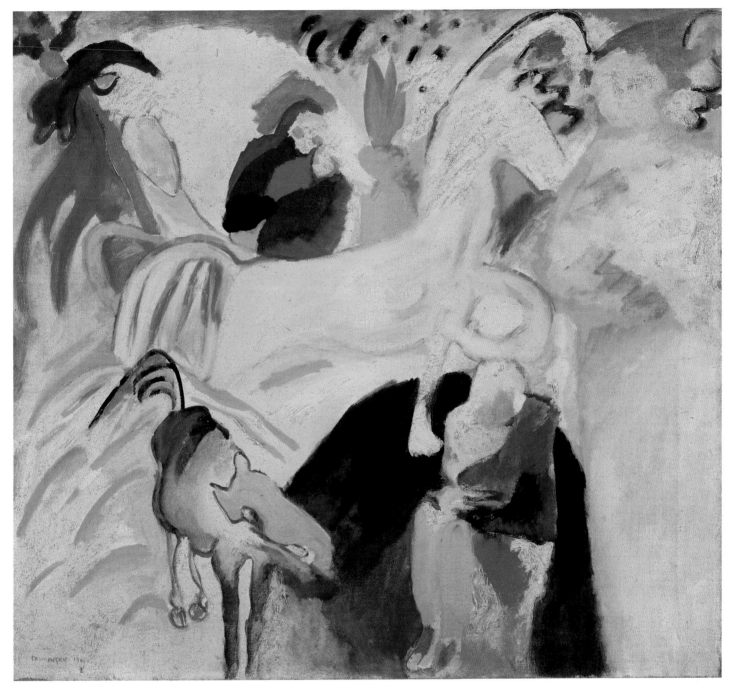

3.21
Vasily Kandinsky
Horses, 1909

ings (*Horses*, *Impression VI*, *Improvisation 30*, *Little Pleasures*, *Improvisation 21a* and *With Sun*), Kandinsky used disjunctures of scale and space as a device to isolate the figures from one another in his compositions. The inspiration for this is in children's drawings such as the two by Elisabeth Busse in the Kandinsky-Münter collection, in which the child traced her hand or drew a bird in the foreground of a page with a drastically smaller house in an entirely unrelated background [figs. 3.31, 3.32]. In *Impression VI (Sunday)*, for example, the two

3.22
Child's drawing
(Annemarie Münter),
August 1910, from the
collection of Kandinsky
and Münter

3.23
Child's drawing
(Annemarie Münter),
11 December 1910, from
the collection of Kandinsky
and Münter

3.24
Child's drawing (Lilja Kenda Dekabr),
dated December 1910 in Russian script
by Kandinsky, from the collection
of Kandinsky and Münter

3.25
Child's drawing (Annemarie Münter),
1 May 1911, from the collection
of Kandinsky and Münter

3.26
Child's drawing, from the collection
of Kandinsky and Münter

3.27
Child's drawing, from the collection
of Kandinsky and Münter

figures in the foreground seem to hover in an undefined space, out of scale to
the other images in the composition and separated from them by abrupt dis-
continuities in perspective; each image in the painting exists in its own separate
universe. This method of breaking apart the narrative coherence of the images
by radical jumps in scale and by the elimination of rational spatial transitions
allowed Kandinsky to exploit the rich associations of a recognizable image
while nevertheless making an abstract picture.

Since 1957 when the art historian Lorenz Eitner first pointed out a little
couple in Bavarian dress walking on a bridge in Kandinsky's 1914 *Improvisation
Chasm*,[13] scholars have come to realize that Kandinsky's prewar "abstraction"
brims over with recognizable, if frequently obscure, references to objects. Sub-
sequent scholarship has shown that the images make discreet allusions to the
apocalypse of the Bible, to the triumph of St. George over the dragon, and the
like. But no one has successfully demonstrated the existence of a systematic
iconography in Kandinsky's work. Indeed, what is radically new about Kandin-
sky's painting of 1909 through the early 1920s from even the most subjective
rendering of any scene, real or imagined, is that these objective references do
not cohere into a narrative, or a consistent space, or even an identifiable train
of association such as might suggest an iconography in the normal sense.

3.28
Child's drawing (Annemarie Münter),
28 August 1913, from the collection
of Kandinsky and Münter

In this way, Kandinsky discovered he could use an object just as he used a
color or sound or a nonobjective gesture to elaborate the associative depth of
his painting. "Here," he said, "I want to emphasize one aspect of good chil-
dren's drawing important to us at the moment: composition."[14] But the idea
has many other sources as well, including the symbolist notion of *dépaysment*
("uprooting"), in which the poet repeats a word over and over, or in some other

3.29
Vasily Kandinsky
Impression VI (Sunday), 1911

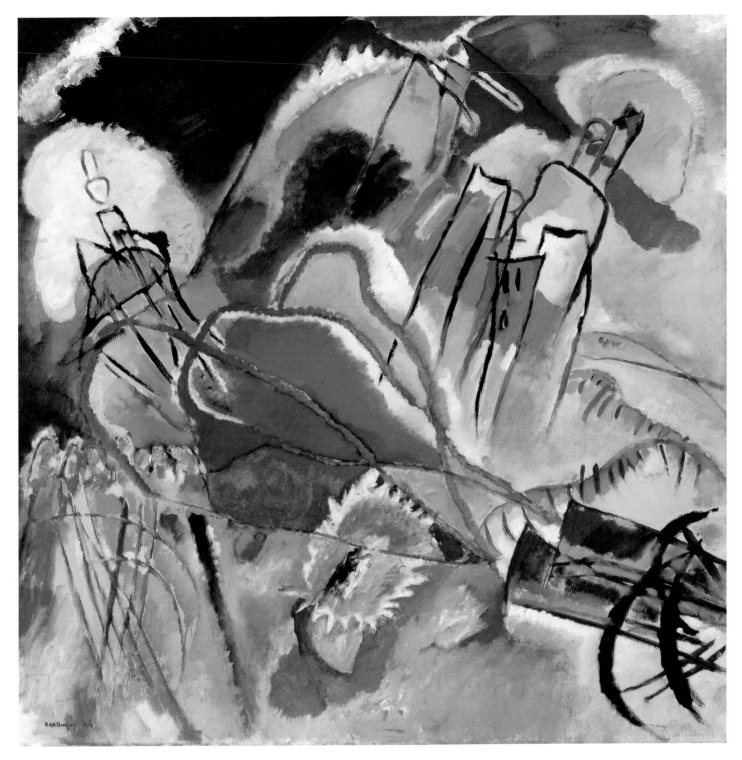

3.30
Vasily Kandinsky
Improvisation 30 (Cannons), 1913

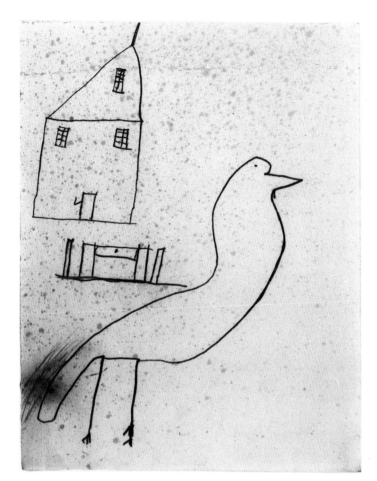

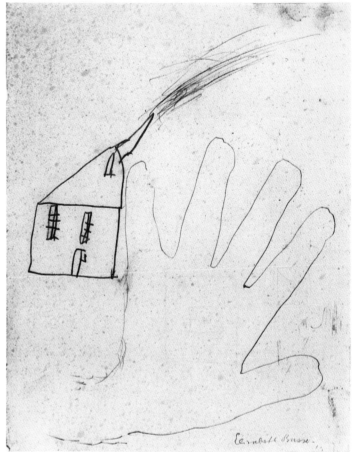

3.31
Child's drawing (Elisabeth Busse),
August 1913, from the collection
of Kandinsky and Münter

3.32
Child's drawing (Elisabeth Busse),
ca. 1912–13, from the collection
of Kandinsky and Münter

way disconnects it from its denotative context to unleash its underlying expressive tone. In his book *On the Spiritual in Art*, Kandinsky wrote:

> *Skillful use of a word (according to poetic feeling)—an internally necessary repetition of the same word twice, three times, many times—can lead not only to the growth of the inner sound, but also bring to light still other, unrealized spiritual qualities of the word. Eventually, manifold repetition of a word (a favorite childhood game, later forgotten) makes it lose its external sense as a name. In this way, even the sense of the word as an abstract indication of the object is forgotten, and only the pure sound of the word remains. We may also, perhaps unconsciously, hear this "pure" sound at the same time as we perceive the real, or subsequently, the abstract object. In the latter case, however, this pure sound comes to the fore and exercises a direct influence upon the soul.[15]*

Perhaps Kandinsky had in mind Stéphane Mallarmé's reflections on poetry: "What is the purpose of the miracle of transposing a fact of nature into its almost vibratory disappearance by means of the play of words, if it is not that there may emanate from it, without the embarrassment of an immediate or concrete reminder, the pure notion."[16] Kandinsky's radical idea of using an

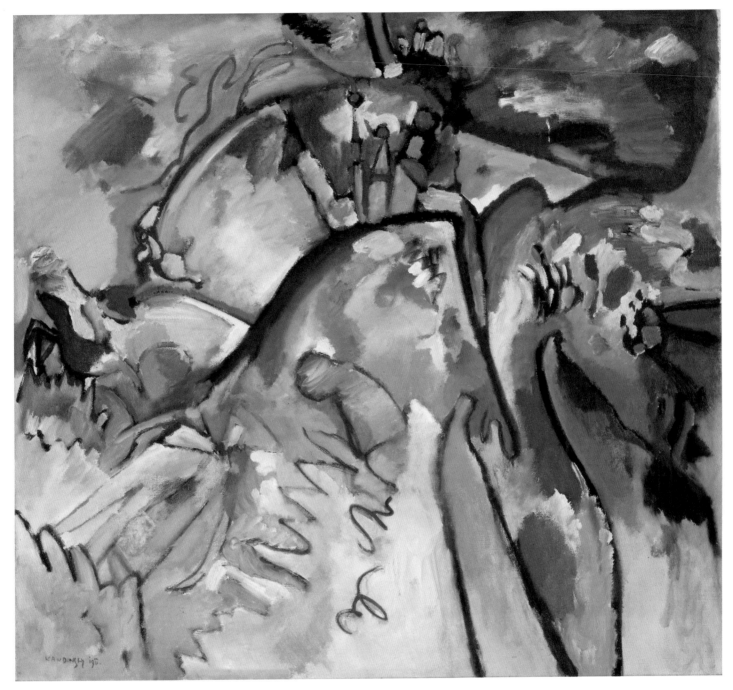

3.33
Vasily Kandinsky
Improvisation 21a (Study for Little Pleasures),
1911

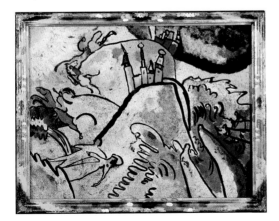

3.34
Vasily Kandinsky
With Sun, 1911

3.35
Child's drawing (Friedel),
page 7 in school notebook,
from the collection of Kandinsky
and Münter

3.36
Child's drawing (Thomas Herrman),
from the collection of Kandinsky
and Münter

object in this way—the central premise of his concept of abstract painting—relies on a synaesthetic merging together of different realms of knowing, and on the belief that every object is a being with an inner sound, communicated by vibrations (a premise elaborated in an article by Henri Rovel in *Les Tendances Nouvelles*, which Kandinsky cited in *On the Spiritual in Art*).[17]

Kandinsky's 1913 *Little Pleasures* and his 1911 paintings *Improvisation 21a* and *With Sun* [figs. 3.33, 3.34] include four horsemen (one of them wielding a staff with scales) ascending the left edge of the canvas and a mountain (in the center), topped with a colorful cluster of city towers that seem to be shaken in a dramatic, cosmic disaster that includes a long cloud of black smoke, a blood-red moon in the upper left, and a celestial city descending from above. All of these subjects are described in the apocalyptic vision of St. John the Apostle on the Island of Patmos, as told in the Bible: the riders who appear following the opening of the first of the seven seals, "the smoke of the pit," the glistening vision of "the new Jerusalem, coming down out of heaven," and the catastrophic destruction of "lightnings and voices and thunders: and there was a great earthquake . . . and the cities of the Gentiles fell."[18] At the same time, this painting has a little red boat with three black oars and little figures in it (at the center of the right edge) and what seems to be a whale in the lower center—The Flood and Jonah and the Whale? Though not a logical iconography, all of these references provide metaphors for the idea of spiritual rebirth.

Once again the vocabulary for Kandinsky's treatment of these themes seems related to the children's drawings in his collection. In particular, the hill in the center foreground with the towers on top and even the way it is drawn with a double outline appear to come directly from a sketch in a notebook by Friedel (Elfriede Schroeter), one of Münter's nieces [fig. 3.35]. Moreover, the layered space of scenes piled over one another instead of in perspectival recession resembles such children's works as the one Kandinsky owned by a German boy named Thomas Herrman [fig. 3.36]. The watercolor by a Russian child in Kandinsky's collection [fig. 3.37] seems suggestive for Kandinsky's way of losing the image in a complex and meandering web of colors and forms with various gravitational orientations.

The collection of Kandinsky and Münter also contains many colorful drawings of houses by children and one can see the reverberations of them in works such as Kandinsky's 1909 *Murnau—Landscape with Rainbow* [figs. 3.38–3.42]. But here the connection to Münter's art is even stronger, as in her paintings of *The Blue Gable* and *Village Street in Winter*, both of 1911 [figs. 3.43, 3.44]. Some particularly striking examples of the seriousness with which Münter studied this material are the three nearly exact copies she made on 23 March 1914 after paintings of houses by children in hers and Kandinsky's collection [figs. 3.45–

3.37
Child's drawing (Wanitschku, Russian),
from the collection of Kandinsky
and Münter

3.50]. Münter's 1913 painting *In the Room* actually shows two paintings by Münter's then eleven-year-old niece Friedel; the pictures are propped up on the floor next to the blond Friedel, seated, reading a book [figs. 3.51–3.53]. These paintings still exist in the Kandinsky-Münter collection today.

Like Kandinsky, Münter found a more simplified, naive expression in the collection of children's drawings and this directly informed her work. But she approached the child art in a more visceral and less metaphysical way. The simplification of the facial features, the bold color and dark outlines, in such paintings as Münter's portrait of Jawlensky, *Listening*, of 1909, and the flattening of perspective in her landscapes also reflect her study of children's art [figs. 3.54–3.56].

Other artists in the Blaue Reiter circle clearly also saw this collection and collected children's drawings themselves. A couple of works from Kandinsky and Münter's collection seem likely to have provided one of the sources for Paul Klee (see page 92), and the influence of child art is also quite evident in Feininger's work after the Blaue Reiter, as in his 1916 *Lovers* [fig. 3.58]. In

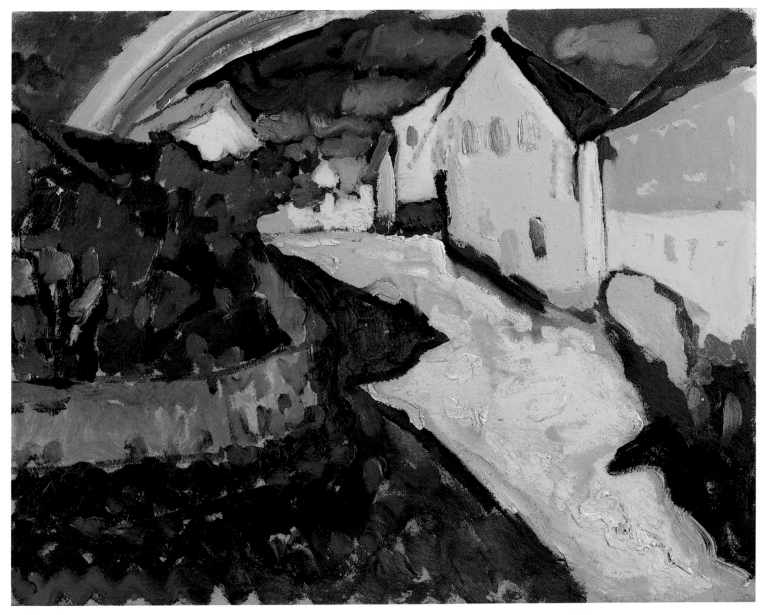

3.42
Vasily Kandinsky
Murnau—Landscape with Rainbow, 1909

Opposite:
3.38
Child's drawing (Käte Busse),
from the collection of Kandinsky and Münter

3.39
Child's drawing (Annemarie Münter),
29 August 1913, from the collection
of Kandinsky and Münter

3.40
Child's drawing (Anna Böhm),
from the collection of Kandinsky and Münter

3.41
Child's drawing (Otto Paskegg),
from the collection of Kandinsky and Münter

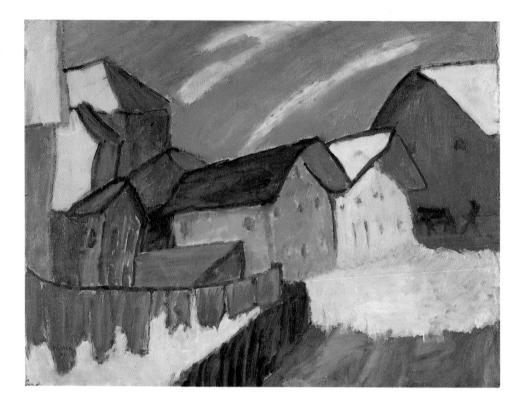

Feininger watercolors of the early 1920s such as *City with Sun* and *The Jetty at Swinemünde* [figs. 3.57, 3.63] and in the many toys Feininger made for children [fig. 3.60] the character of the buildings as well as the rendering of the space and the little figures demonstrate the impact of children's art.

Feininger's classic *Locomotive with Large Wheel* of 1915 [fig. 3.59] may also bear the marks of the artist's encounter with child art in the awkward simplicity of the faces and flat forms. Yet, in this work the prominence of cubism, the heritage of Feininger's activity as a cartoonist, and echoes from contemporary varieties of expressionism make the influence of child art less obvious than in works of the next year, 1916, such as *Lovers.* This may date a turning point in Feininger's concern with infantile sources.

Few of the artists in the Blaue Reiter circle had children themselves at the time, but Jawlensky's son Andreas was the one artist's child around these painters frequently, and he was, in addition, astoundingly gifted. Works such as his *Locomotive* of ca. 1909 (painted when he was seven years old) [fig. 3.62] are so beautifully done that they have occasionally been mistaken for the work of his father [fig. 3.61] and indeed such paintings must have captured the attention of his father as well as some of the other artists. In this work by the younger Jawlensky, as in the paintings of Klee's son, Felix, one can see quite clearly the influence of the adults on the styles of the children too; the children of artists are often unusually talented at art and this may have to do not only with the avail-

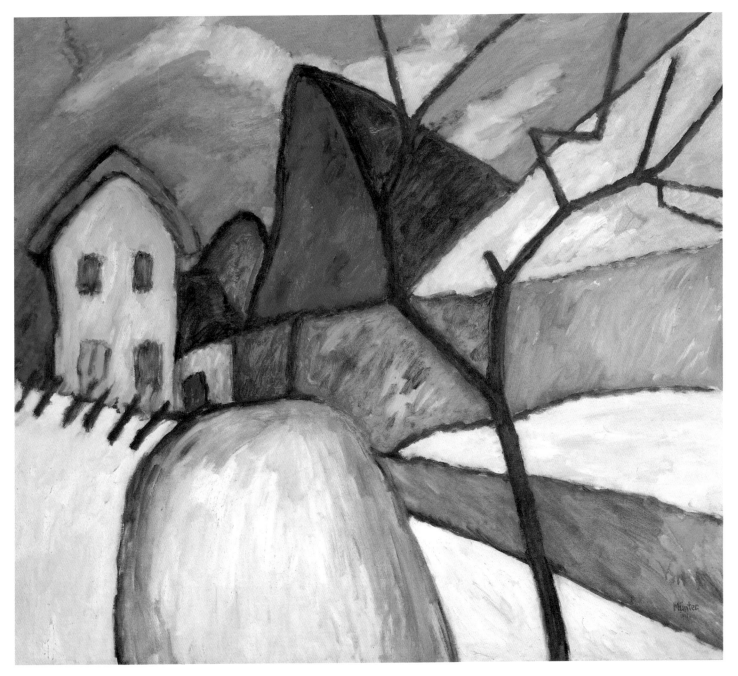

3.44
Gabriele Münter
The Blue Gable, 1911

3.45
Gabriele Münter
House, 23 March 1914

3.46
Gabriele Münter
Untitled, 23 March 1914

3.47
Gabriele Münter
Untitled, 23 March 1914

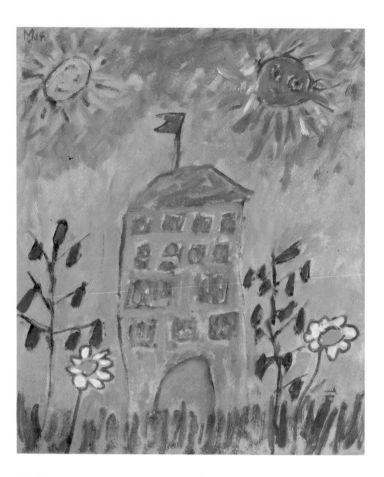

3.48
Child's drawing (Rudi Schindler),
from the collection of Kandinsky
and Münter

3.49
Child's drawing (Martin Mosner),
from the collection of Kandinsky
and Münter

3.50
Child's drawing (Robert Böhm?),
from the collection of Kandinsky
and Münter

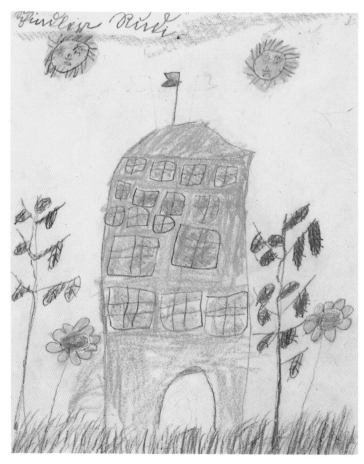

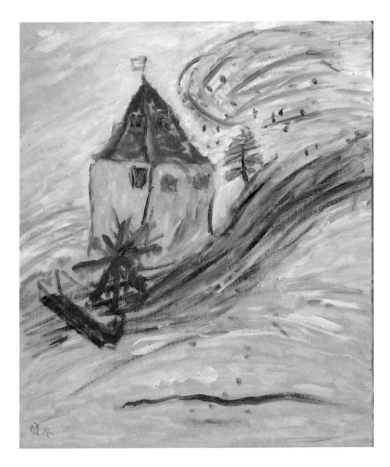

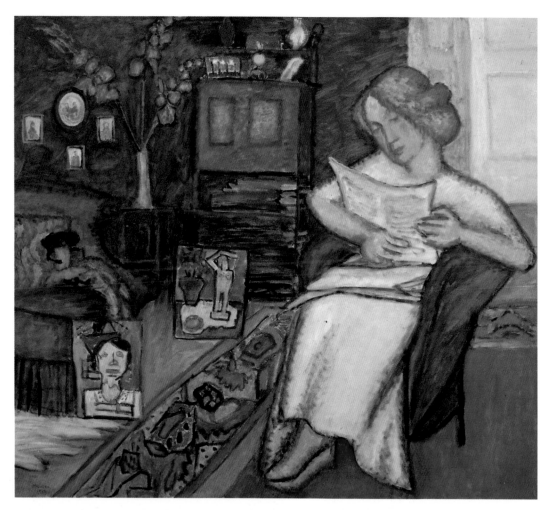

3.51
Gabriele Münter
In the Room (Woman in a White Dress), 1913

3.52
Child's drawing (Friedel),
from the collection of Kandinsky
and Münter

3.53
Child's drawing (Friedel),
from the collection of Kandinsky
and Münter

Opposite, above:
3.54
Gabriele Münter
Listening (Portrait of Jawlensky),
1909

Opposite, below:
3.55
Child's drawing (Friedel),
from the collection of Kandinsky
and Münter

3.56
Child's drawing (Friedel),
October 1913, from the
collection of Kandinsky
and Münter

3.57
Lyonel Feininger
City with Sun, 1921

3.58
Lyonel Feininger
Lovers, 1916

3.59
Lyonel Feininger
Locomotive with Large Wheel, 1915

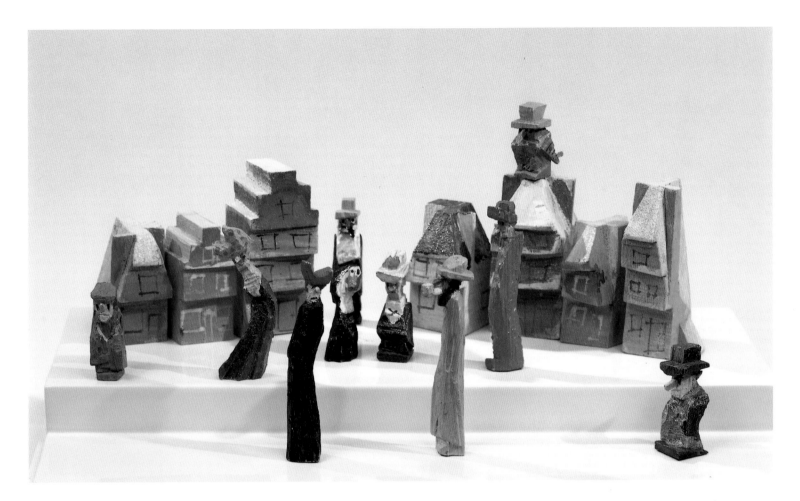

3.60
Lyonel Feininger
Houses and Figures, undated

3.61
Alexei Jawlensky
Murnau Landscape, 1909

3.62
Andreas Jawlensky (age 7)
Locomotive, ca. 1909

ability of better materials but also with the attention paid to visual things in an artist's family.

Kandinsky and the artists with whom he associated closely in the Blaue Reiter period admired the imaginative power and the expressive authenticity in the work of children. "Children," Kandinsky wrote in 1912, are " . . . the greatest fantasists of all time, who in their games make a horse out of a stick, or pretend that paper crows are whole regiments of cavalry, with a fold in the paper sufficing to turn a cavalry officer into a horse."[19] But for Kandinsky what mattered most fundamentally about children's art was that it offered an entrance to the deeper, spiritual meaning of things through which humankind as a whole might grow. Reminiscing about the Blaue Reiter at a distance of twenty-five years, Kandinsky warned that one had to see beyond the hierarchies of formal style to find this level of meaning: "The pernicious habit of not seeing the organic inner root of art beneath outwardly different forms could, in general, result in total loss of reciprocal action between art and the life of mankind."[20]

1. Vasily Kandinsky, "On the Question of Form," in Vasily Kandinsky and Franz Marc, eds., *Der Blaue Reiter Almanac* (1912), new documentary ed., *The Blue Rider Almanac*, ed. Klaus Lankheit (New York: Viking, Documents of 20th Century Art, 1974), 174.
2. See Arthur Schopenhauer, *The World as Will and Representation*, 2 vols., trans. E.F.J. Payne (New York: Dover, 1966).

3. Vasily Kandinsky, "On the Question of Form," in Kandinsky and Marc, eds., *The Blue Rider Almanac* (1974 ed.), 174–78.

4. August Macke, "Masks," in Kandinsky and Marc, eds., *The Blue Rider Almanac* (1974 ed.), 85.

5. According to Reinhold Heller the collection was Gabriele Münter's, but when Armin Zweite and I dug the collection out of the storage of Münter's estate for the first time, it was in a large portfolio-sized envelope stamped with the address of Kandinsky's apartment at 36 Ainmillerstrasse in Munich. In addition it contained many works by Russian children as well as German ones, so it seems reasonable to conclude that this was a joint venture. In addition, the collection remained with Münter after 1916 so it is conceivable that she added to it later. Many of the works, however, are dated to the period 1908–14 and closely resemble images in the major works by Kandinsky of the period.

6. See, for example, Klaus Lankheit, "A History of the Almanac," in Kandinsky and Marc, eds., *The Blue Rider Almanac* (1974 ed.), 31. Burlyuk wrote an essay for *Der Blaue Reiter Alamanac* ("The 'Savages' of Russia"), in which he mentioned Larionov and Goncharova. See Lankheit, 78.

7. It is clear that Kandinsky insisted on including children's drawings in *Der Blaue Reiter*. But there was also, for example, an exhibition of children's art at the 1907 Musée du Peuple in Angers (under the auspices of *Les Tendances Nouvelles*, of which Kandinsky was a founding member) which at the same time featured a large Kandinsky retrospective (see Jonathan Fineberg, ed., *Les Tendances Nouvelles*, facsimile ed. in 4 vols. [New York: Da Capo, 1980], 577). In addition, the 1909 and 1910 Salons organized by Vladimir Izdebsky in Odessa (for which Kandinsky wrote one of the catalogues) included children's drawings. See Vasily Kandinsky, "Content and Form," in *Salon 2*, ed. Vladimir Izdebsky (Odessa, 1910–11), trans. in Kenneth C. Lindsay and Peter Vergo, eds., *Kandinsky: Complete Writings on Art*, vol. 1 (Boston: G. K. Hall, Documents of 20th Century Art, 1982), 85.

8. The girl's age is as cited by Sigrid Köllner, "Der Blaue Reiter und die 'Vergleichende Kunstgeschichte'" (Ph.D. diss., Karlsruhe: 1984), 62. The adult style of the drawings has also been noted by Werckmeister: O. K. Werckmeister, *Versuche über P. Klee* (Frankfurt am Main: Syndikat, 1981), 141.

9. It is perhaps significant that Kandinsky does not express an interest in the work of psychotics, despite the speculation by Stefanie Poley that the four drawings in *Der Blaue Reiter Almanac* which Kandinsky identified as being done by "dilettantes" were actually the work of psychotics. (See Stefanie Poley, "Das Vorbild des Verrückten: Kunst in Deutschland zwischen 1910 und 1945," in Otto Benkert and Peter Gorsen, eds., *Von Chaos und Ordnung der Seele: Ein interdisziplinärer Dialog über Psychiatrie und moderne Kunst*; cited in Reinhold Heller, "Expressionism's Ancients," in Maurice Tuchman and Carol S. Eliel, eds., *Parallel Visions: Modern Artists and Outsider Art* [Los Angeles: Los Angeles County Museum of Art; and Princeton, N.J.: Princeton University Press, 1992], 83.) This may be due to Kandinsky's overriding interest in communicating widely—an aspiration that might be impeded by the vocabulary of an aberrant psyche.

10. In Kandinsky's notes for his Bauhaus lectures of 12 and 15 March 1929—under the heading of "Form and composition in art and technique"—he makes reference to "1) children's drawings ('Pose', *Blaue Reiter* and old locomotive); 2) popular art (*Blaue Reiter* and old locomotive)." See Vasily Kandinsky, "La Synthèse des arts," *Écrits complets*, vol. 3, ed. Phillipe Sers (Paris, 1975), 369, 355. It is tempting to assume that he may have had in mind these drawings of locomotives in his collection from the *Blaue Reiter* period.

11. Some of the drawings in this notebook can be dated to August 1913, after Kandinsky painted *The Black Spot*. Nevertheless, it is not impossible, since the book was made by Münter's niece "Mückchen" (as she was nicknamed), that this particular drawing in the notebook was made earlier and that "Onkel Vas" saw it in 1912.

12. Vasily Kandinsky, *On the Spiritual in Art*, 2d ed. (Munich: 1912), in *Kandinsky: Complete Writings on Art*, vol. 1, 131.

13. Lorenz Eitner, "Kandinsky in Munich," *Burlington Magazine* 99, no. 651 (1957), 193–99.

14. Vasily Kandinsky, "On the Question of Form," in Kandinsky and Marc, eds., *The Blue Rider Almanac* (1974 ed.), 175.

15. Vasily Kandinsky, *On the Spiritual in Art*, in *Kandinsky: Complete Writings on Art*, vol. 1, 147.

16. Stéphane Mallarmé, "Crise de vers" (1886), in "Variations sur un sujet," *Oeuvres complètes de Stéphane Mallarmé* (Paris: Bibliothèque de la Pléiade, NRF, 1945), 368; "A quoi bon la merveille de transposer un fait de nature en sa presque disparition vibratoire selon le jeu de la parole, cependant; si ce n'est pour qu'en émane, sans la gêne d'un proche ou concret rappel, la notion pure."

17. Vasily Kandinsky, *On the Spiritual in Art* in *Kandinsky: Complete Writings on Art*, vol. 1, 196.

18. Rev. 6–16, Douay-Rheims Version.

19. Vasily Kandinsky, *On the Spiritual in Art*, in *Kandinsky: Complete Writings on Art*, vol. 1, 146.

20. Vasily Kandinsky, "Franz Marc," *Cahiers d'Art* (1936), trans. in Kenneth C. Lindsay and Peter Vergo, eds., *Kandinsky: Complete Writings on Art*, vol. 2 (Boston: G. K. Hall, Documents of 20th Century Art, 1982), 796.

4. Reawakening the Beginnings: The Art of Paul Klee

"There were the Useful Presents," Dylan Thomas remembered in *A Child's Christmas in Wales*, like "books that told me everything about the wasp, except why."[1] Adult experience is built around the unanswered questions of childhood. In 1902, after Paul Klee returned from his artistic "finishing" in Rome, he came across some of his own childhood drawings while looking for frames in his parents' storage. The drawings reawakened fundamental questions for the artist and so moved him that he described them in a letter to his fiancée, Lily, as "the most significant [I have made] until now." He praised their highly developed stylistic character and their fresh quality of "naive" observation as well as their "independence from the Italians and Netherlanders" on whose example his painstaking training of the preceding four years was founded![2]

In historical hindsight, we can see that a breathtaking revelation of this kind came to nearly every advanced artist of Klee's generation at more or less the same moment. Nietzsche's attack on aesthetic Socratism and the "archaeology" of Freud, not to mention the broad thrust of symbolist transcendence, exemplify the widespread sense at the turn of the century that artists needed to break away from academic formulas. The vanguard of the new century sought to peel back the layers of an overcultivated, fin-de-siècle Europe and discover what lay buried beneath that skillfully rendered facade.

It took Klee nearly a decade to realize the implications of his particular rediscovery. But by 1911, he had evidently decided how he wanted to position "these primitive beginnings of art,"[3] as he called the impulse embodied in these drawings, in relation to his mature ambitions as an artist. It was in this year, at the age of thirty-two, that Klee started keeping an oeuvre catalogue, which commences with eighteen drawings made between three and ten years of age. He then skipped over all his teenage attempts at naturalism and all but three works made while studying in Munich and then Rome (noting them as "not artistic"). He took up the catalogue again in 1902, the year in which he happened on his childhood works in the shed.[4]

To be sure, it was not only the rediscovery of his childhood drawings that set

Klee on this path; that merely crystallized something that had been brewing for some time. Writing to Lily from Rome in November 1901, Klee took a sarcastic look at the kind of academic painting he found himself doing; he described a picture on his easel which, he said, "has the highly moral title *On the Wrong Path*. It's ridiculous." At that, the painting took on "a satirical tone" for him. A few days later Klee announced that he had just done what would normally have served as the final study for a fully developed composition and that he felt the impulse to work out the detailing, but that, he said, wouldn't be possible because he was dedicating himself "to simplicity, a simplicity that borders on the primitive."[5] Here, it seems, Klee was struggling with his training and with tradition, while at the same time his personality began emerging through his sense of irony (implicitly elevating the generative importance of his adolescent gifts at caricature).

Meanwhile, Klee had also been keeping a diary since 1898, when, at the age of nineteen, he went off to study art in Munich. In 1911, along with the inauguration of his oeuvre catalogue, he transcribed this diary, adding at the front thirty-six "memories of childhood" (vignettes from ages two to twelve).[6] In these two ventures—the diaries and the house catalogue—Klee retrospectively reinvented his artistic development. By then, clearly, he did see the aesthetic importance not only of his youthful satire but of all that he could identify with the mind of his childhood; presumably he believed that such material lay closer to his indigenous nature. Klee had embarked on a search for authenticity, seeking the origins of his own creative mind; in this sense, the rediscovery of his childhood drawings provided coordinates for the gyroscope on which he navigated nearly his entire mature career.

The seventeen *Inventions*, which Klee etched (or drew in preparation for etching) during 1903, 1904 and early 1905, are his most celebrated and accomplished works before 1911. The *Inventions* include such familiar prints as *The Virgin in a Tree*; *The Hero with a Wing*; *Two Men Meet, Each Believing the Other to Be in a Higher Position* and *The Menacing Head*. Klee executed these prints in a style that resembles contemporary symbolist graphics, but the Klees have a peculiarly grotesque and comic distortion about them that is unique to Klee and was already evident in his drawing by the time he was four years old as, for example, in his 1883–85 *Woman with a Parasol* [fig. 4.1].

Klee completed the *Inventions* in March 1905, writing to Lily on 20 March that he was finishing up the last of them and anticipated feeling "liberated, like someone just over an illness and looking forward to a change."[7] Ten days later he reported work on a new picture: "It is of two wretched children occupying themselves with dolls, no philosophy, no literature, only lines and forms, and done in a children's style; that is, as children would draw it. If I have not de-

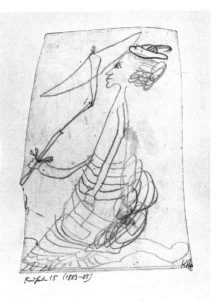

4.1
Paul Klee (age 4–6)
Woman with a Parasol, 1883–85

4.2
Paul Klee
Girl with a Doll, 1905

ceived myself about its worth, I will make an etching of it. It would be a first work in a new manner. . . ."[8] Scholars agree that although the glass paintings *Girl with a Doll* [fig. 4.2] and *Paul and Fritz* of 1905 may not be the precise works to which the letter refers, they do represent the style and it seems clear that this was a critical moment for the artist.

In June, Klee confided to his diary: "I am ripe for the step forward."[9] Six months later, he recounted a dream in his diary that reveals his dawning sense that this "next step forward" would derive from steps back to his earliest beginnings: "Dream. I flew home where the beginning is. It started with brooding and nail-chewing. Then I smelled something or tasted something. . . . If now a delegation came to me and ceremoniously bowed before the artist, pointing thankfully to his works, I would hardly be surprised. For I was there, where the beginning is. I was with my adored Madam Primitive Cell, that means as much as being fertile."[10] Klee later revised his diaries and may even have invented the dream. But if that is the case it only confirms our understanding of the artist's own conscious return to the authenticity of childhood.

Klee's systematic exploration of his own juvenilia began in 1906 and persisted (albeit in three distinct phases) until his death in 1940. His investigation of child art is, of course, only one of several persevering preoccupations in a complex artistic career but it is nevertheless an exceedingly important one that yields a remarkably clear glimpse of Klee's creative processes and ambitions. For about a decade from 1906, Klee focused on the syntax of his childhood drawings and by extension on the schema of children's art in general. Then around 1918 he began to concentrate on the iconography of childhood works (particularly his own) and, finally, in the 1930s his entire style veered toward a childlike directness.

Two drawings from 1906—*Monumental Female with Folded Hands, Contour Only* and *Soothsayers in Conversation* [fig. 4.3]—show Klee experimenting with so-called blind drawing, a type of automatism employed at one time or another by every kindergartner. It seems obvious that the automatist rendering of the clawlike hands in both *Monumental Female* and *Soothsayers* derives directly from the father's almost freeform hand in Klee's *Untitled* pencil drawing of his family out for a walk, done in 1883 at the age of four [fig. 4.4]. Klee seems to be attempting to recapture the childhood state of mind by reliving the gesture of the early drawing (a premise on which Jackson Pollock would, forty years later, build an entire *oeuvre*). In *Soothsayers*, Klee also tried out the variation in line pressure that is evident in the childhood drawing. What is most central to the way he drew the hand is a shift from a form of conscious control with reference to nature into a motor activity that is more directly expressive. In 1908, Klee referred to this kind of line as "psychic improvisation" and explained its nature

1906/33 Auguren im Gespräch

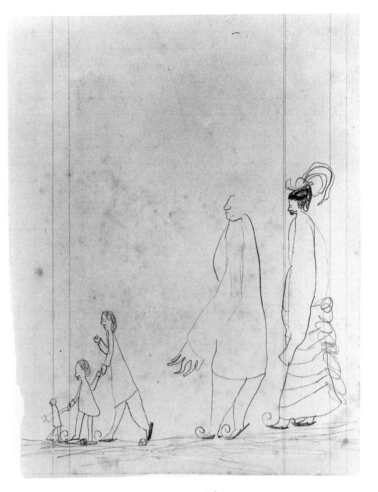

4.3
Paul Klee
Soothsayers in Conversation, 1906

4.4
Paul Klee (age 4)
Untitled (Family Outing), 1883

in his diary: "Bound only very indirectly to an impression of nature, I may again dare to give form to what burdens the soul."[11]

Klee married in September 1906, and on 30 November 1907 his son, Felix, was born.[12] The artist's diaries are filled with detailed observations about Felix; in particular, Klee made phonetic transcriptions of the child's babbles and what Klee understood them to mean. By Felix's fourth birthday, in 1911, the child was drawing copiously, and like many artists' children he made exceptionally interesting and imaginative pictures. Klee took the trouble to mount and preserve many of them so that a number still exist. No wonder then that in the December 1911 review in which he praised the work of the Blaue Reiter artists as reaching right to the "primitive beginnings of art," he should identify its native habitat as "in ethnographic collections, or at home in one's nursery."[13]

Until 1911, Klee's work—like Kandinsky's before 1909—was split between two independently developing genres: the studies from nature and the impulses that grew out of his caricatures into the imaginative, but nonetheless period-style, *Inventions*. Klee made a clear distinction between these genres in the oeuvre catalogue, until 1914 when the separate developments presumably

4.5
Paul Klee
Horsedrawn Carriage, ca. 1883

4.6
Paul Klee
Rider and Outrider (Study for *Candide*),
1911

4.7
Paul Klee
Three Galloping Horses II (Frail Animals), 1912

4.8
Paul Klee
The Expectant Ones, 1912

4.9
Child's drawing
Plate 37 from Georg Kerschensteiner,
*Die Entwicklung der zeichnerischen
Begabung* (The Development
of the gift of drawing),
Munich, 1905

4.10
Child's drawing
Plate 4 from Georg Kerschensteiner,
*Die Entwicklung der zeichnerischen
Begabung*, 1905

4.11
Child's drawing
Plate 61 from Georg Kerschensteiner,
*Die Entwicklung der zeichnerischen
Begabung*, 1905

4.12
Child's drawing
Plate 101 from
Georg Kerschensteiner, *Die Entwicklung
der zeichnerischen Begabung*, 1905

Paul Klee **87**

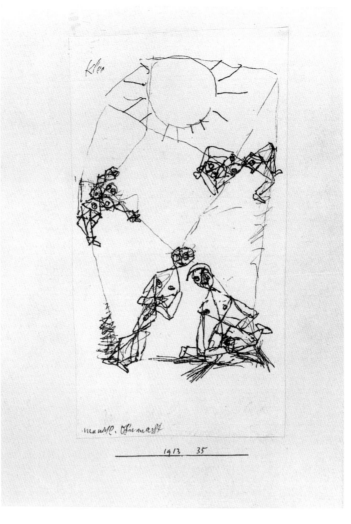

ceased to exist. The year 1911 was the turning point for Klee. His encounter with Kandinsky and the Blaue Reiter group served as a catalyst; particularly important was their keen interest in children's art as well as in vanguard painting from Paris and in a broad range of work from outside the accustomed canon.

In several of Klee's important drawings of 1911, 1912 and 1913 one can see a direct correlation with certain works preserved from his childhood, as has been pointed out by O. K. Werckmeister. For example, Klee seems to take inspiration directly from the *Horsedrawn Carriage* of ca. 1883 (done when he was four) in drawing the legs of the horses in both the 1911 painting on glass, *Rider and Outrider*, and in the 1912 *Three Galloping Horses II* [figs. 4.5–4.7]. In addition, the rendering of the torsos in the form of an X in Klee's 1912 *The Expectant Ones* and the linear web on which he laid the figures in *Human Helplessness* of 1913 both seem directly related to drawings by children illustrated in the pioneering study of child art published by Georg Kerschensteiner, the superintendent of Munich schools, in 1905 [figs. 4.8–4.13].[14]

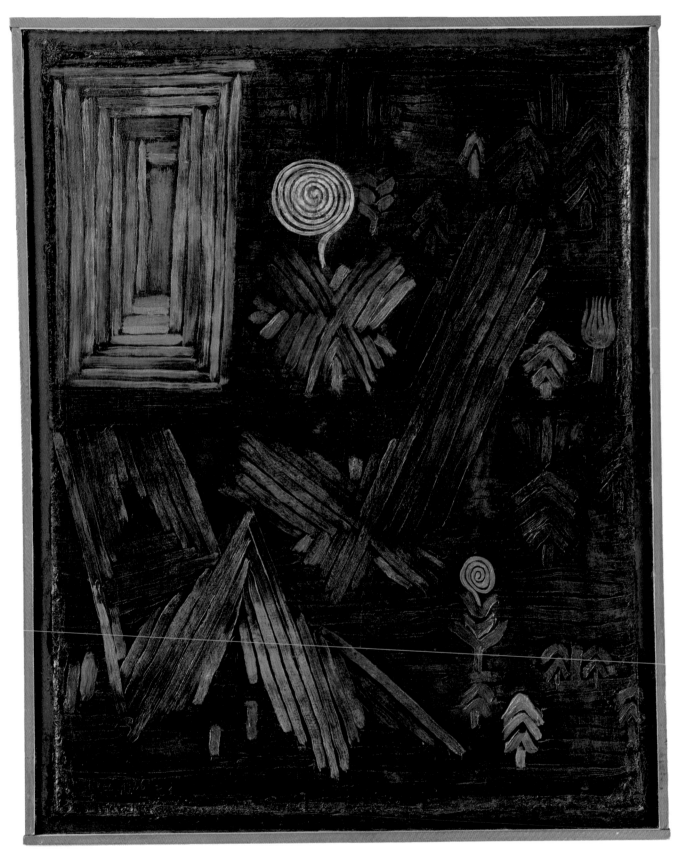

4.14
Paul Klee
Gate in the Garden, 1926

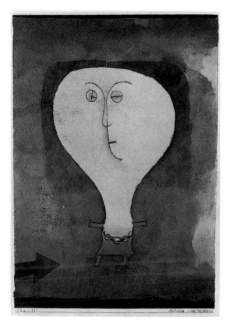

4.15
Paul Klee
Fright of a Girl, 1922

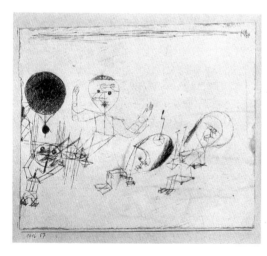

4.16
Paul Klee
With the !, 1916

Plate 101 in Kerschensteiner's book [fig. 4.12], which seems to have inspired Klee's structural concept for *Human Helplessness* [fig. 4.13], shows seven children pelting a slightly larger, central figure (another child or perhaps an adult) with snowballs. The child-artist shows the trajectories of the missiles with dotted lines. This retains the connection of each snowball to the person who threw it, offering an intriguing glimpse into the characteristic narcissism of a child's mind.[15] That was precisely the kind of insight that Klee seemed intent on examining in children's drawing between 1906 and 1916.

Klee continued testing new techniques throughout his career but in the late 1910s and 1920s he took a particular interest in the materials and devices of the young child. *Gate in the Garden* of 1926 [fig. 4.14] has the highly tactile feeling of a finger painting (although it clearly isn't made that way). *Cosmic Composition* of 1919 [fig. 4.17] recalls—aside from its child-inspired manner of description—the common classroom technique of scratching through a dark surface to reveal a multicolored light ground. The enlarged head and tiny torso and arms in *Fright of a Girl* (1922) and in some of the figures in *With the !* of 1916 [figs. 4.15, 4.16] derive from that familiar trait of small children to exaggerate the conceptually important parts (typically the head or hands) without regard to appearance or proper proportion. "Art does not reproduce the visible," Klee noted in 1918, "rather, it makes visible."[16]

In *With the !*, Klee also exploited another device from the art of children: focused attention on one part of the development of the drawing at a time so that a train of association generates the imagery and changes from point to point, as in the house in the lower left which then becomes the torso of a figure with its head in its hands. Finally, the whole series of Klee's 1920s compositions built in registers like a preliterate child's make-believe "writing"—as in *Pastorale* of 1927 [fig. 4.18] and *Tree Nursery* of 1929—may hark back for their structural concept to a child's drawing that Klee probably saw in the Kandinsky and Münter collection in the early 1910s [fig. 4.19], although it is a common enough type of child's drawing that Klee could also have seen it elsewhere.

Nevertheless, Klee began shifting his attention to another aspect of child art around 1917, an aspect more particular to the investigation of his own childhood. From the manner in which children conceive and render form, he turned to the iconography of his first drawings, as if in returning to the subjects he had selected as a child he might also recapture the original impulses which had drawn him to them. The cats he drew in tiers of colorful plants, animals and people in 1890 (as a ten- or eleven-year-old) reappear in works like the 1919 *Tomcat's Turf* [fig. 4.20, 4.21]. The motif of his 1883–84 (age four) *Church, the Clock with Invented Numbers* crops up in works such as the 1922 *Winter Day, Just before Noon* [figs. 4.23, 4.25]. The *Untitled Horse, Sleigh and Two Ladies* of

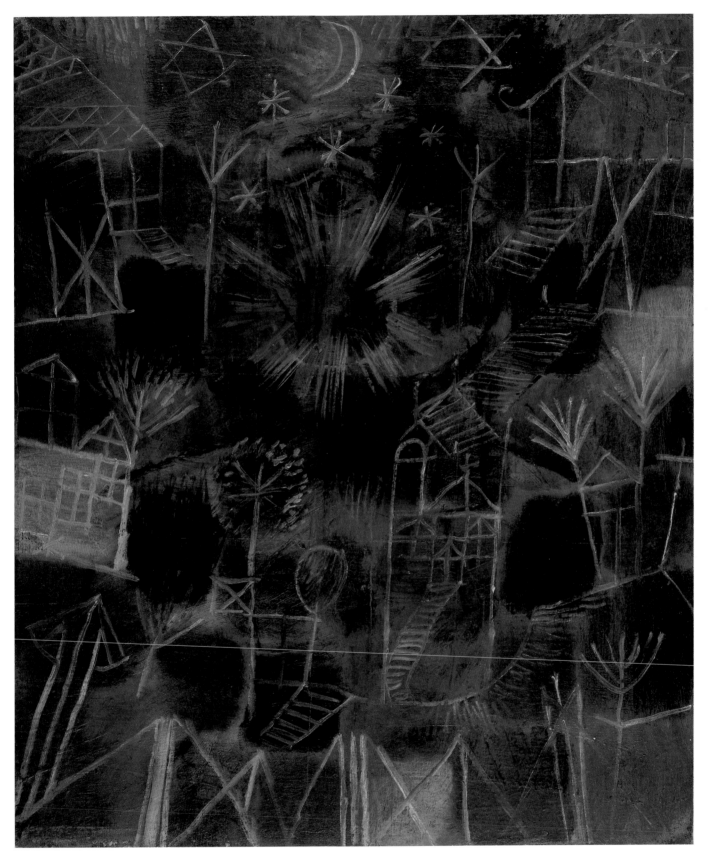

4.17
Paul Klee
Cosmic Composition, 1919

4.18
Paul Klee
Pastorale (Rhythms), 1927

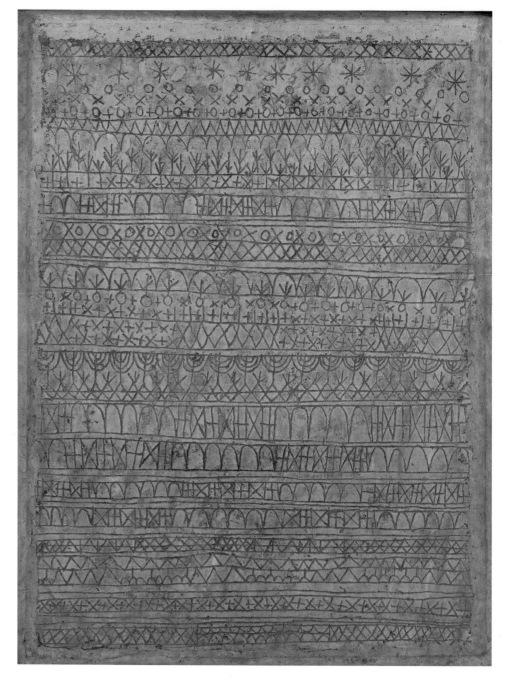

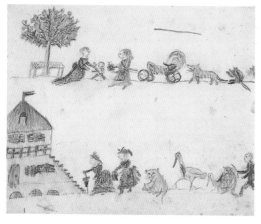

4.19
Child's drawing (Kätchen Busse),
from the collection of Kandinsky
and Münter

4.20
Paul Klee
Untitled, with House and Steps, 1890

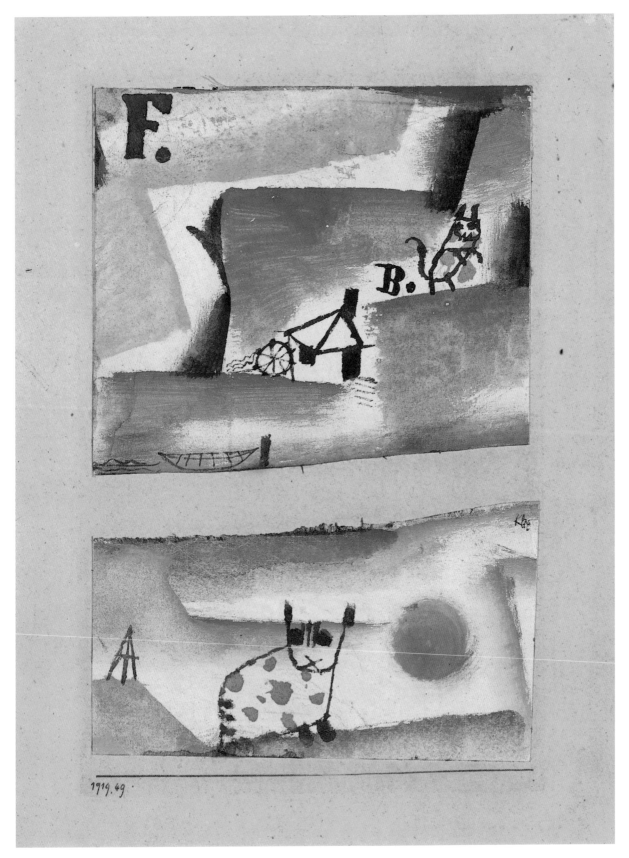

4.21
Paul Klee
Tomcat's Turf, 1919

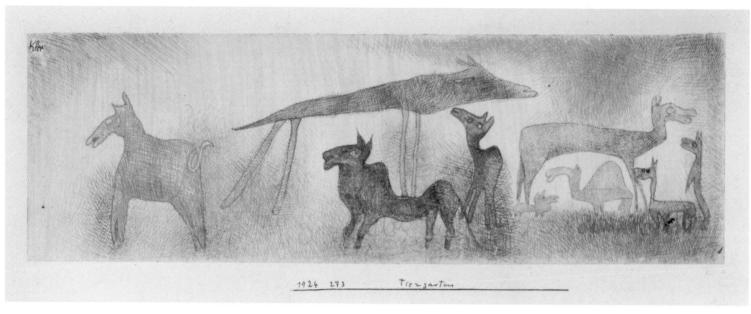

4.22
Paul Klee
Animal Park, 1924

4.23
Paul Klee
Church, the Clock with Invented Numbers,
1883–84

4.24
Paul Klee (age 5)
Untitled Horse, Sleigh and Two Ladies, 1884

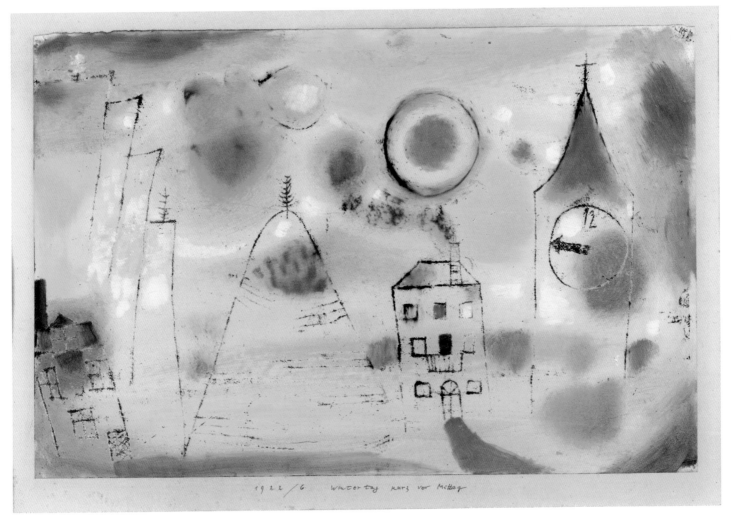

4.25
Paul Klee
Winter Day, Just before Noon, 1922

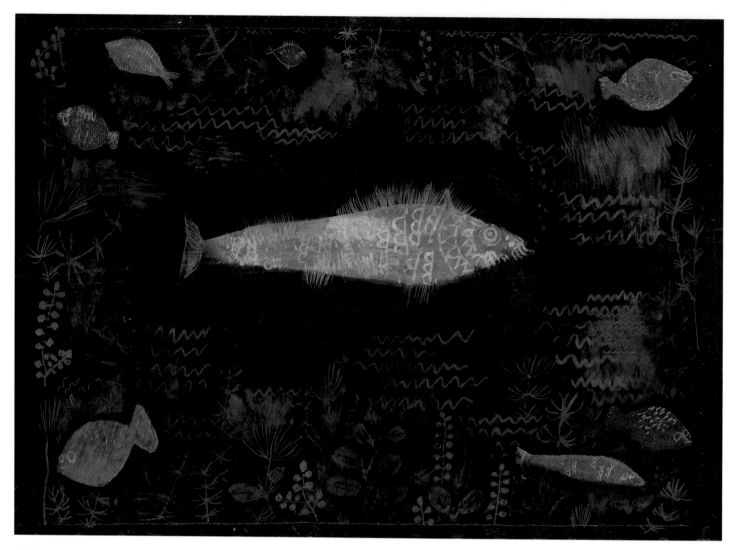

4.26
Paul Klee
The Goldfish, 1925

4.27
Paul Klee
Childhood page of sketches—fish,
Sketchbook, page 14, 1889

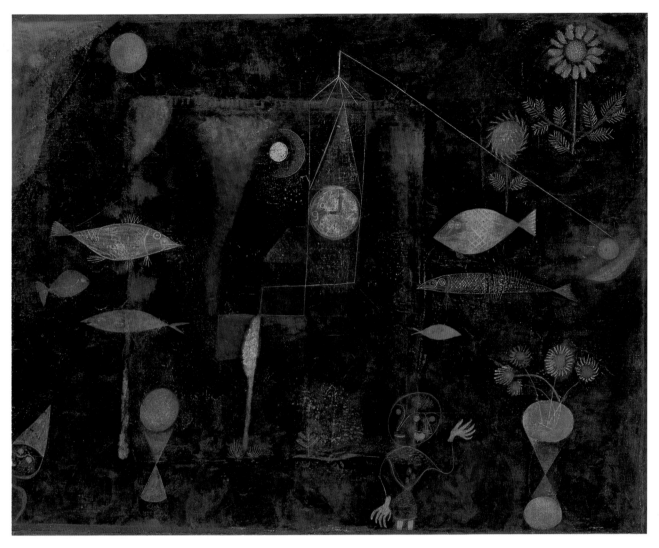

4.28
Paul Klee
Fish Magic, 1925

4.29
Paul Klee
Three Fish, 1939

4.30
Felix Klee
Tent City with Blue River and
Black Zig-Zag Clouds, February 1919

4.31
Paul Klee
Untitled (Tent City in the Mountains), 1920

4.32
Paul Klee
Chance, 1924

4.33
Paul Klee
Promenaders, 1925

1884 (age five) [fig. 4.24] provided one of the childhood sources for works such as Klee's 1924 *Animal Park* and *Chance* and the *Promenaders* of 1925 [figs. 4.22, 4.32, 4.33].[17]

It seems that Klee also began looking at a slightly more advanced stage of childhood art-making at this time. The drawing of a trout and a perch ("Forelle" and "Egli") in an 1899 sketchbook [fig. 4.27], done at the "advanced" age of eleven or twelve, seems to have contributed to the stimulus for the famous series of fish paintings of 1925 (*The Goldfish, Fish Magic*) and 1926 (*Around the Fish*) [figs. 4.26, 4.28]. It may even linger in the ancestral memory of *Three Fish*, one of a group of fish drawings from 1939 [fig. 4.29].

A particularly startling example of Klee's research into the mental state embodied in a child style is a pair of works, one by the twelve-year-old Felix (clearly signed and dated to 1919)[18] and another by Paul Klee that is a characteristic picture of the period, with a family provenance [figs. 4.30, 4.31]. In this instance, Klee has painted a literal *copy* of the top half of Felix's composition![19] The pair makes evident the depth of Klee's commitment to re-creating for himself the world of the child's mind by whatever means! Clearly he meant this process for his own edification, not for the eyes of others; but it helps us understand the fundamental humanness of the questions that drive the development of great masters—questions with which anyone can identify. A good painting by a child has a freshness and vitality that we all feel immediately; here is a great artist probing that experience by attempting to re-create it in his own hand. In the end, of course, the adult's version is still wrapped up in adult problems, such as the rendering of a shallow cubist space, which Klee accomplished here by cutting off the lower half of Felix's conception.

Presumably, no one knew about this particular experiment, but the prevalence of a "childlike" rendering of motifs in Klee's work occasioned much discussion, especially as he became more successful and attracted more critical attention after 1917. Herwarth Walden was the first to write about the childlike quality of Klee's style as one of the artist's great strengths.[20] Furthermore, Klee didn't mind having his pictures compared to "children's scribbles and smears. That's fine!" As he remarked to Lothar Schreyer at the Bauhaus, "the pictures my little Felix paints are better than mine."[21] Theodor Däubler also praised Klee as "a man who sees like a child."[22]

Yet, for all that Klee learned from the vocabulary of child art he certainly did not "see like a child," though at times he took great pains to make individual works that looked as though he did. A case in point is the sequence of stylistic permutations Klee made around 1920 on the childhood theme of a lake steamer, drawn in a sketchbook of 1890 (done at the age of twelve) [fig. 4.34].[23] He took the motif of the boat—with its smokestack, sidewheel and

4.34
Paul Klee
Childhood page of sketches—boat,
Sketchbook, page 12, 1889

4.35
Paul Klee
The Road from Unklaitch to China,
1920

4.36
Paul Klee
Memory of Lugano, 1921

4.37
Paul Klee
Steamship before Lugano, 1922

4.38
Child's drawing of a head and torso, probably 1920s, from the collection of Kandinsky

4.39
Child's drawing of two girls, probably 1920s, from the collection of Kandinsky

anchor—and tried it out in a diverse series of complete stylistic systems. In the 1920 *Road from Unklaitch to China* [fig. 4.35] Klee set the motif in a diagrammatic landscape with a schematized space, arrows and annotations, all in the finely controlled line of an engineering plan. He drew *Memory of Lugano* of 1921 in an expressionist vein and then made a lithograph of it entitled *Steamship before Lugano* in 1922 [figs. 4.36, 4.37]. *Boats, the Sixth at the Pier* of 1926 [fig. 4.41] is yet another variation, this time in the manner of an even younger child than he had been when he drew the original boat.

Yellow Harbor of 1921 [fig. 4.40] provides a more formal and explicitly semiotic version of the ship, setting it in a harbor that simultaneously reads as a flat sheet of paper, a regular rectangle receding in geometric perspective. Klee made *Yellow Harbor* just as he was working out an approach to teaching for the first time at the Bauhaus. He began classes in January 1921 and started his series of Friday evening lectures on composition in May. As any knowledgeable person might, Klee went back to the classical treatises on painting—above all to Leonardo's—for inspiration about how to begin his assignment as a teacher,

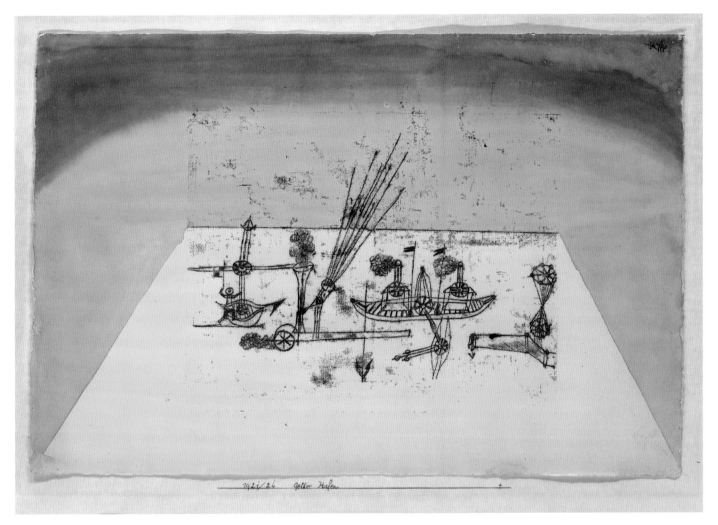

4.40
Paul Klee
Yellow Harbor, 1921

4.41
Paul Klee
Boats, the Sixth at the Pier, 1926

4.42
Child's drawing
Bauhaus 3, no. 3
(July-September 1929), p. 14

and in *Yellow Harbor* Klee seems to refer specifically to Leonardo's advice that you need to pay attention to atmospheric perspective as well as mathematical perspective in rendering space.

The notes for Klee's theory class that began in the late fall also survive. They commence with the point and its extension with lines and planes, as Leonardo does, and then almost immediately they turn to the use of line in aboriginal pictographs and in the first scrawls of children. In his second lecture (of 28 November 1921) he anthropomorphized two converging and then diverging lines into a meeting and parting of two companions and this brought him to discuss perspective in a similarly anecdotal way: "Let us imagine two railway tracks. There is something very misleading about this (?) For in reality these lines are quite divergent. If the rails keep moving farther apart, the train is bound to jump the track. Or suppose they take the opposite direction. Rails that are going to cross somewhere up ahead are almost more alarming (?) What is going on? Well, the fact is we have suddenly passed from the planar to the spatial realm, to the third dimension. We are doing perspective."[24]

In this account of perspective, Klee first placed himself in the reality of the picture as a child does. This naive ability to see what is really there (that is, the actual convergence of lines) rather than the convention (the illusion of distance) suggests part of what interested Klee in child art and underlay the semiotic self-consciousness with which he set his naive childhood rendering of the boat in these various stylistic systems. At the same time, this involves a subtle metaphysics that is not at all childlike.

Klee asserts an essentially symbolist reading of nature as an intermediary realm that imperfectly embodies Platonic "Ideas." The "pure colors" of the rainbow, for example, "are a transcendent matter," he wrote. "The intermediary realm of atmosphere is kind enough to transmit it to us, but only in an intermediate form, not in its transcendent form, which has to be infinite by nature." The imperfection of the rainbow's spectrum, which terminates at violet instead of wrapping around in a perfect continuum with the red at the other end, expresses the eternal tragedy of material existence as of the human condition, according to Klee: "the rupture made by the attack of that power which humanizes and transforms divine things in order to reveal them to us. . . . The color circle was assaulted at violet, and it tore, stretched, and marched off as the row of colored points in the rainbow (the divine tragedy)."[25]

The summer 1929 issue of *Bauhaus* magazine contains several articles on children's art, evidently occasioned by an exhibition of child art organized there by one of Klee's former students, who credits Klee with profoundly influencing her view of the subject.[26] The educational psychologist Hans-Friedrich Geist also contributed an essay to the magazine, discussing his encouragement of

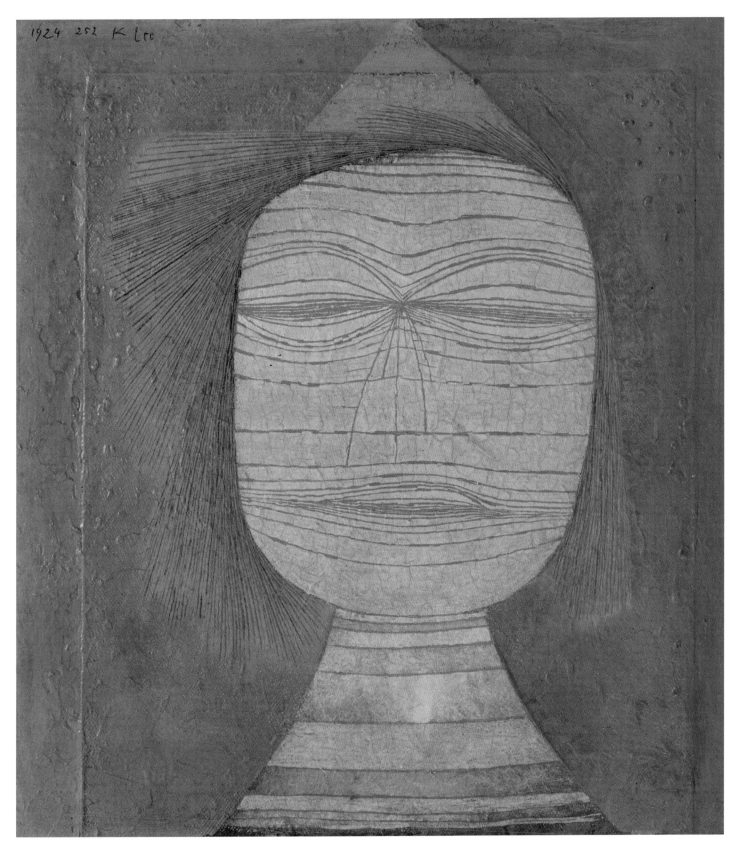

4.43
Paul Klee
Actor's Mask, 1924

4.44
Child's drawing,
acquired by Klee
from Hans Friedrich Geist
around 1930

children to make assemblages of "junk" materials, as in the Bauhaus prelimi-
nary course.[27] It is not hard to imagine Klee, as well as his friend Kandinsky,
directly involved in this exhibition of children's drawings or the collection from
which it was culled; indeed, the German children's drawings that remained in
Kandinsky's possession at the time of his death in 1944 may well date from this
Bauhaus collection [figs. 4.38, 4.39]. If Klee saw these works as the collection
was being assembled rather than merely at the exhibition itself, the horizontal
bands in the child's drawing illustrated on page 14 of *Bauhaus* magazine could
have inspired the description of the head in this fashion in Klee's 1924 *Actor's
Mask* [figs. 4.42, 4.43].

Be that as it may, Klee's interest in child art was well known at the time; Geist
even made him a fiftieth birthday present of a collection of children's water-
colors [figs. 4.44–4.46]. Moreover, Klee continued working out permutations on
child motifs right to the end of his life. His 1939 variations on Felix's 1913 (age
five–six) drawing of a train provide an outstanding example with *Mountain Rail-
road, Compulsion toward the Mountain* and *Railroad Engine* [figs. 4.47–4.50].[28]
The importance of that aspect of Klee's exploration into child art, however, re-

4.45
Child's drawing, acquired by Klee
from Hans Friedrich Geist
around 1930

4.46
Child's drawing, acquired by Klee
from Hans Friedrich Geist
around 1930

4.47
Paul Klee
Railroad Engine, 1939

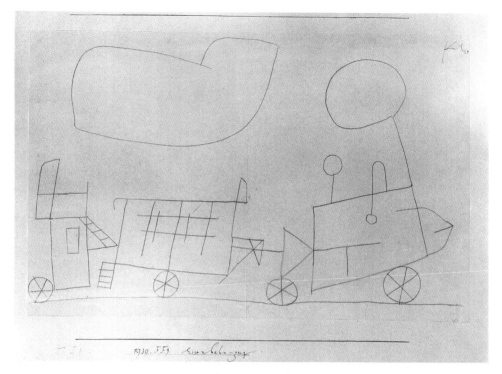

4.48
Felix Klee
Untitled (Railroad), 1913

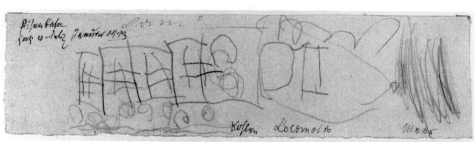

4.49
Paul Klee
Mountain Railroad, 1939

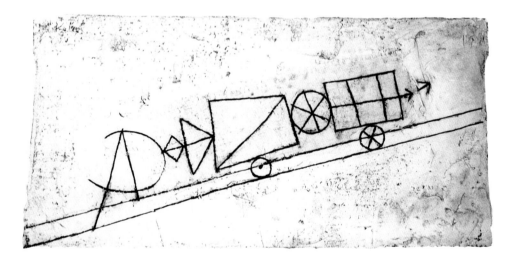

ceded after 1930 in favor of a broader reversion to a childlike freedom of style in Klee's late work.

The cover of this same summer 1929 *Bauhaus* magazine illustrated a collaged mask by a ten-year-old girl which has a striking affinity with some masklike paintings by Klee in the 1930s such as *Bust* (1930), *Ragged Ghost* (1933), and *Hungry Girl* and *Burnt Mask* (1939) [figs. 4.51–4.55]. Klee's work of the 1930s centered on something more direct and immediate than the epistemological revelations he pursued in the 1910s and 1920s. In August 1935 he experienced the first severe onset of a terminal disease known as schleroderma from which he died in the spring of 1940, and in these last (his most productive) years, Klee undertook a spiritual reexploration of childhood in yet another way as he faced his own impending death.

Klee had already become increasingly metaphysical in his presentations to students at the Bauhaus at the end of the 1920s. Moreover, he surely felt the tragedy of the outbreak of war in 1939 and had in general been undergoing a kind of artistic crisis since 1933 when the political conditions in Germany forced him into the isolation of Bern, far from the community of artists as well as the dealers and collectors on whom he had depended for both livelihood and intellectual stimulation over the years in Germany. But it was internal rather than external forces that shaped Klee's late style. Josef Helfenstein has described Klee's late work a "testament" to an inner life, largely played out in drawings (which he refused to sell after 1920).[29]

Drawings of 1938 and 1939 such as *When I Was Still Young*, *Childhood*, *Childlike Again* and *Children Play Tragedy* demonstrate the deliberateness with which the artist reexamined his own beginnings in the last twenty-eight months of his life [figs. 4.56–4.59]. He drew *When I Was Still Young* and *Childhood* with an intentional awkwardness as in the thick and unmodulated gesture of a child; the sparse simplicity of *Childlike Again* and the ironic playfulness of *Children Play Tragedy* signal the emergence of both a heightened sentimentality about life and a bitter irony about death that emerged simultaneously in these last works.

In Klee's 1939 *The Spirit of Ships* the figure of a man magically turns into a ship; in *Graveyard* of that same year the outline of a child's torso (sideways) melts into a landscape. Both works seem to involve a metaphysical speculation on the transformation from one state to another in death. *Itinerant Artist (A Poster)* of 1940 [fig. 4.60] seems almost disembodied into a diagram—perhaps the final state? Indeed, Klee began making these stick-figures in 1935, coincident to the outbreak of his illness.

Klee also painted *By the Blue Bush* [fig. 4.61] in the year before his death. The simplicity and vibrance of the palette, the simplified stick-figure, and the

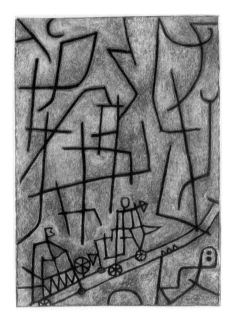

4.50
Paul Klee
Compulsion toward the Mountain, 1939

4.51
Child's collage
Bauhaus 3, no. 3 (July–September 1929),
cover

4.52
Paul Klee
Ragged Ghost, 1933

1939 JJ ii hungriges Mädchen.

4.53
Paul Klee
Hungry Girl, 1939

4.54
Paul Klee
Bust, 1930

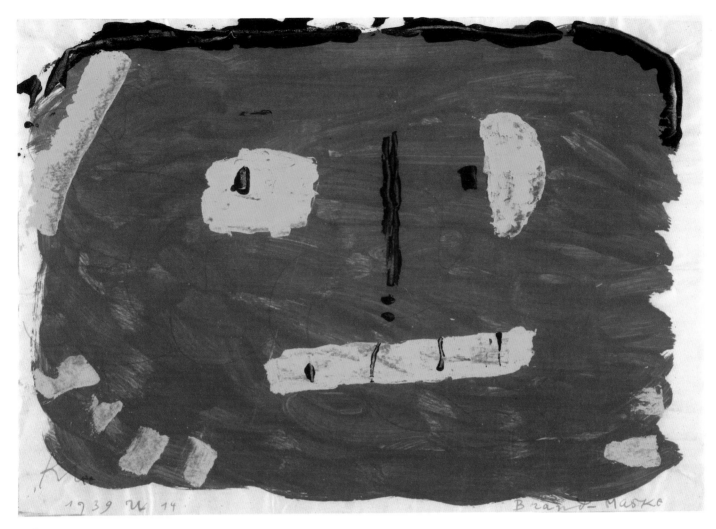

4.55
Paul Klee
Burnt Mask, 1939

4.56
Paul Klee
When I Was Still Young, 1938

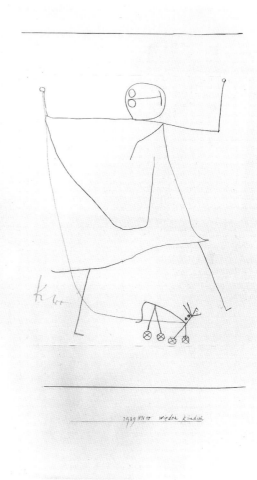

4.57
Paul Klee
Childlike Again, 1939

awkwardly lettered inscription all evoke recollections of childhood attempts at painting. "Stellzich ein bleib tallein" is a child's imperfect, phonetic spelling of "Stellt sich ein, bleibt allein," meaning that he—the artist—asserts a position and thus remains alone. He is alone in his artistic and intellectual search and in his final reckoning with his mortality. The style represents a return to the artist's own childhood as though reviewing his life again in confrontation with death, part of "the divine tragedy." It is an extraordinarily moving reflection on the past, on the origins of his mind, and on the organic cycle of life.

4.58
Paul Klee
Childhood, 1938

4.59
Paul Klee
Children Play Tragedy, 1939

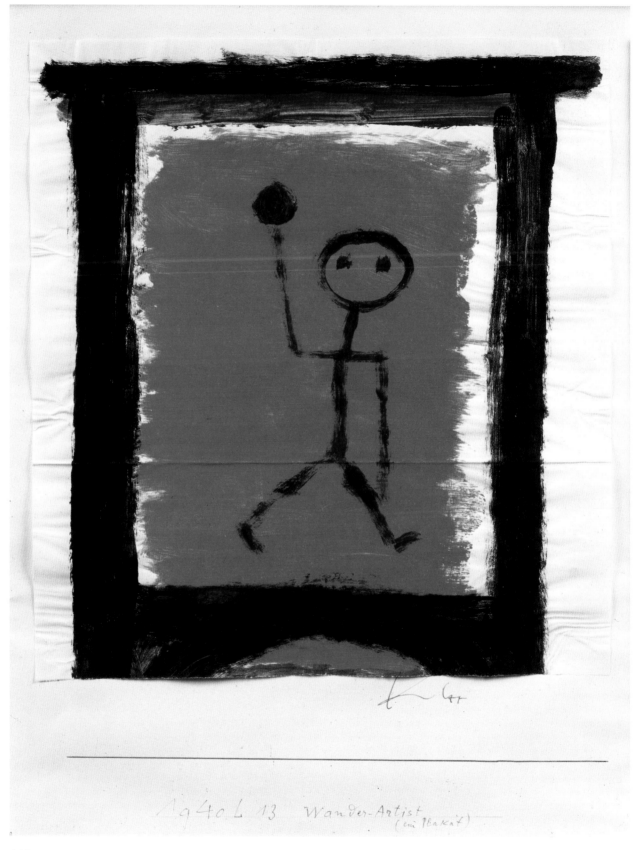

4.60
Paul Klee
Itinerant Artist: A Poster, 1940

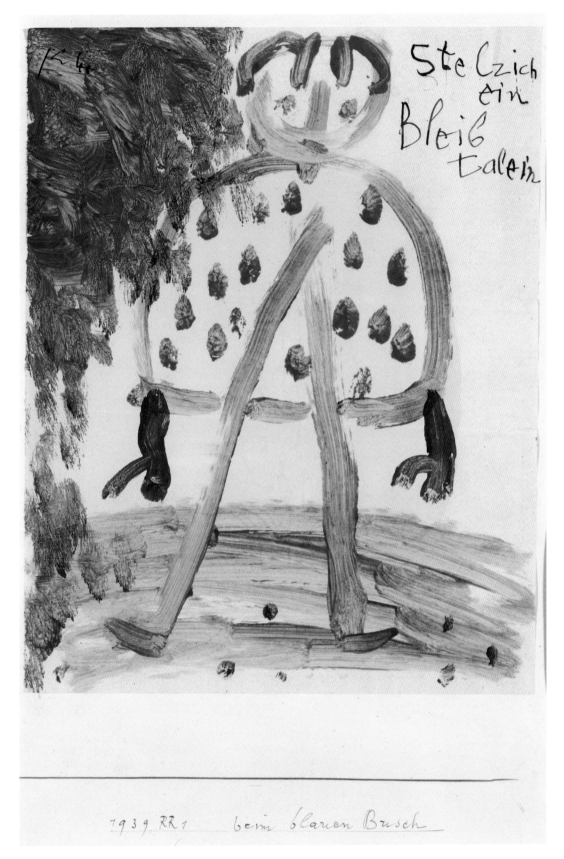

4.61
Paul Klee
By the Blue Bush, 1939

1. Dylan Thomas, *A Child's Christmas in Wales* (New York: New Directions, 1959).
2. Paul Klee, letter to Lily Stumpf, 3 October 1902, in Paul Klee, *Briefe an die Familie*, Band 1, 1893–1906, ed. Felix Klee (Cologne: DuMont, 1979), 273.
3. Paul Klee in a December 1911 review of the *Blaue Reiter* exhibition in Munich for the Swiss journal *Die Alpen*; included in his diaries: Paul Klee, *Tagebücher 1898–1918*, textkritische Neuedition, ed. Wolfgang Kersten (Stuttgart: Verlag Gert Hatje; and Teufen: Verlag Arthur Niggli, 1988), entry 905, pp. 320–22; translated as Felix Klee, ed., *The Diaries of Paul Klee 1898–1918* (London: Peter Owen; Berkeley and Los Angeles: University of California Press, 1965), 266; cited in Robert Goldwater, *Primitivism in Modern Art*, enlarged ed. (Cambridge: Harvard University Press, 1986), 199.
4. See Jürgen Glaesemer, *Paul Klee: Handzeichnungen I* (Bern: Kunstmuseum, 1973), 20. The exceptions are a self-portrait drawing of 1899, and two works made in Italy in 1901.
5. Paul Klee, *Briefe an die Familie*, Band 1, 171, 176; See Jürgen Glaesemer, *Paul Klee: Handzeichnungen I*, 105.
6. Klee would continue revising and annotating the diaries as late as the fall of 1921. See Christian Geelhaar, "Journal intime oder Autobiographie? Über Paul Klees Tagebücher," in *Paul Klee Das Frühwerk 1883–1922*, exh. cat. (Munich: Städtische Galerie im Lenbachhaus, 1980), 251–52.
7. Paul Klee, letter to Lily Stumpf, 31 March 1905, in Paul Klee, *Briefe an die Familie*, Band 1, 489.
8. Ibid., 492; See O. K. Werckmeister, "The Issue of Childhood in the Art of Paul Klee," *Arts Magazine* 52, no. 1 (September 1977), 140; and Marcel Franciscono, *Paul Klee: His Work and Thought* (Chicago: University of Chicago Press, 1991), 90.
9. Paul Klee, *Tagebücher 1898–1918*, entry 633, p. 212; translated as Felix Klee, ed., *The Diaries of Paul Klee 1898–1918*, 176.
10. Paul Klee, *Tagebücher 1898–1918*, entry 748, p. 206; trans., 194–96.
11. Paul Klee, *Tagebücher 1898–1918*, entry 842, p. 282; trans., 232.
12. He also had an illegitimate son in Munich around 1900. He mentions the affair as happening around New Year 1900 (diary entry 90). He mentions this lover again in April (diary entry 98), and late in the year (diary entry 124) he notes: "Recht weit hatte ich's ja nun gebracht. Ich war / Dichter, ich war Lebeman, ich war Satiriker, Künst- / ler, Geiger! Nur etwas war ich nicht mehr: / Vater. Das Kind meines Verhältnisses hatte sich nicht / als lebensfähig erwiesen. / Dafür drohten Schulden, drohte das Militär. / Drohte das Fiasko in der angestrebten idealen Liebe. / Eine Kreuzung von Göttlichem und von Lumpereien / war es." (I have taken things pretty far. I was a poet, I was someone who enjoys life, a satirist, an artist, a violinist! Only one thing I was not any more: a father. The child of my girlfriend was not able to survive. Instead debts threatened and military service threatened. Now the fiasco of an ideal love relationship is on the horizon. What a mixture of the godly and shabbiness.) See Paul Klee, *Tagebücher*, 44, 45, 55.
13. Paul Klee in a December 1911 review of the *Blaue Reiter* exhibition in Munich for the Swiss journal *Die Alpen*; included in his diaries: Paul Klee, *Tagebücher 1898–1918*, entry 905, pp. 320–22; trans., 266; cited in Robert Goldwater, *Primitivism in Modern Art*, 199.
14. Georg Kerschensteiner, *Die Entwicklung der zeichnerischen Begabung* (Munich: Verlag Carl Gerber, 1905). For a more detailed discussion of contemporary studies of child art, see J. S. Pierce, *Paul Klee and Primitive Art* (1961; New York and London: Garland, 1976), and Jonathan Fineberg, *When We Were Young: The Art of the Child* (forthcoming, including a detailed chronology of the exhibition history and literature on child art). Werckmeister also demonstrated the connection of Klee's 1913 *Children as Actors* with an illustration in Kerschensteiner; see O. K. Werckmeister, "The Issue of Childhood in the Art of Paul Klee," 140–46; O. K. Werckmeister, *Versuche über Paul Klee* (Frankfurt am Main: Syndikat, 1981), 143–45; and Marcel Franciscono, *Paul Klee: His Work and Thought*, 156–58.
15. I am grateful to Claude Picasso for this fascinating insight; conversation with the author, Paris, 31 May 1991.
16. Paul Klee, "Schöpferische Konfession," in *Tribune der Kunst und Zeit XIII*, ed. Kasimir Edschmid (Berlin: Erich Reiss, 1920 [written 1918]); translated as "Creative Credo," in Norbert Guterman, *The Inward Vision: Watercolors, Drawings and Writings by Paul Klee* (New York: Harry N. Abrams, 1959), 5–10; and in Jürg Spiller, ed., *The Thinking Eye: The Notebooks of Paul Klee*, trans. Paul Mannheim et al. (London: Lund Humphries; New York: Wittenborn, 1961), 76.
17. There are numerous other examples, including the many landscapes of the late 1910s and 1920s in which the childlike form of the trees derive from any of several watercolor landscapes of around 1890; Werckmeister has suggested such a source for the 1918 *Landscape of the Past* (O. K. Werckmeister, *Versuche über Paul Klee*, 149–51) but one can as readily find such more general motifs in works ranging from *The Niesen* of 1915 to *The Hermitage* and *With the Eagle* of 1918, to works as late as the 1935 *Planting According to Rules*.

18. In a recent exhibition catalogue, *Paul Klee: Im Zeichen der Teilung*, a 1920 photograph of the artist's studio is reproduced and this painting by Felix is shown, displayed by Paul Klee among his own works. In consequence the authors of the catalogue mistakenly identify it as a lost work by Paul Klee. See *Paul Klee: Im Zeichen der Teilung* (Stuttgart: Staatsgalerie; Düsseldorf: Kunstsammlung Nordrhein-Westfalen, 1995), 163, 171.

19. Since the Paul Klee is not dated we must allow the possibility that it antedates the work by Felix. This seems highly unlikely, however, since that would mean the child had made a remarkably faithful copy of the father's work (something beyond the technical control suggested by the rest of the rendering) and that the child did this in only the top half of a canvas and then seamlessly extended the landscape to make a whole. Certainly the more obvious explanation, though we will nevertheless still have to call it speculation, is that the father simply cut off the bottom half of the child's composition (thus eliminating the aspects that provide a more conventional perspective space than Klee was prone to paint) and made a painting of the top half.

20. Herwarth Walden, *Einblick in die Kunst: Expressionismus, Futurismus, Kubismus* (Berlin, 1917), 5, 9; cited in O. K. Werckmeister, *Versuche über Paul Klee*, 148–49.

21. Paul Klee, conversation with Lothar Schreyer at the Bauhaus; in Felix Klee, *Paul Klee* (New York: Braziller, 1962), 182–84; cited in Robert Goldwater, *Primitivism in Modern Art*, 200.

22. Theodor Däubler, "Paul Klee," *Das Kunstblatt* 2 (1918), 24–27; cited in O. K. Werckmeister, *Versuche über Paul Klee*, 149.

23. Klee began testing this motif of the boat with side wheel and smokestacks from his childhood sketchbook as early as his 1917 *Drawing for the Evil Star of Ships* and the 1919 *Fairytale Picture with Lake and Steamboat*, which also have fish and other motifs that may come from his childhood drawings.

24. Paul Klee, lecture of 28 November 1921, in Paul Klee, *Beiträge zur bildnerischen Formlehre, Faksimilierte Ausgabe des Originalmanuskripts von Paul Klees erstem Vortragszyklus am staatlichen Bauhaus Weimar 1921–22*, edited, with an introduction and transcription by Jürgen Glaesemer (Basel and Stuttgart: Schwabe, 1979), 14–15; Paul Klee, *The Thinking Eye: The Notebooks of Paul Klee*, vol. 1, ed. Jürg Spiller, trans. Ralph Manheim et al. (New York: Wittenborn, 1961), 133.

25. Paul Klee, lecture of 28 November 1921, in Paul Klee, *Beiträge zur bildnerischen Formlehre*, 153, 155, 157; cited in (and translated by) Marcel Franciscono, *Paul Klee: His Work and Thought*, 254.

26. Lene Schmidt-Nonne, "Kinderzeichnungen," *Bauhaus* 3, no. 3 (July-September 1929), 13–16.

27. H.-F. Geist, "Schöpferische Erziehung," *Bauhaus* 3, no. 3 (July-September 1929), 17–19.

28. See Tilman Osterwold, *Paul Klee, Die Ordnung der Dinge, Bilder und Zitate*, exh. cat. (Stuttgart, 1975), 82ff.; and O. K. Werckmeister, "Die Porträtphotographien der Zürcher Argentur Photopress aus Anlass des sechzigsten Geburtstages von Paul Klee am 18. Dezember 1939," in Stefan Fry and Josef Helfenstein, eds., *Paul Klee: Das Schaffen im Todesjahr*, exh. cat. (Bern: Kunstmuseum, 1990), 45–46.

29. Josef Helfenstein, "Das Spätwerk als 'Vermächtnis,'" in Stefan Fry and Josef Helfenstein, eds., *Paul Klee: Das Schaffen im Todesjahr*, 61.

5. Pablo Picasso: Playing with Form

Although Picasso kept a few of the paintings and drawings that his own children made [figs. 5.1–5.4],[1] he never did so in any systematic way; there is no Picasso collection such as those assembled by Larionov, Klee, or Kandinsky and Münter. Moreover, Picasso never made direct use of any motifs from children's drawings in his own work. He was, however, exceedingly interested in how children see and in the processes by which they create; he observed them at work with rapt attention.

Picasso's friend Brassaï brought a young boy around to Picasso's studio in 1943 to show Picasso his drawings, which Brassaï thought had some talent. But the way Picasso looked at the child's drawings fascinated Brassaï: "He looks at them as though he had never before seen a drawing. His eyes never leave them. He is totally absorbed by what he is looking at, and indifferent to everything else around him. The entire force of his attention is concentrated here. The greediness of his curiosity and his power of concentration are perhaps the keys to his genius."[2] One can see this same focused concentration in David Douglas Duncan's photographs of the artist watching his daughter Paloma draw at the dining room table in his château, La Californie, in July 1957.[3]

Whether actually drawn by a child or by Picasso himself in a childlike style, childlike images appear on sheets of studies by Picasso (as in the top center of fig. 5.8) from as early as 1899, when he was eighteen; these drawings demonstrate an interest in child styles as well as in caricature. In addition, a Picasso sketchbook from around 1900 includes two pages with drawings that are unmistakably the work of a child [figs. 5.5, 5.6]. On one page, a child has traced his or her hand next to two crudely rendered flowers, labeled "feur" (a misspelling of the French *fleur*). On another page of this same sketchbook a child has drawn figures of a man (labeled "homme") and two women of radically different scale from one another, alongside what seem to be two cherries and some scribbled out, apparently incomplete, forms. Among the excisions are three attempts at writing "Lucie Mar . . . ," evidentally the child's name with the last letters of the surname left illegible.

That Picasso permitted a child to draw in his sketchbook as early as 1900

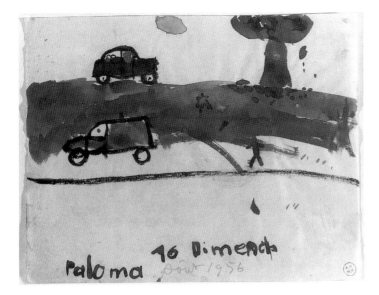

5.1
Paloma Picasso
Untitled (Drawing with Cars), 1956

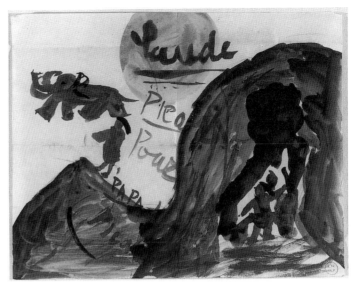

5.2
Claude Picasso
Untitled (Personage, Grotto and Elephant), 1953

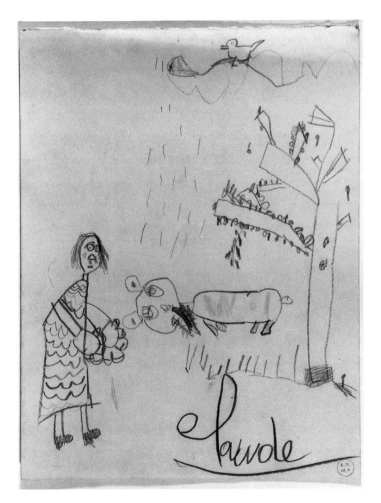

5.3
Claude Picasso
Untitled (Personage and Animal), 18 February 1953

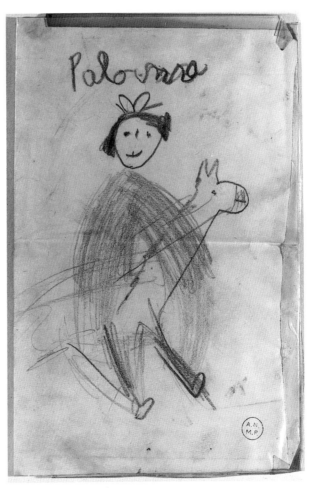

5.4
Paloma Picasso
Untitled (Girl with a Horse), ca. 1956

5.5
Child's drawing (anonymous),
in Picasso's sketchbook
Carnet deux, 1901

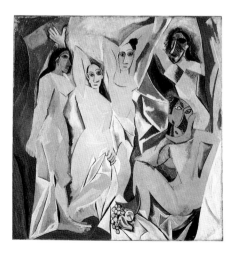

5.6
Child's drawing (anonymous),
in Picasso's sketchbook
Carnet deux, 1901

5.7
Pablo Picasso
Les Demoiselles d'Avignon, June–July 1907

seems, in itself, to suggest a longstanding interest on the part of Picasso in the way children draw. In the 1940s he told Brassaï quite directly: "I always stop when I see children drawing in the street, or on the sidewalk or on a wall. It's surprising—the things that come from their hands. They often teach me something."[4] But precisely *what* did they teach him? As early as 1913, Apollinaire thought that Picasso's art celebrated the freedom of expression in the art of children and he referred to Picasso as working like "a newborn child who orders the universe for his personal use."[5]

Picasso's selection of Matisse's 1906–7 portrait of *Marguerite* [fig. 1.12] in 1907, when the two artists traded paintings, reveals yet another glimpse into Picasso's interest in child art. According to John Richardson, Picasso said that he had chosen the portrait for its bold and daring reductions which, Picasso explained, derived from Matisse's study of drawings by his sons Jean (age seven) and Pierre (age six). "Picasso was very curious to see how Matisse had exploited his children's instinctive vision," Richardson recalled from his conversation with the artist.[6] Meanwhile, Picasso told Pierre Daix that the rendering of the noses of the two central figures in *Les Demoiselles d'Avignon* [fig. 5.7] was directly inspired by Matisse's portrait of Marguerite, whose face Matisse had portrayed straight-on while showing her nose in profile, as children often do.[7]

Picasso, it seems, deliberately sought to recapture, in his *Demoiselles*, some of that "genius of childhood," as he called it, that "period of marvellous vision" that "disappears without a trace" when children grow up.[8] Indeed, a childlike freshness of observation marks most of Picasso's oeuvre, appearing most obviously when he painted his own children, as in *Maya with a Doll* of January 1938, *Claude with His Hobby Horse* of 1949, and *Mother and Children Playing* of 1951 [figs. 5.9, 5.10].

Picasso had four children. His first wife, Olga, was the mother of Paulo (born February 1921). Maya was born to Marie-Thérèse Walter in October 1935 (making her three when Picasso painted the series of portraits of her with a doll and a boat). Françoise Gilot gave birth to Claude in May 1947 and Paloma in April 1949; they were toddlers in the early 1950s when Picasso made such paintings as *Mother and Children Playing* and the playful assemblages of the *Little Girl Jumping Rope* (1950–52) and the 1951 *Baboon and Her Young* [figs. 5.11, 5.12].

Picasso obviously enjoyed his children, observing them [fig. 5.22], on one occasion playfully collaborating with them on a drawing [fig. 5.23], and according them unrestricted access, even to the studio. Paloma described sitting in her father's studio quietly drawing while he worked, and she still warmly remembers his playfulness, as when he or one of the children were in the bath with soap on their faces and he would draw funny eyebrows or moustaches

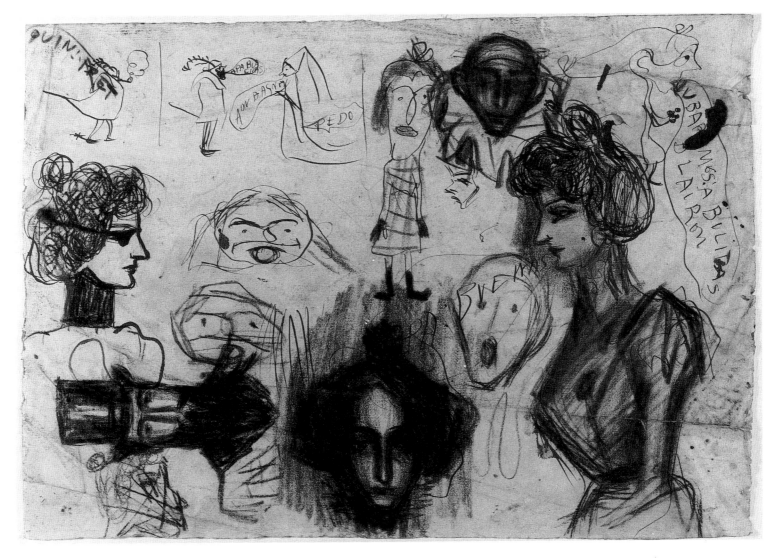

5.8
Pablo Picasso
Sheet of Caricatures, Barcelona, 1899–1900

with the suds and then wipe them out and do it again.[9] He also made his work a natural part of the life of the house, engaging the children in the process; he would often draw at the dining room table and when plates arrived he would just push the drawings aside. Claude recalled as a child being enlisted—and feeling pleased to be a part of the process—to hold something in place while the plaster set or to carve out the larger areas of a linoleum block.[10]

The first half of Picasso's career shows little of the overtly childlike openness that became more apparent in his work after the birth of Maya. By 1950 the artist was near seventy and had not only Claude and Paloma around but soon Catherine (born 1948), the daughter of his new wife, Jacqueline, as well. (Jacqueline had moved in with Picasso in 1954.) At this time, Picasso's work became less classical, less dependent on controlled draftsmanship, and in-

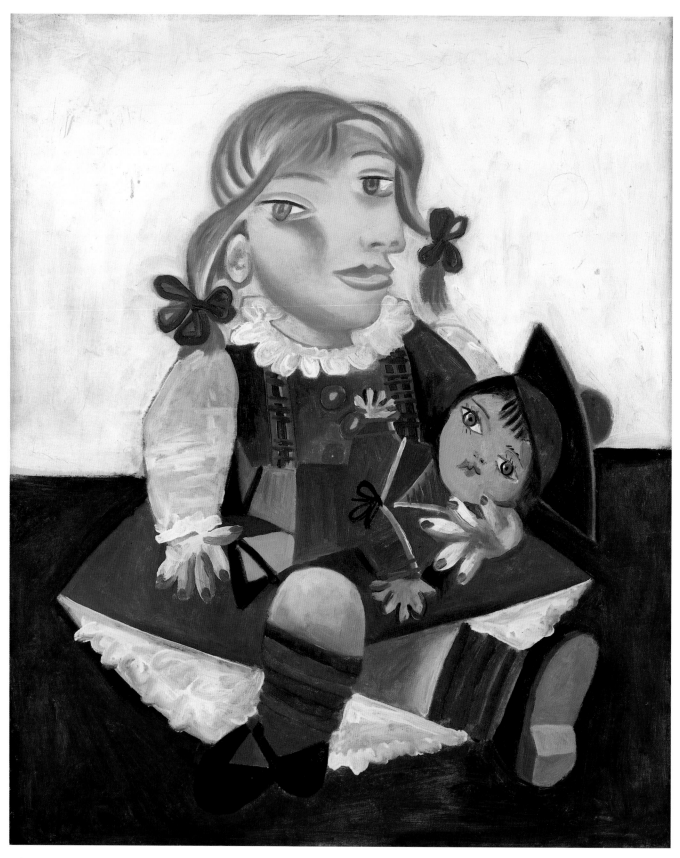

5.9
Pablo Picasso
Maya with a Doll, 16 January 1938

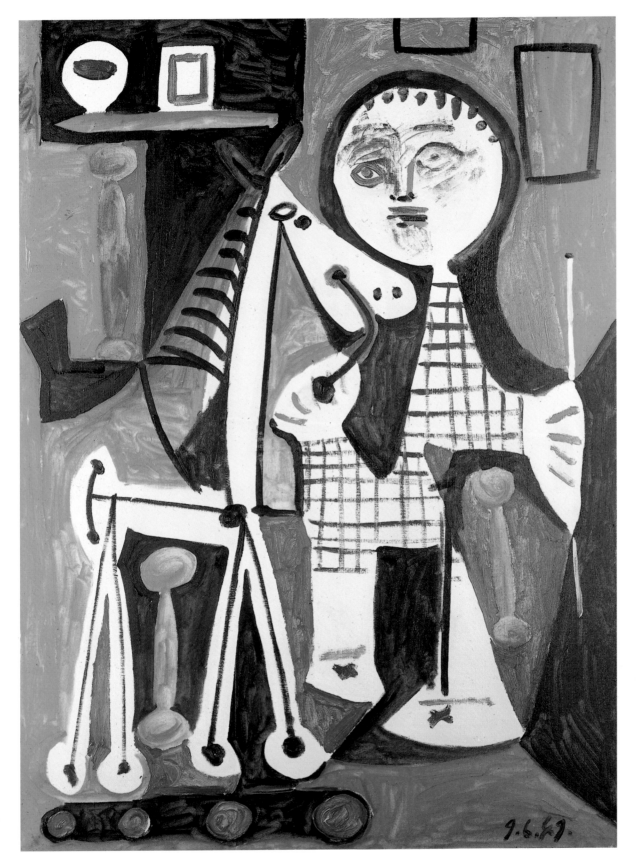

5.10
Pablo Picasso
Claude with His Hobby Horse, 9 June 1949

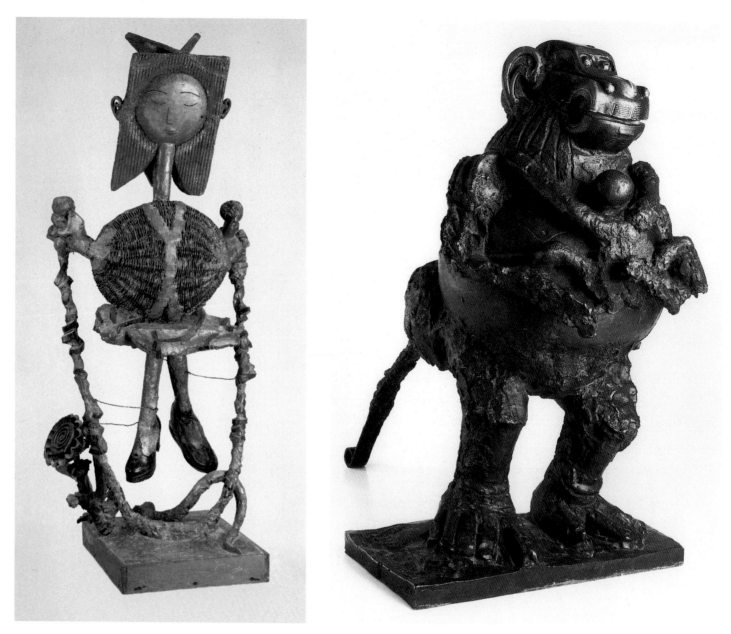

5.11
Pablo Picasso
Little Girl Jumping Rope, Vallauris,
1950–52

5.12
Pablo Picasso
Baboon and Her Young, October 1951

creasingly expressionistic. Picasso's late work [fig. 5.13] is the most uninhibited work of his career: probing sexuality, the tactile pleasures of paint, and an inventive openness toward found objects—all with a childlike innocence.

In this freer, more visceral mood, Picasso also returned to the history of art, reliving the great past masters who had had a formative influence on his development. In paintings such as his variations on *Las Meninas* by Velázquez and Manet's *Le Dejeuner sur l'herbe* [figs. 5.14, 5.15] Picasso reexperienced these great works as though through the eyes of a child. Yet even here, among his most "childlike" works in superficial appearance, the spatial structure of the background to Picasso's *Las Meninas, after Velázquez* and the figural abstrac-

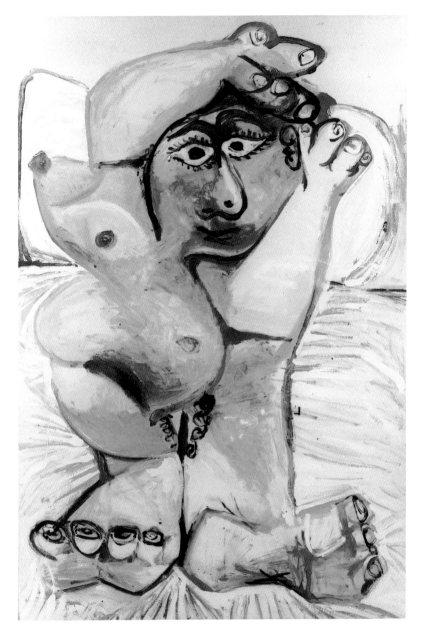

tion of the central nude in his *Le Dejeuner* rely on a sophisticated use of cubism, not to mention a subtle knowledge of art history.

A single source of stylistic inspiration virtually never dominates any of Picasso's mature works. While he may, by his own account, use a device from children's drawings in the faces of the central figures of the *Demoiselles*, Cézanne, Bakota funerary guardians, Egyptian striding figures, and a number of other sources are crucial to its genesis as well. Even in a work like *Maya with a Doll*—so focused on the "childness" of the subject—only the awkwardness of the hands and feet seem unambiguously influenced by children's art, while the complex simultaneity of views in the rendering of the face, for example, has

nothing at all to do with children or child art.

Gertrude Stein's description of Picasso's childlike objectivity of vision, published in the same year in which Picasso painted *Maya with a Doll*, seems particularly germane:

> *A child sees the face of its mother, it sees it in a completely different way than other people see it . . . the child for a little while only sees a part of the face of its mother, it knows one feature and not another, one side and not the other, and in this way Picasso knows faces as a child knows them and the head and the body. . . . Really most of the time one sees only a feature of a person with whom one is, the other features are covered by a hat, by the light, by clothes for sport and everybody is accustomed to complete the whole entirely from their knowledge, but Picasso when he saw an eye, the other one did not exist for him. . . . so the cubism of Picasso was an effort to make a picture of these visible things and the result was disconcerting for him and for the others. . . ."*[11]

It is by now a cliché of art history to say that every vanguard artist sees things in a way that differs—often disconcertingly so—from the way "most people" see them. But nothing could be more shocking than to reveal what all the forces of civilization (through the norms of etiquette, familial socialization and formal education) have systematically undertaken to repress into the adult unconscious, namely the frank sexuality, aggression and possessiveness of the young child that lives on, hidden in all of us. The more profound Picasso became in revealing the persistence of such inner forces the more he was dismissed by viewers as a "child."

Picasso received more than his share of such abuse. In the 1960s, John Berger, for example, attacked Picasso's then contemporary work, insisting that "he is reduced to playing like a child. . . . If there is any fury or passion implied at all, it is that of the artist condemned to paint with nothing to say."[12] Now thirty years later critical opinion is coming to regard works from that same late expressionism that Berger dismissed as ranking among the masterpieces of Picasso's career.[13]

In a child's imagination an andiron can become the tail of an animal, a bowl of water can be a lagoon; children do not feel as constrained as adults to see an object in terms of its conventional uses. It is precisely this objectivity of vision, described by Gertrude Stein with regard to Picasso's own vision, that fascinated Picasso in the art of children. Picasso collaged together his October 1951 *Baboon and Her Young* using a couple of toy cars that his dealer, Kahnweiler, had brought as a gift for the four-year-old Claude, scraps of wood (for the legs), a fragment of a ceramic pot (the belly), a steel car spring (the tail), and

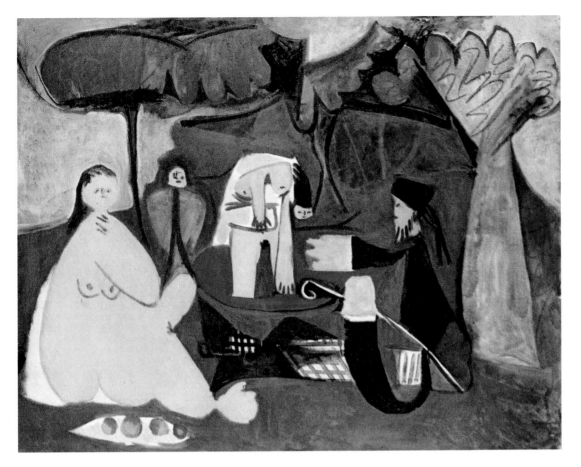

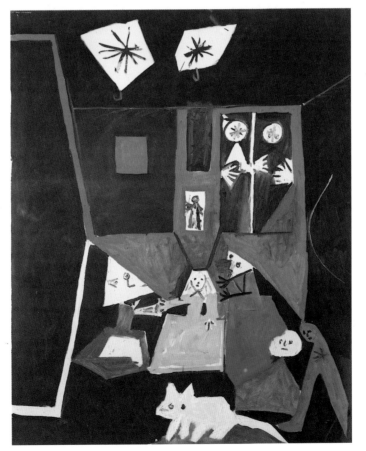

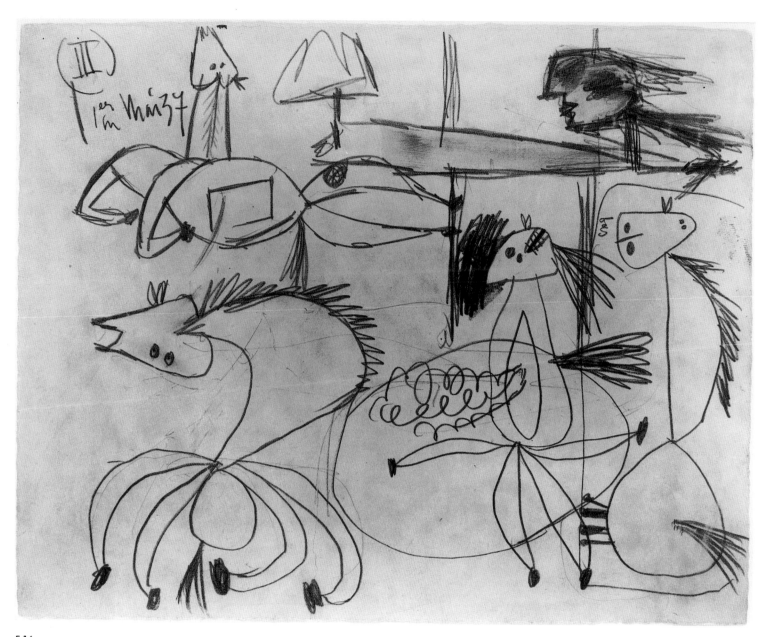

5.16
Pablo Picasso
Composition Study for Guernica (III),
Paris, 1 May 1937

5.17
Pablo Picasso
Horse, Study for Guernica (IV),
Paris, 1 May 1937

some pottery handles (for the shoulders and ears). The work relies on childlike, inventive transformations of everyday objects and materials.

Similarly, Picasso used plaster to bind together the basket torso, the oval chocolate box he used for a face, the cardboard, the shoes, and the cake molds (in the flower) of the *Little Girl Jumping Rope*. The structural problem of supporting the piece on the thin jumprope may have led to the artist's lingering over the completion of the piece,[14] and in the end he added the flower to reinforce one side of the jumprope and a serpent on the other. Meanwhile, the serpent also provides an ironic foil to the "innocence" of the child while at the same time jokingly giving her a good reason to leap into the air.

Picasso's extraordinary lack of inhibition in assembling the disparate parts of these sculptures is built on a process of playing with form that goes all the way back to his invention of cubism and recalls the free, inventive play of children. Picasso's greatest gift was his ability to see things with a naive objectivity as forms, even though, of course, he also knew what everyone else knew about their function and their conventional meanings. This enabled him not only to subordinate found objects and images to a unifying overall concept but also to make a wide range of styles function together within a single picture. Thus, in a painting like his great *Night Fishing at Antibes* of 1939 [fig. 5.18], Picasso successfully alloyed a crudely flattened, childlike rendering of a fish (bottom center) with a fist (holding the four-tonged harpoon) that derives stylistically from a detailed knowledge of anatomy; the two styles work seamlessly together in a unified composition.

Picasso's ability to make disparate styles function side by side also lay at the heart of cubism, especially cubist collage, which he pioneered before World War I. Even in its most intellectually sophisticated form, Picasso's cubism depends on his capacity to see fragments torn from various defined contexts in a neutral way, to see them as the stuff of composition. In his 1914 collage of *The Smoker* (Musée Picasso, Paris), for example, Picasso threw in two scraps of patterned wallpaper as a shirtfront and cuff, in playful defiance of its assertive reality as wallpaper. He also reassembled the human figure as a clattering construction of planes, like doors angled out in a shallow relief; this translation of the figure into the language of planes requires that one see it from the detached perspective of form while simultaneously playing this reading off against its organic reference in the human body.

In one sense, Picasso almost couldn't help himself; his intellectual processes of visual transformation and reordering went to work on everything that he looked at. "My work is like a diary," he often remarked. "It's even dated like a diary."[15] When his longtime friend and secretary Jaime Sabartés asked him why he was so interested in painting and drawing sea urchins at Antibes in the

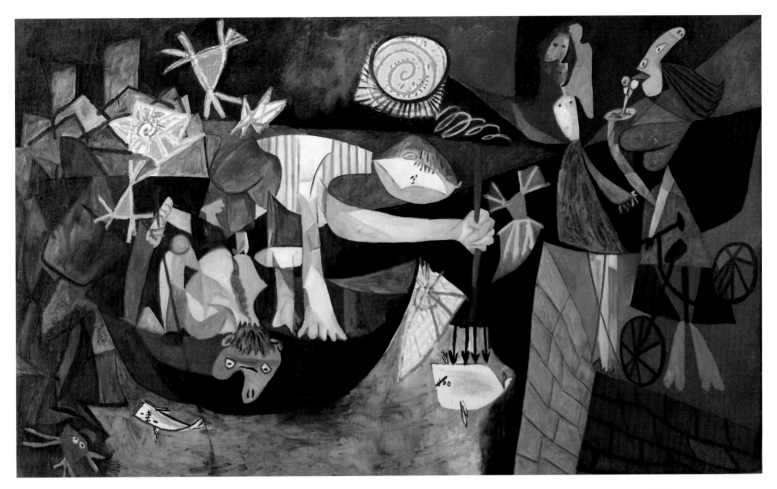

5.18
Pablo Picasso
Night Fishing at Antibes,
Antibes, August 1939

summer of 1946, his reply was almost impatient: "I'm not. I'm neither interested nor uninterested in them. They're like everything else. *It's not my fault* if I saw them."[16]

In this light, one sees more clearly the intent of Picasso's famous remark to Sir Herbert Read, made as they walked through an exhibition of children's art in Paris after World War II. Read reprised the incident in a letter to the *Times* in 1956:

Since the remark you attribute to Picasso in your leading article to-day was made in my presence, and since it has gained currency in several distorted forms, perhaps you would allow me to put on record what Picasso actually did say. I had been showing him round an exhibition of children's drawings sent to Paris by the British Council. He looked at them very carefully, and when he had finished he turned to me and said (I will not pretend to remember the French words he used): "When I was the age of these children I could draw like Raphael. It took me many years to learn how to draw like these children."[17]

What can this mean? Picasso drew relentlessly from early childhood; according to his mother, Picasso could draw before he could speak.[18] Moreover,

5.19
Pablo Picasso
Studies, from the sketchbook
Carnet bleu, 3 May 1943

by the artist's own recollection, "I have never done children's drawings. Never. Even when I was very small. I remember one of my first drawings. I was perhaps six, or even less. In my father's house there was a statue of Hercules with his club in the corridor, and I drew Hercules. But it wasn't a child's drawing. It was a real drawing representing Hercules with his club."[19] Indeed, he seems to have lamented that he attained academic skills so early. As he told Brassaï: "I was making drawings that were completely academic. Their minuteness, their exactitude, frightens me. My father was a professor of drawing, and it was probably he who pushed me prematurely in that direction."[20]

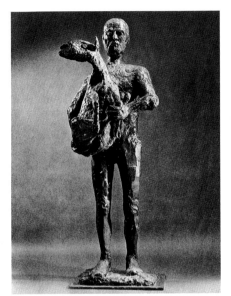

5.21
Pablo Picasso
Man with a Sheep,
Paris, February 1943

5.20
Pablo Picasso
Study for Man with a Sheep (III),
19 August 1942

It is therefore all the more fascinating that at no time in Picasso's career did he come closer to working in a child's style than in his sketches for *Guernica* [figs. 5.16, 5.17], perhaps the most formal, classical, and certainly the most monumental and celebrated masterpiece of his career. The 1 May 1937 study (IV) of the horse actually looks like the drawing of a six-year-old! There is a vast interpretive literature on *Guernica* that need not be reiterated here. But it is worth pointing out that the painting depicts a cataclysmic disaster which, if read in terms of the family constellation, involves a prostrate and dismembered adult man (which is how his biographers figuratively describe Picasso's notably un-

5.22
Alexander Liberman
Pablo Picasso in his studio in
Vallauris, 1953–54. On the easel
is a painting by Picasso of his
children Claude and Paloma
on the floor painting.

5.23
Pablo, Paloma and Claude Picasso,
Françoise Gilot
Untitled, 16 April 1953

successful father) and a crowd of distressed women (like the scene in which he grew up), one of whom holds a dead baby (the death of his younger sister Concha at the age of seven was a tragedy that marked him for life).

Surprisingly, among the first drawings for a number of important works—frequently works like *Guernica* that show little evidence of the influence of child art in their final form—there are several with a quite childlike character. The 1942 studies for the sculpture of *Man with a Sheep*, for example, show an almost infantile first concept toward a final sculpture of a refined, almost classical realism [figs. 5.20, 5.21].[21] Several of the drawings in the so-called *Carnet bleu*,

a sketchbook of 1943, also have this childlike character [fig. 5.19], suggesting that classical naturalism is perhaps an abstraction for Picasso from the primary perception which is childlike in its directness, an experience filtered by the persevering presence of the childhood mind. Picasso's fascination with the visual inventiveness of children relates to his own extraordinary access to the memories and urges of childhood that most of us have buried beyond the reach of our adult consciousness; his interest in the creativity of children stemmed from a desire to comprehend his own creativity, which he regarded as *"un mystère totale."*[22]

1. These are part of a group of about a dozen that were leafed into books that Picasso owned, some of them folded up in a small envelope.
2. Brassaï, *Picasso & Co.*, 17 November 1943 (London: Thames and Hudson, 1967), 80.
3. See, for example, the illustration in the lower right of David Douglas Duncan, *The Private World of Pablo Picasso* (New York: Ridge Press, 1958), 164.
4. Pablo Picasso, in Brassaï, *Picasso & Co.*, 1966, 202ff., 27 November 1946; 1964, 247ff.; 1966, 184ff.; 1964, 226; cited in Irving Lavin, *Past-Present: Essays on Historicism in Art from Donatello to Picasso* (Berkeley and Los Angeles: University of California Press, 1992), 38.
5. Guillaume Apollinaire, "Pablo Picasso," *Monjoie!* (14 March 1913); in Guillaume Apollinaire, *Apollinaire on Art: Essays and Reviews, 1902–1918*, ed. LeRoy C. Breunig, trans. Susan Suleiman (New York: Viking, Documents of 20th Century Art, 1972), 280.
6. John Richardson, *A Life of Picasso: Volume I, 1881–1906* (New York: Random House, 1991), 417.
7. Pierre Daix, *Picasso: Life and Art* (New York: Harper Collins, Icon Editions, 1993), 63–64.
8. Pablo Picasso, cited in Brassaï, *Picasso & Co.*, 17 November 1943, 86.
9. Paloma Picasso, conversation with the author, New York, 30 September 1992.
10. Claude Picasso, conversation with the author, Paris, 31 May 1991.
11. Gertrude Stein, *Picasso* (1938; reprint, Boston: Beacon Press, 1959), 14–15.
12. John Berger, *The Success and Failure of Picasso* (Harmondsworth, England: Penguin Books, 1965), 180, 185.
13. See, for example, Gert Schiff, *Picasso: The Last Years, 1963–73* (New York: Solomon R. Guggenheim Museum and George Braziller, 1983); Klaus Gallwitz, *Picasso: The Heroic Years* (New York: Abbeville Press, 1985); and Marie-Laure Bernadac et al., eds., *Late Picasso: Paintings, Sculpture, Drawings, Prints* (London: Tate Gallery; and Paris: Musée National d'Art Moderne, 1988).
14. Picasso worked on the piece over a couple of years according to Elizabeth Cowling and John Golding, *Picasso: Sculptor/Painter*, exh. cat. (London: Tate Gallery, 1994), 279.
15. John Richardson, *A Life of Picasso: Volume I*, 3.
16. Pablo Picasso, cited in Jaime Sabartés, *Picasso et Antibes* (Paris: R. Drouin, 1948), 29; cited in Jean Sutherland Boggs, "Picasso and Things," *Picasso and Things*, exh. cat. (Cleveland: Cleveland Museum of Art, 1992), 13. Italics are mine.
17. Herbert Read, letter to the *London Times* (27 October 1956), 27. The letter was written in response to a remark in a review in the *Times* of 25 October 1956, p. 11. The exhibition, organized by Read for the British Council, traveled to Paris in 1945 and was reviewed 12 April 1945 in *Le Monde*. The exchange is recounted in Irving Lavin, "Picasso's Lithograph(s) 'The Bull(s)' and the History of Art in Reverse," in *Past-Present: Essays on Historicism in Art from Donatello to Picasso*, 309–10 nn. 54, 55.
18. John Richardson, *A Life of Picasso: Volume I*, 27.
19. Hélène Parmelin, *Picasso Says*, trans. Christine Trollope (London: Allen and Unwin, 1969), 73; cited in John Richardson, *A Life of Picasso: Volume I*, 29. Richardson points out that the drawing was actually done when Picasso was nine.
20. Pablo Picasso, cited in Brassaï, *Picasso & Co.*, 17 November 1943, p. 86.
21. See Werner Spies, *Picasso: Das Plastische Werk* (Stuttgart: Verlag Gerd Hatje, 1983), 206–7.
22. Pablo Picasso, quoted in John Richardson, *A Life of Picasso: Volume I*, 31.

6. Joan Miró's Rhymes of Childhood

Joan Miró admired and meticulously collected the imaginative and often dramatic childhood drawings of his daughter Dolorès, who was born in 1930 [figs. 6.1–6.7]. He archived them in portfolio envelopes, carefully sorted and labeled by year, and thought highly enough of them to send one to Kandinsky in 1935 and two to the important American collector Albert Gallatin in 1938, who eventually donated them with the rest of his famous collection of modern art to the Philadelphia Museum.[1] Miró had a lifelong interest in the expressive freedom of childhood; a vivacious expressivity that recalls child art is the very trademark of Miró's mature work, and those who knew him also remarked on his childlike personality. In an essay of 1941, André Breton went so far as to characterize Miró as having "a certain arresting of his personality at an infantile stage."[2]

Yet, by the age of eight, Miró's own childhood drawings, which he also carefully saved, show a sober attempt at realism rather than the normally more whimsical creativity of a child [figs. 6.8–6.10], and as a mature artist, Miró's fascination with childhood seems to have been less involved with the subject matter or even the formal ideas in the drawings of children than with trying to recover precisely that imaginative exhuberance which his own childhood drawings lacked. As early as 1929, the writer Michel Leiris, a friend of Miró's, pointed out the artist's effort to rediscover childhood as a central issue in his art and described Miró as walking the street wide-eyed like an "amazed child."[3] More than thirty years later, Miró confirmed the perseverance of this concern when he told Dora Vallier, "The older I get and the more I master the medium, the more I return to my earliest experiences. I think that at the end of my life I will recover all the force of my childhood."[4]

Miró was a quiet man who often seemed absent, lost in his private thoughts. He lived an outwardly uneventful life with propriety. To many he even appeared overly tidy, meticulous, punctual, orderly.[5] By his own account, Miró seems to have had an unhappy childhood, aloof from other children. Moreover, in a letter to his biographer, Jacques Dupin, Miró also described himself as having been "a very bad pupil, withdrawn, dreamy, without much to say."[6]

Miró was born in Barcelona in 1893, the son of a prosperous goldsmith. Despite a strong internal rebellion against his father, whom the artist portrayed

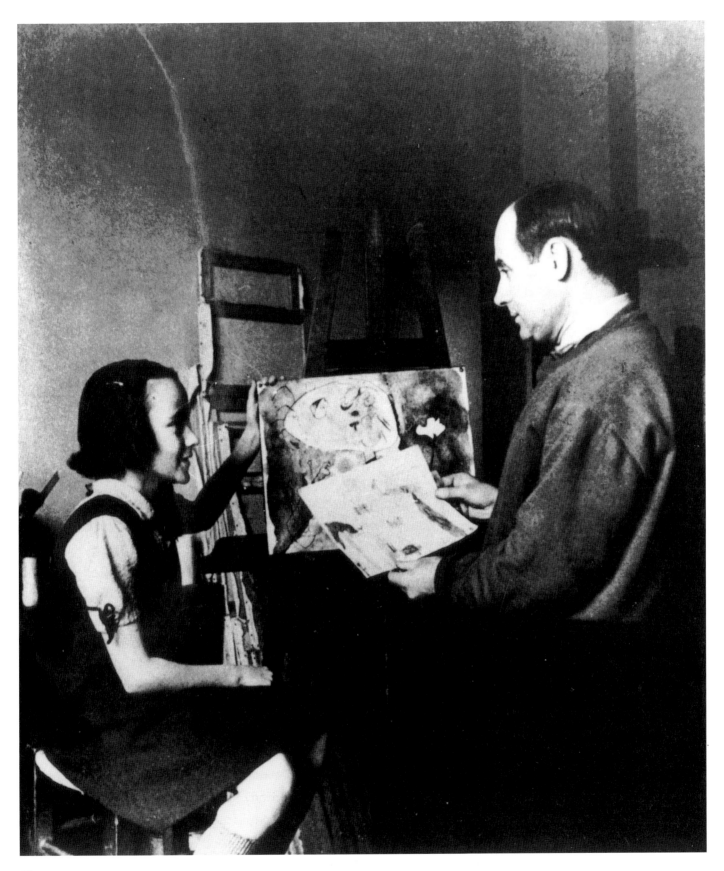

6.1
Joan Miró holding a drawing by
his daughter Dolorès and discussing it
with her, ca. 1938

6.2
Dolorès Miró
Untitled ("El Torneo"),
December 1941

6.3
Dolorès Miró
Untitled ("Adanyeva Fuera del Parais"),
May 1942

6.4
Dolorès Miró
Mother, February 1938

as unsympathetic to early expressions of his aesthetic sensibilities, Miró had a strong attachment to his family roots. He kept a studio in the house where he was born—in the Pasaje del Credito—until 1956, giving it up only at the age of sixty-three when he decided to relocate to Majorca, his mother's ancestral home. In addition, he painted nearly every summer at the farm in Montroig that his father had bought in 1911, near to where Miró's paternal grandfather had worked as the local blacksmith.

Miró's parents attempted to groom him for a business career. They sent him to a preparatory school for commerce and then put him into a menial book-keeping job in 1909. But after two years of such work he suffered a nervous breakdown, compounded by typhoid fever. Miró's father purchased the farm-house in Montroig (to the southwest of Barcelona) with the idea that the boy needed fresh country air to recover.

The following year, in 1912, Miró's stubborn determination to pursue an artistic career finally prevailed and he enrolled in the small Escuela de Arte of Francesc Galí. Galí looked after the young Miró and was quick to recognize the unique character of his gifts. Seeing that Miró could not detach himself enough to draw what he saw with objectivity, Galí encouraged him to try draw-ing from touch instead; he drew objects held behind his back and felt the fea-tures of classmates with his eyes closed.[7] This ultimately led to the transforma-tion of Miró's overwhelming subjectivity from being an obstacle in technique into the wellspring of his mature style.

Miró's 1921–22 painting of *The Farm* [fig. 6.11] relies on precisely this kind of engaged individuality of experience with each element in the composition. In rendering the objects, Miró immersed himself, one by one, in his subjective

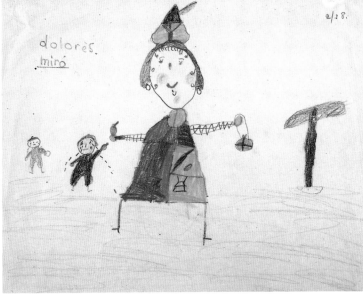

6.5
Dolorès Miró
Untitled (Star-Filled Sky), January 1942

6.6
Dolorès Miró
Mother's Departure, February 1938

impression of each of them. He described every motif as complete unto itself, without regard to external relationships as they might appear in a more objective rendering of the setting as a whole; he ignored the relative scale of one object to another, for example, and the integration of each individual object into its surroundings. Instead, the description of each element is highly developed, and although sometimes quite naturalistic in detail, as in the watering can and bucket, they each exist in conceptual isolation from one another. This aspect of the style of *The Farm* is a direct development out of the early trait that surfaced in Galí's class—Miró's inability to detach himself from the model—and demonstrates the kind of "egocentric thinking" that is common in the way young children depict objects; one can see an example of it in the drawing by Dolorès from May 1942 [fig. 6.3].

On the right side of *The Farm*, Miró represented the rectangular front of the chicken coop as a diagrammatic box, drawn in a fine red line. Behind it he described the exterior of the barn on the right but dematerialized the outside wall in the left half to reveal the events taking place inside, much the way children will sometimes render a house transparent to show what is important inside rather than emphasizing how it looks from a more "objectively" detached point of view. The literature on child art refers to this, as well as to the way children commonly conflate sequential events into a single image, as "intellectual" realism and associates it with an earlier stage of development than more visually accurate approaches. (The conflation of the landscape and the outer wall of the house at the left is an example of this spatial and temporal simultaneity in *The Farm*.)

In her drawing of January 1942, Dolorès devised a formula for stars and

6.7
Dolorès Miró
Untitled

6.8
Joan Miró (age 8)
Flower Pot with Flowers, 1901

6.9
Joan Miró (age 8)
Umbrella, 1901

then repeated it to create a star-filled sky—patterning a whole field within the composition; in her drawings of *Mother* and *Mother's Departure* she used a formula of this sort for the curls of hair spaced in a regular rhythm around the face. Miró invented a similar kind of shorthand in the very distinct areas of ground in *The Farm*. One schema symbolizes a furrowed field. Another serves as an unvarying emblem for rougher terrain, interspersed with an equally un-modulated sign for tufts of grass in the lower right. The point with regard to all these ways in which the syntax of Miró's painting of *The Farm* resembles child art is not that Miró copied children's works but that in rendering his subjective experience of this highly charged landscape with maximum poignancy he made recourse to his own childhood modes of thought, the expressive vocabu-lary that his self-imposed regimen of mastering technique at such an early age had pushed aside.

The next major works on which Miró embarked were the three landscapes: *The Tilled Field, The Hunter (Catalan Landscape)* [fig. 6.13] and *Pastoral* of 1923–24. For all the outward difference in style between them and *The Farm* of the previous year, the childlike ways of comprehending individual objects—that is, according to their subjective meaning rather than through the emotional dis-tance implied in the rendering of visual appearances—lies at the foundation of these landscapes as well as of *The Farm*. In the two-dimensional space, the stick-figure schema, and the conceptual independence of each element in *The Hunter,*

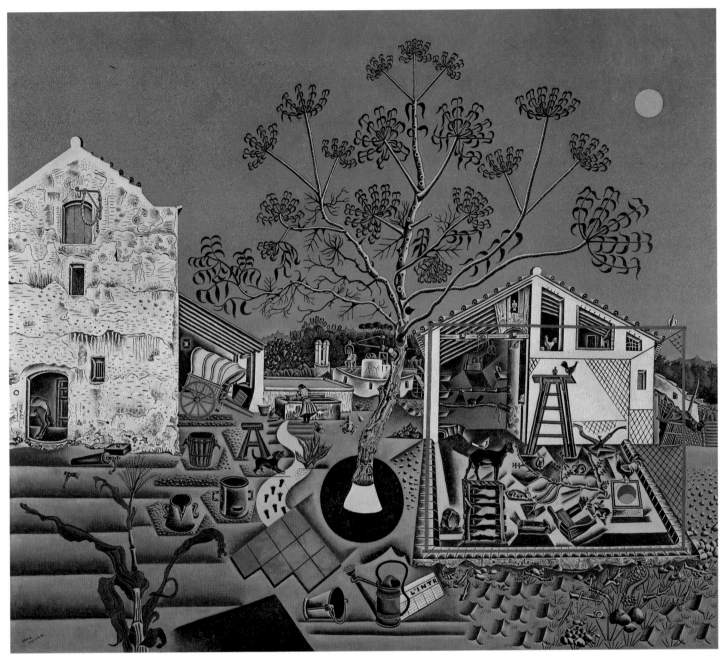

6.11
Joan Miró
The Farm, 1921–22

for example, Miró seems to go backwards developmentally in the way he conceptualizes nature. It is nature in the mind of the child where the subjective immediacy of the experience is paramount. In a 1924 letter to his friend Josep F. Ràfols he explained, "I have managed to escape into the absolute of nature, and my landscapes have nothing in common any more with outside reality. Nevertheless, they are more Montroig than if they had been done from nature."[8]

In *The Hunter*, a large sardine lying across the bottom of the composition laps at a fly with its tongue. The big circle to the right with a single leaf appended by a fine line and an eye jutting out to the left is the fullness of the carob tree, completely out of scale with the far larger sardine. Behind the tree, birds fly

over the waves of the Mediterranean. A strangely spiderlike, black sun hangs in the sky above the eye of the tree, and on the left a peasant in a Catalan cap holds a shotgun in one hand and a rabbit in the other while smoking a pipe.[9] The little cluster of forms with wheels and a ladder in the upper left is the newly instituted Toulouse-Rabat flight that went into service that very summer and flew right over Montroig. This reference to the North-South flight also puns on the title of Pierre Reverdy's poetry journal, *Nord-Sud*, to which Miró was an enthusiastic subscriber.[10] These images bridge time, scale and materiality, creating a childlike hierarchy in which everything in the mind of the artist at a given time is therefore contemporary and all things are given a size and prominence that corresponds to their significance rather than to their appearance.

The key paintings of the 1920s relate to the landscape of Miró's family farm in Montroig and to the Catalan peasants of the region. Meanwhile, the relation to childhood in Miró's process evolved in the mid-1920s into a greater concentration on the sensation rather than the comprehension of objects. In 1926–27, Miró painted three more important landscapes—*Person Throwing a Stone at a Bird* [fig. 6.12], *Dog Baying at the Moon* and *Landscape (The Hare)*—that have an even greater planarity than *The Hunter*. These simple narratives are told in a childlike reduction of flat profiles of highly charged, single images.

However, Miró's exaggeration of the foot on the figure in *Person Throwing a Stone at a Bird* recalls the common device of children of emphasizing the "important" parts of the tactile experience of a story by enlarging them (see the hands of the person reaching out to touch an animal, for example, in fig. 5.3). Miró employs this tactile enlargement of the foot or hand often in the interwar period, as in not only *Person Throwing a Stone at a Bird* but also *The Farmer's Wife* (1922–23), *The Policeman (Figure and Horse)* (1925), *Hand Catching a Bird* (1926), *Dutch Interior (III)* and *Potato* (1928). Moreover, in passages such as the rendering of the blue and red bird in *Person Throwing a Stone at a Bird*, Miró used the color with maximum intensity. He also conveyed the feeling of lightness in the throwing arm and evoked a kinaesthetic sensation in the trajectory of the stone. All of these examples suggest the same fullness of sensation with which younger children "feel" their experiences.

In *Mediterranean Landscape* of 1930 [fig. 6.14] the jagged gesturing in the center goes back to the physicality of scribbling. But after the Second World War, Miró's style as a whole became increasingly gestural and even more directly tactile. Paintings of the 1940s and 1950s, such as *Woman and Bird in the Night* (1945) and *The Bird with Calm Look and Wings in Flames* (1952) [figs. 6.15, 6.16], have a looser, broader, more emotionally spontaneous gestural style and several of them also seem to develop from one passage to the next, like an adolescent's doodle. Instead of subordinating each form to an overriding com-

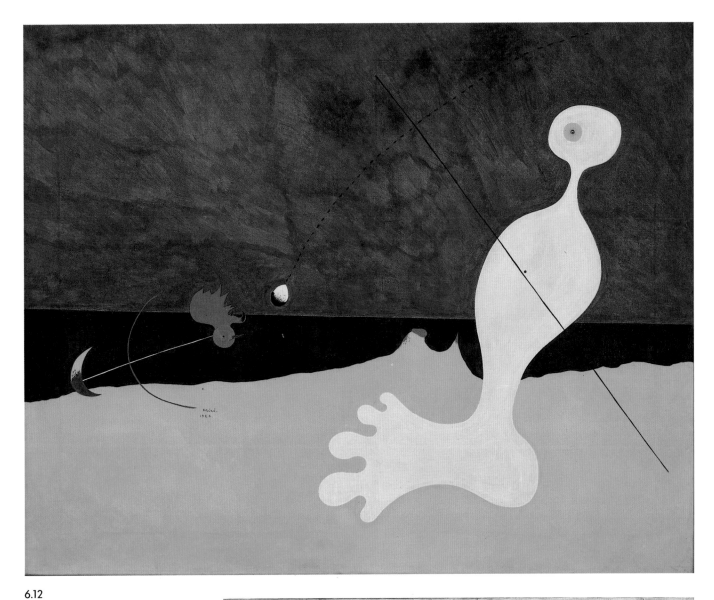

6.12
Joan Miró
Person Throwing a Stone at a Bird,
1926

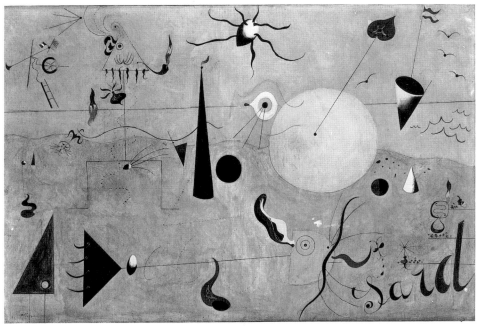

6.13
Joan Miró
The Hunter (Catalan Landscape),
Montroig, July 1923–Winter 1924

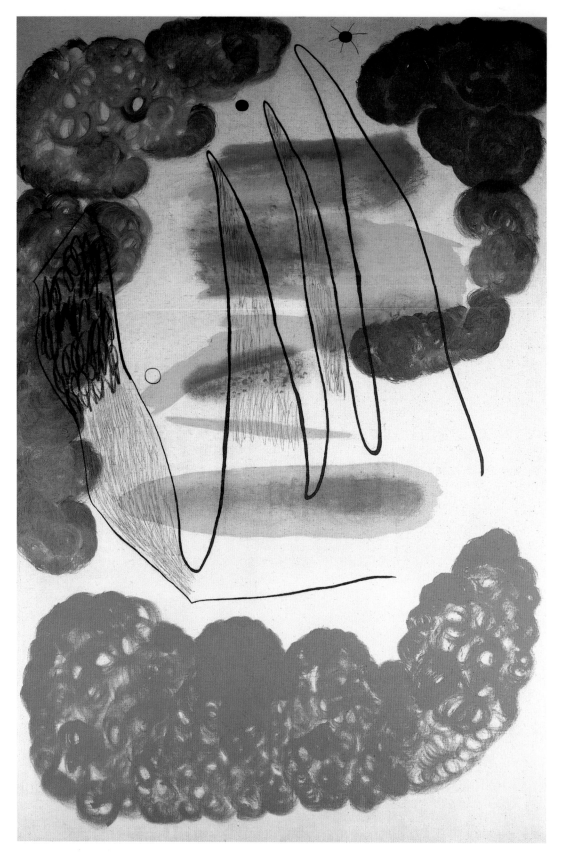

6.14
Joan Miró
Mediterranean Landscape, 1930

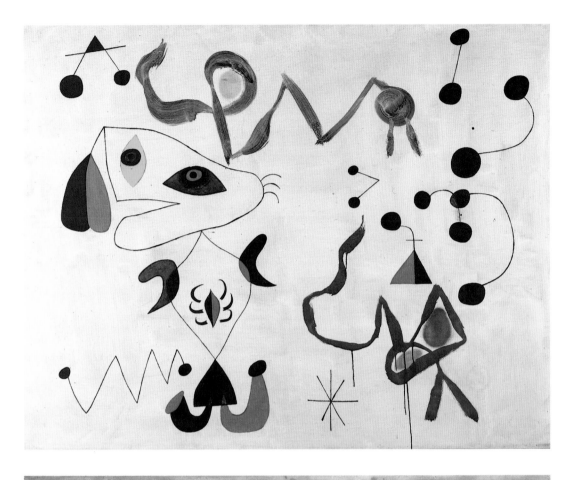

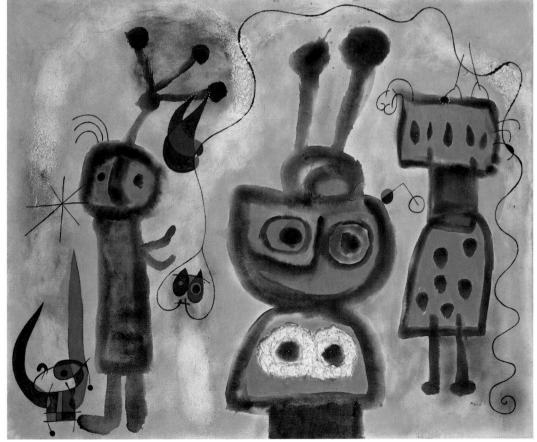

6.16
Joan Miró
The Bird with Calm Look and
Wings in Flames, 1952

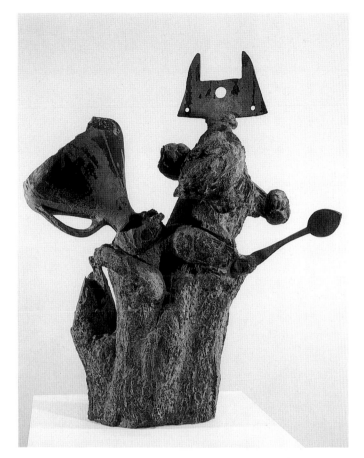

6.17
Joan Miró
Woman with Jug, 1970

6.18
Joan Miró
Woman (The Tightrope Walker), 1970

6.19
Joan Miró
Personage, 1973

positional scheme, works such as *Woman and Bird in the Night* and *The Bird with Calm Look and Wings in Flames* appear to follow a sequence of associations from place to place, jumping from one thought to the next and filling up the space of the canvas with one image after another wherever a space presented itself. But unlike a child, Miró then goes back into his work to refine its style and structure. "I start a canvas without a thought of what it may eventually become," Miró explained in an interview of 1948, ". . . then I take it out and work at it coldly like an artisan, guided strictly by rules of composition after the first shock of suggestion has cooled."[11]

Stories seem to generate many of Miró's works from the late 1920s well into the 1960s. What other modern artist used titles such as *The Tenderness of Moonlight at Dawn Crossed by a Beautiful Bird*? The deadpan recitation of calamity in *The Bird with Calm Look and Wings in Flames*, for example; the epic poetry of a title like *The Beautiful Bird Revealing the Unknown to a Pair of Lovers* (for a gouache of 1941); or the more elegiac *Flight of the Dragonfly before the Sun*, a monumental painting of 1968 [fig. 6.20], all suggest tales devised to "explain" the images as they evolved. In several works of the late 1920s and the 1930s—such as *A Bird Pursues a Snail and Kisses It* (1927) or *Snail-Woman-Flower-Star* (1933–34), for example—Miró literally inscribed the title on the surface (*Escargot-Femme-Fleur-Etoile*). Miró's extended narrative titles provide stories much like the ones told by a child in the process of drawing, always absorbed in the unfolding of the present moment.

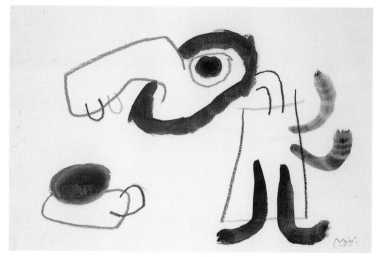

6.21
Joan Miró
The Childhood of Ubu, ca. 1970

6.22
Joan Miró
The Childhood of Ubu, ca. 1970

Miró took up ceramics and bronze casting for the first time in the 1940s (beginning in 1944) and this signaled a general shift in his art toward an increasingly sensual foundation and away from the more intellectual distance of words. In particular, the work in clay revived the artist's memories of the earliest affirmation of his adolescent art-making—the experience of drawing from touch in Galí's school. "Even today, thirty years later, the effects of this experience of drawing from touch are apparent in my interest in sculpture," he told James Johnson Sweeney in that same interview of 1948. "I have a need to mold things with my hands, to pick up a ball of damp clay like a child and to squeeze it. Ever since those days I have experienced a physical sensation [working with clay] that is provided neither by drawing nor by painting."[12] In Miró's bronzes from the 1940s through the 1970s, in works such as *Woman with Jug, Woman (The Tightrope Walker),* and *Personage* [figs. 6.17–6.19], one can immediately feel this tactile sensation.

The preeminence of the sensual process of modeling had also come to the fore in the freedom of Miró's brushwork by the 1950s in both painting and in his painted ceramics. In an interview of the 1970s he commented: "I often work with my fingers; I feel the need to dive into the physical reality of the ink, the pigment, I have to get smeared with it from head to foot."[13] Along with the kinaesthetic pleasure in the looseness of the gesture, some works, such as *The Bird with Calm Look and Wings in Flames,* have accretions of modeled plaster to heighten the expressiveness of the surface still more. By the 1970s, the artist's brushwork became almost liquid, and in all but the most ambitious (and perhaps more formal) compositions, this spontaneous style of gesturing seems to have replaced the storytelling in Miró's painting.

The extensive series of paintings on paper that Miró executed around

1970[14] on the theme of *Ubu Roi* and *The Childhood of Ubu* [figs. 6.21, 6.22]—referring to the legendarily uncouth protagonist in the proto-dada plays of Alfred Jarry—have an "innocent" freshness and immediacy of style, while nevertheless dealing with a subject that represents the most vile levels of human baseness.[15] This series may be a fitting conclusion to a consideration of Miró's interest in the art of children because, finally, child art engaged Miró only as the emblem of the child's mind which persevered in his own consciousness and continued to shape his evolving encounter with the world. Right to the end of his life Miró kept returning to childhood modes of thinking in his art, as though he were Rimbaud's "childman," examining fundamental values with the child's candor. This process, in one sense terrifying, also offers a perpetual renewal of vitality in the wonder and freshness but also in the destructive instinctuality of childhood. In the end, one comes to realize that to the age of ninety—indeed, even more so at the end—Miró assaulted the hierarchies of adult civilization with a subversive innocence.

1. The drawing by Dolorés in Kandinsky's collection accompanied a letter from Miró dated 31 July 1935, in the Archives du Fonds Kandinsky, Legs de Mme. N. Kandinsky, 1981, Musée National d'Art Moderne, Paris (83-D-77). Miró had met Kandinsky for the first time only in 1934. The drawings in the Gallatin Collection are dated February 1938; we don't know precisely when he sent them to Gallatin.
2. André Breton, *Génèse et perspective artistique du surréalisme*, 1941, reprinted in *Le Surréalisme et la peinture* (New York: Brentano, 1945), 94; cited in Robert Goldwater, *Primitivism in Modern Art*, enlarged ed. (Cambridge: Harvard University Press, 1986), 128.
3. Michel Leiris, "Joan Miró," *Documents*, no. 5 (October 1929) 264–65.
4. Joan Miró, in Dora Vallier, "Avec Miró," *Cahiers d'Art* 33–35 (1960), 174; reprinted in Dora Vallier, *L'Intérieur de l'Art* (Paris: Éditions du Seuil, 1982), 144.
5. Jacques Dupin, *Joan Miró: Life and Work* (New York: Harry N. Abrams, 1962), 10–11.
6. Joan Miró, in ibid., 43.
7. See Jacques Dupin, *Joan Miró: Life and Work*, 52.
8. Joan Miró, in ibid., 139.
9. See Miró's description of the iconography in his letter to Ràfols, in Jacques Dupin, *Joan Miró: Life and Work*, 140.
10. See Jacques Dupin, *Joan Miró: Life and Work*, 141.
11. James Johnson Sweeney, "Joan Miró: Comment and Interview," *Partisan Review* (February 1948); reprinted in Joan Miró, *Joan Miró: Selected Writings and Interviews*, ed. Margit Rowell (Boston: G. K. Hall, 1986), 207.
12. Joan Miró, in ibid., 212ff.
13. Joan Miró, in Gaëton Picon, *Joan Miró: Carnets catalans*, vol. 1 (Geneva: Albert Skira, 1976); cited in Werner Schmalenbach, "Drawings of the Late Years," in *Joan Miró: A Retrospective* (New York: Solomon R. Guggenheim Museum, 1987), 51.
14. The series published in an exhibition catalogue—*Miró: L'Enfance d'Ubu, 1953* (Paris: Galerie Marwan Hoss, 1985)—were dated to 1953 but clearly belong to the group dated ca. 1970 by the Fundació Joan Miró in Barcelona; they are on the same paper, they are the same size, and they are of the same style.
15. The artist said that Ubu represented Generalissimo Franco (see Joan Miró, "Fragment of the appendix to the 1978 Spanish edition of *Ceci est la couleur de mes rêves*, Conversations between Joan Miró and Georges Raillard," cited in *Miró: L'Enfance d'Ubu*) as well as crude people generally (see René Bernard, "Miró to *L'Express*: Violence Liberates," *L'Express* [4–10 September 1978]; reprinted in Joan Miró, *Joan Miró: Selected Writings and Interviews*, 303–5).

7. The Strategic Childhood of Jean Dubuffet

With an acrid sarcasm, the narrator in Dostoevsky's *Notes from the Underground* ridicules the notion that science could one day reduce everything to rational formulas. "It is then that the Crystal Palace will be built," he says. "The Golden Age will have dawned again. Of course it is quite impossible to guarantee (it is I who am speaking now) that even then people will not be bored to tears . . . though, on the other hand, everything will be so splendidly rational. . . ." But then, he went on,

> *I would not be at all surprised, for instance, if suddenly and without the slightest possible reason a gentleman . . . were to arise amid all that future reign of universal common sense and . . . say to us all, ". . . what about giving all this common sense a mighty kick . . . send all these logarithms to the devil so that we can again live according to our foolish will?" That wouldn't matter, either, but for the regrettable fact that he would certainly find followers.*[1]

The French artist Jean Dubuffet shared Dostoevsky's regard for the irreducibly irrational in man. His art and theory belong to an existentialist discourse on knowledge and experience that refers to Dostoevsky and to Nietzsche. In particular it was Nietzsche's critique of Occidental culture (its runaway "Socratism," as Nietzsche called it) that Dubuffet had in mind when he complained:

> *Have we lost our joy in celebration of the arbitrary and the fantastic? Is teaching ourselves all we care about? Can't we just as legitimately, at least once (why not, in certain cases, once and for all) forget about truth (it is no less mobile) and go for fickle errors and snares, zestfully assuming our function as drunken dancers?*[2]

Here Dubuffet refers to Nietzsche's duality of Apollo (harmony, reason) and Dionysus (the patron of the wine harvest and of the release from inhibition). In Dubuffet's 1945 "Rough Draft for a Popular Lecture on Painting," he described art as "a compound of intoxication and madness."[3] For him, art provided a means of knowing and of engaging life with a directness and fullness that comes only from that unfettered expression of inner forces which Nietzsche saw in the drunken revelry of the Dionysian rites.

Dubuffet aspired, through art, to "an absolutely immediate and direct projection of what is occurring in the depths of an individual."[4] For him, the entry of the powerful, irrational forces of the unconscious mind, breaking through the ice of conventional thinking, provide a fissure through which one may slip into a simultaneously exhilarating and terrifying authenticity of experience. "The real function of art," he insisted, is " . . . to change mental patterns, . . . making new thought possible."[5]

In order to achieve this liberation with its immediacy and uniqueness, Dubuffet attempted to clear away cultural conventions—which are, by definition, designed to normalize individual experience. It was in this context that he turned to the art of children when he resumed painting in 1942, and then in 1945 to what he called "art brut" ("works executed by people untouched by artistic culture,"[6] including the art of the insane).

Doubtless, Dubuffet had had a long-standing interest in "the outsider" with whom he identified (one can only speculate as to whether this also symbolized his own childhood patterns of interaction among family and peers). But clearly his friends recognized the affinity as early as 1923, when one of them gave him a copy of Hans Prinzhorn's extensively illustrated book *Bildnerei der Geisteskranken* (Artistry of the mentally ill).[7] Prinzhorn's book not only offered a stimulating collection of pictures of the art of the insane but it also examined in detail the art of normal children as a point of comparison for his study. Much has been written of the similarities between Dubuffet's later art theory and this text by Prinzhorn (although Dubuffet could not read German).[8]

It seems clear that later in his career Dubuffet did return to some of the formal ideas visible in the illustrations to Prinzhorn's book. But even if Dubuffet had passages of Prinzhorn's book translated for him, the general themes in the text that strikingly parallel Dubuffet's later work and thought probably come more broadly from the widespread fashion for "primitivism" among the scientists, intellectuals and painters, from Gauguin through the surrealists, who influenced Prinzhorn as well as Dubuffet. Nevertheless, the volume by Prinzhorn embodies a fundamentally important metamorphosis of these influences into the language of scientific discourse—a transformation that took place during Dubuffet's formative period, after World War I.

Prinzhorn used scientific observation to corroborate his intuition of the language of the irrational—essential to the writings of Dostoevsky and Nietzsche and in a new form to Dubuffet's own art theory. Under the heading "The Expressive Urge and the Schema of the Tendencies of Configuration," Prinzhorn wrote: "In contradistinction to the realm of measurable facts we therefore posit the realm of expressive facts, in which psychical elements appear directly and are apprehended equally directly, without the interposition of any intellectual

apparatus."[9] Prinzhorn also noted, in a section entitled "Eidetic Image and Configuration":

Those who are predisposed toward physiological explanations always start with the fallacy (one which is hard to overcome) that all well meaning people could agree on one conception of reality, as we might agree on the results of research . . . we cannot emphasize enough the basic psychological fact that in every "picture" the objective facts have already been actively worked on, not just in recall but as early as the process of cognition.[10]

Prinzhorn's scientific examination of subjectivity and his emphasis on the mental processes through which an individual experiences things, rather than on the things in themselves, partakes of a sea change in the intellectual currents of the period—ranging from the abandonment of causality in physics to French phenomenology—that helped to shape the central tenets of Dubuffet's nascent art theory: "What to me seems interesting," Dubuffet later noted in a collection of retrospective thoughts on his own development,

is to recover in the representation of an object the whole complex set of impressions we receive as we see it normally in everyday life, the manner in which it has touched our sensibility, and the forms it assumes in our memory. . . . I have always tried to represent any object, transcribing it in a most summary manner, hardly descriptive at all, very far removed from the actual objective measurements of things, making many people speak of children's drawings. Indeed, my persistent curiosity about children's drawings, and those of anyone who has never learned to draw, is due to my hope of finding in them a method of reinstating objects derived, not from some false position of the eyes arbitrarily focused on them, but from a whole compass of unconscious glances, of finding those involuntary traces inscribed in the memory of every ordinary human being, and the affective reactions that link each individual to the things that surround him and happen to catch his eye. . . .[11]

After graduating the *lycée* in 1918, Dubuffet moved to Paris and spent six months studying at the Académie Julien. He continued to paint seriously for the next six years, until he reached an emotional crisis in 1925 that caused him to give up painting and leave Paris for the family wine business in Le Havre. He took up his art again briefly in the mid-1930s but soon dropped it once more to maintain the business.

When Dubuffet finally leased out the business and returned to painting full-time in 1942 he was forty-one years old—too old, he thought, to begin a career as a painter.[12] At first he worked in a naive style of flat, unmodeled figures with dark outlines and an opaque application of bright colors; this style tended toward a childlike simplification, as much art of the period did [fig. 7.1]. By his

own account, Dubuffet had a decisive breakthrough in 1943 when he began to navigate pictorially not on *preconceptions* about painting—conventions of style—but on ideas generated *in the process*, making the act of painting a tool of discovery.[13] By February 1944, the fully developed confidence of Dubuffet's mature work is evident.

At just this time, Dubuffet assembled a stunningly colorful and boldly gestural inventory of works by children (for example, figs. 7.2–7.6 and 7.9–7.11) that bear a striking resemblance to his own work of the mid- and later 1940s; indeed, the children's art played a critical role in the emergence of his mature style in 1944. It is difficult to determine precisely when Dubuffet began collecting child art[14]; most of the pictures by children in his collection are undated. But of those that do bear dates, some are as early as 1939 and others were made on the clear side of datable documents of the 1940s, suggesting that most of the collection was created between 1939 and the end of the 1940s—precisely the time of Dubuffet's artistic breakthrough of 1943.

One particularly beautiful tempera color, dated 1939 [fig. 7.6], shows two figures, seen straight-on, standing on a brilliant red road (viewed from above). Flanking the road and making a large loop around a grove of trees at the top of the page is what appears to be another path, itself in the form of a tree. Dubuffet exploited the childlike conceit of showing the figures head-on while looking down on the landscape from an aerial perspective in several important works of 1943 and 1944, as in *Blissful Countryside* [fig. 7.7]. The road in *Blissful Countryside* is not so obviously centered as in the child's picture, but Dubuffet did center the road in other works in this same series, and here the slight eccentricity only accentuates the central axis of the painting. Moreover, Dubuffet's segmentation of the landscape into discrete boxes of patternation and the deliberate naïveté in his rendering of all the imagery clearly derive from child styles, if not necessarily from this particular child's work. The unique representational icons that Dubuffet created in his paintings also resemble the manner in which this child has invented such repeatable icons for the regularized field of trees at the top, the band of yellow flowers, the pattern of green shrubs on the left, and the brown trees on the right.

The small black figure in this child's gouache also recalls the figures in such works as Dubuffet's 1944 *View of Paris: Life of Pleasure* [fig. 7.8], both in the color contrast of their costumes against the red backdrop and in their general stiffness. But the character of the figures and the color intensity in Dubuffet's painting also have an affinity with the awkward frontality of the figures and the brilliant palette of other outstanding children's tempera paintings in his collection (see figs. 7.9, 7.10). The lack of perspective in *View of Paris*—the manner in which the artist has stacked the buildings, flattening them into a single plane,

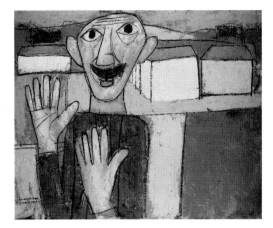

7.1
Jean Dubuffet
Peasant and His Village, February 1943

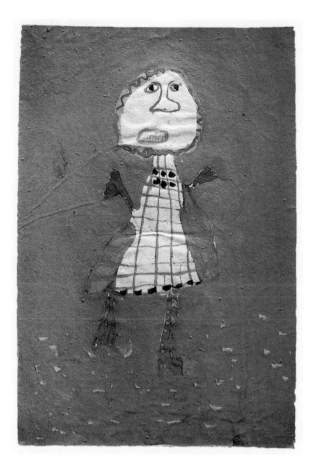

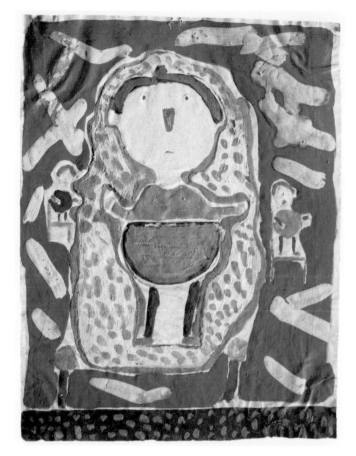

7.2–7.5
Children's drawings,
from the collection of Jean Dubuffet

7.6
Child's drawing, May 1939,
from the collection of Jean Dubuffet

7.7
Jean Dubuffet
Blissful Countryside, August 1944

7.8
Jean Dubuffet
View of Paris: Life of Pleasure, February 1944

7.9–7.11
Children's drawings,
from the collection of Jean Dubuffet

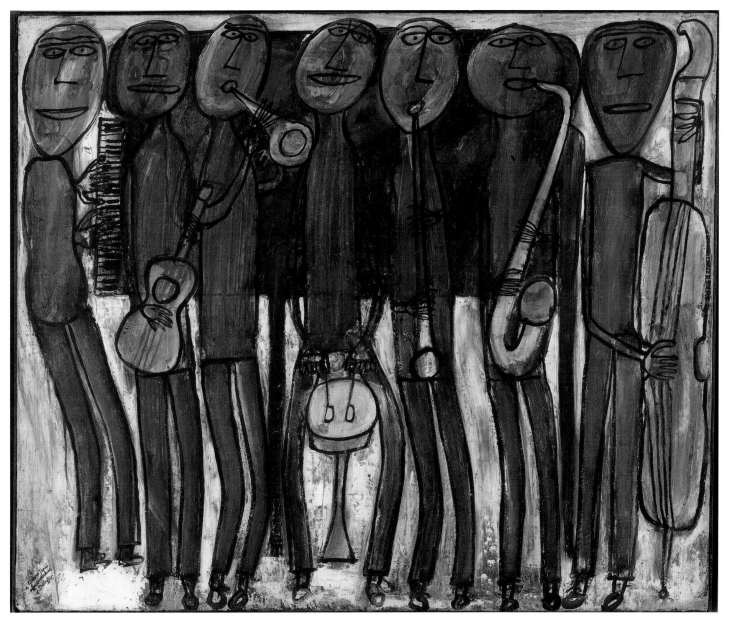

7.12
Jean Dubuffet
Jazz Band (Black Chicago),
December 1944

and lined up the figures in the foreground like duckpins, here and in *Jazz Band (Black Chicago)* of 1944, for example—recall still other conventions from his collection of compositions by children [figs. 7.9–7.12].

The technique and style of Dubuffet's work from 1944 through much of the rest of his career explicitly draw on the art of children in the deliberately crude gesture and awkward materials; at times the look of his work comes surprisingly close to something done by a child [see, for example, fig. 7.13]. In 1947, one critic even called him "the academician [*pompier*] of infantile painting,"[15] and as early as 1945 Dubuffet himself wrote of his admiration for the way children "scrawl and daub, as spontaneously as they speak."[16] Yet, despite the perennial pleasure most people take in the expressive directness of

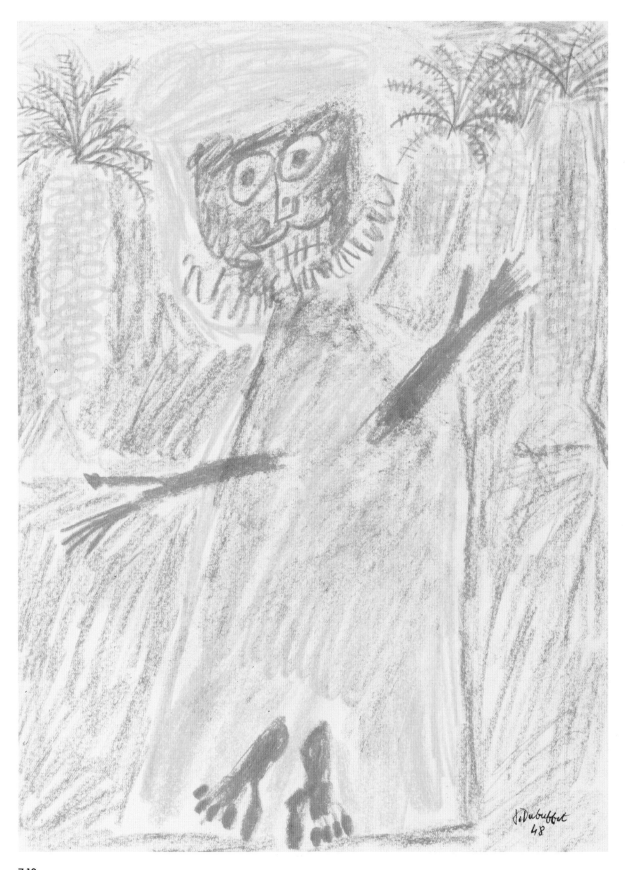

7.13
Jean Dubuffet
Arab and Palm Trees, January 1948

children's art, the public consistently responded to Dubuffet's emulation of it with outrage. "I own a portrait done by an eight-year-old," he observed in an essay of 1945. "One eye is red, the other yellow, and the cheeks are royal blue. People praise the painting for its whimsey and enchantment. But if I add a whim of my own, I am told: 'You have no right to, you're no longer a child.'"[17]

What polite society accepts in expression from a child it expects the adult to eradicate from view. In a famous lecture that Dubuffet delivered at the Arts Club of Chicago in 1951, entitled "Anti-Cultural Positions," he discussed the unacknowledged presence of this content and his wish to bring it back into conscious view: "I, personally, have a very high regard for the values of primitive peoples: instinct, passion, caprice, violence, madness. Nor do I feel that these values are in any way lacking in our western world. On the contrary! But the values celebrated by our culture do not strike me as corresponding to the true dynamics of our minds. . . . I aim at an art that is directly plugged in to our current life, that immediately emanates from our real life and our real moods."[18]

Dubuffet's assault on accepted standards in art belong to a larger repudiation of traditional values in the context of the grim reality of World War II; if these circumstances were the logical outcome of civilized thinking then, as Dubuffet's friend Michel Tapié wrote: "One needed temperaments ready to break up everything, whose works were disturbing, stupefying, full of magic and violence to reroute the public. To reroute into a real future that mass of a so-called advanced public, hardened like a sclerosis around a cubism finished long ago, (but much prolonged), a misplaced geometric abstraction, and a limited puritanism which above anything else blocks the way to any possible, authentically fertile future."[19]

The poet and draughtsman Henri Michaux, whom Dubuffet befriended in 1945, proclaimed: "I paint to decondition myself."[20] Dubuffet dedicated his book *Asphyxiating Culture*[21] to his own "de-culturation," and elsewhere he announced: "Creative invention has surely no greater enemy than social order, with all the appeals to adapt, to conform, to mimic, which social relationships imply."[22] For him, art was not an object to be measured against prescribed standards—thereby confirming the hierarchies of established values—but rather a vehicle of experimental thought and discovery. He wrote:

> *Think particularly about the arts that have no name—fortunately until now they have had no name, people haven't quite come to realize that they are arts, oweing to which ignorance they blossom and abound freely: the art of speaking, the art of walking, the art of blowing cigarette-smoke gracefully or in an off-hand manner. The art of seduction. The art of dancing the waltz, the art of roasting a chicken. The art of giving. The art of receiving.*[23]

In this he anticipated the pronouncement of Joseph Beuys that any act could be a work of art if consciously conceived.[24]

Instead of seeking objects that conform to "elevated" standards of beauty, "if we came to realize," Dubuffet said, "that any object in the world may fascinate and illuminate someone, we would be in much better shape. This idea would, I think, enrich our lives more than the Greek notion of beauty. . . . Art addresses the mind and not the eyes. That is how it has always been regarded by 'primitive' societies; and they are correct. Art is a language, an instrument of cognition and communication."[25]

Dubuffet looked to child art for fresh ways of seeing the everyday things around him. The simply inscribed, irregular circles used to render the outline of the head, the eyes and the mouth of Dubuffet's *Small Sneerer* of March 1944 [fig. 7.14] capture the savagery that a child sees in what seems ordinary in the adult world. Dubuffet's treatment of the background in a grid of flat patterns and his incorporation of the arms into the torso explore the work of ordering that takes place in the child's mind.

Among the children's paintings collected by Dubuffet in the 1940s is a magnificent group of heads of uniform size in tempera paint, presumably done by a class of schoolchildren [figs. 7.15–7.26]. The intensity of color and contrasting (but exceedingly simple) pattern in these heads is stunning. Even more startling is how close in spirit they come to Dubuffet's own work. Any number of his most striking heads from 1944 through the early 1960s [figs. 7.40, 7.41] have affinities of various kinds with this group of children's paintings, even though these precise works may not necessarily have provided the specific source for any particular one of Dubuffet's paintings.

The singular suite of 150 portraits that Dubuffet executed between August 1946 and August 1947 also shows a number of devices derived from child art. These portraits were made in preparation for the artist's August-October 1947 exhibition at the Galerie René Drouin in Paris, entitled *Portraits: These People Are Handsomer Than They Think, Long Live Their True Faces*.[26] The subjects were all associates of Jean Paulhan, the editor of the important prewar literary journal *La Nouvelle revue française*.[27] Paulhan met Dubuffet in 1943 and began introducing him into his circle of brilliant literary friends.

In 1945 Dubuffet made several portraits of Paulhan; in the one illustrated here [fig. 7.27] he outlined the head and shoulders with the simplicity of a cut-out in front of the monochrome ground; as in a child's drawing, it lacks any modeling and has a highly schematic description of the features. Several of the portraits of 1946 and 1947 also have enlarged heads, tiny sticklike arms projecting out of the figures and, in some, a highly tactile surface (as in *Francis Ponge* [fig. 7.28]) that makes them distinctly childlike in still other ways.

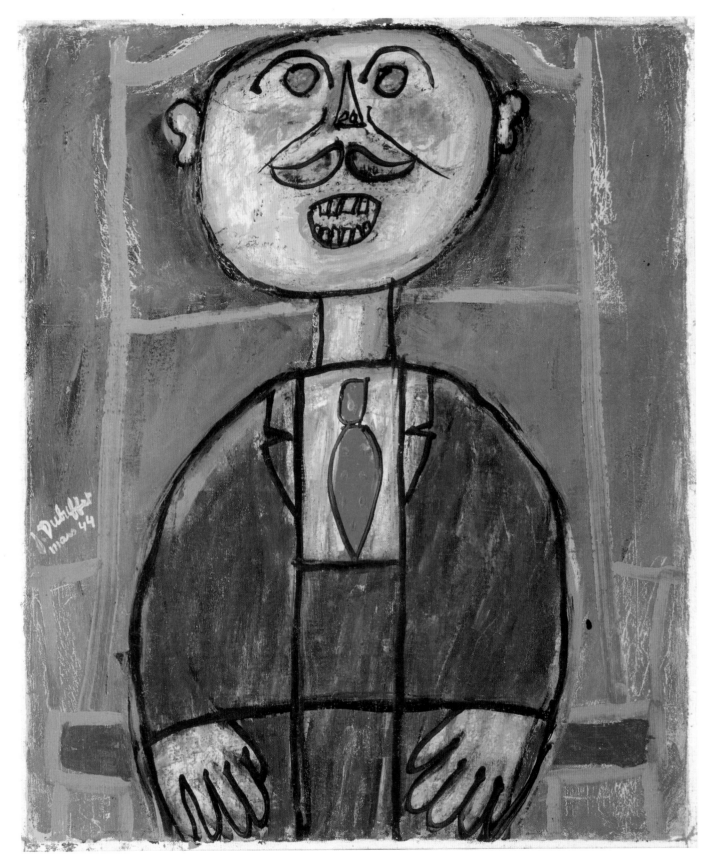

7.14
Jean Dubuffet
Small Sneerer, March 1944

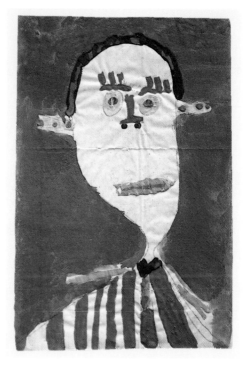

7.15–7.20
Children's drawings,
from the collection of Jean Dubuffet

7.21–7.26
Children's drawings,
from the collection of Jean Dubuffet

7.27
Jean Dubuffet
Portait of Jean Paulhan, July 1945

7.28
Jean Dubuffet
Francis Ponge, June 1947

Obviously, none of these portraits aim at a likeness and the artist has said that "those who have spoken about my portraits as an undertaking aimed at psychological penetration have understood nothing at all, the portraits were anti-psychological, anti-individualistic."[28] Yet Dubuffet does capture psychological traits and individualizing details in them: Léautaud's characteristic scowl (Michel Ragon describes him as "not much given to humor"),[29] Jouhandeau's harelip, the intellectual intensity of Tapié with his close-set eyes and dark eyebrows, and the frailness of Bousquet (a poet who had been partially paralyzed in World War I). But rather than observing his subject (portraying its psychology or appearance) Dubuffet has succeeded in recovering "the manner in which it has touched our sensibility, and the forms it assumes in our memory."

The *Portrait of Henri Michaux;* the series of paintings of *The Dentist; Joë Bousquet in Bed* [figs. 7.29, 7.30]; and several other works from the fall and winter of 1946–47 appear to have been scratched through a dark surface to a white ground, as in the familiar scratchboards given to kindergartners. In this, the influence of the artist's collection of children's art seems quite direct. The *Portrait of Henri Michaux actually is* produced on a commercially manufactured scratchboard; in the drawing of *Joë Bousquet in Bed,* Dubuffet achieved the same

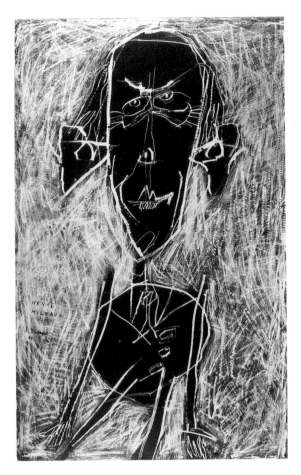

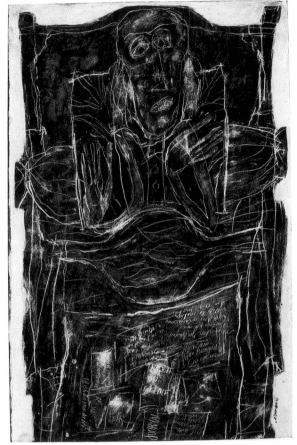

7.29
Jean Dubuffet
Portrait of Henri Michaux, November 1946

7.30
Jean Dubuffet
Joë Bousquet in Bed (from the portrait series
More Beautiful Than They Think), January 1947

7.31
Child's drawing on black scratchboard,
from a portfolio of scratchboard drawings
formerly in the collection of Jean Dubuffet

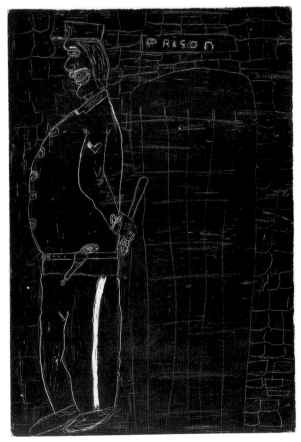

effect by incising through a layer of gouache and ink to a white gesso ground. At this time, Dubuffet possessed a portfolio of black on white-ground scratch- boards done by children, such as the one showing a policeman with a night- stick behind his back, inscribed "prison" [fig. 7.31], that may have directly spawned Dubuffet's scratchboard (or scratchboardlike) paintings.

Dubuffet structured his painting *Villas and Gardens* of 1957 [fig. 7.32] on children's spatial concepts. In a child's poster painting from Dubuffet's collec- tion [fig. 7.33], the child not only simultaneously showed the cars from the side and the road from above, but he or she also placed trees, buildings and, in one case, even an inscription as though gravitationally oriented to a hypothetical traveler on the nearest point on the road *in the painting*. Dubuffet does the same in *Villas and Gardens*, with figures and objects at oblique angles to the bottom of the canvas.

The characteristically self-contained manner in which the artist described the shape of the three-dimensional objects like the houses in *Villas and Gardens*— without regard to their surroundings—and the projection of the artist into the action of the painting in this way are both characteristic of children's drawings, too. Up, down, right and left, which depend on a detached observer's angle of vision, are irrelevant; instead of a comprehensive point of view from outside the picture, children often orient images as though they are inside the picture at the point nearest to the unfolding event, as Dubuffet has done here.

Dubuffet also extrapolated on this involved point of observation in children's drawings for his art theory; in a review of 1966, he wrote, "Mental space does not resemble three-dimensional optical space and has no use for notions such as above and below, in front or behind, close or distant. It presents itself as flowing water, whirling, meandering and therefore its transcription requires entirely different devices from those deemed appropriate for transcribing the observable world."[30] This idea also has important implications for Dubuffet's metaphysics; in another passage he wrote:

> *At this point, we are quite easily led to expand our idea of what is embraced by the term being—although not without a slight hesitation—to certain elements, no longer isolated and with well-defined contours, like . . . the wave in the ocean, the whirlpool in the river, beings of rapid evolution, rapid transformation and disappearance—certainly more rapid than those of the tuft of grass or the human being.*[31]

Dubuffet executed a number of works in the 1950s in which any defined image (and most important, the human form) tends toward dissolution into the chaos of pattern and of the materials of the composition—his *Terres radieuses* series, the *Lieux momentanes*, and the *Pâtes battues* of the early 1950s through the successive series of *Assemblages d'empreintes*, the *Topographies*, and *Tex-*

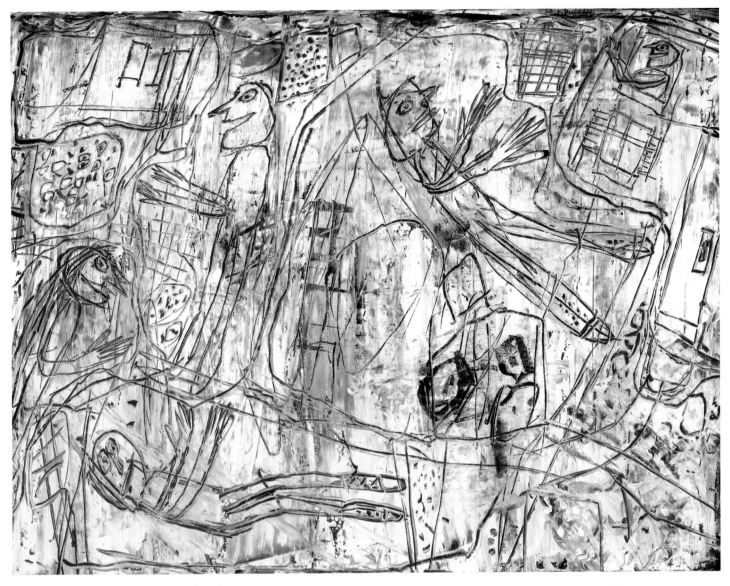

7.32
Jean Dubuffet
Villas and Gardens, 1957

7.33
Child's drawing,
from the collection of Jean Dubuffet

7.34
Jean Dubuffet
Affluence, 22–23 March 1961

7.35
Parisian schoolchildren,
class of Mme. Vigé
and M. Lombard
The Cinema, ca. 1950

7.36
Jean Dubuffet
Cookie Tin Break, 7 June 1962

7.37
Jean Dubuffet
Sighting (Kowloon), 6 April 1983

7.38
Jean Dubuffet
Landscape with Dog, 1958

7.39
Child's collage (Annie Chaissac)
Untitled

turologies at the end of the decade. *Landscape with Dog* of 1958 [fig. 7.38] has one of the more clearly differentiated central images of the *Assemblages d'empreintes* but this also makes more visible its inspiration for its method of construction in children's works from the artist's collection—as in the paper collage by Annie Chaissac from around 1950 [fig. 7.39].[32]

In this child's collage, the scraps of paper are so large and their representational function so crude that the identity of the materials almost becomes more prominent than the represented subject and begins to submerge it. In a number of the *Assemblage d'empreinte* series (and in other paintings of the period), Dubuffet dissolved the subject in this way. A similar effect occurs in the 1940s paintings of Dubuffet's contemporary Jean Fautrier, where the texture takes over as more real and immediate than the subject matter. Much of the tension in Dubuffet's work of the 1950s depends precisely on this tug-of-war between the subject matter of the painting and the *physical* matter of which it is constructed. The artist developed, as he said, a taste "for the little, the almost nothing, and, especially . . . for the landscapes where one finds only the formless—flats without end, scattered stones—every element definitely outlined such as trees, roads, houses, etc., eliminated."[33]

Increasingly in his painting of the 1950s, Dubuffet rendered the chaos of the unconscious mind in terms of the disorder of details seen in a concentrated focus on undistinguished matter. But he was after something more immediate than metaphor. "Painting operates through signs which are not abstract and incorporeal like words," he said. "The signs of painting are much closer to the objects themselves. Further, painting manipulates materials which are themselves living substances. That is why painting allows one to go much further than words do in approaching things and conjuring them . . . painting is a much more immediate and much more direct way than the language of words, much closer to the cry or to the dance."[34] Indeed for Dubuffet, painting became a body experience—as writing did for Roland Barthes who, as early as 1953, spoke of the "biological," preverbal roots of style in writing where "flesh and external reality come together."[35]

Around 1960 Dubuffet painted a series in which the subject became the undifferentiated field of texture itself. Then in 1961 a new color and energy suddenly entered his work. He began to look at the frenetic activity of the urban environment as another kind of disintegrating chaos—personages closed in boxlike cars and crushed in traffic, and the crowded visual environment of the storefronts and pedestrians. Here, too, the eye of the child provided a source to which the artist turned for an uninhibited encounter with his subject. In the carpet of faces in *Affluence* of 1961 [fig. 7.34] the people lose all distinctness in their abundance; a composition in Dubuffet's collection by an anonymous

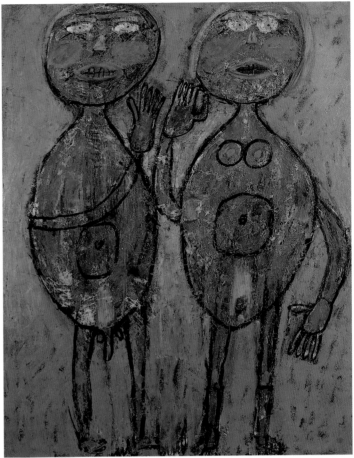

group of Parisian schoolchildren provided an obvious source [fig. 7.35].[36] In works like *Cookie Tin Break* of 1962 [fig. 7.36] the people become frail little scratches on the surface of a patchwork of colors so intense that they virtually drown one another out.

Dubuffet began his *hourloupe* paintings in the summer of 1962, referring to the style as a "constantly uniform line, applied to all things (and I insist, not only to the things we see but also to those which have no concrete being . . .) [which] reduces them to a common denominator and restores to us a continuous undifferentiated universe."[37] The *hourloupe* style of interlocking puzzle pieces in primary colors culminated in total environments like the *Cabinet logologique* of 1967–69, which the artist described as "*a creation of the mind fit to be physically inhabited.* . . . It is as though a fish were to start producing the water in which it lives and in which it finds its food: its own bodily secretion would thus turn into a proper habitat as well as into a steady source of nourishment. . . ."[38]

Dubuffet disintegrated objects with his *hourloupe* script and then he unhinged space itself in the paintings of the late 1970s and early 1980s, ending his career with an almost purely gestural style [fig. 7.37]. In the *Idéoplasmes* of

1984, the artist's last series, the idea is not a sign, as in an "ideograph," but something that floats as though in the biological plasma itself. Armande de Trentinian, who worked closely with the artist at the end of his career, observed that Dubuffet's last drawing is like a fetus, a return through childhood to conception.[39]

For Dubuffet, child art involved more than a lexicon of the formal devices he borrowed from it. He saw in the paintings of children an unself-conscious expression of the "primitive values" that culture pushes out of sight and an openness to seeing all things—anything—without an imposed hierarchy of values. The freshness of the child's encounter with the world, as embodied in Dubuffet's collection of child art, gave Dubuffet a new perspective on otherwise "ordinary" events. That is because in the free "mental space" of the child's mind "the affective reactions that link each individual to the things that surround him" are more accessible. In that glimpse provided by the art of children into "the true dynamics of our minds" Dubuffet discovered a primal unity.

1. Fyodor Dostoevsky, "Notes from the Underground," in *The Best Short Stories of Dostoevsky*, trans. David Magarshack (New York: Modern Library, Random House, 1955), 130–31.
2. Jean Dubuffet, preface, *l'hourloupe*, exh. cat. (Paris: Galerie Jean Bucher, 1964); in Mildred Glimcher, *Jean Dubuffet: Towards an Alternative Reality* (New York: Abbeville Press, 1987), 211.
3. Jean Dubuffet, "Rough Draft for a Popular Lecture on Painting," 1945, trans. Joachim Neugroschel, in Mildred Glimcher, *Jean Dubuffet: Towards an Alternative Reality*, 48.
4. Jean Dubuffet, "Honneur aux valeurs sauvages," lecture to the faculty of Letters at Lille, 10 January 1951; cited in John M. MacGregor, *The Discovery of the Art of the Insane* (Princeton, N.J.: Princeton University Press, 1989), 298.
5. Jean Dubuffet, in Michael Peppiatt, "The Warring Complexities of Jean Dubuffet," *Art News* 76, no. 5 (May 1977), 60.
6. Jean Dubuffet, "L'Art Brut préféré aux arts culturels," October 1949; in Jean Dubuffet, *Prospectus et tous écrits suivants*, vol. I (Paris: Gallimard, 1967), 201–2; cited in (and translated by) Michel Thevos, *Art Brut* (New York: Rizzoli, 1976), 9.
7. According to Peter Selz, *The Work of Jean Dubuffet* (New York: Museum of Modern Art, 1962), 19. This date is also noted in Margit Rowell, *Jean Dubuffet: A Retrospective* (New York: Solomon R. Guggenheim Foundation, 1973), 17; and John M. MacGregor, *The Discovery of the Art of the Insane*, 358 n. 3.
8. See John M. MacGregor, *The Discovery of the Art of the Insane*, 292.
9. Hans Prinzhorn, *Bildnerei der Geisteskranken* (1923; new edition, Heidelberg: Springer-Verlag, 1972), 17; in English: *Artistry of the Mentally Ill*, trans. Eric von Brockdorff (New York: Springer-Verlag, 1972), 13.
10. Ibid., 29.
11. Jean Dubuffet, "Mémoire sur le développement des mes travaux à partir de 1952," 1957, in Jean Dubuffet, *Prospectus et tous écrits suivants*, vol. II, 103–4; reprinted as "Memoir on the Development of My Work from 1952," trans. Louise Varèse, in Peter Selz, *The Work of Jean Dubuffet*, 97, 102.
12. According to Mildred Glimcher, *Jean Dubuffet: Towards an Alternative Reality*, 4.
13. See Jean Dubuffet, *Questionnaire à batons rompus*, quoted in Thomas M. Messer and Fred Licht, *Jean Dubuffet & Art Brut*, exh. cat. (Venice: Peggy Guggenheim Collection and Arnoldo Mondadori Editore, 1986), 10.
14. James Demetrion speculates it may have been stimulated by an exhibition of child art held in Paris in 1942. See James T. Demetrion, *Jean Dubuffet 1943–1963*, exh. cat. (Washington: Hirshhorn Museum and Sculpture Garden, 1993), 44.

15. Georges Pillement, "Les Arts," *Les Lettres françaises* (16 October 1947), 4.

16. Jean Dubuffet, "Rough Draft for a Popular Lecture on Painting," 1945, trans. Joachim Neugroschel, in Mildred Glimcher, *Jean Dubuffet: Towards an Alternative Reality*, 53.

17. Jean Dubuffet, "Notes pour les fins-lettrés," in Jean Dubuffet, *Prospectus et tous écrits suivants*, vol. I, 75–76; this translation comes from Jean Dubuffet, "Notes for the Well-Read," 1945, trans. Joachim Neugroschel, in Mildred Glimcher, *Jean Dubuffet: Towards an Alternative Reality*, 79–80.

18. Jean Dubuffet, *Anti-Cultural Positions*, originally delivered as a lecture in English at the Arts Club of Chicago, 20 December 1951; this version adapted from Dubuffet's French text by Joachim Neugroschel in Mildred Glimcher, *Jean Dubuffet: Towards an Alternative Reality*, 127.

19. Michel Tapié, "Espaces et Expressions," in *Premier bilan de l'art actuel, Le Soleil Noir, Positions*, nos. 3 and 4 (1953), 102; cited in Germain Viatte, "Aftermath, A New Generation," in Germain Viatte, *Aftermath: France 1945–54, New Images of Man*, exh. cat. (London: Barbican Art Gallery, 1982) 13.

20. Henri Michaux, in Peter Broome, *Henri Michaux* (London, 1977), 128; "Né, élevé, instruit dans un milieu et une culture uniquement du 'verbal' . . . je peins *pour me déconditionner*."

21. Jean Dubuffet, *Asphyxiating Culture and Other Writings*, trans. Carol Volk (New York: Four Walls Eight Windows, 1988).

22. Jean Dubuffet, "Les Publications De L'Art Brut: Simone Marye," in Jean Dubuffet, *Prospectus et tous écrits suivants*, vol. I, 368; translated in Margit Rowell, *Jean Dubuffet: A Retrospective*, 22.

23. Jean Dubuffet, "Rough Draft for a Popular Lecture on Painting," 1945, in Mildred Glimcher, *Jean Dubuffet: Towards an Alternative Reality*, 46.

24. See Jonathan Fineberg, *Art Since 1940: Strategies of Being* (London: Laurence King, 1994; Englewood Cliffs, N.J.: Prentice-Hall; New York: Harry N. Abrams, 1995), 233–34.

25. Jean Dubuffet, *Anti-Cultural Positions*; this version adapted from Dubuffet's French text by Joachim Neugroschel in Mildred Glimcher, *Jean Dubuffet: Towards an Alternative Reality*, 131.

26. There is a facsimile of the catalogue in Max Loreau, *Catalogue des travaux de Jean Dubuffet*, vol. III, *Plus beaux qu'ils croient (portraits)*, 38 vols. (Paris: Jean-Jacques Pauvert, 1964–68; Lausanne: Weber, 1969–76; Paris: Les Éditions de Minuit, 1979–91), 13–16.

27. See Susan J. Cooke, "Jean Dubuffet's Caricature Portraits," in James T. Demetrion, *Jean Dubuffet 1943–1963*, 20–33.

28. Jean Dubuffet, "Note," entitled "Portraits," in Jean Dubuffet, *Prospectus et tous écrits suivants*, vol. II, 429.

29. Michel Ragon, *Dubuffet*, trans. Haakon Chevalier (New York: Grove Press, 1959), 24.

30. Jean Dubuffet, "Pièces d'arbres historiées de Bogosav Živković," 1966, in *Prospectus et tous écrits suivants*, vol. I, 448.

31. Jean Dubuffet, "Empreintes," in *Les Lettres Nouvelles*, vol. 48 (Paris, 1957), 507–27; trans. Lucy R. Lippard, in Herschel B. Chipp, *Theories of Modern Art* (Berkeley and Los Angeles: University of California Press, 1968), 614.

32. Annie was the daughter of the painter Gaston Chaissac, whose friendship with Dubuffet began in 1945. This work probably dates from around 1950 based on its style in relation to her age; she was born in 1943.

33. Jean Dubuffet, "Landscaped Tables, Landscapes of the Mind, Stones of Philosophy," catalogue introduction, trans. Dubuffet and Marcel Duchamp, Pierre Matisse Gallery, New York, 1952; cited in Peter Selz, *The Work of Jean Dubuffet*, 68.

34. Jean Dubuffet, *Anti-Cultural Positions*; this reference is from the text as republished in Jean Dubuffet, "Anticultural Positions," *Arts Magazine* (April 1979), 157.

35. Roland Barthes, *L'obvie et l'obtus* (Paris: Editions du Seuil, Collection "Tel Quel," 1982), 17.

36. This was pointed out to me by Michel Thévoz.

37. Jean Dubuffet, letter to Arnold Glimcher, 15 September 1969, in Mildred Glimcher, *Jean Dubuffet: Towards an Alternative Reality*, 223.

38. Jean Dubuffet, notes for an exhibition catalogue, 1978, trans. Joachim Neugroschel, in Mildred Glimcher, *Jean Dubuffet: Towards an Alternative Reality*, 249–50.

39. Armande de Trentinian, Dubuffet's assistant and friend, in a conversation with the author, 31 May 1991.

8. Cobra and "The Child Inside Oneself"

COBRA, an acronym from the first letters of Copenhagen, Brussels and Amsterdam, came together as an art movement at the end of 1948, creating a brief liaison of artists from these three capitals. The most well-known artists in the group were Asger Jorn and Carl Henning-Pedersen from Denmark; Karel Appel, Constant and Corneille from Amsterdam; and Pierre Alechinsky from Brussels. Over the three years of its existence, Cobra produced ten issues of an eponymous journal (largely under the direction of the Belgian poet Christian Dotremont), published small monographs and broadsides and organized several exhibitions. Among some subgroups of the Cobra artists an involved—at times almost familial—exchange took place.

The unifying characteristic of the Cobra artists was their desire for a liberated expression of the self in a direct, sensual interaction with the world (symbolized by the physicality of their paint handling and assemblage materials). "We find the real source of art only in matter," some of the Dutch Cobra wrote in the second issue of *Cobra* magazine. "We are painters and materialism is for us the sensation of the world."[1] This tendency toward a visceral expressionism and the Cobra artists' general rebellion against the strictures of convention were in part a reaction against the grim years of war and German occupation. "Cobra appeared because it was urgent, necessary," Corneille later remarked.[2]

On the masthead of their journal, the Cobra described themselves as "a flexible bond of experimental groups." The most established of these groups dated back fifteen years to the founding of the Danish journal *Linien* in 1933 by Vilhelm Bjerke-Petersen (a former Kandinsky student) and Eiler Bille. Bjerke-Petersen veered off into surrealism around 1937, but by this time the circle around *Linien* had grown to include Richard Mortensen, Henry Heerup, Egill Jacobsen, Carl Henning-Pedersen and Asger Jørgensen (who changed his surname to Jorn in 1945). *Linien* disappeared in 1939, to be replaced by the "Høst" group and the journal *Helhesten*, which Jorn spearheaded in 1941.

After the war, the Dutch Experimental Group evolved around the magazine *Reflex*, founded in 1948 (only months before Cobra) by Constant, Corneille and

Appel. This Dutch group, which was then absorbed into Cobra, included not only the three founders of the journal but also several others, notably Anton Rooskens, Theo Wolvecamp and Eugène Brands. Christian Dotremont formed *Le Bureau International du Surréalisme Révolutionaire* in Brussels in 1947 and was joined in 1949 by the young painter Pierre Alechinsky, constituting the core of Belgian Cobra.

Surrealism had a formative influence on all of the Cobra artists. In particular, it directed their attention to the forces of the unconscious mind. As the veteran surrealist Max Ernst wrote in the March 1949 issue of *Cobra* magazine: "Thanks to automatic writing, to collage, to frottage, and to all the processes which favor automatism and irrational knowledge the surrealists have touched the depths of that invisible and marvelous universe 'the subconscious,' and have described it in all its reality."[3]

The Cobra, however, rejected André Breton's idealistic call for a "pure psychic automatism," as proposed in the *First Manifesto of Surrealism*. According to Asger Jorn, Breton's formulation represented "an insoluble contradiction. One cannot express himself in a purely psychic way. The mere act of expression is physical."[4] Furthermore, the Cobra did not want to exclude from their subject matter the vitality of quotidian experience. "We do not wish to separate beauty and life . . . ," Appel, Constant and Corneille insisted in a joint statement for the first issue of *Cobra* in 1948.[5]

Instead of a "pure psychic automatism," the Cobra aspired to an unrestrained and "impure" encounter with reality, marshaling the irrational forces of the unconscious to engage the variety of life more fully. Like their French contemporary Jean Dubuffet, the call of the Cobra artists for "spontaneity" recognized the complete range of experience—conscious and unconscious—that impinges on the processes of the mind. In particular, they saw imagination as a mechanism that "unforms" the images supplied by perception, an idea they took from psychoanalysis and phenomenology.

This intervention of imagination in the apprehension of events also had an explicit political implication to some of the Cobra artists, as explained by Constant in a manifesto he contributed to the first issue of *Reflex* in 1948. "The general social impotence, the passivity of the masses," he wrote, "are an indication of the brakes that cultural norms apply to the natural expression of the forces of life. . . . Art recognizes only the norms of expressivity, spontaneously directed by its own intuition."[6]

According to Constant, this expression of unconscious or internal norms undermines externally imposed conventions and thereby liberates the individual from conventional thinking. Thus for Constant, "the role of the creative artist can only be that of the revolutionary . . . arousing the creative instincts still

8.1
Cobra 4 (November 1949)
Page 7, illustrating Karel Appel,
Wooden Cat, and a child's drawing

8.2

Cobra 4 (November 1949)
Page 11 and facing page, illustrating
Constant, *Freedom Belongs to Us*,
and children's drawings

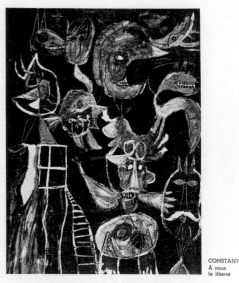

8.3

Cobra 4 (November 1949)
Page 19 and facing page, illustrating
Corneille, *The Happy Rhythms of
the City*, and children's drawings

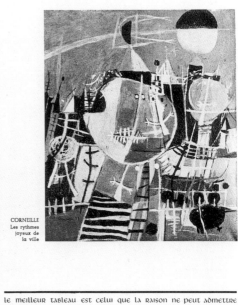

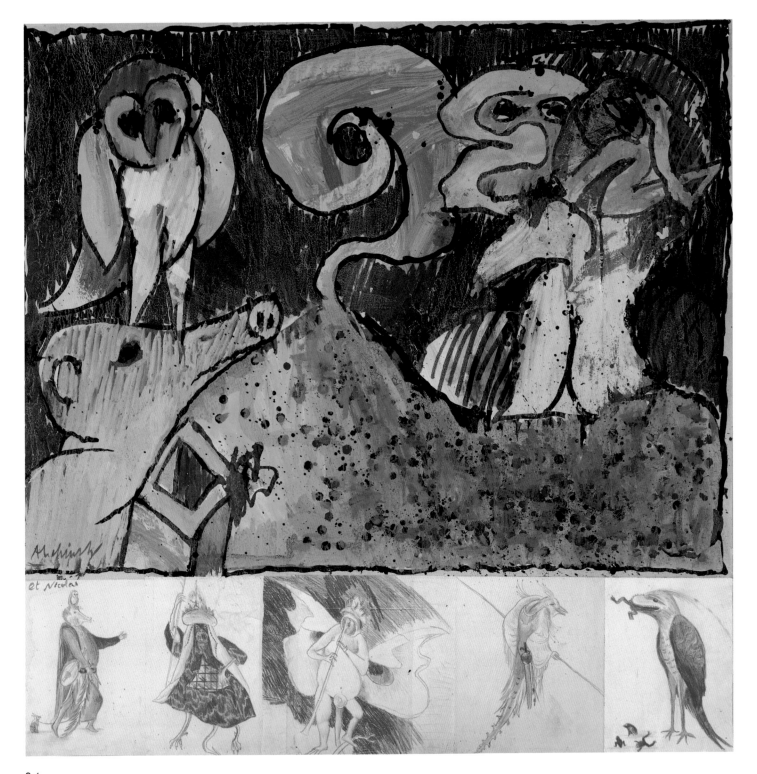

8.4
Pierre Alechinsky (with Nicolas, age 11)
Post Hieronymous, 1969

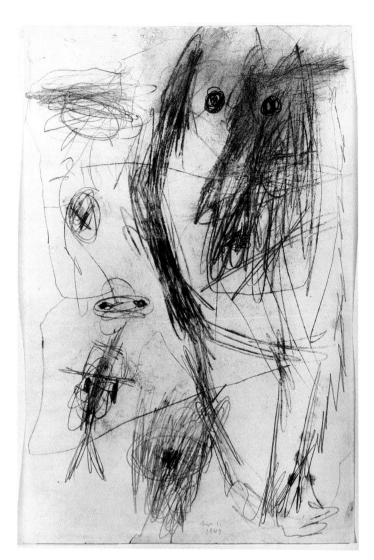

ASGER JORN

STRUCTURE

ET

CHANGEMENT

8.5
Asger Jorn
Untitled, 1943

8.6
Asger Jorn
Cover for the pamphlet "Structure et
Changement," Paris, 1956

slumbering unconscious in the human mind. The masses, brought up with aesthetic conventions imposed from without, are as yet unaware of their creative potential." This wish to make everyone an artist, and thereby individual in defiance of norms of experience, is a recurrent theme in the northern romantic tradition from Novalis to Joseph Beuys. "We see the activation of the urge to create," Constant wrote, "as art's most important task."[7]

In order to achieve this active involvement on the part of the viewer, Constant argued that the artist must engage the viewer in the task of finding and describing the meaning; the artist must present the expressive content with maximum vividness while deliberately not defining its form with too much precision. The kind of openness to experience that this implies naturally attracted the Cobra artists to the art of children, where the unconscious was so much more unmodified and accessible than in the work of the professional artist. Constant observed that in the art "of the untrained, the greatest possible latitude is given

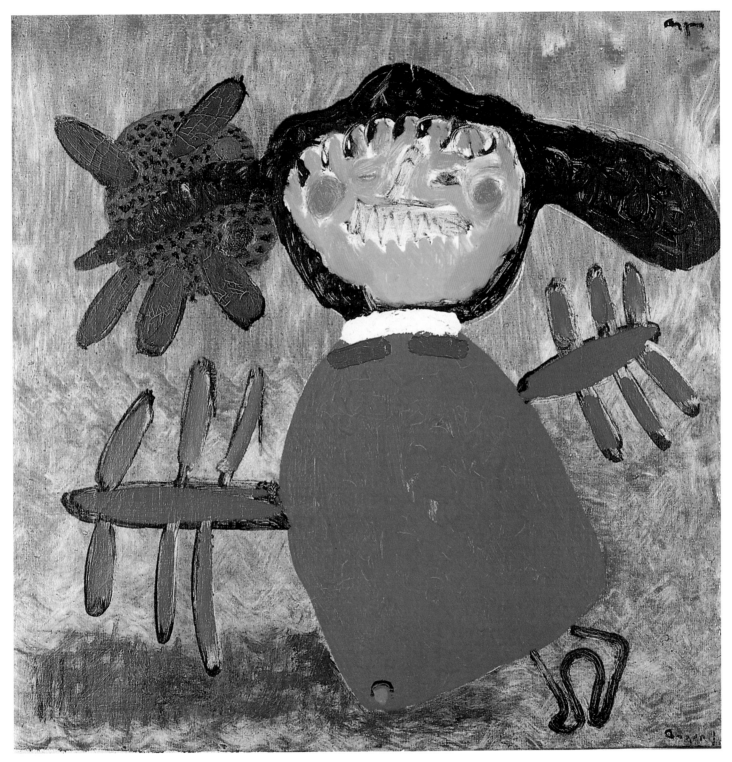

8.7
Asger Jorn
Untitled, 1939

8.8
Asger Jorn
Child's Play, 1960

to the unconscious." Indeed, he insisted that "the child knows of no law other than its spontaneous sensation of life, and feels no need to express anything else."[8]

The Cobra artists sought an unrestrained, organic expressiveness in paint handling and an imagery defined in the individual imagination such as they found in the imaginative play of children. "We wanted to start again like a child," Karel Appel remarked.[9] So, unlike the sober act of existential self-actualization in contemporary abstract expressionism or the morbid metaphysics of Jean Dubuffet, the work of the Cobra artists was effusively optimistic. "No good picture without great pleasure," Corneille insisted.[10]

In December 1948, Willem Sandberg, director of the Stedelijk Museum in Amsterdam, brought to the museum an exhibition of children's drawings called *Kunst en kind* (Art and the child) that profoundly impressed the Cobra group. This may have encouraged the artists to include a number of children's drawings in *Cobra* number 4, which served as the catalogue for the large Cobra anniversary exhibition at the Stedelijk in November 1949. Corneille edited this issue in Amsterdam (generally *Cobra* was edited by Dotremont in Brussels) and in it he set up several deliberate juxtapositions of children's drawings with works by himself, Appel and Constant [figs. 8.1–8.3]. The admiration of the Cobra for the freshness of the child's vision even led to a number of direct collaborations between these artists and their children, as in the famous murals they painted on the walls and ceilings of the house they shared for a month in the summer of 1949 in Bregneröd, just outside of Copenhagen, and in individual works such as Jorn's *Child's Play* (1960) and Alechinsky's *Post Hieronymous* (1969) [figs. 8.4, 8.8].

The Danish group had long seen child art as a paradigm for the contemporary artist. Eiler Bille had written in *Helhesten* in 1942 that: "Whilst the tiniest child still possesses the life rhythms which produce art, this is no longer the case with adults. Only a handful manage to keep in contact with their childhood years and keep their development going, running against the tide of social convention."[11] The preceding year, Jens Sigsgaard had contributed an article to *Helhesten* on child art, reproducing a number of works by children (many of which Jorn acquired and kept until his death).[12] Sigsgaard characterized children's drawings as having their own powerful grasp on reality,[13] which is precisely the aspect of child art that most attracted the Cobra.

In 1937, Jorn had been employed by Le Corbusier to enlarge two drawings by a twelve-year-old into 50-square-meter frescoes for the Pavillon des Temps Nouveaux at the Exposition Universelle in Paris [fig. 1.16]. We don't know if the idea was Jorn's or Le Corbusier's, but from Jorn's earliest mature works the influence of child art is evident, as in the two-foot square *Untitled* painting of

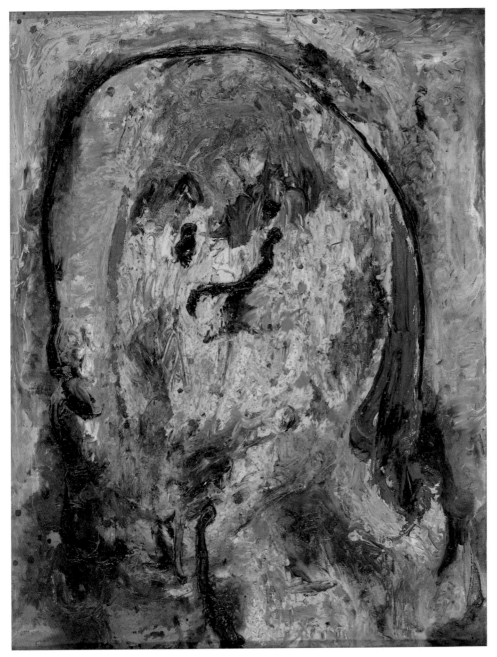

1939 [fig. 8.7], sometimes referred to as "Pige." Graham Birtwistle is certainly correct that Jorn did not single out children's drawings in his theories of the 1940s on "natural" art any more than he did non-Western, prehistoric and folk arts,[14] even though in several works of the early 1940s Jorn displayed a more childlike freedom of gesture and form [see fig. 8.5].

By 1949, however, a significant loosening up emerged in Jorn's style in a fashion that seems specifically informed by the art of children. The paintings of 1956–59 and 1970–72, which Guy Atkins singled out as the best of Jorn's career,[15] are also the works most clearly and consistently influenced by the freedom of image and gesture in children's paintings, though it is evident in many

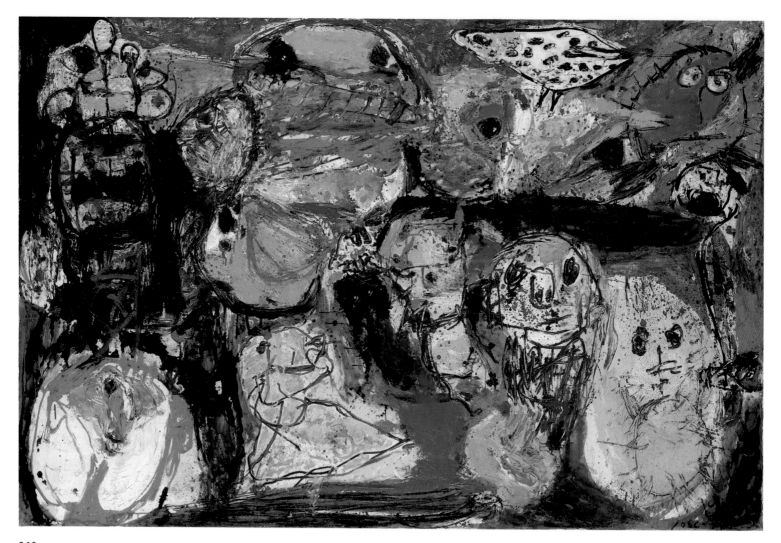

8.10
Asger Jorn
Letter to My Son, 1956–57

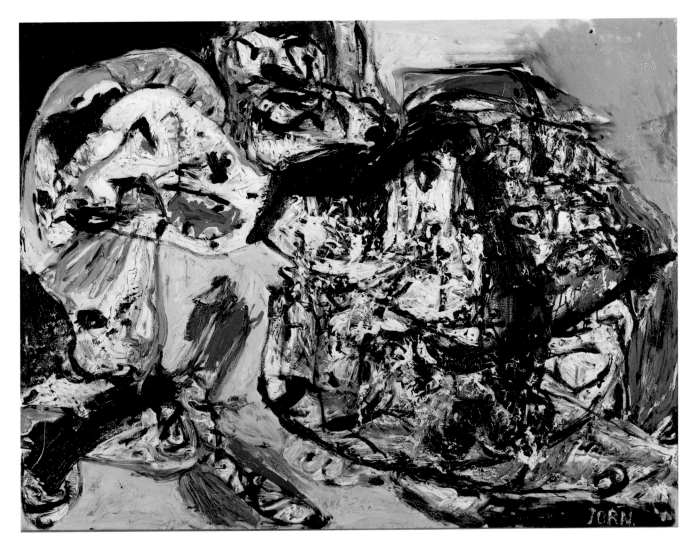

8.11
Asger Jorn
The Hanging, 1958

8.12
Asger Jorn
Wall Flowers, 1958

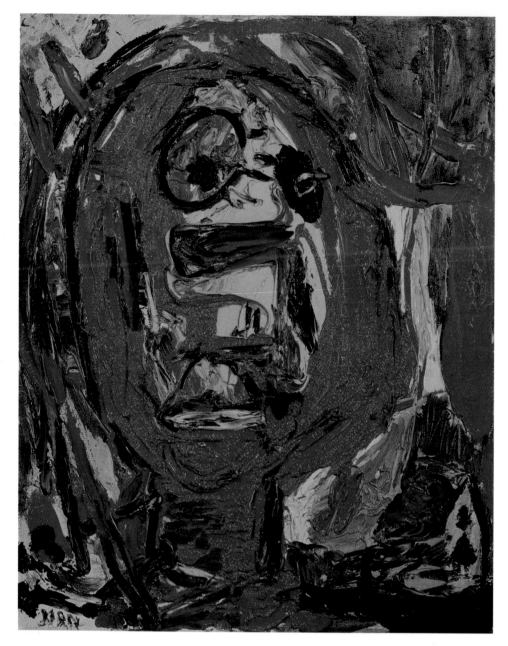

works of the 1960s as well [figs. 8.9–8.15]. Indeed, Jorn seems to have found his voice as a painter through this exploration of child art. When Jorn painted *Letter to My Son* in 1956–57 [fig. 8.10], his son Ole was six years old and his daughter Bodil was five. Many of the images in the painting, such as the white bird with black spots and the face with close-set eyes in the upper right corner, seem as though derived from the drawings of a five- or six-year-old. The painting on Jorn's pottery, a medium he took up seriously in 1953,[16] also draws directly on the vocabulary of child art; he used a particularly striking example of this as the cover photo for his 1956 pamphlet *Structure et Changement* [fig. 8.6].

The children's drawings that Corneille chose to juxtapose with his own painting, *The Happy Rhythms of the City* (1949) [figs. 8.3, 8.19], in the fourth

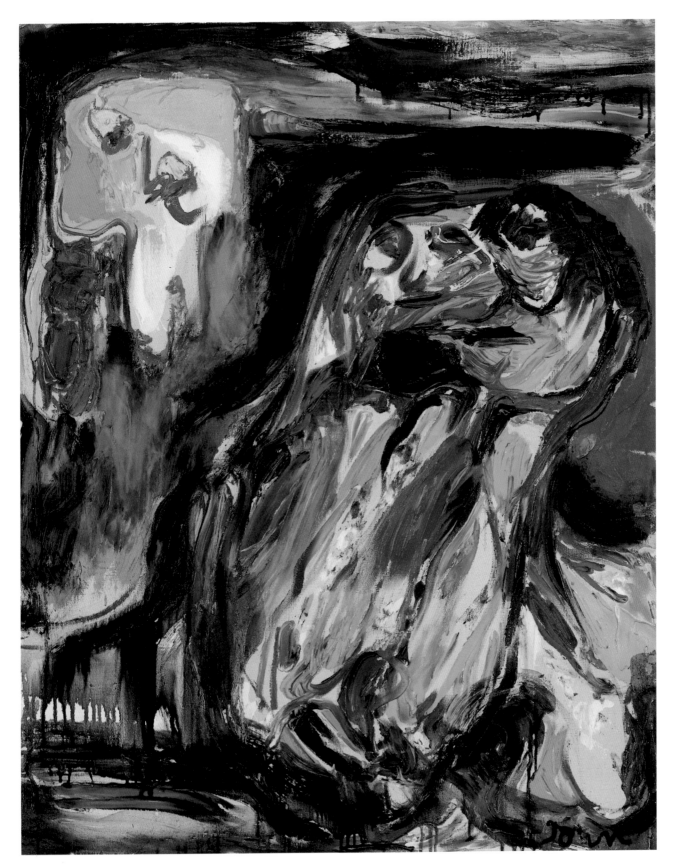

8.13
Asger Jorn
Farewell on the Shores of Death, 1958

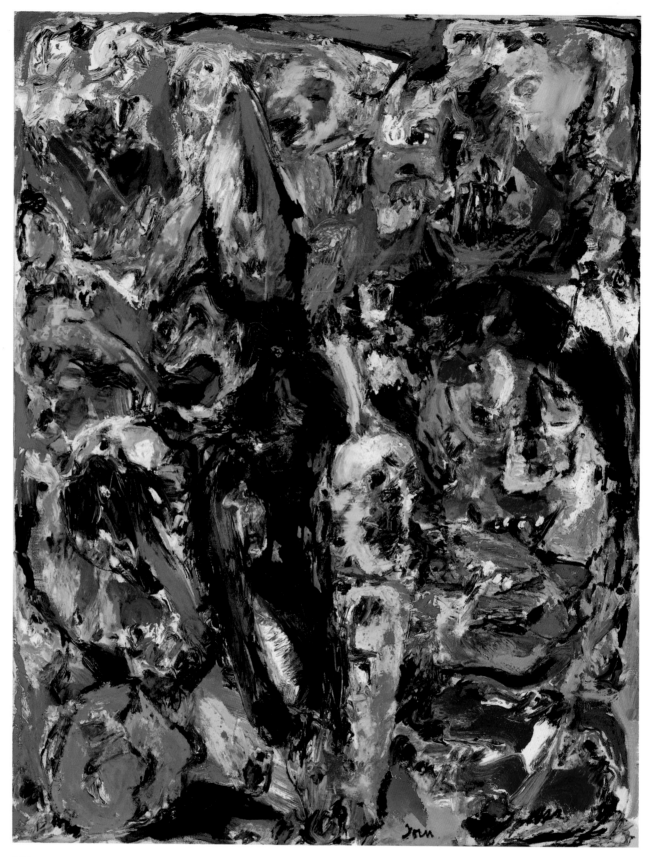

8.14
Asger Jorn
The Bad Year, 1963

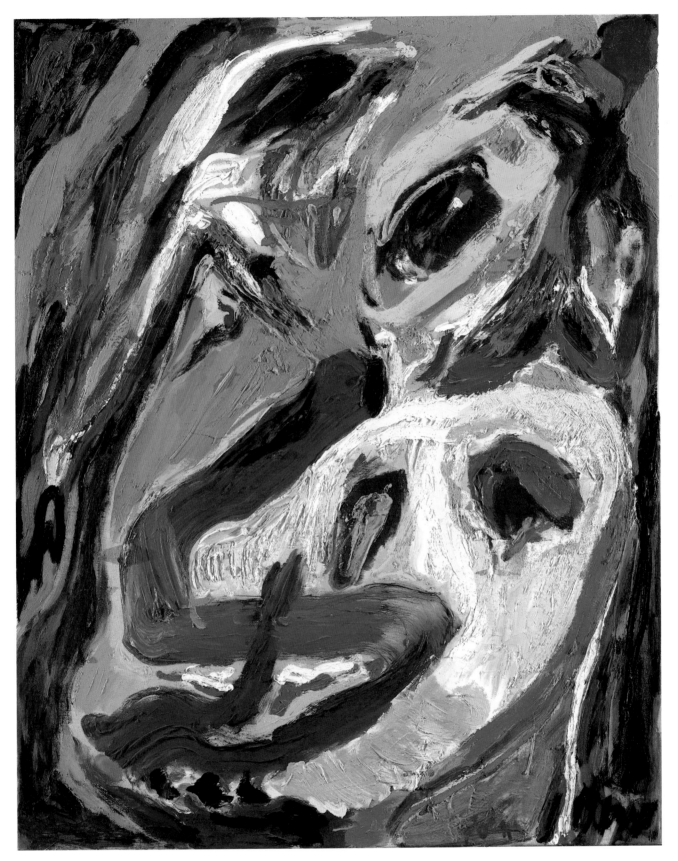

8.15
Asger Jorn
One Says So Much, 1968

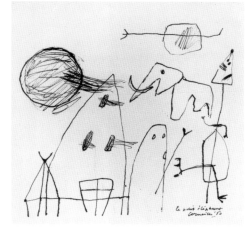

8.16
Corneille
The Little Elephant, 1950

8.17
Corneille
Untitled, 1950

8.18
Corneille
The Man Who Planted the First Flower on the Moon, 1950

number of *Cobra* magazine resemble the painting principally in the superimposition of distinctly different frames of reference over one another in the representation; the top child's drawing, for example, shows a full human figure while at the same time rendering the torso as a face. Corneille exploits this idea in, for example, the central face in his composition—which simultaneously contains another face and a figure. The bright colors, the flatness of the forms, and the free gestural character of the line used to describe the images also resemble child art, although other sources—most notably the work of Paul Klee—are evident, too.

However, the child's drawing juxtaposed in *Cobra* number 4 with the painting by Constant, *Freedom Belongs to Us* (1949) [figs. 8.2, 8.22], comes so close in style to the painting as to seem at first glance like it might be a drawing by the artist himself. The fantastic character of the animals, the scattered composition, and the lack of depth are remarkably similar. Constant has also eliminated a ground plane, which the child includes, and in the child's drawing the creatures interact in a seemingly narrative way, whereas the images in the painting by Constant hang like masks and idols (which they also resemble). In addition, Constant includes in his composition a house and ladder, drawn in the flat linear vocabulary of a child. Constant's work of 1948 and 1949 [figs. 8.20–8.22] derives more explicitly from child art than the work of any other Cobra artist. They are his greatest works and they number among the greatest paintings of the movement.

The initial influence of child art on the work of Karel Appel also dates from the Cobra period (1948–50), although it has continued ever since [figs. 8.23–8.34]. Appel's *Questioning Children*, a mural painted on the wall of the City Hall canteen in Amsterdam in 1949, derived from memories of the faces of the starving children in Germany after the Second World War, innocent victims who had no way to understand the origins of their suffering. The public found the mural

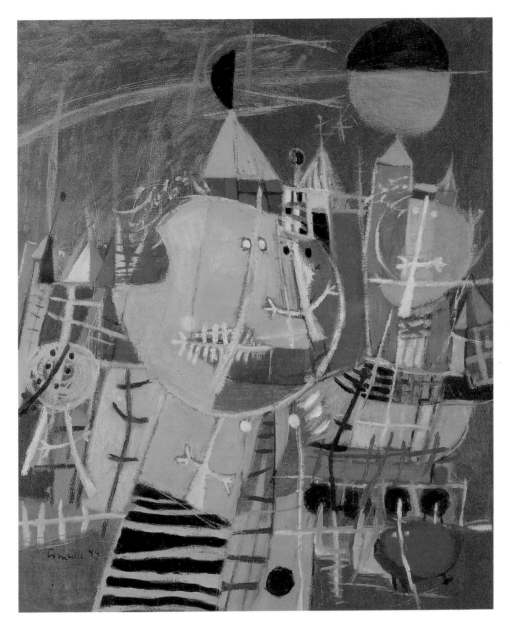

shocking and, under public pressure, the city council of Amsterdam covered it up. The series of relief studies Appel made on this theme in 1948 and 1949 are works of breathtaking quality [figs. 8.25–8.27].

Appel constructed these *Questioning Children* studies from found pieces of wood on a plane of boards. These works are consciously in the tradition of the wooden constructions of Picasso, Schwitters, Arp and Miró but they also derive from the crudely painted play effigies that children make from wooden scraps. Like the *Wooden Cat* by Appel, illustrated in *Cobra* number 4 [figs. 8.1, 8.23], this series of reliefs is painted in a child's palette of flat, bright colors with an exaggeratedly simplified use of large brushstrokes to describe the features. The schematic faces and figures, which also derive from the schema of early childhood drawings, hang frontally oriented on a single plane.

8.20
Constant
Faun, 1949

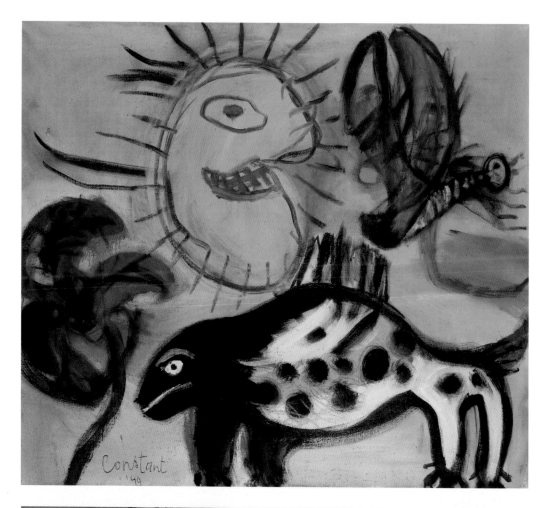

8.21
Constant
Festival of Sadness, 1949

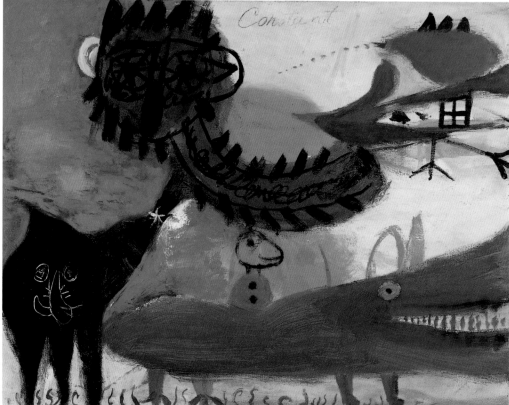

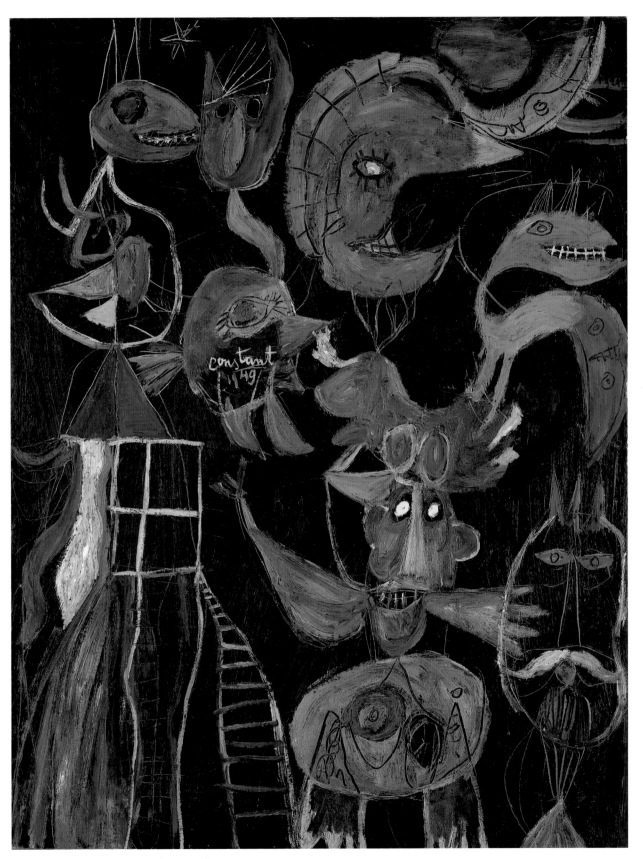

8.22
Constant
Freedom Belongs to Us, 1949

8.23
Karel Appel
Wooden Cat, 1947

8.24
Karel Appel
Totem Pole, 1948

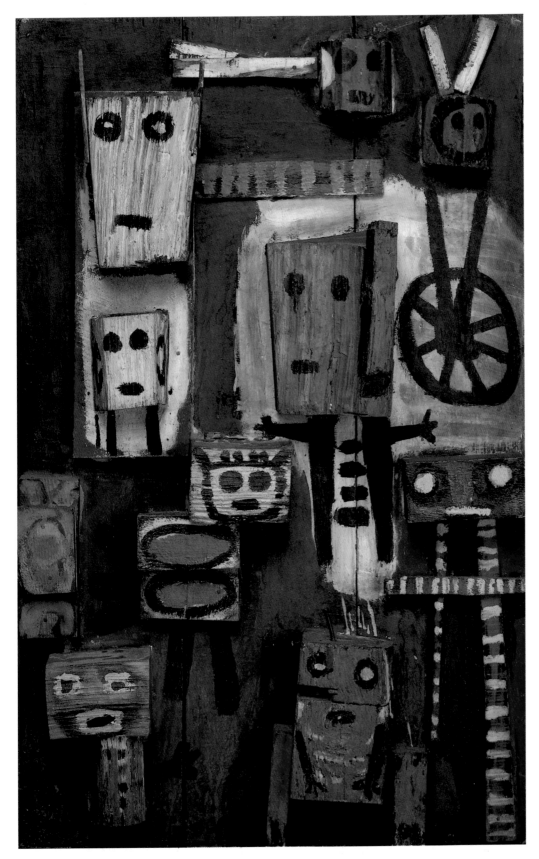

8.25
Karel Appel
Questioning Children, 1949

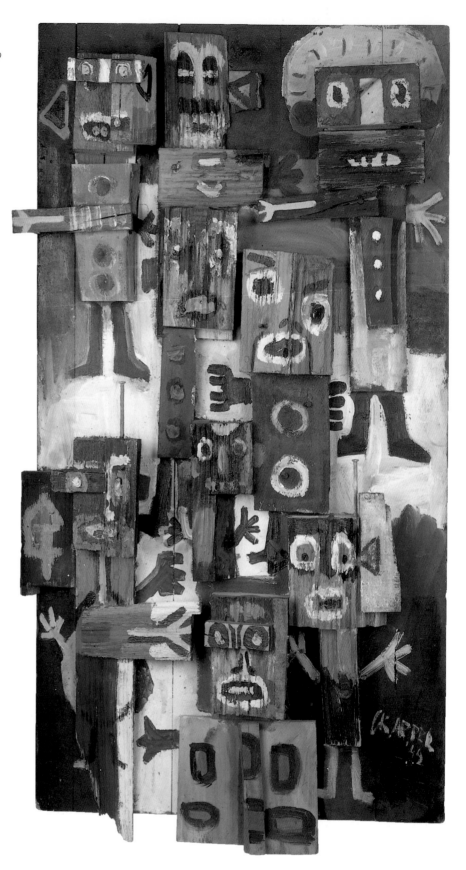

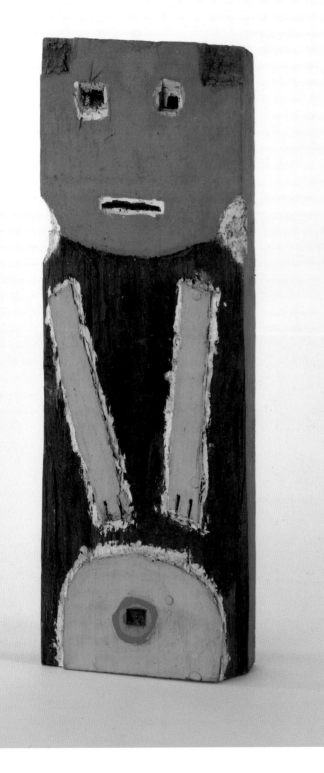

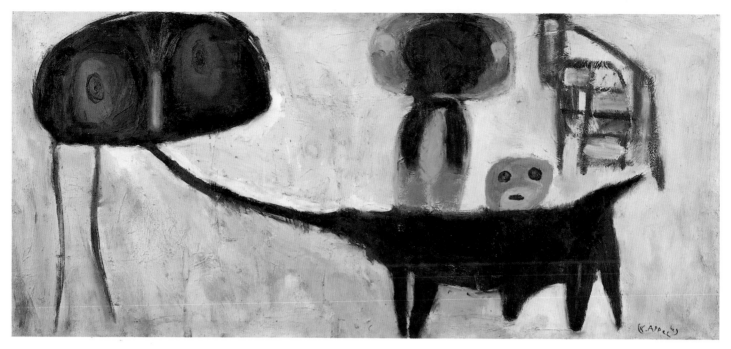

8.28
Karel Appel
Child with a Donkey, 1949

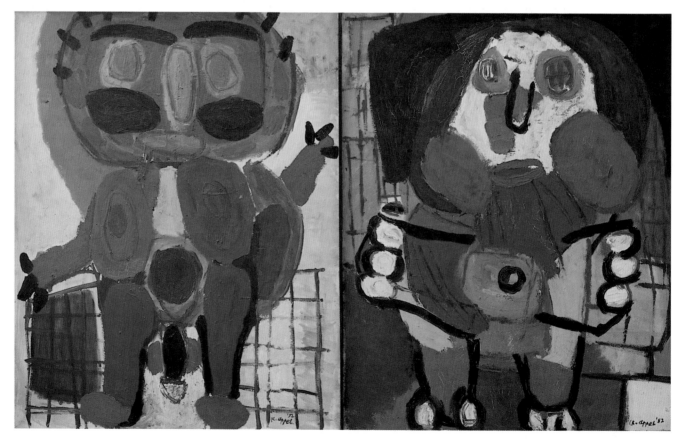

8.29
Karel Appel
Woman and Man, 1952

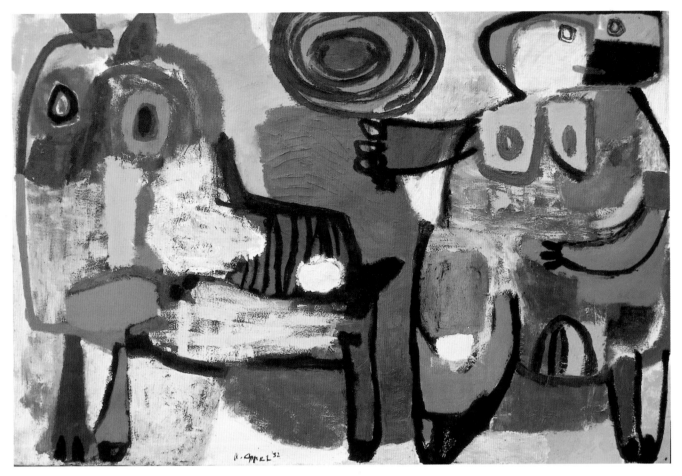

8.30
Karel Appel
Woman and Horse, 1952

Shortly after painting the *Questioning Children* reliefs, Appel was walking in the mountains in the south of France and "suddenly it was snowing," he recalled; hundreds of small sheets of paper started raining down from the sky. On these leaves were children's drawings, which he gathered up as best he could [figs. 8.31, 8.32]. He searched for a school bus or a group of children, but there was no one in sight, and he never did figure out where they came from. Appel made recourse to this collection of children's drawings as a source of inspiration for a number of years thereafter.[17]

In general, it seems that the best works of Dutch Cobra are those that tap into this inspiration of child art (see also Corneille's drawings, figs 8.16–8.18). Another example of this is in the work of Lucebert (Lubertus J. Swaanswijk), a poet in the Cobra circle who turned to painting only after the Cobra had officially disbanded; paintings such as his 1962 *In Egypt* [fig. 8.41] have a tactile palette of rich colors, a flat space, and a simply described imagery of fabulous creatures that evokes the child's formal imagination. Eugène Brands painted only in a distinctly childlike vocabulary in 1950 and 1951, about the time his daughter Eugénie (born in 1947) just began to draw. These paintings, the

8.31
Child's drawing,
from the collection of Karel Appel

8.32
Child's drawing,
from the collection of Karel Appel

8.33
Karel Appel
Child on a Hobby Horse, 1949

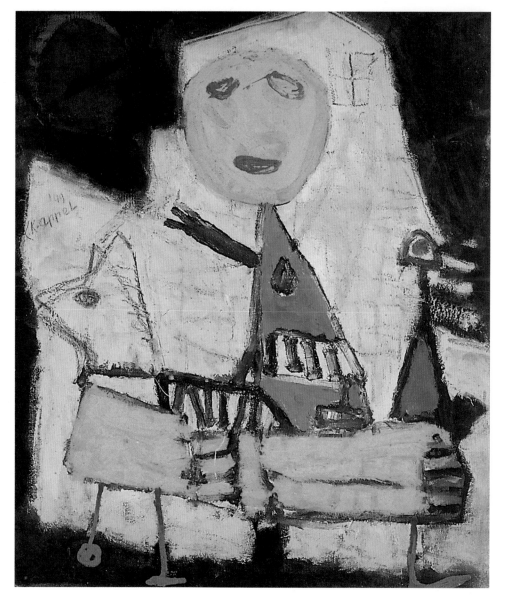

strongest of his career, capture the poignant directness of emotion in children's art [figs. 8.35–8.40].[18]

For Pierre Alechinsky, as for Jorn, Cobra provided more of a starting point than a pinnacle to his artistic development. Like Jorn, he experienced an expressive liberation through the emotional directness of child art and through the physical immediacy of painting. But whereas Jorn approached both in a completely intuitive fashion, Alechinsky—influenced by psychoanalyis and by the materialism of the French philosopher Gaston Bachelard—proceeded with more analytical self-awareness, and the influence of specific works by children seems less important for his development than it was for Jorn's or Appel's.

Alechinsky encountered Cobra in the March 1949 exhibition *Le Groupe Surréaliste-Révolutionaire* in Brussels and immediately signed on to help Dotre-

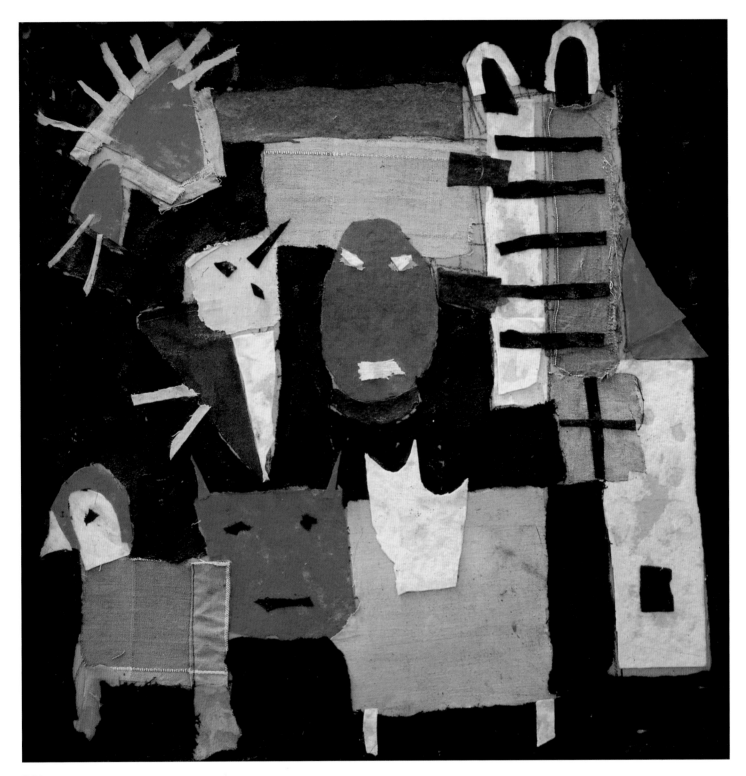

8.34
Karel Appel
Animals of the Night, 1948

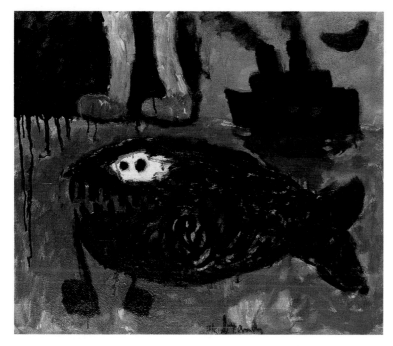

8.35
Eugène Brands
Angry Fish, 1951

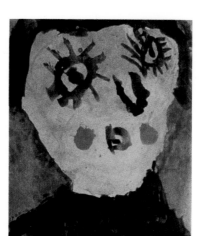

8.37
Eugénie Brands (age 4½)
Portrait of Mama,
27 December 1951

8.38
Eugénie Brands (age 5½)
Woman with Exotic Hat,
28 September 1952

8.39
Eugénie Brands (age 5½)
The Purple Doll Carriage,
1 October 1952

8.40
Eugénie Brands (age 4½)
*Dad in Red Painting Shirt
at the Easel*,
27 December 1951

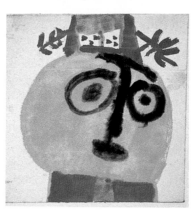

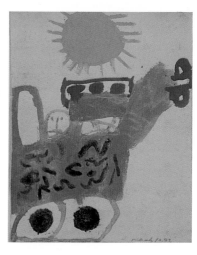

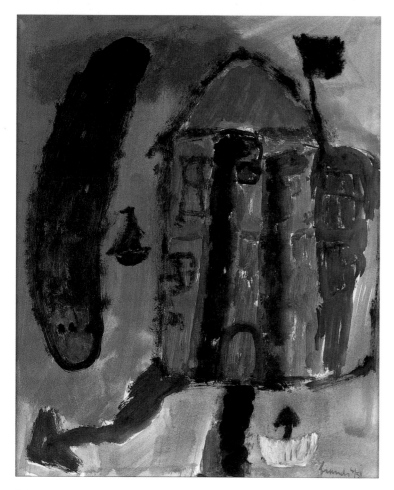

8.36
Eugène Brands
Falling Moon, 1951

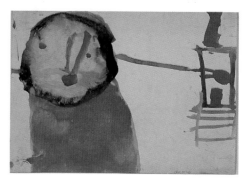

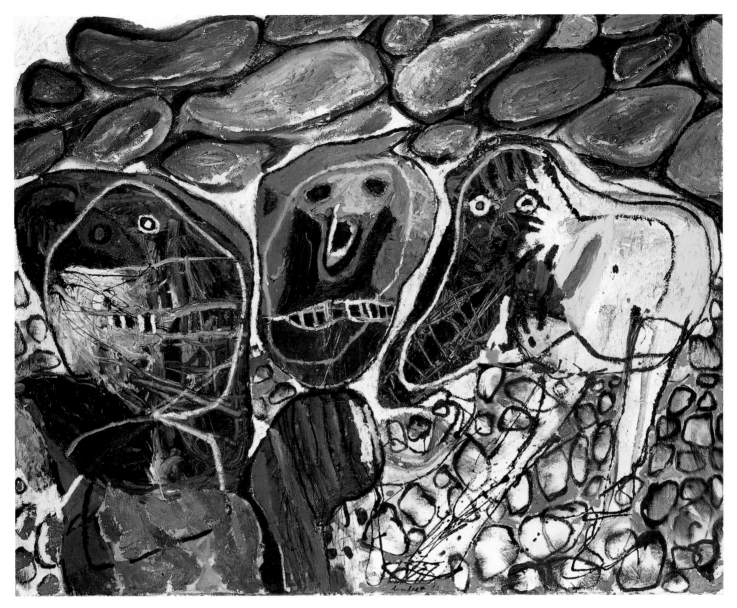

8.41
Lucebert
In Egypt, 1962

mont in publishing the magazine. He was only twenty-one when Cobra formed but almost immediately moved into a mature style that brought together a surrealist metamorphosis of the human form with an expressionist tradition of painterliness. Alechinsky's embracing intellectualism has also enriched his painting with a thoughtful evolution in style and a conceptually experimental approach that has included collaborations with poets, with other artists, and in one case with his own child: Pierre Alechinsky painted only the top three quarters of *Post Hieronymous* [fig. 8.4]; the predella-like band of characters at the bottom were drawn after Hieronymus Bosch by Alechinsky's then eleven-year-old son, Nicolas. In this collaboration, the father emulated the expressive directness of childhood in both his imagery and in his style, whereas the eleven-year-old aspired to the sophisticated mastery of the adult.

As distinct from the important influence of surréalist theory on the Cobra artists, the precursors whose styles most influenced them were Kandinsky, Klee, Picasso and Miró—a list that not surprisingly resembles the dominant narrative of this book; if Larionov is absent, it is perhaps because his work was still largely unknown in the West until the fall of communism, and Dubuffet, also absent but admired by the Cobra, was a contemporary. For the Cobra, the art of children offered a paradigm for coming to terms with the world through art, in a fashion that was both uninhibited and filled with a refreshing expectation of pleasure in the encounter. "It takes years to find the child inside oneself," Alechinsky explained, speaking of himself and of the other artists in the Cobra group. It wasn't that the Cobra artists wanted to *be* naive, but that the child's proximity to the vivid emotions of the unconscious mind attracted them. "Cobra," Alechinsky said, "is a form of art which heads toward childhood . . . with the means available to adults."[19]

1. "Groupe Experimental Hollandais," *Cobra*, no. 2 (21 March 1949), 6; reprinted in facsimile as *Cobra 1948–1951* (Paris: Éditions Jean-Michel Place, 1980).

2. Corneille, in André Laude, *Corneille Le Roi-Image* (Paris: Editions S.M.I. Exclusivite Weber, 1973), 25; cited in Eleanor Flomenhaft, *The Roots and Development of Cobra Art* (Hempstead, New York: Fine Art Museum of Long Island, 1985), 33.

3. Max Ernst, "Comment Ils . . . S'Encadrent," *Cobra*, no. 2 (21 March 1949), 5; reprinted in facsimile as *Cobra 1948–1951*.

4. Asger Jorn, cited in Eleanor Flomenhaft, *The Roots and Development of Cobra Art*, 17.

5. "Declaration of Appel, Constant, and Corneille," (Land og Folk, 3 December 1948), *Cobra*, no. 1 (December 1948), 24; reprinted in facsimile as *Cobra 1948–1951*.

6. Constant Nieuwenhuys, "Manifesto," *Reflex*, no. 1 (September-October 1948), trans. Leonard Bright, in Willemijn Stokvis, *COBRA: An International Movement After the Second World War*, trans. Jacob C. T. Voorhuis (New York: Rizzoli, 1988), 29–30.

7. Ibid.

8. Ibid.

9. Karel Appel, from an interview with Eleanor Flomenhaft, 16 October 1975; cited in Eleanor Flomenhaft, *The Roots and Development of Cobra Art*, 33.

10. Corneille, cited in Jean-Clarence Lambert, *Cobra* (New York: Abbeville Press, 1984), 137.

11. Eiler Bille, *Helhesten*, no. 1, 2d year (October 1942); cited in Graham Birtwistle, "Primitivism of the Left: Helhesten, Cobra and Beyond," in Foundation Cobra and the National Fund De Nieuwe Kerk, *Cobra 40 Years After* (Amsterdam: Sdu Publishers, 1988), 39.

12. Some examples are illustrated in Troels Andersen, "Magic Figures: Jorn, Cobra and Children's Drawings," in Jonathan Fineberg, ed., *Discovering Child Art: Essays on Childhood, Primitivism, and Modernism* (Princeton, N.J.: Princeton University Press, forthcoming).

13. Jens Sigsgaard, "When Children Draw," *Helhesten* 1, no. 4 (1941), 117ff.; discussed in Graham Birtwistle, *Living Art: Asger Jorn's Comprehensive Theory of Art between Helhesten and Cobra, 1946–1949* (Utrecht: Reflex, 1986), 24.

14. Graham Birtwistle, *Living Art: Asger Jorn's Comprehensive Theory of Art between Helhesten and Cobra 1946–1949*, 178–83.

15. Guy Atkins, *Asger Jorn, The Crucial Years: 1954–1964* (London: Lund Humphries, 1977), 25.

16. In the spring of 1954 Jorn moved to Albisola, Italy, and worked in a ceramic workshop with a number of artists, including Appel, Baj, Corneille, Fontana and Matta. From 1955 until his death in May 1973, Jorn divided his time between Paris and Albisola.

17. Karel Appel, conversation with the author, Amsterdam, 2 October 1994.

18. I want to thank Donald Taglialatella of the Avanti Galleries in New York for suggesting that I incorporate the work of Brands and his daughter into this volume.

19. Pierre Alechinsky, cited in Jean-Clarence Lambert, *Cobra*, 183. [The book has no notes so one cannot ascertain the source or date of the quotation.]

9. Mainstreaming Childhood

After World War II, the assimilation of psychoanalysis into the mainstream of popular culture and the widespread focus on the baby boom brought children and childhood to the foreground for more artists than ever. However, the meticulous analysis of child art by artists such as Kandinsky and Klee gave way to a more abstract *feeling* of childhood as the context for the appropriation of the mind or the memory of the child in art after 1950. If some artists today, such as Jasper Johns, take an overtly less empathic attitude than others in dealing with child art or childhood, it is not because the language of child art requires further analysis in itself but because they seek a new kind of detachment with regard to their self-analysis that neither Kandinsky nor Klee desired.

Young American artists of the 1940s such as Jackson Pollock and Mark Rothko took an existentialist point of view with regard to the act of painting, making personal introspection the source of artistic content.[1] Tracing the evolution of the mind back to childhood was the inevitable result. The work of Pollock—the chaotic spilling out of unconscious images and, by the end of 1946, the free, gestural drawing—increasingly resembled childlike scribbling precisely *because* he sought to free himself of the dissimulating structure of adult consciousness, in effect to recover childhood through painting.

Pollock and his friends split off the reenactment of what Freud called "primary process"—the still vital but buried traces of infantile thinking that persevere into adult life—from the symbolism of childhood (Larionov), from concerns for its universality as a language for spiritual values (Kandinsky), from the examination of its syntax and iconography for personal discovery (Münter and Klee), and from an epistemological exploration of childhood thought processes (Dubuffet). They sought a more direct experience, related to that envisioned by the Cobra artists (their contemporaries in Europe). Building on the technique of automatic drawing in surrealism, Pollock recaptured the childhood *feeling* of drawing; in terms of the evolution of the individual psyche, it was a deliberately regressive technique in which the artist, on occasion, even reverted to the tactile experience of putting the paint on directly with his hands, as in *Number One*, 1948 [fig. 9.1].

There is no evidence that Pollock made conscious reference to child art in his work, yet his derivation from artists who did—Picasso, Kandinsky, Klee, Miró and Matisse—puts him in a tradition to which child art is intrinsic. Nor did Robert Motherwell look directly at child art as a source material, but he, too, looked at these artists for whom it was central. A preoccupation with childhood (more or less overtly) moved to the foreground of subject matter for this entire school of painting. The hidden subject of virtually all of Arshile Gorky's greatest works—his paintings of the 1940s—derived from the emotionally charged recollections of his family and childhood in the Armenian village of Khorkom. Franz Kline named many of his grandest abstractions after the trains he remembered from his childhood in the Lehigh Valley; Barnett Newman returned for the generative inspiration underlying his entire oeuvre (which centered on the question of origins) to his early religious training; and monumental, maternal figures provided de Kooning with the most preoccupying motif of his career. All of these artists depended in one way or another upon a return to childhood as a reservoir of originating content.

Of all the abstract expressionists, Rothko is the one who made the most direct and conscious use of child art. On a theoretical level, Rothko regarded childhood as a point of naive encounter with the eternal tragedy of the human condition that was his central subject matter. He taught art to children at the Academy of the Brooklyn Jewish Center from 1929 until 1952, and when he had his first one-man show in 1933 he included a selection of work by these children beside his own paintings.[2] He made extensive notes on children's art—in particular, he studied the theories of the Viennese art educator Franz Cižek[3]—and he was fascinated by the idea that children's art is ahistorical, that children unconsciously followed eternal laws of form and construction.

Rothko's interest in children's art was recognized by the critics as early as 1940. In a review of that year, a writer for *Art News* noted, "The artist has taught children for many years, and one feels that they in turn have helped to make him see and feel with their own simplicity and instinct for truth. *The Party* [one of the canvases that Rothko exhibited] condenses the gaiety and high spirits of a children's celebration into a design of real structural beauty."[4]

To achieve "the simple expression of the complex thought, . . . the impact of the unequivocal," as Rothko expressed it in his famous 1943 letter to the *New York Times*,[5] he relied on the scale of the color blocks in his mature style [fig. 9.5] to create an overpowering material presence—a presence of something *undefinable*. Rothko observed in a notebook from the late 1930s that "the scale conception involves the relationship of objects to their surroundings—the emphasis of things *or* space. It definitely involves a *space* emotion. A child may limit space arbitrarily and then heroify his objects. Or he may infinitize space,

9.1
Jackson Pollock
Number One, 1948

9.2
David Smith
Horse, 1961

9.3
David Smith
Becca, 1965

9.4
David Smith
Study for Becca

dwarfing the importance of objects, causing them to merge and become part of the space of the world."[6]

In his mature painting, Rothko has "heroified" the central color forms. But the lack of particularizing form creates an immediacy that is free from the secondary influence of narrative and cultural interpretation. As in the writings of Sartre, existence precedes essence in Rothko's paintings; the subjective experience of the viewer's encounter with the painted object provides the starting point for definitions of object and self.

In the 1950s, Freudian psychology entered the mainstream of popular culture and everyone took for granted that childhood influences not only continued into adulthood but substantially shaped it. Moreover, the 1950s were the zenith of the "baby boom" and that, too, fostered a greater interest in childhood than ever before. An awareness of child art became a part of the visual experience which artists since the 1950s have taken for granted. The influence of children and their aesthetic sensibilities on art since 1950 is thus common, but it is also remarkably diverse in its particular applications.

The simplest cases are the more narrowly formal ones. David Smith, for example, appropriated a paper horse made by his daughter Rebecca into a monumental sculpture in stainless steel of 1965 entitled *Becca* (named after her) [fig. 9.3].[7] Rebecca had made her horse out of pasted-together pieces of paper and her sister Candida recalled their father's fascination with the way in which Rebecca had fastened the strips of paper for the legs on opposite sides of the piece she had used for the body; this was an idea that both reflected the reality of the subject and at the same time retained a pictorial conception of the image because of the physical flatness of the paper. This same duality lay at the heart of Smith's evolution as a sculptor, and the spontaneous simplicity with which the child addressed it must have drawn him to her playful construction. Smith made a sterling silver copy of Rebecca's horse [fig. 9.2], which he gave her as a

9.5
Mark Rothko
Green and Tangerine on Red, 1956

9.6
Elizabeth Murray
Joanne in the Canyons, Fall-Winter 1990–91

9.7
Daisy Murray-Holman (age 4½)
Empire State Building, 1990

birthday present, and on the base he inscribed it: "DRAWN BY REBECCA MADE BY DAVID SMITH APRIL 4TH HAPPY BIRTHDAY." But this sterling silver horse is more than a casual object made for a child's birthday; one can clearly see the legacy of it in the way the appendages of the stainless steel *Becca* are affixed on opposite sides of the central forms, and in the collage technique of the pasted-paper study [fig. 9.4].[8]

The New York painter Elizabeth Murray is another artist who has used a specific work or a facet of the aesthetic of children in such an ancillary way. Her work centers on the complex and often arbitrary layering of experience in her everyday life, transformed and reconfigured into visual images. In her Fall-Winter 1990–91 painting, *Joanne in the Canyons*, she incorporated into the bottom center a red, blocklike rendition of the Empire State Building by her then four-and-a-half-year-old daughter Daisy [figs. 9.6, 9.7].[9] Here, however, the child's drawing constituted only a fragment of the subject matter rather than the single key to an overarching theme. Similarly, when Robert Wilson directly engaged the participation of a mentally handicapped teenager into his work, he did so as part of his wider exploration of perception and the mind.

Meanwhile, Joel Shapiro has used a toylike scale and imagery in his sculpture generally to escape the austerity of an essentially minimalist form. Similarly, when Donald Baechler found an anonymous child's drawing in a trash basket

9.8
Child's drawing
From the collection of Donald Baechler

9.9
Elsie Dolliver
(Donald Baechler's grandmother)
Untitled

9.10
Anonymous
Ruchy Number Book, single page
(Delhi: Indian Book Depot)

at the Rhode Island School of Design and combined it with images taken from an Indian counting instruction book for children and a "childlike" drawing by his eighty-year-old grandmother as the sources for his painting of *Balzac* [figs. 9.8–9.11], these sources reflected the defining character of his style as a whole. In the same way, there is a spectacular pastel of 1985 by Francesco Clemente [fig. 9.12] in which the artist swallowed up a drawing by his own child, tapping into its experiential immediacy. This almost bodily presence to imaginative events is at the core of Clemente's whole oeuvre.

The graffiti-like notations of the German artist A. R. Penck draw on lingering sensations of childhood art-making, as in his loosely autobiographical painting, *Ralf,* of 1962 [fig. 9.13]. At about the same time, the California artist Peter Saul was developing paintings on the compositional principle of working sequentially from vignette to vignette (as in an adolescent doodle) rather than from a preconceived and unified compositional whole. Although the individual images are more discretely formed (and *informed* by the comics) than those of Penck, his working process was nonetheless also an outgrowth of the same free associative character of compositional development.

Another artist whose work has roots in an intuition of childhood mark-making and other early tactile experiences is the New York painter Terry Winters, who pointed specifically to the work of Pollock as a precedent in this return to the state of mind of infantile gesturing.[10] At the time that Winters made this remark in 1991, he had only recently rediscovered a drawing he himself had done at the age of eight and was startled to see how much his then current work—the space, the evocation of tactile experience, the eccentricity of the

9.11
Donald Baechler
Balzac, 1989

9.12
Francesco Clemente
Untitled, 1985

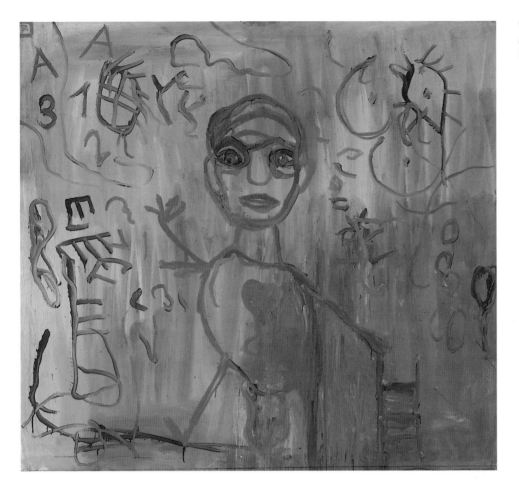

composition, and even the character of the organic forms—seemed to have been implied in his childhood aesthetic [figs. 9.14, 9.15].

Also rooted in a free flow of gestural association (as in Pollock's drip style), the works of Julian Schnabel evoke a primal physicality that carries viewer and painter alike back to preverbal experience. Schnabel is omniverous in his consumption of visual sources—"I look at everything"[11]—and his use of children's art is no more important in his work than other strongly felt sources; it is chiefly the reevocation of childhood feeling that is important. In a magnificently sensual painting entitled *Matador on a Stick* (1983) [figs. 9.16, 9.17], Schnabel has ingested motifs from a childhood drawing by his then wife Jacqueline side by side with intuitively assimilated motifs from other sources.

Keith Haring's creative process was so vividly engaged with the character of childhood (and especially adolescent) imagination that he actually collaborated with children in the 1980s; he painted a number of his large banners with a teenager named LA2 and he drew one of his last suites of etchings (eleven prints, done in 1989) together with a nine-year-old boy named Sean Kalish [fig. 9.18]. To Jean-Michel Basquiat it also seemed natural to collaborate with children and, at one point, he even *hired* an eight-year-old, at twenty dollars a

9.14
Terry Winters (age 8)
Untitled, 1957

9.15
Terry Winters
Numeral, 1985

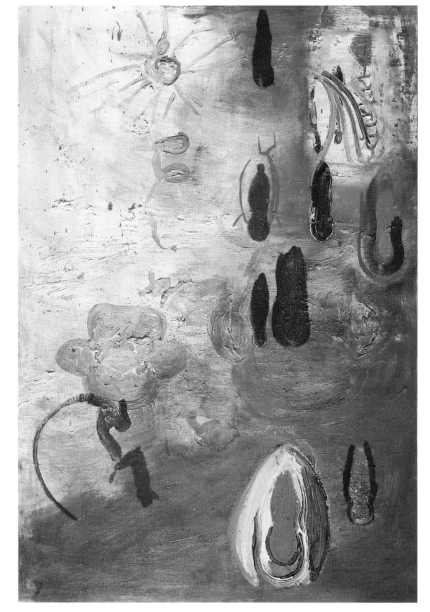

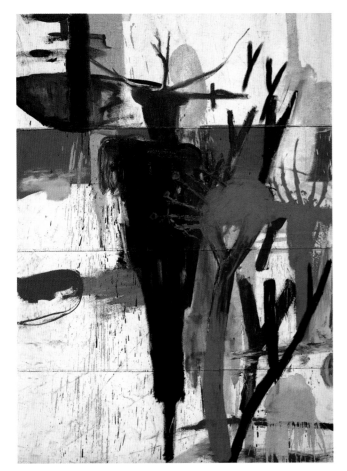

9.16
Julian Schnabel
Matador on a Stick, 1983

9.17
Jacqueline Beaurang Schnabel
I'm Looking at a Frog, 29 October 1962

9.18
Keith Haring, in collaboration
with Sean Kalish (age 9)
Untitled, 1989

9.19
Jean-Michel Basquiat
*The Revised Undiscovered Genius of
the Mississippi Delta*, 1983

9.20
Jean-Michel Basquiat,
in collaboration with Cora
Bischofberger (age 4–5)
Untitled, 1984

9.22
Joseph Beuys
Eurasia, 34th Section of the Siberian Symphony,
photograph of the objects after the end
of the performance at Gallery 101,
Copenhagen, 15 October 1966

9.21
Jean-Michel Basquiat
Empire, ca. 1980

9.23
Claes Oldenburg (age 11)
Collage of Airplane

9.24
Claes Oldenburg
Ray Gun Poster (Airplane), 1959

drawing, to sketch motifs such as the fishing pole in *The Revised Undiscovered Genius of the Mississippi Delta* of 1983 and the Empire State Building in his painting *Empire* of ca. 1980 [figs. 9.19, 9.21].[12] He also painted a canvas in 1984 with Cora, the young daughter of his Swiss dealer, Bruno Bischofberger [fig. 9.20]. During his 1986 opening at the Mary Boone Gallery in New York, Basquiat introduced Jasper Lack, the boy who drew the motifs for *The Revised Undiscovered Genius of the Mississippi Delta* and *Empire*, to Andy Warhol as "the best painter in New York,"[13] and when Bischofberger asked him in 1982 which of his contemporaries Basquiat most admired, the painter replied without a moment's hesitation that he would prefer the art of a three- or four-year-old to that of any contemporary artist.[14]

Many postwar artists have used their conscious memories of childhood as a springboard for their artistic imagination. The installations and performances of Joseph Beuys find much of their meaning in the rich resonances of his childhood recollections; in the 1966 performance of *Eurasia*, for example, Beuys returned to adolescent fantasies about the hare and stag moving freely across the frontiers, penetrating deep into the steppes of Asia and connecting his

home in Cleves, Germany, to the farthest reaches of China [fig. 9.22]. Beuys's 1960 *Opus 1*, the metal tub in which he was bathed as a child, was intended, he said, "to recall my point of departure, and with it the experience and feel of my childhood. It acts as a kind of autobiographical key: an object from the outer world, a solid material thing invested with energy of a spiritual nature."[15]

Many of the themes of Claes Oldenburg's work also derive from childhood drawings and imaginings, especially from the highly elaborated, fictive country of Neubern, which he invented with his brother when they were children [figs. 9.23, 9.24]. "Everything I do is completely original," he remarked in 1966, "I made it up when I was a little kid."[16] Indeed, his revolutionary soft sculpture of the 1960s and his monumental architectural sculpture of the 1970s and 1980s are unmistakably derived from childhood experience. "It's something I don't deny," he explained. "It's something I believe in and try to maintain. The idea of a child being much smaller than an object is hard to remember but it probably remains in the mind. For a child there is a point at which things seem very large. . . ."[17]

For Alice Aycock, extensions of childhood fantasies drive the imaginary narratives implied in installations and machines such as *The Machine that Makes the World* [fig. 9.25] and *How to Catch and Manufacture Ghosts*, both of 1979. Jonathan Borofsky's work looks back at the accumulation of childhood thought patterns and memories as they shape one's ongoing experience of the world, as in *Mom, I Lost the Election at 1,933,095* of 1972 [fig. 9.26].

The German artist Jörg Immendorff wasn't going back to his own childhood experience but rather appropriating the symbolism of childhood for political purposes in his "Lidl" series of 1968–70. The term comes from the sound of a baby rattle and at the same time refers to Rimbaud's idea of the child artist who introduced the revolutionary forces of irrationality into society. The world of the child, in Immendorff's work, had to do with symbolic beginnings—wanting to start over after the spiritual and physical desecration of Germany by fascism. He even created baby talk manifestos and performances to undermine the "bourgeois" connection of child art with modern art, which had been used against progressive art by the Nazis.[18]

The conceptual artist John Baldessari remembered, from his experience as a teacher, watching small children lining up blocks one way then another: "If you were to ask them if they were doing art, they would say no. But to me it seemed a very natural kind of art; sophistication had not entered in yet."[19] Baldessari started collecting children's drawings in the 1960s. His detached, semiotic perspective on them grew out of a shift that took place at the end of the 1950s in the work of Jasper Johns and of pop artists such as Andy Warhol and David Hockney away from psychology and introspection

9.25
Alice Aycock
The Machine that Makes the World, 1979

9.26
Jonathan Borofsky
Mom, I Lost the Election at 1,933,095, 1972

9.27
David Hockney
Cruel Elephant, 1962

and toward a concern with *how* we know what we know about the world. The pop artists, in particular, addressed themselves directly to the way in which popular culture and media had fundamentally changed our point of reference from nature (conceived as an objectively measurable entity) to culture (as a mutating interface that shapes all human experience right from the moment of perception).

A painting like Hockney's 1962 *Cruel Elephant* [fig. 9.27] seems to have evolved through an ongoing narrative, as in a story, rather than from a preconcieved compositional hierarchy of the classical type, and the imagery refers not to an elephant in nature but to *images* of elephants in children's literature and cartoons.[20] Indeed, the experience of childhood itself has been transformed since the mid-1950s by the pervasive interpreting of childhood *back* to children through cartoons, advertising and popular "child psychology."

One of the most oblique but intriguing examples of the ongoing interest among artists today in the art of children is the use Jasper Johns has made of a drawing by an autistic child, which he saw reproduced in a *Scientific American* article of 1952. Sometime between 1984 and 1991 Johns recalled having seen this essay by the psychoanalyst Bruno Bettelheim and dug it out. He then began a group of three paintings built around a schematic rendering of the child's drawing reproduced in the magazine [figs. 9.28–9.31]. The center of Johns's *Sketch for Montez Singing*, of 1988, has nearly the same composition as these untitled works of 1991–94: including a little curlique in the lower left and a mouth and eyes dispersed to the edges (drawn from the memory of details from a preformed image he had seen—namely Picasso's treatment of the facial features in his *Woman in a Straw Hat* of 1936). But whereas the upper center of the canvas of the *Sketch for Montez Singing* features a small empty picture hanging from a wire and a nail, these three untitled canvases show a slightly larger and lower rendering of the child's drawing in its place. *Sketch for Montez Singing* is itself prefigured by several works of the 1980s including the 1985 painting *Untitled (A Dream)*, which has in the center a jigsaw puzzle from another preformed image instead of the blank frame.

Johns described his involvement with this imagery as aiming for "an infantile quality. I think it's some early kind of recognition of eyes, mouths, first images or forms of a child. I have some memory of seeing some drawings by children that have this."[21] It seems to have been this child's drawing from the Bettelheim article that he had in mind when he said this. Somewhat later he explained: "I associated my memory of the child's drawing with my paintings showing eyes, nose and mouth distributed at the edge of a rectangle, no later than 1988, possibly as early as 1984."[22]

9.28
Photograph of a child's drawing from an essay by Bruno Bettelheim in *Scientific American* on which the Johns paintings are based

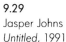

9.29
Jasper Johns
Untitled, 1991

Johns has also said that his childhood nurse, who was hired after his parents divorced, sang and played piano and was associated by him with his *Sketch for Montez Singing*. But as he told Peter Fuller in 1978, "everything I do is attached to my childhood,"[23] although he qualified this statement to make clear that he did *not* see art as an attempt to regain the intensity of early experience. Instead, for Johns, the explicit subject of his work is always the "richness and uncertainty of visual experience."[24]

A significant part of (especially early) child art is a set of unconscious "conventions" determined by development. An adult can only go back to them self-consciously. This set of conventions is one of the things that seems to interest Johns about child art, and in this sense the drawing by the autistic child resem-

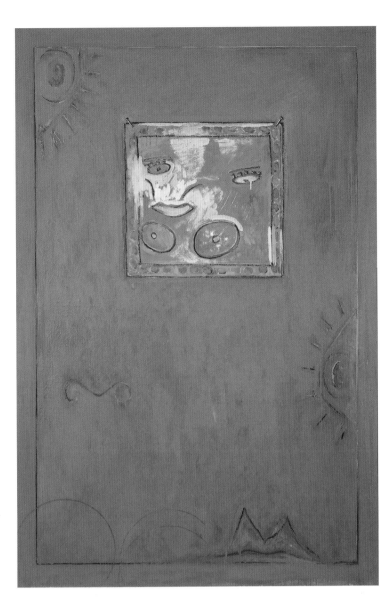

9.30
Jasper Johns
Untitled, 1991

9.31
Jasper Johns
Untitled, 1991–94

bles most of the other objects Johns has painted in the course of his career, beginning with the *Flags* and *Numbers* of the 1950s. Here, as elsewhere, Johns has found a way to render personal experience and feelings disguised in the borrowed forms of visual conventions and "prefabricated" images.

This appropriation and rearranging of expression in the work of Jasper Johns contrasts markedly from the existential model of the abstract expressionists. It represents a new concept of individuality in relation to the depersonalizing world of mass markets and "virtual reality." Indeed, many artists today, informed by the now common knowledge that childhood perseveres in every adult consciousness, seek out that still vital child in themselves for the very purpose of achieving Ruskin's "condition of childhood."[25]

1. For a fuller discussion of the aims of these artists in relation to existentialism, see Jonathan Fineberg, *Art Since 1940: Strategies of Being* (London: Lawrence King, 1994; Englewood Cliffs, N.J.: Prentice-Hall; New York: Harry N. Abrams, 1995).

2. Dore Ashton, *About Rothko* (New York: Oxford University Press, 1983), 20, 26. According to Ashton, some of the drawings in the collection belonged to Mrs. J. B. Neumann, the wife of the dealer who had introduced Rothko to German expressionism.

3. Bonnie Clearwater, *Mark Rothko: Works on Paper* (New York: Hudson Hills Press, 1984), 22. Clearwater notes that Rothko quoted from the writings of Franz Cižek in his personal notebooks. Rothko also made extensive notes from L. W. Rochowanski, *Die Wiener Jugendkunst: Franz Cižek und seine Pflegestätte* (Vienna, 1946), which he owned. Cižek's ideas were widely disseminated in English by Wilhelm Viola in such books as *Child Art and Franz Cižek* (Vienna: Austrian Red Cross), 1936.

4. James Lane, "Three Moderns: Rothko, Gromaire, Solman," *Art News* 38, no. 16 (20 January 1940), 12.

5. June 7, 1943 letter by Mark Rothko and Adolph Gottlieb [with the unacknowledged help of Barnett Newman] in Edward Alden Jewell, "The Realm of Art: A New Platform and Other Matters: 'Globalism' Pops into View," *New York Times* (13 June 1943), 9. Cited in Diane Waldman, *Mark Rothko, 1903–1970: A Retrospective* (New York: Harry N. Abrams, 1978), 39.

6. Mark Rothko, some notes on art education in an unpublished notebook of the late 1930s, collection of the George C. Carson family; cited in Bonnie Clearwater, *Mark Rothko: Works on Paper*, 36.

7. There are other sculptures by Smith of the 1960s (such as the 1961 *Dida's Circle* and the 1965 *Hi Candida*) which look as though they may derive from works by his children.

8. In a series of conversations with Candida Smith in the spring of 1995, she recalled to me that her father had made the sterling silver sculpture after the paper horse. She explained that her father had found the way the legs had been pasted on particularly intriguing and that this served as a basis for the sculpture *Becca* of 1965 in the Metropolitan Museum of Art, New York. I am grateful to Candida and Rebecca Smith and to Peter Stevens and Robert Panzer for their help in finding the documentation for this.

9. In a conversation with the author of 5 December 1990, Murray remarked that she now sees how central childhood is to everything she paints. She also said that the work of Klee and Dubuffet, which she looked at long ago but hadn't thought of consciously for years, has been very important all along too.

10. Conversation with the author, 8 May 1991.

11. Telephone conversation with the author, 6 December 1990, about his use of children's drawings by his former wife Jacqueline and by his children Lola (b. 1981), Stella (b. 1983) and Vito (b. 1986). He also told me that his painting *Death of a Mountain Guide* (1986, oil and tempera on muslin, 376 x 523 cm) was based on a child's drawing (by Vincent Taylor); that he and Lola (then age seven) made a book together for Vito; and that his painting *To Stella* derives from a drawing by Stella. In addition, he mentioned that he and Lola had collaborated on a drawing as well, sometime around 1983.

12. The eight-year-old collaborator was named Jasper Lack, the son of a painter named Stephen Lack. Other kids also did many drawings for Basquiat in the early 1980s. Basquiat's painting *Jasper's Arm* is a reference to Jasper Lack. All of this confirmed in a telephone conversation with Stephen Lack, 3 December 1990.

13. According to Stephen Lack, 3 December 1990, telephone conversation with the author.

14. Bruno Bischofberger, from St. Moritz, telephone conversation with the author, 7 January 1991.

15. Joseph Beuys, cited in John Russell, "The Shaman as Artist," *New York Times Magazine*, 28 October 1979, 40.

16. Claes Oldenburg, *Claes Oldenburg Sculpture and Drawings*, exh. cat. (Stockholm: Moderna Museet, 1966), iv.

17. Claes Oldenburg, cited in Martin Friedman, *Oldenburg: Six Themes*, exh. cat. (Minneapolis: Walker Art Center, 1975), 11.

18. See Pamela Kort, *Jörg Immendorff: Early Works and Lidl* (New York: Gallery Michael Werner, 1991).

19. Coosje van Bruggen, *John Baldessari* (New York: Rizzoli, 1990), 53.

20. David Hockney's later set designs for the triple performance of Satie, Poulenc and Ravel at the Metropolitan Opera were based on his idea of a child's view of the universe as the underlying theme. See Martin Friedman, *Hockney Paints the Stage*, exh. cat. Walker Art Center, Minneapolis (New York: Abbeville Press, 1983), 168–71.

21. Jasper Johns, in Amei Wallach, "Jasper Johns and His Visual Guessing Game," *New York Newsday* (28 February 1991), in *Jasper Johns: 35 Years, Leo Castelli*.

22. Jasper Johns, letter to the author, 20 September 1994.

23. Peter Fuller, "Jasper Johns Interviewed," part II, *Art Monthly* 19 (September 1978), 7; cited in Richard Francis, *Jasper Johns* (New York: Abbeville Press, 1984), 16.

24. Jasper Johns, cited in Roberta Bernstein, *Jasper Johns* (New York: Rizzoli, 1992), 4.
25. John Ruskin, *The Seven Lamps of Architecture*, 1849, in E. T. Cook and Alexander Wedderburn, eds., *The Works of John Ruskin*, vol. VIII (London: G. Allen; New York: Logman's, Green, and Co., 1903–12), 194.

List of Illustrations

Chapter 1. The Postman Did It

1.1
Hans Hofmann
Art News, no. 3 (December 1954), cover
© 1997 Artists Rights Society (ARS), New York/VG Bild-Kunst, Bonn

1.2
Giovanni Francesco Caroto
Fanciullo con Pupazzetta, ca. 1520
Oil on wood
14 ¹/₂ x 11 ¹/₂ in. (37 x 29 cm)
Museo di Castelvecchio, Verona

1.3
Rembrandt Harmensz van Rijn
Christ Preaching (La Petite Tombe), ca. 1652
Etching
6 ¹/₈ x 8 ¹/₈ in. (15.5 x 20.7 cm)
The Pierpont Morgan Library, New York

1.4
Gustave Courbet
The Painter's Studio, a real allegory describing a seven year period of my artistic life, 1855
Oil on canvas
11 feet, 10 in. x 19 feet, 7 ¹/₂ in. (361 x 598 cm)
Musée d'Orsay, Paris

1.5
Thomas Cole
The Course of Empire: The Arcadian Pastoral, 1836
Oil on canvas
39 ³/₈ x 63 ³/₈ in. (100 x 161 cm)
New York Historical Society, New York

1.6
Pieter Janszoon Saenredam
Interior of the Buurkerck, Utrecht, detail, 1644
Oil on wood
23 ⁵/₈ x 19 ⁵/₈ (60 x 50 cm)
National Gallery, London

1.7
Sir David Wilkie
The Blind Fiddler, 1806
Oil on panel
22 ³/₄ x 31 ¹/₄ in. (57.8 x 79.4 cm)
The Tate Gallery, London

1.8
Ernest Meissonier
Portrait of the Sergeant, 1874
Oil on canvas
28 ³/₄ x 24 ³/₈ (73 x 62 cm)
Hamburger Kunsthalle, Hamburg

1.9
Ernest Meissonier
Portrait of the Sergeant, detail

1.10
Henri Matisse
The Young Sailor (II), Collioure, summer 1906
Oil on canvas
40 x 32 ³/₄ in. (101.5 x 83 cm)
Metropolitan Museum of Art, New York, The Jacques & Natasha Gelman Collection
© 1997 Succession H. Matisse/Artists Rights Society (ARS), New York

1.11
Henri Matisse
Woman on a High Stool (Germaine Reynal), early 1914
Oil on canvas
57 ⁷/₈ x 37 ⁵/₈ in. (147 x 95.5 cm)
Museum of Modern Art, New York, Gift of Florene M. Schoenborn and Samuel A. Marx (the former retaining a life interest)
© 1997 Succession H. Matisse/Artists Rights Society (ARS), New York

1.12
Henri Matisse
Marguerite, 1906–7
Oil on canvas
25 ¹/₂ x 21 ¹/₄ in. (65 x 54 cm)
Musée Picasso, Paris, formerly collection of Pablo Picasso
© 1997 Succession H. Matisse/Artists Rights Society (ARS), New York

1.13
Henri Matisse
The Pink Onions, Collioure, summer 1906
Oil on canvas
18 ¹/₈ x 21 ⁵/₈ in. (46 x 55 cm)
Statens Museum for Konst, Kopenhagen
© 1997 Succession H. Matisse/Artists Rights Society (ARS), New York

1.14
E.-L. Kirchner (age 3)
Railroad Train, 21 January 1884
Pencil on paper
6 ¹/₂ x 9 in. (16.7 x 22.7 cm)
Private collection, Switzerland

1.15
E.-L. Kirchner
Railroad, 1926–27
Woodcut
3 ¹/₄ x 3 ¹/₂ in. (8.3 x 8.9 cm)
Private collection, Switzerland

1.16
Le Corbusier

Pavillon des Temps Nouveaux, 1937
L'architecture d'aujourd'hui (8 September 1937).
from *Le Corbusier: Oeuvre Plastique, peintures et dessins architecture* (Paris: Éditions Albert Morancé, 1938), plate 36, showing a mural enlarged by Asger Jorn from a child's drawing of harvesters, 1937
© 1997 Artists Rights Society (ARS), New York/ADAGP, Paris

Chapter 2. Mikhail Larionov and the "Childhood" of Russia

2.1
Kasimir Malevich
Bather, 1911
Gouache on paper
41 x 27 in. (104 x 68.5 cm)
Stedelijk Museum, Amsterdam

2.2
Nataliya Goncharova
Mystical Images of War: Angels and Airplanes, Moscow, 1914
Lithograph
13 x 9 7/8 in. (33 x 25 cm)
New York Public Library, New York
© 1997 Artists Rights Society (ARS), New York/ADAGP, Paris

2.3
Child's drawing
Dog on a Chain
Oil on tin
7 7/8 x 14 1/8 in. (20 x 36 cm)
Formerly collection of Mikhail Larionov, collection of Igor Sanovich, Moscow, photograph by Igor Palmin

2.4
Child's drawing
Cock and Dog
Oil on tin
11 3/4 x 14 3/8 in. (30 x 36.5 cm)
Formerly collection of Mikhail Larionov, collection of Igor Sanovich, Moscow, photograph by Igor Palmin

2.5
Mikhail Larionov
The Gypsy Woman (The Gypsy in Tiraspol), 1909
Oil on canvas
37 3/8 x 31 7/8 in. (95 x 81 cm)
Formerly Tomalina-Larionov collection, State Tretyakov Gallery, Moscow
© 1997 Artists Rights Society (ARS), New York/ADAGP, Paris

2.6
Mikhail Larionov
The Blue Pig, 1909
Oil on canvas
25 5/8 x 29 1/2 in. (65 x 75 cm)
Musée National d'Art Moderne, Paris
© 1997 Artists Rights Society (ARS), New York/ADAGP, Paris

2.7
Mikhail Larionov
The Officer's Barber, 1909–10
Oil on canvas
46 x 35 in. (117 x 89 cm)
Formerly Tomalina-Larionov collection, State Tretyakov Gallery, Moscow
© 1997 Artists Rights Society (ARS), New York/ADAGP, Paris

2.8
Child's drawing
Papuan
Oil on tin
9 5/8 x 7 in. (24.5 x 17.7 cm)
Formerly collection of Mikhail Larionov, collection of Igor Sanovich, Moscow, photograph by Igor Palmin

2.9
Mikhail Larionov
Soldier on a Horse, ca. 1911
Oil on canvas
34 1/2 x 39 in. (87 x 99.1 cm)
The Tate Gallery, London
© 1997 Artists Rights Society (ARS), New York/ADAGP, Paris

2.10
Child's drawing
Plate 60, from Georg Kerschensteiner,
Die Entwicklung der zeichnerischen Begabung (The Development of the gift of drawing), Munich, 1905

2.11
Mikhail Larionov
Venus and Mikhail, 1912
Oil on canvas
26 3/4 x 33 3/4 in. (68 x 85.5 cm)
State Russian Museum, St. Petersburg
© 1997 Artists Rights Society (ARS), New York/ADAGP, Paris

2.12
Mikhail Larionov
Spring (from The Seasons), 1912
Oil on canvas
56 x 46 1/2 in. (142 x 118 cm)
State Tretyakov Gallery, Moscow
© 1997 Artists Rights Society (ARS), New York/ADAGP, Paris

2.13
Mikhail Larionov
Autumn (from The Seasons), 1912
Oil on canvas
53 3/4 x 45 1/4 in. (136.5 x 115 cm)
Musée National d'Art Moderne, Paris
© 1997 Artists Rights Society (ARS), New York/ADAGP, Paris

2.14
Mikhail Larionov
A Happy Autumn, 1912
Oil on canvas
21 x 17 1/2 in. (53.5 x 44.5 cm)
State Russian Museum, St. Petersburg
© 1997 Artists Rights Society (ARS), New York/ADAGP, Paris

2.15
Mikhail Larionov
Winter (from The Seasons), 1912
Oil on canvas
29 3/8 x 48 in. (100 x 122.3 cm)
State Tretyakov Gallery, Moscow
© 1997 Artists Rights Society (ARS), New York/ADAGP, Paris

2.16
Diagram showing the transmutation of the initial of Larionov's last name, the Cyrillic *L*, into a schematic head

2.17
Mikhail Larionov
Cover for the futurist book *Pomade*, by Kruchenykh, 1913
Lithograph
6 x 4 1/4 in. (15.2 x 10.9 cm)
Ex-Libris, New York
© 1997 Artists Rights Society (ARS), New York/ADAGP, Paris

Chapter 3. In Search of Universality: The Vasily Kandinsky and Gabriele Münter Collection

(All the children's drawings in this chapter are from the collection of Kandinsky and Münter, and are currently housed in the Gabriele Münter- und Johannes Eichner-Stiftung, Munich. They are designated by a KIZ number. r = front; v = back. Unless otherwise indicated, the children are presumed to be German.)

3.1
Child's drawing (Paulot Seddeler, age 4),
1910–12
Pencil on paper
8 1/8 x 6 in. (20.7 x 15.3 cm)
KIZ89v

3.2
Child's drawing (Kätchen Busse)
Pencil on paper
8 3/8 x 6 5/8 in. (21.2 x 16.7 cm)
KIZ27v

3.3
Child's drawing (Joseph Wechsler)
Pencil on paper
8 x 9 3/8 in. (20.2 x 23.9 cm)
KIZ114v

3.4
Child's drawing
Pencil on white cardboard
3 5/8 x 9 3/8 in. (9.2 x 24.1 cm)
KIZ79r

3.5
Child's drawing (Robert Böhm)
Pencil on paper
7 7/8 x 9 3/8 in. (20 x 23.9 cm)
KIZ118v

3.6
Child's drawing (Lilja Kenda, Russian)
Colored pencil and pencil on lined paper
7 1/8 x 8 3/4 in. (18 x 22.3 cm)
KIZ226v

3.7
Child's drawing
Crayon on light green paper
10 1/4 x 11 3/4 in. (26.1 x 29.8 cm)
KIZ175

3.8
Child's drawing (Lilja Kenda, Russian)
Pencil and colored pencil on paper
3 3/4 x 5 1/8 in. (9.5 x 13 cm)
KIZ92v

3.9
Vasily Kandinsky
The Elephant, 1909
Oil on cardboard
18 x 27 in. (46 x 68.5 cm)
Courtesy Galerie Thomas, Munich
© 1997 Artists Rights Society (ARS), New
York/ADAGP, Paris

3.10
Vasily Kandinsky

Landscape Near Murnau with Locomotive, 1909
Oil on cardboard
19 7/8 x 28 5/8 in. (50.4 x 65 cm)
Solomon R. Guggenheim Museum, New York
© 1997 Artists Rights Society (ARS), New
York/ADAGP, Paris

3.11
Child's drawing (Ella Reiss)
Pencil on beige cardboard
7 7/8 x 9 3/8 in. (20 x 24 cm)
KIZ138v

3.12
Vasily Kandinsky
Murnau with Locomotive, 1911
Oil on canvas
37 1/2 x 40 1/4 in. (95.5 x 102.5 cm)
St. Louis Art Museum, Missouri
© 1997 Artists Rights Society (ARS), New
York/ADAGP, Paris

3.13
Child's drawing (Joseph Wechsler, age 10),
7 October 1906
Pencil and colored crayon on drawing board
6 7/8 x 8 1/4 in. (17.5 x 21.1 cm)
KIZ154r

3.14
Vasily Kandinsky
The Black Spot, 1912
Oil on canvas
39 1/2 x 51 in. (100 x 130 cm)
State Russian Museum, St. Petersburg
© 1997 Artists Rights Society (ARS), New
York/ADAGP, Paris

3.15
Vasily Kandinsky
Sketch for The Black Spot I, 1912
Black ink and red pencil on paper
4 x 6 1/2 in. (10.5 x 16.4 cm)
Städtische Galerie im Lenbachhaus, Munich,
GMS430
© 1997 Artists Rights Society (ARS), New
York/ADAGP, Paris

3.16
Child's drawing (Annemarie Münter), page 13
of a sketchbook
Colored crayon and pencil on paper
8 3/8 x 6 5/8 in. (21.2 x 16.7 cm)
KIZ168

3.17
Vasily Kandinsky
Painting with Troika, 1911
Oil on cardboard
27 1/2 x 39 3/8 in. (70 x 100 cm)
Art Institute of Chicago

© 1997 Artists Rights Society (ARS), New
York/ADAGP, Paris

3.18
Vasily Kandinsky
Sketch for Composition II, 1910
Oil on canvas
38 3/8 x 51 5/8 in. (97.5 x 131.2 cm)
Solomon R. Guggenheim Museum, New York
© 1997 Artists Rights Society (ARS), New
York/ADAGP, Paris

3.19
Child's drawing (Maschura), inscribed in
Russian by Kandinsky
Watercolor and pencil on paper
5 1/4 x 7 3/4 in. (13.5 x 19.6 cm)
KIZ171v

3.20
Child's drawing (child of Albert Bloch),
10 November 1913
Colored pencil on paper
6 3/8 x 10 1/8 in. (16.2 x 25.6 cm)
KIZ49v

3.21
Vasily Kandinsky
Horses, 1909
Oil on canvas
38 x 42 1/4 in. (97 x 107.3 cm)
Städtische Galerie im Lenbachhaus, Munich,
GMS53
© 1997 Artists Rights Society (ARS), New
York/ADAGP, Paris

3.22
Child's drawing (Annemarie Münter), August
1910
Pencil on paper
8 1/2 x 4 3/4 in. (21.6 x 12.1 cm)
KIZ86r

3.23
Child's drawing (Annemarie Münter),
11 December 1910
Colored pencil on paper
7 3/8 x 5 5/8 in. (18.8 x 14.4 cm)
KIZ42v

3.24
Child's drawing (Lilja Kenda Dekabr), dated
December 1910 in Russian script by Kandinsky
Pencil on paper
3 5/8 x 6 1/2 in. (9.1 x 16.6 cm)
KIZ15

3.25
Child's drawing (Annemarie Münter),
1 May 1911

Pencil on paper
8 5/8 x 5 1/2 in. (22 x 14.2 cm)
KIZ21v

3.26
Child's drawing
Watercolor and pencil on paper
7 x 9 5/8 in. (17.8 x 24.4 cm)
KIZ33

3.27
Child's drawing
Watercolor
5 x 6 5/8 in. (12.8 x 16.9 cm)
KIZ107v

3.28
Child's drawing (Annemarie Münter),
28 August 1913
Watercolor over pencil on paper
8 3/8 x 6 5/8 in. (21.2 x 16.7 cm)
KIZ113v

3.29
Vasily Kandinsky
Impression VI (Sunday), 1911
Oil on canvas
42 1/4 x 37 1/2 in. (107.5 x 95 cm)
Städtische Galerie im Lenbachhaus, Munich
© 1997 Artists Rights Society (ARS), New
York/ADAGP, Paris

3.30
Vasily Kandinsky
Improvisation 30 (Cannons), 1913
Oil on canvas
43 1/2 x 43 1/2 in. (110 x 110 cm)
Art Institute of Chicago
© 1997 Artists Rights Society (ARS), New
York/ADAGP, Paris

3.31
Child's drawing (Elisabeth Busse), August 1913
Pencil on paper
8 1/4 x 6 5/8 in. (21.1 x 16.7 cm)
KIZ24

3.32
Child's drawing (Elisabeth Busse), ca. 1912–13
Pencil on paper
8 1/4 x 6 5/8 in. (21.1 x 16.7 cm)
KIZ7v

3.33
Vasily Kandinsky
Improvisation 21a (Study for Little Pleasures),
1911
Oil on canvas
43 1/4 x 47 1/8 in. (109.8 x 119.7 cm)
Städtische Galerie im Lenbachhaus, Munich,
GMS82

© 1997 Artists Rights Society (ARS), New
York/ADAGP, Paris

3.34
Vasily Kandinsky
With Sun, 1911
Painting on glass
12 x 15 7/8 in. (30.6 x 40.3 cm)
Städtische Galerie im Lenbachhaus, Munich,
GMS120
© 1997 Artists Rights Society (ARS), New
York/ADAGP, Paris

3.35
Child's drawing (Friedel), page 7 in school
notebook
Pencil and colored crayon on paper
6 3/8 x 4 1/8 in. (16.3 x 10.4 cm)
KIZ167

3.36
Child's drawing (Thomas Herrman)
Pencil on paper
7 7/8 x 9 1/4 in. (20 x 23.5 cm)
KIZ116v

3.37
Child's drawing (Wanitschku, Russian)
Watercolor and pencil on paper
8 3/4 x 7 1/8 in. (22.2 x 18 cm)
KIZ34v

3.38
Child's drawing (Käte Busse)
Watercolor and pencil on paper
7 1/2 x 5 1/8 in. (19 x 13.1 cm)
KIZ70v

3.39
Child's drawing (Annemarie Münter),
29 August 1913
Watercolor and pencil on paper
8 1/4 x 6 1/2 in. (21.1 x 16.6 cm)
KIZ26v

3.40
Child's drawing (Anna Böhm)
Pencil and colored crayon on paper
9 3/8 x 7 1/2 in. (23.9 x 19.2 cm)
KIZ125v

3.41
Child's drawing (Otto Paskegg)
Watercolor and pencil on paper
6 3/4 x 4 1/2 in. (17.3 x 11.4 cm)
KIZ192v

3.42
Vasily Kandinsky
Murnau—Landscape with Rainbow, 1909
Oil on canvas

13 x 17 in. (32.8 x 42.8 cm)
Städtische Galerie im Lenbachhaus, Munich,
GMS41
© 1997 Artists Rights Society (ARS), New
York/ADAGP, Paris

3.43
Gabriele Münter
Village Street in Winter, 1911
Oil on cardboard on wood
20 5/8 x 27 1/8 in. (52.4 x 69 cm)
Städtische Galerie im Lenbachhaus, Munich,
GMS664
© 1997 Artists Rights Society (ARS), New
York/VG Bild-Kunst, Bonn

3.44
Gabriele Münter
The Blue Gable, 1911
40 x 44 5/8 in. (101.6 x 113.3 cm)
Oil on canvas
Krannert Art Museum, University of Illinois,
Champaign
© 1997 Artists Rights Society (ARS), New
York/VG Bild-Kunst, Bonn

3.45
Gabriele Münter
House, 23 March 1914
Oil on cardboard
14 1/2 x 12 3/4 in. (37 x 32.5 cm)
Gabriele Münter- und Johannes Eichner-
Stiftung, Munich
© 1997 Artists Rights Society (ARS), New
York/VG Bild-Kunst, Bonn

3.46
Gabriele Münter
Untitled, 23 March 1914
Oil on cardboard
14 1/2 x 12 3/4 in. (37 x 32.5 cm)
Gabriele Münter- und Johannes Eichner-
Stiftung, Munich, Mü3
© 1997 Artists Rights Society (ARS), New
York/VG Bild-Kunst, Bonn

3.47
Gabriele Münter
Untitled, 23 March 1914
Oil on cardboard
14 1/2 x 12 3/4 in. (37 x 32.5 cm)
Gabriele Münter- und Johannes Eichner-
Stiftung, Munich, Mü4
© 1997 Artists Rights Society (ARS), New
York/VG Bild-Kunst, Bonn

3.48
Child's drawing (Rudi Schindler)
Crayon over pencil on watercolor paper
9 3/8 x 7 7/8 in. (23.9 x 19.9 cm)
KIZ121

3.49
Child's drawing (Martin Mosner)
Crayon over pencil on cardboard
11 $^3/_4$ x 7 $^7/_8$ in. (29.9 x 20 cm)
KIZ117

3.50
Child's drawing (Robert Böhm?)
Crayon over pencil on drawing board
9 $^1/_2$ x 7 $^7/_8$ in. (24 x 19.9 cm)
KIZ144

3.51
Gabriele Münter
In the Room (Woman in a White Dress), 1913
Oil on canvas
34 $^5/_8$ x 39 $^3/_8$ in. (88 x 100 cm)
Private collection, Germany
© 1997 Artists Rights Society (ARS), New York/VG Bild-Kunst, Bonn

3.52
Child's drawing (Friedel)
Oil on cardboard
14 x 13 $^1/_8$ in. (35.7 x 33.4 cm)
KIZ185v

3.53
Child's drawing (Friedel)
Oil on cardboard
18 $^3/_4$ x 12 $^7/_8$ in. (47.5 x 32.8 cm)
KIZ180v

3.54
Gabriele Münter
Listening (Portrait of Jawlensky), 1909
Oil on cardboard
19 $^1/_2$ x 26 in. (49.7 x 66.2 cm)
Städtische Galerie im Lenbachhaus, Munich, GMS657
© 1997 Artists Rights Society (ARS), New York/VG Bild-Kunst, Bonn

3.55
Child's drawing (Friedel)
Oil on cardboard
9 $^7/_8$ x 11 $^5/_8$ in. (25 x 29.6 cm)
KIZ181v

3.56
Child's drawing (Friedel), October 1913
Oil on cardboard
13 $^1/_8$ x 14 $^1/_8$ in. (33.4 x 35.9 cm)
KIZ186v

3.57
Lyonel Feininger
City with Sun, 1921
Watercolor
8 x 11 $^1/_2$ in. (20.3 x 28.6 cm)
Galleria d'Arte "Il Castello," Trient

© 1997 Artists Rights Society (ARS), New York/VG Bild-Kunst, Bonn

3.58
Lyonel Feininger
Lovers, 1916
Oil on canvas
17 $^3/_8$ x 15 $^7/_8$ in. (44.2 x 40.2 cm)
Musée National d'Art Moderne, Paris
© 1997 Artists Rights Society (ARS), New York/VG Bild-Kunst, Bonn

3.59
Lyonel Feininger
Locomotive with Large Wheel, 1915
Oil on canvas
22 $^3/_8$ x 49 $^1/_4$ in. (56.8 x 125 cm)
Achim Moeller Fine Art, New York
© 1997 Artists Rights Society (ARS), New York/VG Bild-Kunst, Bonn

3.60
Lyonel Feininger
Houses and Figures, undated
Carved and painted wood
Fifteen pieces between 1 $^1/_2$ and 3 $^7/_8$ in. (3.7 and 9.7 cm)
Achim Moeller Fine Art, New York
© 1997 Artists Rights Society (ARS), New York/VG Bild-Kunst, Bonn

3.61
Alexei Jawlensky
Murnau Landscape, 1909
Oil on cardboard
20 x 23 $^1/_2$ in. (50.5 x 59.5 cm)
Städtische Galerie im Lenbachhaus, Munich, GMS678
© 1997 Artists Rights Society (ARS), New York/VG Bild-Kunst, Bonn

3.62
Andreas Jawlensky (age 7)
Locomotive, ca. 1909
Oil on textured paper
10 $^5/_8$ x 14 $^3/_8$ in. (27 x 36.5 cm)
Long Beach Museum of Art, Long Beach, California
© 1997 Artists Rights Society (ARS), New York/VG Bild-Kunst, Bonn

3.63
Lyonel Feininger
The Jetty at Swinemünde, 1921
Watercolor, tusche, pen and ink on paper
7 $^5/_8$ x 11 $^3/_8$ in. (19.4 x 28.8 cm)
Collection E.W.K., Bern
© 1997 Artists Rights Society (ARS), New York/VG Bild-Kunst, Bonn

Chapter 4. Reawakening the Beginnings: The Art of Paul Klee

4.1
Paul Klee (age 4–6)
Woman with a Parasol, 1883–85
Pencil on paper
4 $^3/_8$ x 3 $^1/_4$ in. (11.2 x 8.2 cm)
Klee-Stiftung, Kunstmuseum, Bern
© 1997 Artists Rights Society (ARS), New York/VG Bild-Kunst, Bonn

4.2
Paul Klee
Girl with a Doll, 1905
Painting behind glass with watercolor
7 x 5 in. (17.8 x 12.9 cm)
Klee-Stiftung, Kunstmuseum, Bern
© 1997 Artists Rights Society (ARS), New York/VG Bild-Kunst, Bonn

4.3
Paul Klee
Soothsayers in Conversation, 1906
Pencil and ink
8 $^3/_8$ x 6 $^3/_4$ in. (21.3 x 17.1 cm)
Klee-Stiftung, Kunstmuseum, Bern
© 1997 Artists Rights Society (ARS), New York/VG Bild-Kunst, Bonn

4.4
Paul Klee (age 4)
Untitled (Family Outing), 1883
Pencil on paper
11 $^1/_8$ x 7 $^1/_4$ in. (28.2 x 18.4 cm)
Private collection, Bern
© 1997 Artists Rights Society (ARS), New York/VG Bild-Kunst, Bonn

4.5
Paul Klee
Horsedrawn Carriage, ca. 1883
Pencil and colored crayon
4 $^1/_8$ x 5 $^3/_4$ in. (10.6 x 14.7 cm)
Klee-Stiftung, Kunstmuseum, Bern, 14A
© 1997 Artists Rights Society (ARS), New York/VG Bild-Kunst, Bonn

4.6
Paul Klee
Rider and Outrider (Study for Candide), 1911
Painting behind glass
5 $^1/_8$ x 7 $^1/_8$ in. (13 x 18 cm)
Private collection
© 1997 Artists Rights Society (ARS), New York/VG Bild-Kunst, Bonn

4.7
Paul Klee
Three Galloping Horses II (Frail Animals), 1912

Pen and ink
3 x 9 in. (7.6 x 22.7 cm)
Klee-Stiftung, Kunstmuseum, Bern
© 1997 Artists Rights Society (ARS), New York/VG Bild-Kunst, Bonn

4.8
Paul Klee
The Expectant Ones, 1912
Pen and ink
2 1/2 x 5 3/4 in. (6.8 x 14.9 cm)
Klee-Stiftung, Kunstmuseum, Bern
© 1997 Artists Rights Society (ARS), New York/VG Bild-Kunst, Bonn

4.9
Child's drawing
Plate 37 from Georg Kerschensteiner,
Die Entwicklung der zeichnerischen Begabung
(The Development of the gift of drawing),
Munich, 1905

4.10
Child's drawing
Plate 4, from Georg Kerschensteiner,
Die Entwicklung der zeichnerischen Begabung,
Munich, 1905

4.11
Child's drawing
Plate 61 from Georg Kerschensteiner,
Die Entwicklung der zeichnerischen Begabung,
Munich, 1905

4.12
Child's drawing
Plate 101 from Georg Kerschensteiner,
Die Entwicklung der zeichnerischen Begabung,
Munich, 1905

4.13
Paul Klee
Human Helplessness, 1913
Ink on paper
7 x 4 in. (17.8 x 9.9 cm)
Klee-Stiftung, Kunstmuseum, Bern
© 1997 Artists Rights Society (ARS), New York/VG Bild-Kunst, Bonn

4.14
Paul Klee
Gate in the Garden, 1926
Oil color on cardboard
21 1/2 x 17 1/4 in. (54.5 x 44 cm)
Klee-Stiftung, Kunstmuseum, Bern
© 1997 Artists Rights Society (ARS), New York/VG Bild-Kunst, Bonn

4.15
Paul Klee
Fright of a Girl, 1922

Watercolor and oil transfer on paper
11 3/4 x 8 7/8 in. (29.8 x 22.5 cm)
Solomon R. Guggenheim Museum, New York
© 1997 Artists Rights Society (ARS), New York/VG Bild-Kunst, Bonn

4.16
Paul Klee
On the !, 1916
India ink
5 x 5 3/4 in. (12.7 x 14.6 cm)
Cleveland Museum of Art
© 1997 Artists Rights Society (ARS), New York/VG Bild-Kunst, Bonn

4.17
Paul Klee
Cosmic Composition, 1919
Oil on cardboard
19 x 16 1/8 in. (48 x 41 cm)
Kunstsammlung Nordrhein-Westfalen,
Düsseldorf
© 1997 Artists Rights Society (ARS), New York/VG Bild-Kunst, Bonn

4.18
Paul Klee
Pastorale (Rhythms), 1927
Oil on canvas on cardboard
27 1/8 x 20 1/2 in. (69 x 52 cm)
Museum of Modern Art, New York
© 1997 Artists Rights Society (ARS), New York/VG Bild-Kunst, Bonn

4.19
Child's drawing (Kätchen Busse)
Pencil on paper
8 3/8 x 6 5/8 in. (21.2 x 16.7 cm)
Collection of Kandinsky and
Münter, Gabriele Münter- und
Johannes Eichner-Stiftung, Munich,
KIZ52v

4.20
Paul Klee
Untitled, with House and Steps, 1890
Colored pencil
5 3/4 x 7 1/4 in. (14.9 x 18.3 cm)
Private collection
© 1997 Artists Rights Society (ARS), New York/VG Bild-Kunst, Bonn

4.21
Paul Klee
Tomcat's Turf, 1919
Watercolor
8 3/4 x 5 3/4 in. (22.5 x 14.5 cm)
Metropolitan Museum of Art, New York,
Berggruen Bequest
© 1997 Artists Rights Society (ARS), New York/VG Bild-Kunst, Bonn

4.22
Paul Klee
Animal Park, 1924
Colored pencil on letter paper
2 3/4 x 8 1/2 in. (7 x 21.8 cm)
Formerly collection of Rudolf Ibach of Wuppertal, Von-der-Heydt-Museum, Wuppertal
© 1997 Artists Rights Society (ARS), New York/VG Bild-Kunst, Bonn

4.23
Paul Klee
Church, the Clock with Invented Numbers,
1883–84
Pencil and colored crayon on paper, mounted
on cardboard
8 3/4 x 7 1/8 in. (22.5 x 18.1 cm)
Klee-Stiftung, Kunstmuseum, Bern
© 1997 Artists Rights Society (ARS), New York/VG Bild-Kunst, Bonn

4.24
Paul Klee (age 5)
Untitled Horse, Sleigh and Two Ladies, 1884
Pencil and crayon
2 3/4 x 6 3/4 in. (7 x 17.3 cm)
Klee-Stiftung, Kunstmuseum, Bern
© 1997 Artists Rights Society (ARS), New York/VG Bild-Kunst, Bonn

4.25
Paul Klee
Winter Day, Just before Noon, 1922
Oil on paper, mounted on cardboard
11 3/4 x 18 in. (29.8 x 45.9 cm)
Kunsthalle, Bremen
© 1997 Artists Rights Society (ARS), New York/VG Bild-Kunst, Bonn

4.26
Paul Klee
The Goldfish, 1925
Oil and watercolor on canvas
19 1/2 x 27 1/4 in. (49.6 x 69.2 cm)
Kunsthalle, Hamburg
© 1997 Artists Rights Society (ARS), New York/VG Bild-Kunst, Bonn

4.27
Paul Klee
Childhood page of sketches—fish, *Sketchbook*,
page 14, 1889
Pencil on paper
8 x 6 1/2 in. (20.2 x 16.9 cm)
Private collection
© 1997 Artists Rights Society (ARS), New York/VG Bild-Kunst, Bonn

4.28
Paul Klee
Fish Magic, 1925
Oil and watercolor on canvas

30 ³/₈ x 38 ¹/₂ in. (77.5 x 98.4 cm)
Philadelphia Museum of Art
© 1997 Artists Rights Society (ARS), New
York/VG Bild-Kunst, Bonn

4.29
Paul Klee
Three Fish, 1939
Pencil on paper
8 ¹/₄ x 11 ⁵/₈ in. (20.9 x 29.7 cm)
Klee-Stiftung, Kunstmuseum, Bern
© 1997 Artists Rights Society (ARS), New
York/VG Bild-Kunst, Bonn

4.30
Felix Klee
*Tent City with Blue River and Black Zig-Zag
Clouds*, February 1919
Watercolor on paper
9 ¹/₄ x 6 ⁵/₈ in. (23.7 x 16.8 cm)
Private collection, Bern

4.31
Paul Klee
Untitled (Tent City in the Mountains), 1920
Oil on cardboard
7 ¹/₂ x 10 ³/₈ in. (19 x 26.5 cm)
Private collection, Bern
© 1997 Artists Rights Society (ARS), New
York/VG Bild-Kunst, Bonn

4.32
Paul Klee
Chance, 1924
Watercolor and oil-color drawing on paper
7 ¹/₂ x 10 ³/₈ in. (27.5 x 33.5 cm)
Private collection, Bern
© 1997 Artists Rights Society (ARS), New
York/VG Bild-Kunst, Bonn

4.33
Paul Klee
Promenaders, 1925
Tusche and watercolor on paper
9 ³/₈ x 11 in. (24 x 28 cm)
Mrs. Eleanor B. Saidenberg, New York
© 1997 Artists Rights Society (ARS), New
York/VG Bild-Kunst, Bonn

4.34
Paul Klee
Childhood page of sketches—boat, *Sketchbook*
page 12, 1889
Pencil on paper
8 x 6 ¹/₂ in. (20.2 x 16.9 cm)
Private collection, Bern
© 1997 Artists Rights Society (ARS), New
York/VG Bild-Kunst, Bonn

4.35
Paul Klee
The Road from Unklaitch to China, 1920

Pen and ink on paper, mounted on cardboard
7 ¹/₄ x 11 in. (18.6 x 28.2 cm)
Klee-Stiftung, Kunstmuseum, Bern
© 1997 Artists Rights Society (ARS), New
York/VG Bild-Kunst, Bonn

4.36
Paul Klee
Memory of Lugano, 1921
Ink on paper
8 ¹/₂ x 11 ¹/₄ in. (21.5 x 28.5 cm)
Dr. E. W. Kornfeld, Bern
© 1997 Artists Rights Society (ARS), New
York/VG Bild-Kunst, Bonn

4.37
Paul Klee
Steamship before Lugano, 1922
Lithograph, 6/10
11 x 15 ¹/₄ in. (27.8 x 38.8 cm)
Klee-Stiftung, Kunstmuseum, Bern
© 1997 Artists Rights Society (ARS), New
York/VG Bild-Kunst, Bonn

4.38
Child's drawing of a head and torso, probably
1920s, from the collection of Kandinsky
Pencil and watercolor on paper, mono-
grammed lower right, "U. W."
13 ¹/₂ x 9 in. (34.2 x 23 cm)
Musée National d'Art Moderne, Centre
Georges Pompidou, Paris, Archives du Fonds
Kandinsky, Legs de Mme. N. Kandinsky, 1981.
83-D-68

4.39
Child's drawing of two girls, probably 1920s,
from the collection of Kandinsky
Crayon and colored pencil on paper
13 x 9 ¹/₄ in. (32.8 x 23.8 cm)
Musée National d'Art Moderne, Centre
Georges Pompidou, Paris, Archives du Fonds
Kandinsky, Legs de Mme. N. Kandinsky, 1981.
83-D-62

4.40
Paul Klee
Yellow Harbor, 1921
Oil and watercolor on paper, mounted on
cardboard
12 ¹/₂ x 19 in. (31.8 x 48.3 cm)
Metropolitan Museum of Art, New York,
Berggruen Bequest
© 1997 Artists Rights Society (ARS), New
York/VG Bild-Kunst, Bonn

4.41
Paul Klee
Boats, the Sixth at the Pier, 1926
Oil crayon on paper
8 ⁷/₈ x 15 ¹/₈ in. (22.5 x 38.4 cm)

Private collection, Bern
© 1997 Artists Rights Society (ARS), New
York/VG Bild-Kunst, Bonn

4.42
Child's drawing
Bauhaus 3, no. 3 (July-September 1929), p. 14
Documentaton du Musée Nationale d'Art
Moderne, Centre Georges Pompidou, Paris,
Archives du Fonds Kandinsky, Legs de Mme. N.
Kandinsky, 1981

4.43
Paul Klee
Actor's Mask, 1924
Oil on canvas, mounted on board
14 ³/₈ x 13 ¹/₄ in. (36.7 x 33.8 cm)
Museum of Modern Art, New York, The Sidney
and Harriet Janis Collection
© 1997 Artists Rights Society (ARS), New
York/VG Bild-Kunst, Bonn

4.44
Child's drawing, acquired by Klee from Hans
Friedrich Geist around 1930
Watercolor and crayon on paper
12 ³/₈ x 14 in. (31.5 x 35.5 cm)
Private collection, Bern

4.45
Child's drawing, acquired by Klee from Hans
Friedrich Geist around 1930
Watercolor and crayon on paper
11 ⁵/₈ x 13 ¹/₈ in. (29.7 x 33.3 cm)
Private collection, Bern

4.46
Child's drawing, acquired by Klee from Hans
Friedrich Geist around 1930
Watercolor and crayon on paper
13 ³/₈ x 15 ⁵/₈ in. (34 x 39.8 cm)
Private collection, Bern

4.47
Paul Klee
Railroad Engine, 1939
Pencil on paper
10 ⁵/₈ x 16 ⁷/₈ in. (27 x 43 cm)
Klee-Stiftung, Kunstmuseum, Bern
© 1997 Artists Rights Society (ARS), New
York/VG Bild-Kunst, Bonn

4.48
Felix Klee
Untitled (Railroad), 1913
Pencil, pen and tusche on paper
1 ⁵/₈ x 6 ¹/₂ in. (4.2 x 16.5 cm)
Private collection, Bern

4.49
Paul Klee

Mountain Railroad, 1939
Charcoal, watercolor and gesso on linen
8 ¼ x 17 in. (20.9 x 43.2 cm)
Private collection
© 1997 Artists Rights Society (ARS), New
York/VG Bild-Kunst, Bonn

4.50
Paul Klee
Compulsion toward the Mountain, 1939
Oil on canvas
37 ³/₈ x 27 ½ in. (95 x 70 cm)
Private collection
© 1997 Artists Rights Society (ARS), New
York/VG Bild-Kunst, Bonn

4.51
Child's collage
Bauhaus 3, no. 3 (July–September 1929), cover
Documentaton du Musée Nationale d'Art
Moderne, Centre Georges Pompidou, Paris,
Archives du Fonds Kandinsky, Legs de Mme. N.
Kandinsky, 1981

4.52
Paul Klee
Ragged Ghost, 1933
Pigmented paste, watercolor on drawing paper
18 ⁷/₈ x 13 in. (48 x 33.1 cm)
Klee-Stiftung, Kunstmuseum, Bern
© 1997 Artists Rights Society (ARS), New
York/VG Bild-Kunst, Bonn

4.53
Paul Klee
Hungry Girl, 1939
10 ½ x 8 ¼ in. (27 x 21 cm)
Private collection, Switzerland
© 1997 Artists Rights Society (ARS), New
York/VG Bild-Kunst, Bonn

4.54
Paul Klee
Bust, 1930
Oil on paper, mounted on canvas
14 x 21 ½ in. (35.5 x 54.5 cm)
Private collection, Switzerland, on loan to the
Städtische Kunsthalle, Mannheim
© 1997 Artists Rights Society (ARS), New
York/VG Bild-Kunst, Bonn

4.55
Paul Klee
Burnt Mask, 1939
Pigmented paste on paper
8 ¹/₈ x 11 ³/₄ in. (20.8 x 29.7 cm)
Private collection, Switzerland
© 1997 Artists Rights Society (ARS), New
York/VG Bild-Kunst, Bonn

4.56
Paul Klee

When I Was Still Young, 1938
Black paste on letter paper on linen backing,
mounted on cardboard
11 x 7 in. (28 x 17.8 cm)
Klee-Stiftung, Kunstmuseum, Bern
© 1997 Artists Rights Society (ARS), New
York/VG Bild-Kunst, Bonn

4.57
Paul Klee
Childlike Again, 1939
Pencil on paper on linen backing, mounted on
cardboard
10 3/5 x 8 ½ in. (27 x 21.5 cm)
Klee-Stiftung, Kunstmuseum, Bern
© 1997 Artists Rights Society (ARS), New
York/VG Bild-Kunst, Bonn

4.58
Paul Klee
Childhood, 1938
Colored paste on paper
10 ½ x 16 ⁷/₈ in. (27 x 42.8 cm)
Klee-Stiftung, Kunstmuseum, Bern
© 1997 Artists Rights Society (ARS), New
York/VG Bild-Kunst, Bonn

4.59
Paul Klee
Children Play Tragedy, 1939
Black oil crayon on paper on linen, mounted
on cardboard
8 ¼ x 11 ⁵/₈ in. (20.9 x 29.6 cm)
Klee-Stiftung, Kunstmuseum, Bern
© 1997 Artists Rights Society (ARS), New
York/VG Bild-Kunst, Bonn

4.60
Paul Klee
Itinerant Artist: A Poster, 1940
Colored paste on paper
12 ¹/₈ x 11 ³/₈ in. (31 x 29 cm)
Private collection, Switzerland
© 1997 Artists Rights Society (ARS), New
York/VG Bild-Kunst, Bonn

4.61
Paul Klee
By the Blue Bush, 1939
Colored paste on paper
13 ¼ x 9 in. (34 x 23 cm)
Wilhelm-Hack Museum, Ludwigshafen
© 1997 Artists Rights Society (ARS), New
York/VG Bild-Kunst, Bonn

Chapter 5. Pablo Picasso: Playing with Form

5.1
Paloma Picasso
Untitled (Drawing with Cars), 1956
Gouache on paper
8¼ x 10⁵/₈ in. (21 x 27 cm)
Private collection, Paris

5.2
Claude Picasso
Untitled (Personage, Grotto and Elephant), 1953
Gouache on paper
8¼ x 10⁵/₈ in. (21 x 27 cm)
Private collection, Paris

5.3
Claude Picasso
Untitled (Personage and Animal), 18 February
1953
Colored pencil on paper
10⁵/₈ x 8¼ in. (27 x 21 cm)
Private collection, Paris

5.4
Paloma Picasso
Untitled (Girl with a Horse), ca. 1956
Pencil on paper
8¼ x 5¼ in. (21 x 13.5 cm)
Private collection, Paris

5.5
Child's drawing (anonymous), in Picasso's
sketchbook *Carnet deux*, 1901
Charcoal on paper
5¹/₈ x 8¼ in. (13 x 21 cm)
Musée Picasso, Paris, MP1990-94-1R

5.6
Child's drawing (anonymous), in Picasso's
sketchbook *Carnet deux*, 1901
Charcoal on paper
5¹/₈ x 8¼ in. (13 x 21 cm)
Musée Picasso, Paris, MP1990-94-1R

5.7
Pablo Picasso
Les Demoiselles d'Avignon, June–July 1907
Oil on canvas
8 feet x 7 feet, 8 in. (245 x 235 cm)
Museum of Modern Art, New York
© 1997 The Estate of Pablo Picasso/Artists
Rights Society (ARS), New York

5.8
Pablo Picasso
Sheet of Caricatures, Barcelona, 1899–1900
Conté crayon and colored pencil on paper
8²/₃ x 12½ in. (22 x 31.8 cm)
Museo Picasso, Barcelona, MPB110.662

© 1997 The Estate of Pablo Picasso/Artists
Rights Society (ARS), New York

5.9
Pablo Picasso
Maya with a Doll, 16 January 1938
Oil on canvas
28 7/8 x 23 5/8 in. (73.5 x 60 cm)
Musée Picasso, Paris, MP170
© 1997 The Estate of Pablo Picasso/Artists
Rights Society (ARS), New York

5.10
Pablo Picasso
Claude with His Hobby Horse, 9 June 1949
Oil on canvas
51 1/4 x 38 1/4 in. (130.2 x 97 cm)
Collection Marina Picasso, 1981, Courtesy
Galerie Jan Krugier, Geneva
© 1997 The Estate of Pablo Picasso/Artists
Rights Society (ARS), New York

5.11
Pablo Picasso
Little Girl Jumping Rope, Vallauris, 1950–52
Metal frame, wicker basket, shoes, wood, cake
pans, plaster
59 7/8 x 25 5/8 x 26 in. (52 x 65 x 66 cm)
Spies 408(1), Musée Picasso, Paris, MP336
© 1997 The Estate of Pablo Picasso/Artists
Rights Society (ARS), New York

5.12
Pablo Picasso
Baboon and Her Young, October 1951
Bronze
21 x 13 1/4 x 20 3/4 in. (53.2 x 33.2 x 61 cm)
Private collection
© 1997 The Estate of Pablo Picasso/Artists
Rights Society (ARS), New York

5.13
Pablo Picasso
Reclining Nude, 14 June 1967
Oil on canvas
76 3/4 x 51 1/8 in. (195 x 130 cm)
Musée Picasso, Paris
© 1997 The Estate of Pablo Picasso/Artists
Rights Society (ARS), New York

5.14
Pablo Picasso
Le Dejeuner sur l'herbe, 27 February 1960
Oil on canvas
43 1/2 x 57 in. (114 x 146 cm)
Private collection
© 1997 The Estate of Pablo Picasso/Artists
Rights Society (ARS), New York

5.15
Pablo Picasso
Las Meninas, after Velázquez, 19 September
1957
Oil on canvas
63 3/4 x 51 1/4 in. (162 x 130 cm)
Museo Picasso, Barcelona, MPB70.464
© 1997 The Estate of Pablo Picasso/Artists
Rights Society (ARS), New York

5.16
Pablo Picasso
Composition Study for Guernica (III), Paris,
1 May 1937
Pencil on blue paper
8 1/4 x 10 5/8 in. (21 x 27 cm)
Museo del Prado, Madrid, on deposit in the
Museo Nacional Centro de Arte Reina Sofía,
Madrid
© 1997 The Estate of Pablo Picasso/Artists
Rights Society (ARS), New York

5.17
Pablo Picasso
Horse, Study for Guernica (IV), Paris,
1 May 1937
Pencil on blue paper
8 1/4 x 10 1/2 in. (21 x 26.7 cm)
Museo del Prado, Madrid, on deposit in the
Museo Nacional Centro de Arte Reina Sofía,
Madrid
© 1997 The Estate of Pablo Picasso/Artists
Rights Society (ARS), New York

5.18
Pablo Picasso
Night Fishing at Antibes, Antibes, August 1939
Oil on canvas
6 feet, 9 in. x 11 feet, 4 in. (213 x 345 cm)
Museum of Modern Art, New York, Mrs. Simon
Guggenheim Fund
© 1997 The Estate of Pablo Picasso/Artists
Rights Society (ARS), New York

5.19
Pablo Picasso
Studies, from the sketchbook *Carnet bleu*,
3 May 1943
Gouache on paper
12 1/4 x 14 1/2 in. (31 x 37 cm)
Zervos, vol. 13, no. 6, pl. 4, Private collection,
formerly collection of Marie-Thérèse Walter
© 1997 The Estate of Pablo Picasso/Artists
Rights Society (ARS), New York

5.20
Pablo Picasso
Study for Man with a Sheep (III), 19 August
1942
China ink on paper
13 1/8 x 8 3/8 in. (33.3 x 21.3 cm)

Private collection
© 1997 The Estate of Pablo Picasso/Artists
Rights Society (ARS), New York

5.21
Pablo Picasso
Man with a Sheep, Paris, February 1943
Bronze
87 1/2 x 30 3/4 x 30 3/4 in. (222.5 x 78 x 78 cm)
Philadelphia Museum of Art, Gift of R. Sturgis
and Marion B. F. Ingersoll, s280.11
© 1997 The Estate of Pablo Picasso/Artists
Rights Society (ARS), New York

5.22
Alexander Liberman
Pablo Picasso in his studio in Vallauris, 1953–
54. On the easel is a painting by Picasso of his
children Claude and Paloma on the floor paint-
ing. Photograph courtesy Alexander Liberman,
from *The Artist in His Studio* (Random House,
1960)
© 1997 Alexander Liberman

5.23
Pablo, Paloma and Claude Picasso, Françoise
Gilot
Untitled, 16 April 1953
Pencil and colored pencil on paper
26 x 19 1/2 in. (66 x 49.5 cm)
Private collection
© 1997 The Estate of Pablo Picasso/Artists
Rights Society (ARS), New York

Chapter 6. Joan Miró's Rhymes of Childhood

6.1
Joan Miró holding a drawing by his daughter
Dolorès and discussing it with her, ca. 1938
Photograph courtesy Dolorès Miró

6.2
Dolorès Miró
Untitled ("El Torneo"), December 1941
Pencil and crayon on paper
8 1/4 x 10 3/4 in. (21.3 x 27.1 cm)
Collection Dolorès Miró

6.3
Dolorès Miró
Untitled ("Adanyeva Fuera del Parais"), May
1942
Pencil and crayon on paper
8 1/4 x 10 in. (14 x 25.4 cm)
Collection Dolorès Miró

6.4
Dolorès Miró
Mother, February 1938
Colored crayon and pencil on paper
8¼ x 10⁹/₁₆ in. (20.9 x 26.8 cm)
Philadelphia Museum of Art, Gallatin
Collection, acc. no. 52-61-139

6.5
Dolorès Miró
Untitled (Star-Filled Sky), January 1942
Pencil and crayon on paper
5½ x 8¼ in. (14 x 21.3 cm)
Collection Dolorès Miró

6.6
Dolorès Miró
Mother's Departure, February 1938
Colored crayon and pencil on paper
8¼ x 10⁹/₁₆ in. (20.9 x 26.8 cm)
Philadelphia Museum of Art, Gallatin
Collection, acc. no. 52-61-140

6.7
Dolorès Miró
Untitled, with a letter from Miró dated 31 July
1935
Pencil on paper
8¼ x 10½ in. (21 x 27 cm)
Documentaton du Musée Nationale d'Art
Moderne, Centre Georges Pompidou, Paris,
Archives du Fonds Kandinsky, Legs de Mme. N.
Kandinsky, 1981. 83-D-77

6.8
Joan Miró (age 8)
Flower Pot with Flowers, 1901
Pencil on paper
8⁵/₁₆ x 4¾ in. (21.1 x 12 cm)
Fúndació Joan Miró, Barcelona, FJM20
© 1997 Artists Rights Society (ARS), New
York/ADAGP, Paris

6.9
Joan Miró (age 8)
Umbrella, 1901
Pencil on paper
7¼ x 4½ in. (18.5 x 11.6 cm)
Fúndació Joan Miró, Barcelona, FJM19
© 1997 Artists Rights Society (ARS), New
York/ADAGP, Paris

6.10
Joan Miró (age 8)
Pedicure, 1901
Colored pencil, watercolor and ink on paper
4⁵/₈ x 6¹¹/₁₆ in. (11.6 x 17.7 cm)
Fúndació Joan Miró, Barcelona, FJM22
© 1997 Artists Rights Society (ARS), New
York/ADAGP, Paris

6.11
Joan Miró
The Farm, 1921–22
Oil on canvas
48¼ x 55¼ in. (122.6 x 140.3 cm)
National Gallery of Art, Washington, Gift of
Mary Hemingway
© 1997 Artists Rights Society (ARS), New
York/ADAGP, Paris

6.12
Joan Miró
Person Throwing a Stone at a Bird, 1926
Oil on canvas
29 x 36¼ in. (73.7 x 92.1 cm)
Museum of Modern Art, New York, Purchase
© 1997 Artists Rights Society (ARS), New
York/ADAGP, Paris

6.13
Joan Miró
The Hunter (Catalan Landscape), Montroig, July
1923–Winter 1924
Oil on canvas
25½ x 39½ in. (64.8 x 100.3 cm)
Museum of Modern Art, New York, Acquired
through the Lillie P. Bliss Bequest
© 1997 Artists Rights Society (ARS), New
York/ADAGP, Paris

6.14
Joan Miró
Mediterranean Landscape, 1930
Oil on canvas
93⅛ x 61¾ in. (235 x 155 cm)
Galerie Gmurzynska, Cologne
© 1997 Artists Rights Society (ARS), New
York/ADAGP, Paris

6.15
Joan Miró
Woman and Bird in the Night, 1945
Oil on canvas
44⅞ x 57½ in. (114 x 146 cm)
Kunstsammlung Nordrhein-Westfalen,
Düsseldorf
© 1997 Artists Rights Society (ARS), New
York/ADAGP, Paris

6.16
Joan Miró
The Bird with Calm Look and Wings in Flames,
1952
Oil and plaster on canvas
31⅞ x 39⅜ in. (81 x 100 cm)
Staatsgalerie, Stuttgart
© 1997 Artists Rights Society (ARS), New
York/ADAGP, Paris

6.17
Joan Miró

Woman with Jug, 1970
Bronze
33⁹/₁₀ x 29½ x 14 in. (86 x 75 x 36 cm)
Fúndació Joan Miró, Barcelona, FJM7319
© 1997 Artists Rights Society (ARS), New
York/ADAGP, Paris

6.18
Joan Miró
Woman (The Tightrope Walker), 1970
Bronze
21¾ x 11½ x 4⅛ in. (55.5 x 29 x 10.5 cm)
Fúndació Joan Miró, Barcelona, FJM7328
© 1997 Artists Rights Society (ARS), New
York/ADAGP, Paris

6.19
Joan Miró
Personage, 1973
Bronze
17⅜ x 13 x 13 in. (44 x 33 x 33 cm)
Fúndació Joan Miró, Barcelona, FJM7374
© 1997 Artists Rights Society (ARS), New
York/ADAGP, Paris

6.20
Joan Miró
The Flight of the Dragonfly before the Sun,
26 January 1968
Oil on canvas
68½ x 96 in. (173.9 x 243.8 cm)
National Gallery of Art, Washington, Collection
Mr. and Mrs. Paul Mellon, 1983.1.23
© 1997 Artists Rights Society (ARS), New
York/ADAGP, Paris

6.21
Joan Miró
The Childhood of Ubu, ca. 1970
Watercolor and colored pencil on paper
19⅞ x 12 in. (32.5 x 50 cm)
Galerie Marwan Hoss, Paris
© 1997 Artists Rights Society (ARS), New
York/ADAGP, Paris

6.22
Joan Miró
The Childhood of Ubu, ca. 1970
Wash and colored pencil on paper
19⅞ x 12 in. (32.5 x 49.5 cm)
Galerie Marwan Hoss, Paris
© 1997 Artists Rights Society (ARS), New
York/ADAGP, Paris

Chapter 7. The Strategic Childhood of Jean Dubuffet

(All the children's drawings in this chapter are from the collection of Jean Dubuffet, and are currently housed in the Collection de l'Art Brut, Lausanne. They are designated by an AB number.)

7.1
Jean Dubuffet
Peasant and His Village, February 1943
Oil on canvas
23⅝ x 28¾ in. (60 x 73 cm)
Private Collection, Courtesy Donald Morris Gallery, Inc., Bermingham, Michigan
© 1997 Artists Rights Society (ARS), New York/ADAGP, Paris

7.2
Child's drawing
Gouache on paper
11 4/5 x 8 in. (30 x 20.3 cm)
AB763.68

7.3
Child's drawing
Gouache on paper
12½ x 9 4/5 in. (32 x 25 cm)
AB763.9

7.4
Child's drawing
Gouache on paper
6¾ x 8¾ in. (17 x 22 cm)
AB763.78

7.5
Child's drawing
Gouache on paper
15¾ x 12¾ in. (40 x 32.5 cm)
AB763.81

7.6
Child's drawing, May 1939
Gouache on paper
12⅖ x 9 in. (31.5 x 22.8 cm)
AB705.9

7.7
Jean Dubuffet
Blissful Countryside, August 1944
Oil on canvas
50¾ x 34 in. (130 x 97 cm)
Musée nationale d'art moderne, Centre Georges Pompidou, Paris
© 1997 Artists Rights Society (ARS), New York/ADAGP, Paris

7.8
Jean Dubuffet
View of Paris: Life of Pleasure, February 1944
Oil on canvas
35 x 45¾ in. (88.5 x 116 cm)
Private collection, New York
© 1997 Artists Rights Society (ARS), New York/ADAGP, Paris

7.9
Child's drawing
Gouache on paper
6¾ x 8¾ in. (17.5 x 22 cm)
AB763.3

7.10
Child's drawing
Gouache on paper
8 x 11 4/5 in. (20.5 x 30 cm)
AB763.76

7.11
Child's drawing
Gouache on paper
9½ x 13½ in. (24.3 x 34.5 cm)
AB705.2

7.12
Jean Dubuffet
Jazz Band (Black Chicago), December 1944
Oil on canvas
38⅛ x 51⅛ in. (97 x 130 cm)
Kunstsammlung Nordrhein-Westfalen, Düsseldorf
© 1997 Artists Rights Society (ARS), New York/ADAGP, Paris

7.13
Jean Dubuffet
Arab and Palm Trees, January 1948
Crayon on paper
12½ x 9¼ in. (32 x 23.7 cm)
Musée Nationale d'Art Moderne, Centre Georges Pompidou, Paris, Donation Daniel Cordier
© 1997 Artists Rights Society (ARS), New York/ADAGP, Paris

7.14
Jean Dubuffet
Small Sneerer, March 1944
Oil on canvas
21¾ x 18¼ in. (55.2 x 46.4 cm)
Art Institute of Chicago, Lindy and Edward Bergman Collection
© 1997 Artists Rights Society (ARS), New York/ADAGP, Paris

7.15
Child's drawing
Gouache on paper

12⅜ x 8¼ in. (31.5 x 21 cm)
AB763.10

7.16
Child's drawing
Gouache on paper
10¾ x 8¼ in. (27 x 21 cm)
AB763.14

7.17
Child's drawing
Gouache on paper
10¾ x 8¼ in. (27 x 21 cm)
AB763.15

7.18
Child's drawing
Gouache on paper
12 33/8 x 9⅞ in. (31.5 x 25 cm)
AB763.26

7.19
Child's drawing
Gouache on paper
12 1/5 x 9¾ in. (31 x 24.5 cm)
AB763.27

7.20
Child's drawing
Gouache on paper
10¾ x 8¼ in. (27.5 x 21 cm)
AB763.34

7.21
Child's drawing
Gouache on paper
12 1/5 x 9½ in. (31 x 24 cm)
AB763.42

7.22
Child's drawing
Gouache on paper
12 1/5 x 9½ in. (31 x 24 cm)
AB763.46

7.23
Child's drawing
Gouache on paper
12½ x 9⅞ in. (32 x 25 cm)
AB763.50

7.24
Child's drawing
Gouache on paper
10¾ x 8¼ in. (27.5 x 21 cm)
AB763.57

7.25
Child's drawing
Gouache on paper

8.5
Asger Jorn
Untitled, 1943
Pencil and pastel on paper
18 3/8 x 11 3/4 in. (46.8 x 29.9 cm)
Silkeborg Kunstmuseum, The Asger Jorn
Donation (inv. no. 136.1963)
© 1997 The Asger Jorn Foundation,
Kopenhagen

8.6
Asger Jorn
Cover for the pamphlet "Structure et
Changement," Paris, 1956
Silkeborg Kunstmuseum, The Asger Jorn
Donation
© 1997 The Asger Jorn Foundation,

8.7
Asger Jorn
Untitled, 1939
Oil on canvas
24 x 24 in. (61 x 61.2 cm)
Børge Venge, Arhus
© 1997 The Asger Jorn Foundation,
Kopenhagen

8.8
Asger Jorn
Child's Play, 1960
Oil on canvas
51 1/4 x 51 1/4 in. (130 x 130 cm)
Private collection, Denmark
© 1997 The Asger Jorn Foundation,
Kopenhagen

8.9
Asger Jorn
Portrait of Balzac, 1956
Oil on canvas
25 5/8 x 19 5/8 in. (65 x 50 cm)
Collection Otto van de Loo, Munich
© 1997 The Asger Jorn Foundation,
Kopenhagen

8.10
Asger Jorn
Letter to My Son, 1956–57
Oil on canvas
51 1/8 x 76 3/4 in. (130 x 195 cm)
The Tate Gallery, London
© 1997 The Asger Jorn Foundation,
Kopenhagen

8.11
Asger Jorn
The Hanging, 1958
Oil on canvas
38 1/8 x 51 1/8 in. (97 x 130 cm)
Stedelijk Van Abbemuseum, Eindhoven, Nether-
lands

© 1997 The Asger Jorn Foundation,
Kopenhagen

8.12
Asger Jorn
Wall Flowers, 1958
Oil and lacquer on canvas
19 5/8 x 15 3/4 in. (50 x 40 cm)
Galerie van de Loo, Munich
© 1997 The Asger Jorn Foundation,
Kopenhagen

8.13
Asger Jorn
Farewell on the Shores of Death, 1958
Oil on canvas
39 3/8 x 31 1/2 in. (100 x 80 cm)
Galerie van de Loo, Munich
© 1997 The Asger Jorn Foundation,
Kopenhagen

8.14
Asger Jorn
The Bad Year, 1963
Oil on canvas
57 1/2 x 44 7/8 in. (146 x 114 cm)
Städtische Galerie im Lenbachhaus, Munich
© 1997 The Asger Jorn Foundation,
Kopenhagen

8.15
Asger Jorn
One Says So Much, 1968
Oil on canvas
31 7/8 x 25 5/8 in. (81 x 65 cm)
Städtische Galerie im Lenbachhaus, Munich
© 1997 The Asger Jorn Foundation,
Kopenhagen

8.16
Corneille
The Little Elephant, 1950
Pen and ink on paper
8 x 8 7/8 in. (20.4 x 22.6 cm)
Silkeborg Kunstmuseum
© 1997 Artists Rights Society (ARS), New
York/ADAGP, Paris

8.17
Corneille
Untitled, 1950
Pen and ink on paper
9 1/4 x 11 1/8 in. (23.7 x 28.3 cm)
Silkeborg Kunstmuseum
© 1997 Artists Rights Society (ARS), New
York/ADAGP, Paris

8.18
Corneille
*The Man Who Planted the First Flower on the
Moon*, 1950
Tusche on paper
8 7/8 x 8 7/8 in. (22.7 x 22.5 cm)

Silkeborg Kunstmuseum
© 1997 Artists Rights Society (ARS), New
York/ADAGP, Paris

8.19
Corneille
The Happy Rhythms of the City, 1949
Oil on canvas
23 x 19 1/4 in. (58.5 x 49 cm)
Stedelijk Museum, Amsterdam
© 1997 Artists Rights Society (ARS), New
York/ADAGP, Paris

8.20
Constant
Faun, 1949
Oil on canvas
27 1/2 x 33 1/2 in. (70 x 85 cm)
Private collection, Bern
© 1997 Estate of Constant/Licensed by VAGA,
New York, NY

8.21
Constant
Festival of Sadness, 1949
Oil on canvas
33 1/2 x 43 1/4 in. (85 x 110 cm)
Museum Boymans-van Beuningen, Rotterdam
© 1997 Estate of Constant/Licensed by VAGA,
New York, NY

8.22
Constant
Freedom Belongs to Us, 1949
Oil on canvas
54 7/8 x 42 1/8 in. (139.5 x 107 cm)
The Tate Gallery, London
© 1997 Estate of Constant/Licensed by VAGA,
New York, NY

8.23
Karel Appel
Wooden Cat, 1947
Gouache on wood
4 3/4 x 20 7/8 x 4 3/4 in. (12 x 53 x 12 cm)
Private collection
© 1997 Karel Appel Foundation/Licensed by
VAGA, New York, NY

8.24
Karel Appel
Totem Pole, 1948
Gouache on wood
33 1/8 x 9 1/2 x 3 7/8 in. (84 x 24 x 10 cm)
Private collection
© 1997 Karel Appel Foundation/Licensed by
VAGA, New York, NY

8.25
Karel Appel
Questioning Children, 1949
Gouache on wood

41 x 26 3/8 in. (104 x 67 cm)
Stedelijk Museum, Amsterdam
© 1997 Karel Appel Foundation/Licensed by
VAGA, New York, NY

8.26
Karel Appel
Questioning Children, 1949
Gouache on wood
42 x 23 1/8 in. (106.7 x 58.7 cm)
Private collection
© 1997 Karel Appel Foundation/Licensed by
VAGA, New York, NY

8.27
Karel Appel
Questioning Child, 1950
Gouache on wood
18 1/8 x 6 1/8 x 2 1/8 in. (46 x 15.3 x 5.7 cm)
Private collection
© 1997 Karel Appel Foundation/Licensed by
VAGA, New York, NY

8.28
Karel Appel
Child with a Donkey, 1949
Oil on canvas
27 1/2 x 61 in. (70 x 155 cm)
Private collection
© 1997 Karel Appel Foundation/Licensed by
VAGA, New York, NY

8.29
Karel Appel
Woman and Man, 1952
Oil on canvas
39 x 63 3/4 in. (99.1 x 161.9 cm)
Private collection
© 1997 Karel Appel Foundation/Licensed by
VAGA, New York, NY

8.30
Karel Appel
Woman and Horse, 1952
Oil on canvas
44 1/2 x 66 7/8 in. (113 x 170 cm)
Private collection
© 1997 Karel Appel Foundation/Licensed by
VAGA, New York, NY

8.31
Child's drawing
4 3/8 x 6 3/4 in. (11.2 x 17.3 cm)
Collection of Karel Appel

8.32
Child's drawing
3 1/2 x 4 3/8 in. (8.9 x 11 cm)
Collection of Karel Appel

8.33
Karel Appel

Child on a Hobby Horse, 1949
Oil on canvas
29 1/2 x 25 5/8 in. (75 x 65 cm)
Private collection
© 1997 Karel Appel Foundation/Licensed by
VAGA, New York, NY

8.34
Karel Appel
Animals of the Night, 1948
Fabric and oil on cardboard
23 1/4 x 21 5/8 in. (59 x 55 cm)
Private collection
© 1997 Karel Appel Foundation/Licensed by
VAGA, New York, NY

8.35
Eugène Brands
Angry Fish, 1951
Oil on canvas
23 5/8 x 27 1/2 in. (60 x 70 cm)
Museum Van Bommel-Van Dam, Venlo
© 1997 Eugène Brands

8.36
Eugène Brands
Falling Moon, 1951
Gouache on paper
17 1/2 x 18 1/2 in. (44.5 x 47 cm)
Museum Van Bommel-Van Dam, Venlo
© 1997 Eugène Brands

8.37
Eugénie Brands (age 4 1/2)
Portrait of Mama, 27 December 1951
Gouache on paper
9 1/2 x 9 7/8 in. (24 x 25 cm)
Collection Eugène Brands, Amsterdam

8.38
Eugénie Brands (age 5 1/2)
Woman with Exotic Hat, 28 September 1952
Gouache on paper
11 x 11 1/4 in. (28 x 28.5 cm)
Collection Eugène Brands, Amsterdam

8.39
Eugénie Brands (age 5 1/2)
The Purple Doll Carriage, 1 October 1952
Gouache on paper
11 x 9 in. (28 x 23 cm)
Collection Eugène Brands, Amsterdam

8.40
Eugénie Brands (age 4 1/2)
Dad in Red Painting Shirt at the Easel,
27 December 1951
Gouache on paper
9 7/8 x 14 1/8 in. (25 x 36 cm)
Collection Eugène Brands, Amsterdam

8.41
Lucebert
In Egypt, 1962
Oil on canvas
45 1/4 x 57 in. (115 x 145 cm)
Stedelijk Museum, Amsterdam

Chapter 9. Mainstreaming Childhood

9.1
Jackson Pollock
Number One, 1948
Oil on canvas
68 x 104 in. (172.7 x 264.2 cm)
Museum of Modern Art, New York
© 1997 Pollock-Krasner Foundation/Artists
Rights Society (ARS), New York

9.2
David Smith
Horse, 1961
Sterling silver
13 5/8 x 7 3/4 x 2 1/4 in. (34.6 x 19.6 x 5.7 cm)
Collection of Rebecca Smith, New York
© 1997 Estate of David Smith/Licensed by
VAGA, New York, NY

9.3
David Smith
Becca, 1965
Stainless steel
9 feet, 5 1/4 in. x 10 feet, 3 in. x 2 feet, 6 1/2 in.
(287.7 x 312.4 x 77.5 cm)
Metropolitan Museum of Art, purchase,
Bequest of Adelaide Milton de Groot (1876–
1967), by exchange, 1972 (1972.127)
© 1997 Estate of David Smith/Licensed by
VAGA, New York, NY

9.4
David Smith
Study for Becca
Paper collage, framed with markings on glass
by the artist
Metropolitan Museum of Art, Purchase, Roy R.
and Mary S. Newberger Foundation and
anonymous gift, 1978 (1978.410)
© 1997 Estate of David Smith/Licensed by
VAGA, New York, NY

9.5
Mark Rothko
Green and Tangerine on Red, 1956
Oil on canvas
93 1/2 x 69 1/8 in. (237.5 x 175.6 cm)

The Phillips Collection, Washington, D.C.
© 1997 Kate Rothko-Prizel & Christopher
Rothko/Artists Rights Society (ARS), New York

9.6
Elizabeth Murray
Joanne in the Canyons, Fall-Winter 1990–91
Oil on canvas
78 x 84 x 6^1/$_2$ in. (198.1 x 213.4 x 16.5 cm)
Collection S. I. Newhouse, New York

9.7
Daisy Murray-Holman (age 4^1/$_2$)
Empire State Building, 1990
Crayon on paper
12 x 9 in. (30.5 x 22.9 cm)
Collection Daisy Murray-Holman

9.8
Child's drawing
Pencil on paper
24 x 18 in. (60.9 x 45.7 cm)
Collection Donald Baechler, New York

9.9
Elsie Dolliver (Donald Baechler's grandmother)
Untitled
Pencil on paper
12 x 9 in. (45.7 x 30.5 cm)
Collection Donald Baechler, New York

9.10
Anonymous
Ruchy Number Book, single page (Delhi:
Indian Book Depot)
Collection Donald Baechler, New York

9.11
Donald Baechler
Balzac, 1989
Acrylic, oil, collage on linen
9 feet, 3 in. x 9 feet, 3 in. (281.9 x 281.9 cm)
Collection Julian Schnabel, New York

9.12
Francesco Clemente
Untitled, 1985
Pastel on paper
26 x 19 in. (66 x 48 cm)
Collection Bruno Bischofberger, Zurich

9.13
A. R. Penck
Ralf, 1962
Oil on canvas
48^1/$_2$ x 52^3/$_4$ in. (123.5 x 134 cm)
Galerie Michael Werner, Cologne

9.14
Terry Winters (age 8)
Untitled, 1957
12 x 18 in. (30.5 x 45.7 cm)

Graphite, chalk and charcoal on paper
Collection Terry Winters

9.15
Terry Winters
Numeral, 1985
Oil on canvas
58 x 40 in. (147.3 x 101.6 cm)
Courtesy Sonnabend Gallery, New York

9.16
Julian Schnabel
Matador on a Stick, 1983
Oil on tarpaulin
11 x 8 feet (335 x 244 cm)
Collection Bruno Bischofberger, Zurich

9.17
Jacqueline Beaurang Schnabel
I'm Looking at a Frog, 29 October 1962
Crayon on paper
Collection Julian Schnabel, New York

9.18
Keith Haring, in collaboration with Sean Kalish
(age 9)
Untitled, 1989
Etching, from a suite of 11
8 x 8 in. (20.3 x 20.3 cm)
Keith Haring Foundation, New York

9.19
Jean-Michel Basquiat
*The Revised Undiscovered Genius of the
Mississippi Delta*, 1983
Acrylic and oil stick on canvas
78 x 156^1/$_2$ in. (198.1 x 397.5 cm)
Private collection
© 1997 Artists Rights Society (ARS), New
York/ADAGP, Paris

9.20
Jean-Michel Basquiat, in collaboration with
Cora Bischofberger (age 4–5)
Untitled, 1984
Acrylic on canvas
47^1/$_4$ x 47^1/$_4$ in. (120 x 120 cm)
Collection Bruno Bischofberger, Zurich
© 1997 Artists Rights Society (ARS), New
York/ADAGP, Paris

9.21
Jean-Michel Basquiat
Empire, ca. 1980
Oil stick on linen
57^3/$_4$ x 16^2/$_3$ in. (147 x 42.5 cm)
Andrea Caratsch, Zurich
© 1997 Artists Rights Society (ARS), New
York/ADAGP, Paris

9.22
Joseph Beuys

Eurasia, 34th Section of the Siberian Symphony,
photograph of the objects after the end of the
performance at Gallery 101, Copenhagen,
15 October 1966, photographer unknown.
© 1997 Artists Rights Society (ARS),
New York/VG Bild-Kunst, Bonn

9.23
Claes Oldenburg (age 11)
Collage of Airplane
Collection Claes Oldenburg

9.24
Claes Oldenburg
Ray Gun Poster (Airplane), 1959
Monotype with tusche
23^7/$_8$ x 17^7/$_8$ in. (60.5 x 45.4 cm)
Öffentliche Kunstsammlung, Basel,
Kupferstichkabinett

9.25
Alice Aycock
The Machine that Makes the World, 1979
Wood and steel
12 x 8 x 38 feet (365.8 x 243.8 x 1158 cm)
Sheldon Memorial Art Gallery, University of
Nebraska at Lincoln, Gift of the artist and Klein
Gallery

9.26
Jonathan Borofsky
Mom, I Lost the Election at 1,933,095, 1972
Oil on canvasboard
16 x 40 in. (40.6 x 101.6 cm)
Collection Paula Cooper, New York

9.27
David Hockney
Cruel Elephant, 1962
Oil on canvas
48 x 60 in. (122 x 153 cm)
Private collection

9.28
Photograph of a child's drawing from an essay
by Bruno Bettelheim in *Scientific American* on
which the Johns paintings are based

9.29
Jasper Johns
Untitled, 1991
Oil on canvas
60 x 40 in. (152.4 x 101.6 cm)
Collection Jasper Johns, photo courtesy
Anthony d'Offay Gallery, London, A010043
© 1997 Jasper Johns/Licensed by VAGA,
New York, NY

9.30
Jasper Johns
Untitled, 1991
Encaustic on canvas

60 x 40 in. (152.4 x 101.6 cm)
Collection Jasper Johns, photo courtesy
Anthony d'Offay Gallery, London, A011240
© 1997 Jasper Johns/Licensed by VAGA,
New York, NY

9.31
Jasper Johns
Untitled, 1991–94
Oil on canvas
60¼ x 40 in. (153 x 101.5 cm)
Collection Jasper Johns, photo courtesy
Anthony d'Offay Gallery, London, A010042
© 1997 Jasper Johns/Licensed by VAGA,
New York, NY

Bibliography of Works Cited

Adorno, Theodor. *Minima Moralia: Reflections from Damaged Life*. 1951. London: Verso, 1978.

Apollinaire, Guillaume. *Apollinaire on Art: Essays and Reviews, 1902–1918*. Ed. L.-C. Breunig; trans. Susan Suleiman. New York: Viking, Documents of 20th Century Art, 1972.

Ashton, Dore. *About Rothko*. New York: Oxford University Press, 1983.

———. *Picasso on Art*. New York: Viking, 1972.

Atkins, Guy. *Asger Jorn, The Crucial Years: 1954–1964*. London: Lund Humphries, 1977.

———. *Jorn in Scandinavia, 1930–1953*. London: Lund Humphries, 1968.

Bakst, Leon. "Puti klassitsizma v iskusstve." *Apollon*, no. 2 (November 1909), 63–78.

Ball, Hugo. *Flight Out of Time: A Dada Diary*. New York: Viking, 1974.

Barr, Alfred H., Jr. *Matisse, His Art and His Public*. New York: Museum of Modern Art, 1951.

Barris, Roann. "Chaos By Design: The Constructivist Stage and Its Reception." Ph.D. dissertation. Urbana-Champaign: University of Illinois, 1994.

Barthes, Roland. *L'obvie et l'obtus*. Paris: Editions du Seuil, Collection "Tel Quel," 1982.

Baudelaire, Charles. *Oeuvres Complètes*. Paris: Gallimard, 1961.

Benua, Aleksandr. "Vystavka 'Iskusstva v shizne rebenka.'" *Rech* (26 November 1908).

Berger, John. *The Success and Failure of Picasso*. Harmondsworth, England: Penguin Books, 1965.

Bernadac, Marie-Laure, Isabelle Monod-Fontaine, and David Sylvester, eds. *Late Picasso: Paintings, Sculpture, Drawings, Prints*. London: Tate Gallery; Paris: Musée National-d'Art Moderne, 1988.

Bernstein, Roberta. *Jasper Johns*. New York: Rizzoli, 1992.

Birtwistle, Graham. *Living Art: Asger Jorn's Comprehensive Theory of Art between Helhesten and Cobra, 1946–1949*. Utrecht: Reflex, 1986.

———. "Primitivism of the Left: Helhesten, Cobra and Beyond." In Foundation Cobra and the National Fund De Nieuwe Kerk. *Cobra 40 Years After*. Amsterdam: Sdu Publishers, 1988.

Boas, George. *The Cult of Childhood*. London: Studies of the Warburg Institute, vol. 29, 1966.

Boggs, Jean Sutherland. *Picasso and Things*, exhibition catalogue. Cleveland: Cleveland Museum of Art, 1992.

Bowlt, John E. "Esoteric Culture and Russian Society." In Maurice Tuchman, ed., *The Spiritual in Art: Abstract Painting 1890–1985*. Los Angeles: County Museum of Art; New York: Abbeville Press, 1986.

———. *Russian Art 1875–1975: A Collection of Essays*. New York: MSS Information Corp., 1976.

———. *Russian Art of the Avant-Garde, Theory and Criticism 1902–1934*. New York: Viking, 1976.

Brassaï. *Picasso & Co*. London: Thames and Hudson, 1967.

Breton, André. *Le Surréalisme et la peinture*. New York: Brentano, 1945.

Broome, Peter. *Henri Michaux*. London, 1977.

Burlyuk, David. "Kubizm." *Poshchechina obshchestvennomu vkusu*. Moscow, December 1912.

Caffin, Charles. *How to Study the Modern Painters*. New York: Century Co., 1914.

Castagnary, Jules. *Salons (1857–1870)*, vol. I. Paris: G. Charpentier, 1892.

Cézanne, Paul. *Souvenirs sur Paul Cézanne*. Paris: Michel, n.d.

Clearwater, Bonnie. *Mark Rothko: Works on Paper*. New York: Hudson Hills Press, 1984.

Cobra 1948–1951. Paris: Editions Jean-Michel Place, 1980.

Coleridge, Samuel Taylor. *The Collected Works of Samuel Taylor Coleridge*, vol. 7, *Biographia Literaria*. Eds. James Engell and W. J. Bate. Princeton, N.J.: Princeton University Press, 1982.

Compton, Susan P. *The World Backwards: Russian Futurist Books 1912–16*. London: British Museum, 1978.

Cooke, Susan J. "Jean Dubuffet's Caricature Portraits." In James T. Demetrion, *Jean Dubuffet 1943–1963*, exhibition catalogue. Washington: Hirshhorn Museum and Sculpture Garden, 1993.

Corot raconté par lui-même et par ses amis, vol. I. Vésenaz and Geneva: Pierre Cailler, 1946.

Cowling, Elizabeth, and John Golding. *Picasso: Sculptor/Painter*, exhibition catalogue. London: Tate Gallery, 1994.

Daix, Pierre. *Picasso: Life and Art*. New York: Harper Collins, Icon Editions, 1993.

Däubler, Theodor. "Paul Klee." *Das Kunstblatt* 2 (1918), 24–27.

Daulte, François, et al. *Larionov Goncharova Rétrospective*. Brussels: Musée d'Ixelles, 1976.

Demetrion, James T. *Jean Dubuffet 1943–1963*, exhibition catalogue. Washington: Hirshhorn Museum and Sculpture Garden, 1993.

Denis, Maurice. *Théories, 1890–1910, du symbolisme et de Gauguin vers un nouvel ordre classique*. 4ème ed. Paris: L. Rouart et J. Watelin, 1920.

Derain, André. *Lettres à Vlaminck*. Paris, 1955.

Diehl, Gaston. *Henri Matisse*. Paris: Pierre Tisné, 1954.

Dubuffet, Jean. *Anti-Cultural Positions*. Trans. Joachim Neugroschel. In Mildred Glimcher, *Jean Dubuffet: Towards an Alternative Reality*. New York: Abbeville Press, 1987.

———. "L'Art Brut préféré aux arts culturels." October 1949. In Jean Dubuffet, *Prospectus et tous écrits suivants*, vol. I. Paris: Gallimard, 1967.

———. *Asphyxiating Culture and Other Writings*. Trans. Carol Volk. New York: Four Walls Eight Windows, 1988.

———. "Mémoire sur le développement des mes travaux à partir de 1952." 1957. In Jean Dubuffet, *Prospectus et tous écrits suivants*, vol. II. Paris: Gallimard, 1967. In English: "Memoir on the Development of My Work from 1952." Trans. Louise Varèse. In Peter Selz, *The Work of Jean Dubuffet*. New York: Museum of Modern Art, 1962.

———. Preface. *l'hourloupe*, exhibition catalogue. Paris: Galerie Jean Bucher, 1964. In

Mildred Glimcher, *Jean Dubuffet: Towards an Alternative Reality*. New York: Abbeville Press, 1987.

———. *Prospectus et tous écrits suivants*, 2 vols. Paris: Gallimard, 1967.

———. "Rough Draft for a Popular Lecture on Painting." 1945. Trans. Joachim Neugroschel. In Mildred Glimcher, *Jean Dubuffet: Towards an Alternative Reality*. New York: Abbeville Press, 1987.

Duchamp, Marcel. *Notes*. Trans. Paul Matisse. Boston: G. K. Hall, Documents of 20th Century Art, 1983.

Duncan, David Douglas. *The Private World of Pablo Picasso*. New York: Ridge Press, 1958.

Dupin, Jacques. *Joan Miró: Life and Work*. New York: Harry N. Abrams, 1962.

Eitner, Lorenz. "Kandinsky in Munich." *Burlington Magazine* 99, no. 651 (June 1957), 193–99.

Elderfield, John. *Henri Matisse: A Retrospective*. New York: Museum of Modern Art, 1992.

———. *Matisse in the Collection of the Museum of Modern Art*. New York: Museum of Modern Art, 1978.

Ernst, Max. *Beyond Painting*. New York: Wittenborn, Schultz, Inc., 1948.

Fineberg, Jonathan. *Art Since 1940: Strategies of Being*. London: Laurence King, 1994; Englewood Cliffs, N.J.: Prentice-Hall and New York: Harry N. Abrams, 1995.

———. *When We Were Young: The Art of the Child*, exhibition catalogue, forthcoming.

Fineberg, Jonathan, ed. *Discovering Child Art: Essays on Childhood, Primitivism, and Modernism*. Princeton, N.J.: Princeton University Press, forthcoming.

———. *Les Tendances Nouvelles*, facsimile edition in 4 volumes. New York: Da Capo, 1980.

Flam, Jack, ed. *Matisse: A Retrospective*. New York: Hugh Lanter Levin Associates, 1988.

Flam, Jack. *Matisse: The Man and His Art, 1869–1918*. Ithaca and London: Cornell University Press, 1986.

Flomenhaft, Eleanor. *The Roots and Development of Cobra Art*. Hempstead, New York: Fine Art Museum of Long Island, 1985.

Francis, Richard. *Jasper Johns*. New York: Abbeville Press, 1984.

Franciscono, Marcel. *Paul Klee: His Work and Thought*. Chicago: University of Chicago Press, 1991.

Friedman, Martin. *Hockney Paints the Stage*, exhibition catalogue. Walker Art Center, Minneapolis; New York: Abbeville Press, 1983.

———. *Oldenburg: Six Themes*, exhibition catalogue. Minneapolis: Walker Art Center, 1975.

Friedrich, Caspar David. *Caspar David Friedrich in Briefen und Bekenntnissen*. Ed. Sigrid Hinz. Munich: Rogner and Bernhard, 1968.

Fry, Stefan, and Josef Helfenstein, eds. *Paul Klee: Das Schaffen im Todesjahr*, exhibition catalogue. Bern: Kunstmuseum, 1990.

Fuller, Peter. "Jasper Johns Interviewed," part II. *Art Monthly* 19 (September 1978).

Gabler, Karlheinz. *E. L. Kirchner Dokumente*. Aschaffenburg: Museum der Stadt Aschaffenburg, 1980.

Gabo, Naum. *Of Divers Arts*. Bollingen series 11:XXXV. Princeton, N.J.: Princeton University Press, 1962.

Gallwitz, Klaus. *Picasso: The Heroic Years*. New York: Abbeville Press, 1985.

Gauguin, Paul. *Intimate Journals*. Trans. Van Wyck Brooks. New York: Crown Publishers, 1936.

———. *Oviri, écrits d'un sauvage*. Ed. Daniel Guérin. Paris: Gallimard, 1974.

———. *Noa Noa*. Trans. O. F. Theis. New York: Noonday Press, 1957.

Gautier, Théophile. "Du beau dans l'art." *L'art moderne*. Paris, 1856.

Geelhaar, Christian. "Journal intime oder Autobiographie? Über Paul Klees Tagebücher." In *Paul Klee Das Frühwerk 1883–1922*, exhibition catalogue. Munich: Städtische Galerieim Lenbechhaus, 1980.

Geist, H.-F. "Schöpferische Erziehung." *Bauhaus* 3, no. 3 (July-September 1929), 17–19.

George, Waldemar. *Larionov*. Paris: La Bibliothèque des Arts, 1966.

Georgel, Pierre. "L'Enfant au Bonhomme." In Klaus Gallwitz and Klaus Herding, eds., *Malerei und Theorie: Das Courbet-Colloquium 1979.* Frankfurt am Main: Städelschen Kunstinstitut, 1980, 105–115.

Glaesemer, Jürgen. *Paul Klee: Handzeich-nungen I.* Bern: Kunstmuseum, 1973.

Glimcher, Mildred. *Jean Dubuffet: Towards an Alternative Reality.* New York: Abbeville Press, 1987.

Golding, John. *Duchamp: The Bride Stripped Bare by Her Bachelors, Even.* New York: Viking, 1972.

Goldwater, Robert. *Primitivism in Modern Art.* Enlarged ed. Cambridge: Harvard University Press, 1986.

Gould, Stephen Jay. *The Mismeasure of Man.* New York and London: W. W. Norton, 1981.

Gray, Camilla. *The Great Experiment: Russian Art, 1863–1922.* London: Thames and Hudson, 1962.

Grisebach, Lothar, ed. *Maler des Expressionismus im Briefwechsel mit Eberhard Grisebach.* Hamburg: Christian Wegner Verlag, 1962.

Grohmann, Will. *E. L. Kirchner.* New York: Arts Inc., 1961.

Guro, Elena. *Nebesnye verbliuzhata.* St. Petersburg, 1914.

Hartrick, A. S. *A Painter's Pilgrimage Through Fifty Years.* Cambridge, England: The University Press, 1939.

Helfenstein, Josef. "Das Spätwerk als 'Vermächtnis.'" In Stefan Fry and Josef Helfenstein, eds., *Paul Klee: Das Schaffen im Todesjahr,* exhibition catalogue. Bern: Kunstmuseum, 1990.

Heller, Reinhold. "Expressionism's Ancients." In Maurice Tuchman and Carol S. Eliel, eds., *Parallel Visions: Modern Artists and Outsider Art.* Los Angeles: Los Angeles County Museum of Art; Princeton, N.J.: Princeton University Press, 1992.

Herbert, Robert L., ed. *The Art Criticism of John Ruskin.* New York: Doubleday, 1964.

Hogg, Thomas Jefferson. *The Life of Percy Bysshe Shelley,* vol. 1. London: E. Moxon, 1858.

Howard, Jeremy. *The Union of Youth: An Artists' Society of the Russian Avant-Garde.* Manchester: Manchester University Press; New York: St. Martin's Press, 1992.

Ives, Colta, Helen Giambruni, and Sasha M. Newman. *Pierre Bonnard: The Graphic Art.* New York: Metropolitan Museum of Art and Harry N. Abrams, 1989.

Jakobson, Roman. "Art and Poetry: The Cubo-Futurists." In Stephanie Barron and Maurice Tuchman, eds., *The Avant-Garde in Russia, 1910–1930: New Perspectives.* Los Angeles: Los Angeles County Museum of Art; Cambridge, Mass.: MIT Press, 1980.

Jefferson, Thomas. *Thomas Jefferson: Writings.* Ed. Merrill Peterson. New York: Library of America, 1984.

Jensen, Kjeld Bjornager. *Russian Futurism, Urbanism and Elena Guro.* Denmark, 1977.

Kamensky, Vasily. *Devushki bosikom.* Tiflis, 1916.

Kandinsky, Vasily. "Content and Form." Introduction to *Salon 2,* exhibition catalogue. Ed. Vladimir Izdebsky. Odessa, 1910–11. In Kenneth C. Lindsay and Peter Vergo, eds., *Kandinsky: Complete Writings on Art,* vol. 1. Boston: G. K. Hall, Documents of 20th Century Art, 1982.

———. "Franz Marc." *Cahiers d'Art.* Paris, 1936. In Kenneth C. Lindsay and Peter Vergo, eds., *Kandinsky: Complete Writings on Art,* vol. 2. Boston: G. K. Hall, Documents of 20th Century Art, 1982.

———. "La Synthèse des arts." *Écrits complets,* vol. 3. Ed. Phillipe Sers. Paris, 1975.

———. "On the Question of Form." In Vasily Kandinsky and Franz Marc, eds., *The Blue Rider Alamanac.* 1912. New documentary ed., ed. Klaus Lankheit. New York: Viking, Documents of 20th Century Art, 1974.

———. *On the Spiritual in Art.* 2d ed. Munich, 1912. In Kenneth C. Lindsay and Peter Vergo, eds., *Kandinsky: Complete Writings on Art,* vol. 1. Boston: G. K. Hall, Documents of 20th Century Art, 1982.

Kennedy, Janet. *The "Mir iskusstva" Group and Russian Art.* New York: Garland, 1977.

Kerschensteiner, Georg. *Die Entwicklung der zeichnerischen Begabung.* Munich: Verlag Carl Gerber, 1905.

Khlebnikov, Velimir. *Riav Perchatki 1908–1914.* St. Petersburg: 1914.

———. *Sadok sudei.* St. Petersburg, April 1910.

———. *Sadok sudei 2.* St. Petersburg, February 1913.

Kirchner, E.-L. *E. L. Kirchners Davoser Tagebuch.* Ed. Lothar Grisebach. Cologne: DuMont, 1968.

Klee, Felix. *Paul Klee.* New York: Braziller, 1962.

Klee, Paul. *Beiträge zur bildnerischen Formlehre, Faksimilierte Ausgabe des Originalmanuskripts von Paul Klees erstem Vortragszyklus am staatlichen Bauhaus Weimar 1921–22.* Ed. Jürgen Glaesemer. Basel and Stuttgart: Schwabe, 1979.

———. *Briefe an die Familie,* Band 1, 1893–1906. Ed. Felix Klee. Cologne: DuMont, 1979.

———. "Creative Credo." In Norbert Guterman, *The Inward Vision: Watercolors, Drawings and Writings by Paul Klee.* New York: Harry N. Abrams, 1959.

———. *The Diaries of Paul Klee 1898–1918.* Ed. Felix Klee. London: Peter Owen; Berkeley and Los Angeles: University of California, 1965.

———. "Schöpferische Konfession." In Kasimir Edschmid, *Tribune der Kunst und Zeit XIII.* Berlin: Erich Reiss, 1920.

———. *Tagebücher 1898–1918,* textkritische Neuedition. Ed. Wolfgang Kersten. Stuttgart: Verlag Gert Hatje; Teufen: Verlag Arthur Niggli, 1988.

———. *The Thinking Eye: The Notebooks of Paul Klee.* Ed. Jürg Spiller; trans. Paul Mannheim with Dr. Charlotte Weidler and Joyce Wittenborn. New York: Wittenborn, 1961.

Köllner, Sigrid. "Der Blaue Reiter und die 'Vergleichende Kunstgeschichte.'" Ph.D. dissertation. Karlsruhe, 1984.

Kort, Pamela. *Jörg Immendorff: Early Works and Lidl.* New York: Gallery Michael Werner, 1991.

Kovtun, Yevgeny. "Mikhail Larionov i Zhivopisnaia Vyveska." In Jochen Poetter and Eugeniia A. Petrova, eds., *Avangard i ego russkie istochniki.* St. Petersburg: State Russian Museum, 1993.

Kruchenykh, Aleksei. "Novye puti slova." In *Troe*. September 1913.

———. *Porosiata*. St. Petersburg, 1914.

———. *Sobstvennye Razskazy I Risunki Detei*. St. Petersburg, 1914.

Kruchenykh, Aleksei, and Velimir Khlebnikov. *Mirskonsa*. Moscow, 1912.

Kulbin, Nikolai. "Svobodnoe iskusstvo kak osnova zhini." 1908. In *Studija impressionistov*. St. Petersburg: 1910.

Lambert, Jean-Clarence. *Cobra*. New York: Abbeville Press, 1984.

Lane, James. "Three Moderns: Rothko, Gromaire, Solman." *Art News* 38, no. 16 (20 January 1940), 12.

Larionov, Mikhail. *Katalog Vystavki Kartin Gruppy Khudozhnikov Mishen'*. Moscow, 1913.

Laude, André. *Corneille Le Roi-Image*. Paris: Editions S.M.I. Exclusivite Weber, 1973.

Lavin, Irving. *Past-Present: Essays on Historicism in Art from Donatello to Picasso*. Berkeley and Los Angeles: University of California Press, 1992.

Leiris, Michel. "Joan Miró." *Documents*, no. 5 (October 1929), 264–65.

Lodder, Christina. *Russian Constructivism*. New Haven and London: Yale University Press, 1983.

Lombroso, Cesare. *L'homme criminel*. Paris: F. Alcan, 1887.

Loreau, Max. *Catalogue des travaux de Jean Dubuffet*, 38 volumes. Paris: Jean-Jacques Pauvert, 1964–68; Lausanne: Weber, 1969–76; Paris: Les Editions de Minuit, 1979–91.

MacChesney, Clara T. "A Talk with Matisse, Leader of Post-Impressionism." *New York Times Magazine*, 9 March 1913.

MacGregor, John. *The Discovery of the Art of the Insane*. Princeton, N.J.: Princeton University Press, 1989.

Macke, August. "Masks." In Vasily Kandinsky and Franz Marc, eds., *The Blue Rider Alamanac*. 1912. New documentary ed., ed. Klaus Lankheit. New York: Viking, Documents of 20th Century Art, 1974.

Mallarmé, Stéphane. *Oeuvres complètes de Stéphane Mallarmé*. Paris: Bibliothèque de la Pléiade, NRF, 1945.

Marcadé, Valentine. *Le Renouveau de l'art pictural russe 1863–1914*. Lausanne: Editions l'age d'homme, 1971.

Markov, Vladimir. *Russian Futurism: A History*. Berkeley and Los Angeles: University of California Press, 1968.

Mathews, Patricia. *Aurier's Symbolist Art Criticism and Theory*. Ann Arbor: U.M.I. Research Press, 1986.

Matisse, Henri. *Matisse on Art*. Ed. Jack Flam. London: Phaidon Press, 1973.

———. "Looking at Life with the eyes of a child." *Art News and Review* (6 February 1954).

Messer, Thomas M., and Fred Licht. *Jean Dubuffet & Art Brut*, exhibition catalogue. Venice: Peggy Guggenheim Collection & Arnoldo Mondadori Editore, 1986.

Meyerhold, V. E. *Meyerhold on Theatre*. Trans. Edward Braun. New York: Hill and Wang, 1969.

Minardi, Tommaso. "On the Essential Quality of Italian Painting from Its Renaissance to the Period of Its Perfection." 1834. Excerpted in Joshua C. Taylor, ed., *Nineteenth-Century Theories of Art*. Berkeley and Los Angeles: University of California Press, 1987.

Minsky, N. "Filosofskie razgovory." *Mir Isskustva*, no. 6 (1901), 1–16.

Miró, Joan. *Joan Miró: Selected Writings and Interviews*. Ed. Margit Rowell. Boston: G. K. Hall, 1986.

Misler, Nicoletta, and John E. Bowlt, trans. and ed. *Pavel Filonov: A Hero and His Fate*. Austin, Tex.: Silvergirl, 1983.

Nietzsche, Friedrich. *The Birth of Tragedy and the Genealogy of Morals*. Trans. Francis Golffing. New York: Doubleday, 1956.

Nolde, Emil. *Jahre der Kämpfe*. Berlin: Rembrandt-Verlag, 1934.

Norman, Dorothy. *Alfred Stieglitz: An American Seer*. New York: Random House, 1960.

Oldenburg, Claes. *Claes Oldenburg Sculpture and Drawings*, exhibition catalogue.

Stockholm: Moderna Museet, 1966.

Osterwold, Tilman. *Paul Klee, Die Ordnung der Dinge, Bilder und Zitate*, exhibition catalogue. Stuttgart, 1975.

Paley, William. *Natural Theology; or Evidences of the Existence and Attributes of the Deity*. 1802. Ed. Frederick Ferre. Indianapolis: University of Indiana Press, 1964.

Parmelin, Hélène. *Picasso Says*. Trans. Christine Trollope. London: Allen and Unwin, 1969.

Parton, Anthony. *Mikhail Larionov and the Russian Avant-Garde*. Princeton, N.J.: Princeton University Press, 1993.

Paul Klee: Im Zeichen der Teilung. Stuttgart: Staatsgalerie; Düsseldorf: Kunstsammlung Nordrhein-Westfalen, 1995.

Peppiatt, Michael. "The Warring Complexities of Jean Dubuffet." *Art News* 76, no. 5 (May 1977), 68–70.

Perry, Lilla Cabot. "Reminiscences of Claude Monet from 1889 to 1909." *American Magazine of Art* 18, no. 3 (March 1927), .

Picasso, Pablo. *Picasso on Art*. Ed. Dore Ashton. New York: Viking, 1972.

Picon, Gaëton. *Joan Miró: Carnets catalans*, vol. 1. Geneva: Albert Skira, 1976.

Pierce, J. S. *Paul Klee and Primitive Art*. 1961. New York and London: Garland, 1976.

Povelikhina, Alla, and Yevgeny Kovtun. *Russian Painted Shop Signs and Avant-Garde Artists*. Leningrad: Aurora Art Publishers, 1991.

Prakhov, Nikolai. *Stranitsy proshlogo*. Kiev: Derzhavne vidavnitstvo, 1958.

Prinzhorn, Hans. *Bildnerei der Geisteskranken*. 1923. New edition, Heidelberg: Springer-Verlag, 1972. In English: *Artistry of the Mentally Ill*. Trans. Eric von Brockdorff. New York: Springer-Verlag, 1972.

Ragon, Michel. *Dubuffet*. Trans. Haakon Chevalier. New York: Grove Press, 1959.

Richardson, John. *A Life of Picasso: Volume I, 1881–1906*. New York: Random House, 1991.

Rochowanski, L. W. *Die Wiener Jugendkunst: Franz Cižek und seine Pflegestätte*. Vienna, 1946.

Rousseau, Jean-Jacques. *Emile or On Education*. Trans. Allan Bloom. New York: Basic Books, 1979.

Rowell, Margit. *Jean Dubuffet: A Retrospective*. New York: Solomon R. Guggenheim Foundation, 1973.

Rubin, William, ed. *"Primitivism" in 20th Century Art*. New York: Museum of Modern Art, 1984.

Ruskin, John. *The Eagle's Nest* (1872). In E. T. Cook and Alexander Wedderburn, eds. *The Works of John Ruskin*, vol. XXII. London: G. Allen; New York: Logman's, Green, and Co., 1903–12.

———. *The Elements of Drawing* (1857). In E. T. Cook and Alexander Wedderburn, eds. *The Works of John Ruskin*, vol. XV. London: G. Allen; New York: Logman's, Green, and Co., 1903–12.

———. *The Seven Lamps of Architecture* (1849). In E. T. Cook and Alexander Wedderburn, eds. *The Works of John Ruskin*, vol. VIII. London: G. Allen; New York: Logman's, Green, and Co., 1903–12.

Russell, John. "The Shaman as Artist." *New York Times Magazine*, 28 October 1979.

Sabartés, Jaime. *Picasso et Antibes*. Paris: R. Drouin, 1948.

Samaltanos, Katia. *Apollinaire: Catalyst for Primitivism, Picabia, and Duchamp*. Ann Arbor: UMI Research Press, 1984.

Sarab'ianov, Dmitrii. *Russkaia zhivopis'—kontsa 1900-kh do nachala 1910-kh godov*. Moscow, 1971.

Schapiro, Meyer. "Courbet and Popular Imagery." In *Modern Art*. New York: George Braziller, 1978.

Schiff, Gert. *Picasso: The Last Years, 1963–73*. New York: Solomon R. Guggenheim Museum and George Braziller, 1983.

Schiller, Friedrich. *Schillers Werke*, Band 1. Berlin and Weimar: Aufbau-Verlag, Bibliothek Deutscher Klassiker, 1967.

Schmalenbach, Werner. "Drawings of the Late Years." In *Joan Miró: A Retrospective*. New York: Solomon R. Guggenheim Museum, 1987.

Schmidt-Nonne, Lene. "Kinderzeichnungen." *Bauhaus* 3, no. 3 (July–September 1929), 13–16.

Schopenhauer, Arthur. *The World as Will and Representation*, 2 vols. Trans. E.F.J. Payne. New York: Dover, 1966.

Selz, Peter. *The Work of Jean Dubuffet*. New York: Museum of Modern Art, 1962.

Shevchenko, Aleksandr. *Neoprimitivism: Its Theory, Its Potentials, Its Achievements*. Moscow, November 1913. In John E. Bowlt, *Russian Art of the Avant-Garde, Theory and Criticism 1902–1934*. New York: Viking, 1976.

Sigsgaard, Jens. "When Children Draw." *Helhesten* 1, no. 4 (1941), 117ff.

Société des Artistes Indépendants. *Catalogue de la 26ᵐᵉ Exposition*. Paris: 18 Mars au 1ᵉʳ Mai, 1910.

Spies, Werner. *Picasso: Das Plastische Werk*. Stuttgart: Verlag Gerd Hatje, 1983.

Staroseltseva, N., ed. *Revoliutsiia, iskusstvo, deti*. Moscow: Prosveshchenie, 1966–67.

Starr, S. Frederick. "Foreword." *Russian Avant-Garde: 1908–1922*, exhibition catalogue. New York: Leonard Hutton Galleries, 1971.

Stein, Gertrude. *Picasso*. 1938. Boston: Beacon Press, 1959.

Stokvis, Willemijn. *COBRA: An International Movement After the Second World War*. Trans. Jacob C. T. Voorhuis. New York: Rizzoli, 1988.

Stuckey, Charles F. "Monet's Art and the Act of Vision." In John Rewald and Frances Weitzenhoffer, eds., *Aspects of Monet: A Symposium on the Artist's Life and Times*. New York: Harry N. Abrams, 1984.

Tapié, Michel. "Espaces et Expressions." In *Premier bilan de l'art actuel, Le Soleil Noir, Positions*, nos. 3 and 4 (1953).

Thevos, Michel. *Art Brut*. New York: Rizzoli, 1976.

Thiers, Adolphe. "On Naïveté in the Arts." *Le Constitutionnel* (1822). Excerpted in Joshua C. Taylor, ed., *Nineteenth-Century Theories of Art*. Berkeley and Los Angeles: University of California Press, 1987.

Töpffer, Rodolphe. *Réflexions et menus propos d'un peintre génevois*. Genève, 1848.

Tuchman, Maurice, ed. *The Spiritual in Art: Abstract Painting 1890–1945*. Los Angeles: Los Angeles County Museum of Art, 1986.

Tupitsyn, Margarita. "Collaborating on the Paradigm of the Future." *Art Journal* 52, no. 4 (Winter 1993), 18–24.

Vallier, Dora. *L'Intérieur de l'Art*. Paris: Editions du Seuil, 1982.

Van Bruggen, Coosje. *John Baldessari*. New York: Rizzoli, 1990.

Van Gogh, Vincent. *The Letters of Vincent van Gogh*. Greenwich, Conn.: New York Graphic Society, 1958.

Viatte, Germain. *Aftermath: France 1945–54, New Images of Man*, exhibition catalogue. London: Barbican Art Gallery, 1982.

Viola, Wilhelm. *Child Art*. Peoria: Chas. A. Bennett Co., 1944.

———. *Child Art and Franz Cizek*. Vienna: Austrian Red Cross, 1936.

Vlaminck, Maurice. *Dangerous Corner*. 1929. Trans. Michael Ross. London: Elek Books, 1961.

Walden, Herwarth. *Einblick in die Kunst: Expressionismus, Futurismus, Kubismus*. Berlin, 1917.

Waldman, Diane. *Mark Rothko, 1903–1970: A Retrospective*. New York: Harry N. Abrams, 1978.

Wallach, Amei. "Jasper Johns and His Visual Guessing Game." *New York Newsday* (28 February 1991). In *Jasper Johns: 35 Years, Leo Castelli*. New York: Leo Castelli Gallery, 1992.

Werckmeister, O. K. "The Issue of Childhood in the Art of Paul Klee." *Arts Magazine* 52, no. 1 (September 1977), 138–51.

———. "Die Porträtphotographien der Zürcher Argentur Photopress aus Anlass des sechzigsten Geburtstages von Paul Klee am 18. Dezember 1939." In Stefan Fry and Josef Helfenstein, eds., *Paul Klee: Das Schaffen im Todesjahr*, exhibition catalogue. Bern: Kunstmuseum, 1990.

———. *Versuche über P. Klee*. Frankfurt am Main: Syndikat, 1981.

Wordsworth, William. "My heart leaps up when I behold." In Stephen Gill, ed. *William Wordsworth*. New York and London: Oxford University Press, 1984.

Jonathan Fineberg is Professor of Art History and University Scholar at the University of Illinois, Urbana-Champaign. He has won numerous awards, including the Pulitzer Fellowship in Critical Writing and the National Endowment for the Arts Art Critic's Fellowship. Fineberg has curated major exhibitions in the United States and Europe and has published widely on modern art. His most recent book is *Art since 1940: Strategies of Being*.

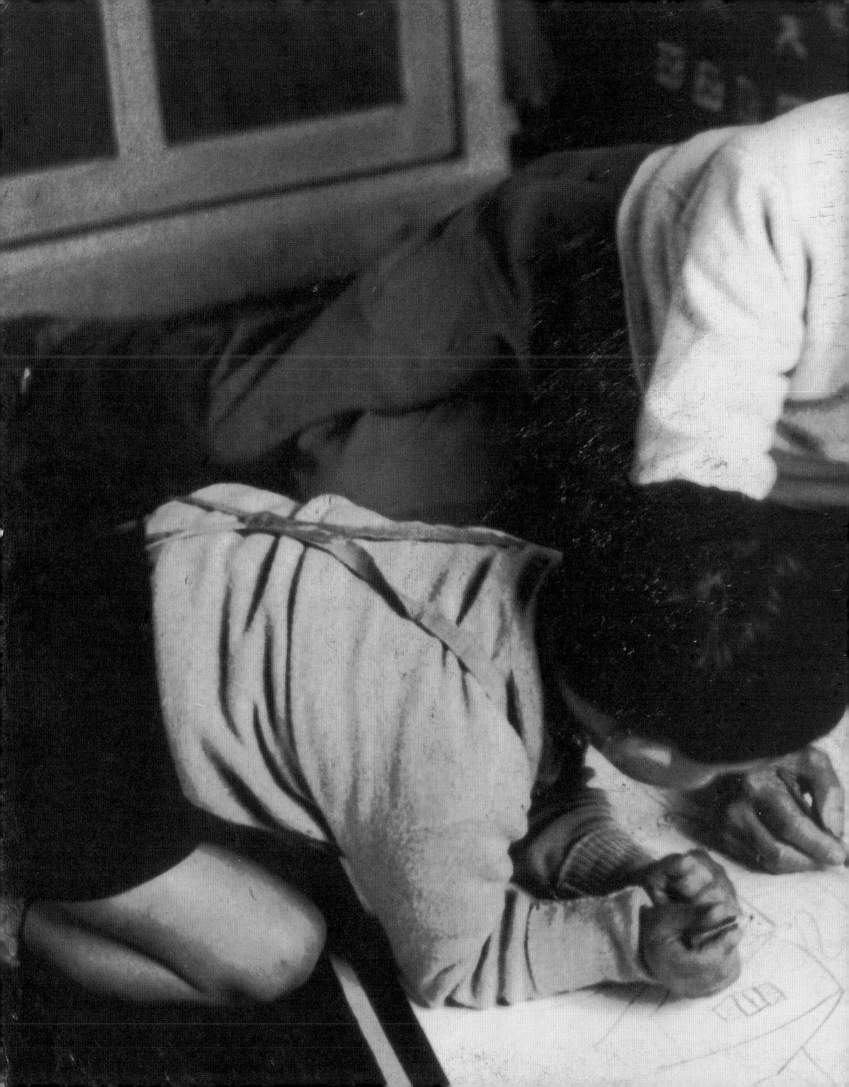

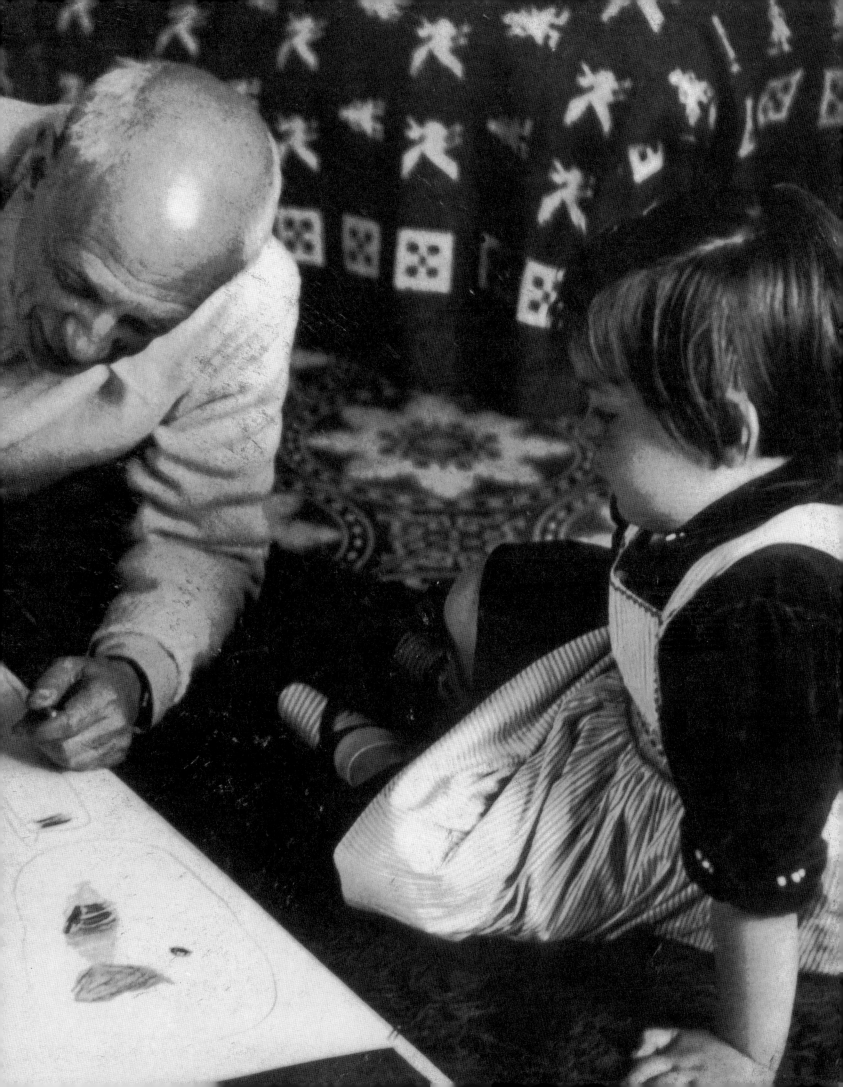